Getting Started in 3D
with Maya

As always, to my beautiful and exciting Kirsten, Anaya, and Isaiah.

Getting Started in 3D with Maya

Create a Project from Start to Finish
Model, Texture, Rig, Animate, and Render in Maya

Adam Watkins

AMSTERDAM • BOSTON • HEIDELBERG • LONDON
NEW YORK • OXFORD • PARIS • SAN DIEGO
SAN FRANCISCO • SINGAPORE • SYDNEY • TOKYO
Focal Press is an imprint of Elsevier

Focal Press is an imprint of Elsevier
225 Wyman Street, Waltham, MA 02451, USA
The Boulevard, Langford Lane, Kidlington, Oxford, OX5 1GB, UK

Notices
Knowledge and best practice in this field are constantly changing. As new research and experience broaden our understanding, changes in research methods, professional practices, or medical treatment may become necessary.

Practitioners and researchers must always rely on their own experience and knowledge in evaluating and using any information, methods, compounds, or experiments described herein. In using such information or methods they should be mindful of their own safety and the safety of others, including parties for whom they have a professional responsibility.

To the fullest extent of the law, neither the Publisher nor the authors, contributors, or editors, assume any liability for any injury and/or damage to persons or property as a matter of products liability, negligence or otherwise, or from any use or operation of any methods, products, instructions, or ideas contained in the material herein.

Library of Congress Cataloging-in-Publication Data
Application submitted.

British Library Cataloguing-in-Publication Data
A catalogue record for this book is available from the British Library.

ISBN: 978-0-240-82042-2

For information on all Focal Press publications
visit our website at *www.elsevierdirect.com*

Printed in the United States of America

12 13 14 15 5 4 3 2 1

Typeset by: diacriTech, Chennai, India

Working together to grow
libraries in developing countries

www.elsevier.com | www.bookaid.org | www.sabre.org

ELSEVIER BOOK AID International Sabre Foundation

Contents

Contents

Contents

Contents

Acknowledgments

Books are always a team effort. Of especial help with this one was the tireless work of my tech editor, former student, colleague, and friend Jake Green. His contribution toward maintaining the consistency and the tone of the book was invaluable. His work is inspiring and his progress over the years has been tremendous.

Kelly Michel and the VISIBLE team at the Los Alamos National Laboratory – where this book was incubated – also provided tremendous help. It was good fun working with that team and there are great things ahead.

Finally, in this, my tenth book, I give a special shout-out to my high school English teacher – Ms. Eva Torres back at Edinburg North High School. Her excitement for literature and writing has been highly inspiring, and I often find myself looking back on her instructions and ideas as I tidy up what I have planned to write. I graduated a long time ago – it's amazing how important that high school teacher can be. Many thanks Ms. Torres – can I get some extra credit for this….?

Introduction

3D. It's everywhere. From stereoscopic movies to online logos to billboards along the side of the road, chances are, even today you've seen 3D content. In recent years, 3D has gone from a specialty (and sometimes gimmicky) afterthought to a staple of the creative industry. The products you use were visualized in 3D before being manufactured, the streets you drive down are likely flanked by buildings that were previsualized in 3D before being built, and often the street itself (if it's recent) was created in some 3D software before construction was begun. And of course, all of this is in addition to the ubiquitous presence of 3D in most every form of entertainment and in every form of digital entertainment.

Like many new forms of digital art, at the beginning, the technology was instantly available to everyone, but the on-ramp was steep and often difficult to ascend. The area was flooded with hobbyists who could get their hands on the software, but continually produced uninspired work. This happened in the professional world as well – for all the never-ending genius of Pixar and the nice work of early Dreamworks, there emerged as competition, some really poorly conceived and even more poorly executed feature films that really besmirched the hallowed artwork of 3D animation.

Now, after many years, viewers have become more discerning in what they consider "good" 3D and 3D animation. Reviewers for games are no longer dazzled by the fact that games are 3D, but they start making real commentary on the artistry and efficacy of modeling, style, and animation choices. Movie reviews have become incredibly discerning, and substandard technique in modeling and animation is quickly caught and called out. Animation consumers have come of age.

Benefits and Drawbacks of Tool Sophistication

This is good and bad for animators or aspiring animators. It's great because as the consumer's eye for animation has grown in sophistication, the tools that allow for the production have grown increasingly robust. This means that there are many very powerful toolsets that have allowed for further power, faster, and at a lower skill set. From the early days of having to use the command line to create a cube, the current click and drag to get full cloth dynamics and fluid integration into a project is a huge leap forward. However, the bad news is that viewers of 3D are simply less impressed with another bit of dazzling technology – they demand a compelling story and a deft touch in handling the visuals of any project (game, TV, film, web, etc.). The days of blindly dazzling effects are over – consumers are just too savvy.

What this means is that the most successful 3D projects will come from people who have done a lot of work beyond the technical – people who have studied light, composition, form, and movement (just to get started). Often times, this comes from formal training (college, university, art school, etc.), but not always. There are clearly folks who are able to intuitively produce products that show these skills, and others who gain these skills in the old fashioned way – through reading and immense amounts of sweat equity to grow the skills themselves.

Having said this, no matter what the art and composition skills of the artist are, without knowledge of how to use the tool – the skills will never have a chance to be put on display. So in addition to traditional skills, the competitive 3D artist of today also must understand the tools – and how to use the tools to convey their knowledge of story or art. This book is designed to assist in getting into dynamic, complex, and very powerful tools faster, so that great artwork can find a visual voice and great work can be produced.

Who's It For?

With the goal of this book being a facilitator to help the reader gain a new instrument in your tool chest, it's worth while pointing out that there are multiple situations in which this book can be effective:

Hobbyist

So you've loved the 3D work that has evolved in recent years. It seems like magic, and more importantly, it looks like fun. The 3D hobbyist market has become increasingly sophisticated in recent years. There was a time that a bit of Bryce and some simple Poser satisfied the weekend 3D warrior. But those days are past for the most part. Today's hobbyists – like today's consumers – know that there is much to partake of in the 3D world and want to get into the craft deeper more quickly. If this is you, this book has many sections that will get you up to speed (well beyond a dabbler) in a hurry.

Because each chapter starts with some background information, it will help those of you without a technical background in 3D graphics to get a chance to understand what the core ideas are before diving into the tutorials. However, since the book is full of tutorials, you will very quickly be "doing it" – creating 3D, and producing work that will be fun to show off and fulfilling to create.

Student

I've been teaching 3D for a long time (almost 15 years now), and I have seen a lot of students come through my programs, classes, and curricula. I know how students learn 3D and how some of the concepts come quicker than

others. I also know that different students learn in different ways. Some learn aurally – they listen to a lecture and they grasp the idea and are off the races. Some learn visually – they watch the demo and seeing is learning. Still others find that careful listening and visual learning is a good start, but that some text helps cement the concepts – and a tutorial helps move the "I saw it done" into the "I just did it, and now I understand it."

This book is heavily tutorial based. It's chock full of step by step pages of "do this and then do that." For students who are using this as a textbook, or as a supplement to in-class instruction, be sure to take a moment and ask yourself "why?" Why is the author having me do this now? What's the goal behind this collection of steps? And most importantly: How can I use this technique in my own work? Do this and the book will be much more than just a collection of steps – and become a platform to creating your own projects.

Teacher

Hopefully you're out of a college or university program in which you did extensive 3D training and you're looking for a book to allow you to learn/teach a new technology to supplement your current skills. If this is your situation, this book should move quite quickly for you, and you might be able to skip past most of the theoretical discussions at the beginnings of each chapter as you learn to translate your current vocabulary into Maya-speak. But, if you're not (and this is the case at most middle schools, junior high schools, high schools, and even some colleges and universities), this book will be of great help. The "Whys" of 3D are covered in every chapter. It's critical – especially when attempting to teach this stuff – that the core ideas and principles are understood. 3D is deep and goes way beyond hitting the right tools at the right time. The questions that come up in class – and the dark alleyways of the software that students wander down – demand an understanding of what's really happening behind the GUI.

For you, the descriptions of the technology at the beginning of every chapter and tutorial will be critical. Be sure to read those parts carefully and take a careful look at how those ideas are being illustrated through the course of the tutorials. The tutorials all have a pedagogical goal that goes beyond just following the tutorial recipe. Grasp that goal and it will speed your mastery of the tool and allow you a firm footing upon which to lift your students.

Book Organization

The book has nine chapters. These chapters are split up into the basic steps of 3D creation: Modeling, UV Layout, Texturing, Lighting and Rendering, Rigging and Skinning, and finally Animation. Each of these chapters will begin with

some discussion of the core ideas of that corner of the 3D creation world. Some of it is theoretical, and much of it is metaphorical. The idea is to make sure that the concepts are introduced before getting mired in Maya's implementation of those ideas. After the Introduction, there will be several tutorials designed to illustrate how the concepts work.

These tutorials will be the bulk and meat of the book. Detailed instructions will be given on how Maya works and how to work with Maya's power and around Maya's eccentricities to create great products.

Appendices

Occasionally, there will be a technique that is a precursor to a collection of tools within Maya which may get in the way of a smooth flow of ideas in the text – or simply be out of the scope of the tutorials. In these cases, appendices have been created for some quick reference. You may already know these ideas from past Photoshop work or work in some other 3D package – but they are there in case you need them for reference.

Homework and Challenges

The real goal of this book should not be a successful completion of the tutorials. It is true that these tutorials can be an important tool in learning Maya; but they are the means to an end. The end is (or should be) creating your own projects. If all you can do after finishing the tutorials is do the tutorials again – the book has failed. Making the "great leap" into your own production is the real aim here.

To achieve that goal, each tutorial has a few short challenges. If this book is being used as a textbook, they could be great homework assignments – but if you're self-teaching and using this book to get up to speed with Maya – consider these challenges from me to you. They will help you determine if you have really grasped the ideas presented in the chapter or if the chapter should be reworked. If you are able to successfully complete the challenges – it's likely you've mastered the concepts presented and you're ready to move on.

Of course, you can skip these all together – but I've found that students who tackle these are more likely to be able to retain the ideas of the chapter when they have applied them to these mini-problems as they go along.

Why?

More important than knowing what to do next is knowing why to do it next. Throughout all the tutorials, I will be taking time to talk through the "whys" of that step. Although you could just skip over that narrative and continue onto the next step, take some time to look that over. These parts of the text will help to explain the method to the madness of the tutorials and help to ensure that you are getting the most out of the tutorials.

Tips and Tricks

In addition to the Why? sections of the text, there will be other sections that help you to make more effective use of Maya's workflow. Sometimes these sections will include hints as to workflow, other times they will remind you of keyboard shortcuts. In all cases, they aren't critical to the tutorial, but can certainly help you work smarter.

Warnings and Pitfalls

Maya is powerful, but it can be a little like weeding your garden with a backhoe; it can simply have too much power. Similarly, it is such a complex tool that it can have *too many* options for some of the simpler tasks. The Warnings and Pitfalls sections will give you the heads up on problems that are often encountered by new Maya users. These are born of many years of teaching Maya and hopefully will save you from many hours of frustration.

Other Conventions

When text is to be entered into a text field in Maya, it will appear like `this` (in Courier) in the book.

Maya has several different **modes** that allow the user to do different things. Of some considerable confusion, this means that certain pull-down menus are only available at certain times. We will talk more of this, but the mode will always be listed before a bar (|). So, "Polygons|Mesh > Combine" means to look for the Combine command in the Mesh pull-down menu, which is only available in Polygons Mode. Much more on these various modes later – but don't be looking for a "Polygons" pull-down menu (it doesn't exist).

Some of Maya's tools (that are available with pull-down menus) have options associated with the tool. This is indicated with a little square after the tool name in the pull-down menu (Fig. 0.1). If we need to access the options in the course of a tutorial, I'll indicate this with (Options). So, "Polygons|Mesh > Combine (Options)" means to be sure and move the mouse out to the options square in the pull-down menu so we can change some of the settings on the tool before the tool is finalized.

FIG 0.1 Options are available for some tools and will be represented with a square.

What You'll Need

Maya will really run on any relatively recent machine; although there are certainly better machines than others. For more information on specific recommendations, be sure to read Chapter 2 to see what to spend your money on if you don't have a big machine.

One note here though: Regardless of which platform you are running on, make sure you have a good three-button mouse (or a two button mouse with a scroll wheel that will act as the third button). I'm a Mac fan (also a PC fan), but Apple's long-time insistence on a single button mouse was silly. I'm still not a fan of Apples Magic Mouse either – yes, I know it has a bazillion buttons and the whole mouse is a multi-touch sensor and yes I love it when using things like Final Cut Pro, but for Maya, I have a blasphemous three-button Microsoft mouse connected to my Mac. You PC users out there are probably already in a good place with your mouse. Make sure that all three buttons work.

Other than a recent Mac or PC and this book, obviously you'll also need Maya. The tutorials covered in this book were made using Maya 2012; however most of the techniques have been around a long time and could be done with earlier versions of Maya as well. If you don't have Maya yet, be sure to go grab it at http://usa.autodesk.com/maya/. There is a free trial available and if you are a student there are particularly generous options (as in free); just enter "Education Community" in the search field at Autodesk's site.

Conclusion

So there it is – or here we go. Make sure you've got a computer, Maya, and this book and the beginning of the 3D journey with Maya is afoot. Now that we know the conventions of the text, let's look at how animation works and how we can think of Maya fitting into all the areas of this workflow. Please be sure to visit the book's web site, www.GettingStartedin3D.com.

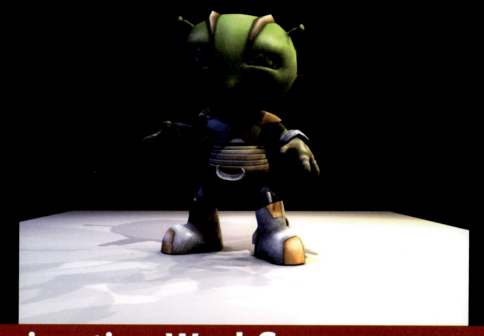

Animation Workflow

So what is 3D? The term has become a bit muddled lately with the rise of stereoscopic movies, TV, and games that have been termed "3D." For our purpose, 3D will be the process of creating forms that exist digitally in three dimensions that can then be animated and rendered from any direction.

But even in this more narrow definition, 3D can mean several things that have different goals and different technical benefits or limitations. We will generally lump them into two areas – high rez and low rez (short for high and low resolution).

High-Rez 3D

High-rez animation refers to the amount of polygons and the size of the textures used to describe the surface attributes of those polygons. The medium that high rez is usually delivered through is either film or TV. Because both of these formats are linear forms of motion pictures, what we are really talking about are many pre-rendered frames that are played in rapid succession to create the illusion of movement. Because the frames are pre-rendered (all the information of the model is assembled and "drawn" by

the computer), the fidelity of the assets rendered can be incredibly high. And in fact, in cases like film (and increasingly with TV with the rise of HD), the amount of information needed to hold up on the big screen or on high-resolution TV is pretty immense. There's little room for pixilated textures or renders.

All this information is beautiful but also intensive to work with and costly to render. It's not unusual to have a single frame of high-rez animation take many minutes or even hours to render. When film is running at 24 frames per second, an intensive render of an hour per frame can mean that it takes an entire day for 1 second of finished animation. Now generally, rendering times are carefully monitored by studios where time is really money, and individual frames are broken up into layers that allow for quite a bit of flexibility and quicker rendering times. But in any case, rendering times of even minutes a frame means that either a studio has a rendering farm of machines to do that work or there is time when just the computer has to do its work.

High-rez work is fun to do because the final product has a great deal of polish, and each frame can be carefully crafted and tweaked. In this book, we will do some high-rez work as it allows (and requires) for some special considerations in the construction of forms and textures.

Low-Rez 3D

Low-rez 3D are assets that computers can draw more quickly. The broadest and well-known instance of low-rez animation is in games. While high rez can take hours to render a single frame, games have to render at least 30 frames every single second. Tons of polygons or textures that are really huge may be beautiful, but a data set that big simply cannot be drawn fast enough by the hardware of today to make the game interactive.

Games work at a higher frame rate by using a very careful polygon count. Forms tend to be blockier as there is less information describing the form. Textures are smaller and always at a "power of two" size (much more on this). Everything that can be done to help hardware draw faster is incorporated to ensure a smooth experience for the player.

This sort of efficiency can be a formidable challenge and takes some careful consideration throughout the creation process. In this book, we will be doing some low-rez work (both a game level and a game character) that will illustrate these ideas. Fortunately, because the amount of data is lower, it's often times a great way to get started in 3D as the tool set is slightly narrower and the amount of manipulatable data is more manageable.

Now as the technology has increased, the gap between low rez and high rez has been closed. Sometimes, at first glance, it can even be hard to see the difference in low- and high-rez assets; but as you learn more about the 3D process, it will become more and more clear which is which.

The important thing is to know what is being created. Some assets may be reusable between high-rez and low-rez projects – but this is seldom the case. Know from the beginning if you're building a game or building a movie as it will control many choices in the hours, days, and years to come on the project.

Workflow

Regardless of whether someone is creating low- or high-rez animation, the term "animation workflow" is a bit deceptive. It tends to imply that there is a linear progression in the process of creating animation. In reality, animation of all types tends to be a cyclical process of creating assets, reviewing, recreating assets, reviewing, refining assets, and so on. Perhaps the only two parts of the workflow that really do reliably happen in order is that the animation starts with a sketch and ends with rendering.

However, describing that animation process as "just a bunch of things that happen" is fairly unfulfilling – and is pretty tough for the beginner to grasp. Further, it is true that very broadly speaking, some things do happen before others (a model must be created before its UVs can be laid out for instance). With this in mind, we can start to visualize how projects come together by linearly defining the process. However, as we work through these steps, keep in mind that it's a very broadly painted image and that there will undoubtedly be some fluidity of order in the process.

An Idea, a Sketch, Lots of Research, and New Inspiration

There is this myth that sometimes floats around the uninitiated that great 3D happens when someone knows 3D software well enough and suddenly the brilliance just flows out of the computer. The reality is very, very far from this. Great 3D animation almost always begins on a paper – drawn with good old traditional media of pencil, charcoal, or paints. No doubt, the final rendered digital output must pass through a computer before its final output – but there is no technical expertise that can compensate for poorly conceptualized or poorly designed projects.

This is why when students contact me before starting our program here at the University of the Incarnate Word and ask what software they should be working on – I always tell them to put the computer down and draw. It is true that there are some 3D artists who cannot draw but can create effective or accurate 3D forms; but generally, if an artist can't understand a form on paper, they can't understand it digitally.

Of course, this does not mean that 3D folks are all Leonardo protégés; and usually a good sketch artist is about all that can be expected. But drawing and

sketching develops an eye to proportion, anatomy, understanding lighting, and form development.

On the business side, 3D production is time intensive and thus costly. It is much cheaper to approve the 12th sketch of a character or game level than it is to approve the 12th digital model created.

Thus, the first step of most animation projects is planning in the form of drawings. These drawings can be maps of game levels, character style sheets, character pose studies, story boards, set designs, mood renderings, etc. Sometimes these sketches are simply out of the imagination of the artist, director, or other mastermind of a project; but sometime along the line, the critical stage of research must be taken.

Research

As part of the myth that floats around, that computers create great 3D animation (rather than great artists using computers to create great animation), is the idea that designers just sit down and great stuff just appears in their sketchbooks (or designs). In reality, great designs – whether they are game levels, movie characters, or stunning visual matte paintings – are born of research, lots and lots of research.

Here at the University of the Incarnate Word (where I teach), before students begin putting any polygons together digitally, they assemble mounds of research that helps inform their design choices. This doesn't mean that designs are simply copies of other real-world environments or people, but they make sure that the designer remembers that usually doors have frames around them, the bottoms of walls have floor boards, that breast tissue starts at the collar bone and wraps around the side of the rib cage, and that ears do not have a ledge on their front. Research helps a 3D genius to understand the cut of World War II Nazi criminals, and see the stylized muscles present in comic book heroes and how the proportions are tweaked to create epic heroes.

Take a look at any online gallery of 3D work, and there is almost always a clear dividing line of relevant detail that is missing by those who have failed to do their research. Good research doesn't guarantee good projects – but will certainly provide the visual building blocks to make sure that the 3D projects have a plausibility that the viewer will accept.

As you can see, I'm a big fan of proper research and doing the hard conceptual work on paper before working digitally. There is simply no "Make Great Animation" pull-down menu. There are rarely happy accidents in 3D; every frame is a hard fought battle and is the result of many choices made along production pathways that culminate in the finished, rendered frame. Ensuring that options have been explored quickly through sketches that are informed by good research will make sure that the production choices yield a product worthy of the blood, sweat, and tears poured into that frame.

Modeling

So assuming that the designer (which may be you) has done due diligence in researching and designing their space or character, the time comes that the first asset must be created digitally. Usually, this happens through modeling: the process of assembling the building blocks of 3D forms (called **polygons**) into shapes that define volume and shape (**Fig. 1.1**).

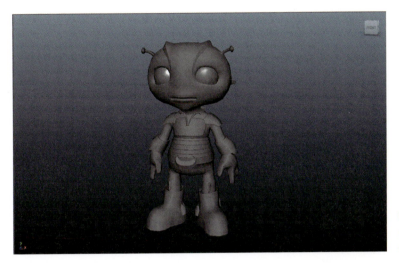

FIG 1.1 Results of the modeling process. Form is defined, but everything is gray plastic.

Maya is not actually the most amazing modeling package. To be sure, it is sufficient and has become very good in recent years in adapting techniques and tools that are seen in other packages. But to be honest, it's not my favorite – especially when high accuracy (like architectural visualization) is required.

However, the other benefits of Maya make the modeling shortfalls worth working around, and keeping the entire workflow within one package is a great way to begin work, so we will be modeling a game level, game character, and high poly bust using Maya's modeling tools.

The result of the modeling process is a collection of gray polygons that show the form of a physical space or character. It is a critical part of the process, and choices made in modeling will affect the possibilities of almost all the rest of the animation process. Poor choices of polygon organization will make animation difficult and can make proper deformation nearly impossible. Too many polygons can make a beautiful set or character unusable in certain situations (like games), while too few will yield a boxy form that simply doesn't hold up in higher resolution forms like TV and movies. Getting the modeling right – and the **topology** (the way the polygons are organized) – is very important. We will spend a good amount of time in the coming chapters talking about these considerations.

5

UV Layout

The forms that the modeling process creates can be great, but they are devoid of any of the surface attributes (color, bump, and specular highlights) that make an object look like anything by gray plastic. However, before we can start getting good textures on a surface, we have to define how that surface will attach to textures – or how textures will attach to that surface.

UVs are a coordinate system that works out how a 3D object is "unfolded" into the 2D space of textures (**Fig. 1.2**). UV mapping – the process of laying the 3D form out into 2D space – can be a bit tricky to understand. It's a bit abstract and not particularly approachable for beginning animators; but it can't be skipped over. A bad UV map takes the most amazing textures and stretches or squishes them over a surface (makes stubble on a chin look like long black scratches), so that the texture is reduced to a mushy collection of pixels that make a form look worse than before it was textured.

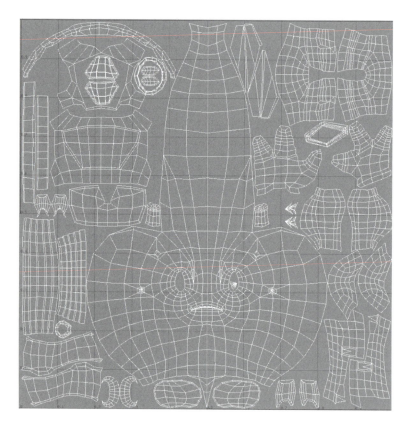

FIG 1.2 UV mapping converts 3D forms (done in the modeling stage) into 2D space where texture can be defined onto particular parts of the surface.

In the following chapters (particularly Chapter 5), we will look at UV layout very closely. Good UV layout will ensure that great textures look great on your beautiful geometry.

Texture

After the form is modeled, and the UV layout for that form is created, the textures can be painted that will be applied to that form. There are lots of terms that get thrown around and sometimes thought to be interchangeable – such as textures, materials, etc. – but there are actually some important differences between them (which we'll work through in Chapter 6); the basic idea is that "texturing" a model is the process of defining the surface attributes of that model. Is it smooth or rough? What's the color? Is the surface transparent? All of these questions can be defined with some quick texturing.

At its most powerful, the texturing process can also be used to indicate geometry. Textures can be used to make certain parts of a form transparent as though it had holes (that weren't actually modeled). Or – more powerfully – surface deformities like pock marks, scars, bullet holes, and even armor details can be defined through painted textures rather than extensive modeling. This becomes incredibly powerful in areas where the number of polygons matter – like games (Fig. 1.3).

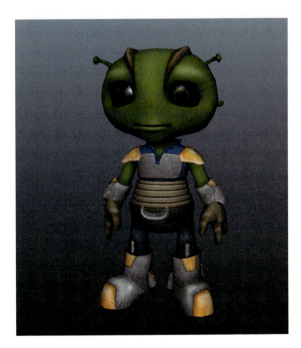

FIG 1.3 Texturing (and especially Normal maps) can add visual detail and indicate geometric forms that are only available in the texture file.

Rigging and Skinning

Rigging and skinning is the process of creating organization or deformation objects that allow a geometric form to be manipulated and animated. Usually, this refers to the characters and the process of creating skeletal structures with Maya's Joint paradigm that allows the polygons of a character to be

bent into action. It can also refer to non-organic things like vehicles (car tires rotation mechanism, shocks, weapons attached to a vehicle, etc.) or even environments (doors opening properly, mechanical elements in a scene that are kinetic, etc.).

Technically, **rigging** is the process of creating the organization or objects that deform the meshes, and **skinning** is the process of attaching the polygons to those deformation objects. They are really two different procedures and concepts but are certainly intertwined and must be mutually considered throughout the process (**Fig. 1.4**).

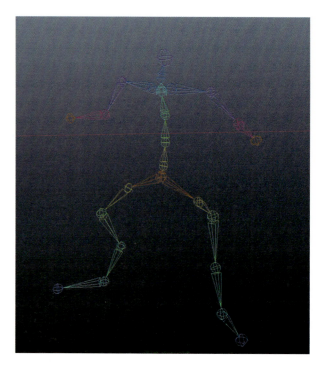

FIG 1.4 Rigging and skinning begins to bring collections of polygons to life.

Animation

This is the sexy part of the workflow. It's where all the ground work comes to life. This is where the model forms and textures, that were carefully rigged and skinned, are assigned keyframes that allow for changes over time. Animation is where the "life" of the workflow is at – it's also one of the most difficult parts of the workflow and can take an amazing amount of time.

When I'm doing character animation, if I can get a good 2 or 3 seconds of acceptable finished animation done in a day, I feel pretty good about my progress. This doesn't mean simply having a character move, but having the character move in a mechanically believable way and having him emote or

perform, so that the viewer makes some sort of connection with the pile of polygons. There's a reason why 3D-animated feature films take full studios years to complete – and it's that animation that is a multifaceted thing, which requires many, many passes to get right.

But, having said all that, animation can also be one of the most rewarding parts of the workflow. It's slow, but just makes you feel good when it's done right (**Fig. 1.5**).

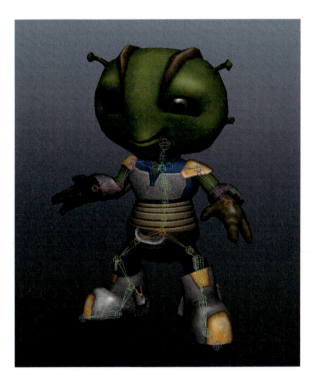

FIG **1.5** The process of animation is tough, but immensely rewarding.

Lighting and Rendering

Lighting is the process of creating and placing virtual lights that illuminate the forms being created and animated. **Rendering** is the process of the computer drawing the finished frame that incorporates all the forms, textures, animation, and lighting.

Whether to put this at the end or up with texturing is always a difficult call when laying out this sort of workflow illustration. In all reality, textures are nothing without effective lighting and rendering. I've seen many a great form be completely ruined by crummy lighting; and many a mediocre shape with uninspired textures look like a million bucks in the hands of a great lighting wrangler. So often, the process of lighting a model and figuring out how to render it occurs much earlier in the process. However, in all cases, after all is

said and done, the animation and forms must be rendered – and this is usually the last step before going to post-production (for color balancing or other tweaks) and then to editing (**Fig. 1.6**).

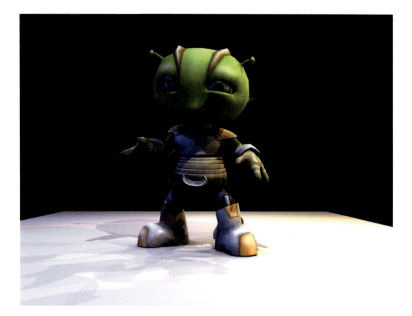

FIG 1.6 Rendering and lighting.

Flexibility in the Process

When laid out as it is in the preceding pages, the process feels very linear. Without a doubt, there are parts that are indeed sequential – you can't render until you have geometry modeled. However, it's very natural and quite usual to end up jumping back into previous steps as the process goes along: the animation is going great, but you find that there are some poses that are needed but just not reachable with the current rig – so you jump back into rigging to add functionality to the character to allow for the needed poses. Or, midway through animating, you discover that the texture that seemed to do the trick just doesn't hold up for the cinematography called for in the shot – so it is suddenly back to the texturing process. There are always times where things need to be tweaked – or assets added – as a project progresses.

Maya allows for some very flexible methodology, so that this process can indeed be fluid. Namely, it's proxy and referencing system allows for all sorts of changes to be made at all sorts of times in the process and then those changes are propagated through the project. Very powerful. It's so powerful that there is even the possibility for a rigger to build a character rig before the model is complete, and the animator to start roughing out shots using this rig long before the model, UV, or textures are done. Allowing a team to work

in parallel is an incredible option – and with a little planning is well within the realm of Maya's workflow.

There are a few things that really should be done in order (be sure to have the UV layouts done before skinning or risk watching textures crawl across a surface as it's animated); but even these sorts of steps have become less rigid in Maya's recent incarnations. When the order of events is important, we'll talk through them in the coming chapters.

Conclusion

So there's a brief sketch of the process of animation. Keeping in mind that it's flexible, the next step is understanding our tool for accomplishing these steps. In the next chapter, we will look a bit at Maya and how it works. We'll see where it came from, how it is organized (philosophically), and how we are going to use it to gain the core skills needed to create fantastic 3D work.

Maya Philosophy

Maya is currently owned by the behemoth of the 3D world – Autodesk. They have owned Maya since 2005, and few 3D softwares have as deep a market penetration or as wide a name recognition. At a recent presentation that I gave at the Los Alamos National Laboratory, there were two pieces of 3D software that this group of nuclear scientists had heard of, Blender (a free open-source competitor) and Maya. None of the other 3D competitors were even on their radar.

A Bit of History

This wasn't always so. Maya began as part of Alias Research, Inc. that ironically was first developed for the Mac. The code was ported to IRIX (the porting process was code named Maya) and joined to Wavefront Technologies, Inc., upcoming 3D technology. Silicon Graphics, Inc., which at the time was really a player, was battling it out with Microsoft, which had just acquired a rival high-end product, SoftImage.

Maya then only ran on SGI IRIX machines, which is where most old timers first encountered Maya. The first time I used Maya was on an IRIX box on a Silicon

Graphics Octane machine, which (at the time) was stunningly expensive. The Octane was many thousands of dollars, and Maya was charging a per-seat license that was thousands of dollars per year. Our lab had three machines and three licenses, and the budget was well over $100,000.

Early in its life cycle, Maya made some stunning market expansions. Maya 1.0 was released in 1998 (then usually referred to as Alias|Wavefront Maya) and quickly won high-profile clients such as Industrial Light and Magic and Tippet studios from SoftImage. By the way, SoftImage after freeing itself from Microsoft has made a real resurgence and has some really amazing technologies. Ironically, it too has recently been acquired by Autodesk – and thus is now the step-cousin of Maya, which was acquired by Autodesk in 2005.

Since 1998, Maya has been through many iterations and some confusing "Complete" and "Unlimited" editions. It made its way to Windows and into a Mac OSX version. Now, it has settled into a single version and is released as an updated version nearly every summer. Nowadays, Maya is not versioned by number, but by year – Maya 2012 is the current version as of this writing.

So What Is It?

Maya aims to be a one-stop shop, and indeed, it is an incredibly robust, powerful, flexible, customizable, expanding, and complicated tool. Most any emerging tool in 3D – from particles, to cloth, to hair, to fluids, to motion tracking – finds an early iteration in Maya. Maya is very quick to develop and exploit new techniques and ideas.

Now sometimes, this move to be on the bleeding edge can be a problem. Yeah, fluid effects are awesome – but it can be pretty hard to use for the uninitiated and takes a huge amount of development horsepower for Maya developers. And at the end of the day, how many projects really use fluid – or need realistically rendered fluid effects? In the past, this has meant that as Maya has chased the newest big things, old things like modeling tools have remained in very static forms as other competing softwares (who aren't necessarily chasing the absolute latest technology) refined their core modeling, texturing, and animation tools. For a while there, this was of great frustration as Maya showed new cloth simulations but still had modeling tools that were 10 years old, and indeed, many animators and animation houses found that supplementing Maya's tools with other more specialized tools was a good thing.

Luckily, especially since their Autodesk acquisition, Maya has made some good progress in continuing to evolve their core tool sets. It is this set of core tools (modeling, texturing, animation, and rendering) that is the basis of all 3D projects and the technology we will be exploring through this volume.

So, for our purposes, Maya is a 3D-production tool that allows us to model forms, texture them to indicate surface qualities, animate those forms, and render out the frames to sequential stills. Note that it is not a game engine (you can't really export a game from Maya). However, Maya allows for assets (including animated assets) to be exported in a variety of formats that can then be imported into various game engines and made interactive.

What You Need to Run It

In its evolution, Maya moved from IRIX to Windows, where of course its potential customer base increased dramatically (SGI machines were always powerful but expensive). More recently, it has also found a home on Mac OSX. Increasingly, the hardware required to run Maya has become available to the masses – regardless of your OS persuasion. One of the things I *really* like about Maya is that its cross-platform nature is pretty flawless. Generally, the keyboard shortcuts are even the same between Macs and PCs. Files generally flow quite well from one platform to the other (although sometimes there are some strange inconsequential error messages that show up). I will frequently work with a student who worked on a Mac at home, worked on the project in class on a PC, sent it to me where I worked with it on my PC at home and continued working with it on my MacBook Pro at school the next day, only to pass it back to the student on a PC. Few problems arise. In fact, over the course of this book, some tutorials will be written using Maya 2012 for Mac and some with Maya 2012 for PC.

Having said that, hardware matters, although not in the ways you may think. At its core, hardware (for our needs) includes a) processor b) memory c) video card d) hard drive, and e) monitor.

Processor

The processor is the brain of your system. It is important in the creation process, but is especially critical in the rendering stage. Bigger processor = quicker rendering. However, big multi-core, multi-processor systems can get expensive quickly. Generally, I advise my students to not put huge amounts of money into getting huge numbers of cores or big processors – there are other areas that their money could be better spent in. Usually, beginners have more time than money and if it takes a little bit extra to render while you sleep – that's OK. Most any processor available today will run Maya.

Memory

RAM can make a big difference for big projects. At the Los Alamos National Laboratory, we recently had a very large project, and on my machine which, at the time, had 4 GB of RAM, we were unable to assemble all of the assets. We upgraded to 48 GB, and suddenly my machine was much happier and opened

about whatever I needed. Now 48 GB of RAM is expensive and, frankly, (for most) unnecessary, but the point is that more RAM allows you to open larger and more assets (not to mention allows you to effectively run things like Photoshop at the same time).

RAM is also critical in the rendering process, and the more RAM you have, the faster your machine will render. How much RAM is needed is a tough call. With each generation of operating system getting to be an increasing RAM hog (don't even think of running Window 7 without at least 2 GB of RAM), the amount of RAM you have is no longer a luxury. As a beginner, start with at least 4 GB of RAM. It's unlikely there will be need for more than that for a while. But keep in mind that if there is a little money available, RAM is a relatively cheap way to upgrade a computer.

Video Processor

This is an area often misunderstood by people new to 3D. Especially, if you've been buying off-the-shelf hardware, you may be unaware of what a video card even is. At its core, the video card is responsible for drawing the information that the computer is chewing on to the monitor. In 3D, this is a huge consideration. A small video card means that a very small data set (meaning few objects with few polygons and fewer textures) can be drawn at a time. A small video card means that the creation process can be slow and downright painful. It can make animation nearly impossible, as the machine simply won't be able to draw the information fast enough to preview any motion.

Of further confusion, many video cards today are shared on the mother board of the computer. Stay way, way clear of these setups. A separate video card by either ATI or NVidia is really the only way to go when considering a computer system. This will allow for upgrading later (new video cards are amazingly cheap these days).

Measuring video card speed is a complicated thing, but the most basic measurement has to do with memory size. Although a simplistic measurement, a 1 GB video card will push a lot more information to a monitor than a 256 MB card, the older iMac I'm typing on now has a very hard time running a game I'm building with a team at more than 5–8 frames per second with its 256 MB video card. But when I run it on the machine next to it – my PC with a 1 GB video card, I'm getting well over 90 frames per second.

Put your money into a good video card. A gaming card is fine (no need generally for beginners to use high-end workstation cards). A good video card will ensure that the workflow continues to be smooth, and that textures, forms, and (importantly) movement is shown quickly and smoothly.

I recommend to my students to look at 1 GB cards at the least. They are easy to get for less than $100 and make a huge difference in the creation process.

One final note, I'm not compensated in any way for this recommendation. I have always had better luck using NVidia cards with Maya. I've personally worked extensively on a dozen PCs or so in my 3D workflow, and in almost every case, there have been strange occurrences (ghosting manipulators, incorrectly rendered textures, etc.) on ATI cards. Additionally, after a few hundred students; if there are strange video phenomenon, the first question out of my mouth is "what kind of video card do you have" and more times than not they answer "ATI." Sometimes the solution is found by downgrading their driver, sometimes updating the driver, but in any case, my anecdotal evidence is that Maya and NVidia work together better.

Monitor

Strangely, beginners will spend all their extra money on a bigger processor and then scrimp on the monitor. At the end of the day, you have spent a lot more time looking at your monitor than the CPU. Because of this, make sure you have a good-sized monitor that will allow you to work at a good resolution (at least 1600 × 1200). Maya has a lot of tools and screen real estate is a premium. The bigger monitor with the bigger resolution will allow much more space for content and make the size of the tools less important.

Three Button Mouse

I mentioned this in the Introduction, but if you skipped over that part let me mention this again. Maya uses three mouse buttons. No way around it. Yes, I know that there are magic key combinations on a Mac to approximate other mouse buttons, but there's really no substitute if you plan to get anything done. So, if you're on a PC, make sure you've got a three button mouse, and especially if you're on a Mac (even if you have Apple's Magic Mouse), go out and buy yourself a good ol' three button regular mouse (or a two button mouse with a scroll wheel that will act as the third button). It will save you tons of time and will put you in sync with how the commands in this book will be called out.

Conclusion

So, let's assume you've equipped yourself with a nice system (including a three button mouse) and you've downloaded and installed Maya. We've talked about what it is; let's talk about how it works.

How Maya "Thinks"

So Maya is robust. Maya is flexible. Part of the reason it's accumulated this reputation is due to its nodal structure. This is a little different than how most 3D software works – shoot, it's different than how most any software works.

Here's the idea: when you do things in Maya, you essentially create a node. Maya keeps track of these nodes in something called **History**. What this means is that an object will build up a collection of nodes that can just be thought of as a collection of instructions. So here's where it gets interesting. In most applications, let's say five things were done to an object. If there was a mistake in Step 2, it can be undone by using the Undo function to go back to that step. However, to get back to the state of things where they were earlier, the next three steps have to be done again.

In Maya, these five steps are all indicated by nodes that are accessible via the Channels Box and Attribute Editor. By selecting one of these nodes, the parameters of that node become accessible and editable. When changed, Maya automatically uses the new information in that node to recalculate all the rest of the nodes attached – it recalculates all the other instructions that are "downstream" of the instruction just altered.

Indeed, this is a powerful idea, but has a few restrictions. Objects collecting these nodes – collecting this history – can slow Maya down. Every change the user makes essentially causes Maya to relook at everything it's done to the object and redo it again.

It also means that things have to happen pretty linearly in many cases. For instance, if a model is done and then rigged and skinned, so that there are joints deforming the mesh, and then the UV map is altered (thus changing how the texture is applied to the surface), Maya distorts the model first (as per the joints) and then applies the texture (as per the UV map), but the UVs at this point are no longer in the same place as when they were applied (they've been deformed by the joints). What this means is that the texture crawls across the form and doesn't stay where it was intended to be.

Now, both of these examples are solvable. Maya allows models to be worked on without saving the History. Further, even if the History is saved through the process, if things get slow, the History can be deleted. In the joints/UV example, recent versions of Maya allow for "Non-Deformer History" to be deleted – essentially allowing changes like UV map adjustments to no longer be dynamically calculated which means the texture won't crawl across the surface as it is deformed.

The core idea here is to remember this nodal structure as we will be referring to it often through the coming tutorials. It's central to Maya's design and, like any powerful tool, when used correctly can be intensely useful or amazingly problematic if not considered.

Interface

We're going to avoid extensive interface exploration here. I always find those mind-numbingly boring and feel as though they don't really move the reader's knowledge forward much. However, a brief overview will assist in understanding how Maya works.

Figure 2.1 shows a screenshot of Maya 2012 with a quick breakdown of the various areas. These are not necessarily Maya's labels, but mine.

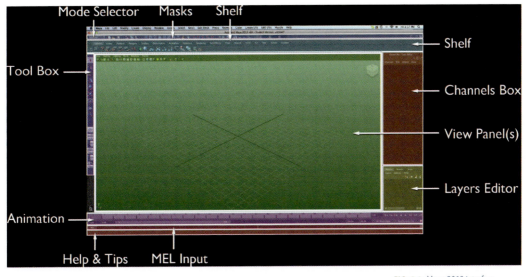

FIG 2.1 Maya 2012 interface.

View Panel

The View Panel is the panel where the models are viewed (go figure). Think of the View Panels as the viewfinder for a camera. We are looking through a camera at this digital 3D world. This 3D world by default has a grid lying on the ground to help the artist understand where things are within this digital space. This grid is only a guide and does not show up in any renders.

Notice that in the bottom left of the View Panel is a little XYZ indicator to help keep the user oriented in the 3D space by indicating the three axes. The Y-axis is the up direction (which is a different system than if you are coming from something like 3DS Max), while X and Z indicate the other two directions. These directions are important as this Euclidian grid organization is how Maya keeps track of where objects are in digital space (much more on this later).

Navigation

The way Maya allows us to understand this digital space is to allow the camera (through which we are looking) to be moved. The **alt** key is the magic button here. The alt key on both my Mac and PC is either dirty, so that you can't see the key any longer, or the text has been rubbed completely off. By using the alt key and mouse, the camera becomes mobile. Open Maya and *with the mouse inside the View Panel*, try these combos:

> **Alt-Left-Mouse Button-Drag (Alt + LMB):** Tumbles the camera. What this means is the camera rotates around the center of the world or an active object or object parts.

Alt-Middle-Mouse Button-Drag (Alt + MMB): Tracks the camera. This means the camera acts as though it was on tracks and can move side to side and up and down in a flat plane relative to the active object or object parts.

Alt-Right-Mouse Button-Drag (Alt + RMB): Dollies the camera. What's happening here is the camera is moving closer or farther from the active object or object parts. Note that it's not zooming; we aren't changing the virtual camera lens. Rather, the camera itself is moving closer or farther away from the object.

Tips and Tricks

Alternately, if your mouse has a scroll wheel, this can be used to dolly the camera as well. I tend to use Alt + RMB from my old IRIX days when the mice really did have three buttons (and no scroll wheel) and I find that I have more control with Alt + RMB. But my students – who laugh at my three button mouse – tend to do just fine with the scroll-wheel. So do what works best for you.

Orthographic Versus Perspective

The View Panel can actually be split into multiple panels to view the models from multiple cameras in multiple ways. Try this as an experiment. Still in Maya, move the mouse into the View Panel. Hit the Spacebar quickly and watch the View Panel change to four panels (**Fig. 2.2**).

FIG 2.2 Splitting the View Panel into four by hitting the Spacebar.

What this is doing is showing the same space from four different viewpoints. The top right, labeled "persp" for perspective, is the view that we had just seen. Think of this again as the viewfinder of a regular video camera. Perspective works as you'd expect (vanishing points and all that); objects farther from the camera are smaller than those closer, etc.

The interesting part is the other three View Panels: top, front, and side. These are a little unintuitive, but very useful View Panels. These views are clearly different than the persp View Panel. This is because these are **orthographic** View Panels.

Take a look at **Fig. 2.3**. It shows a character model with a bunch of spheres surrounding him. The View Panel has been split into four (persp and the three orthographic views, top, front, and side). The first thing to notice about these three orthographic views is that the grid is flat to the camera – it's not laying flat on the floor. Now look carefully at those spheres. In the perspective View Panel (persp), the spheres that are closest to us are larger while those farther away appear smaller (as they would through a "real" camera). But in the other three View Panels, all the spheres are the same size – regardless of their distance from us.

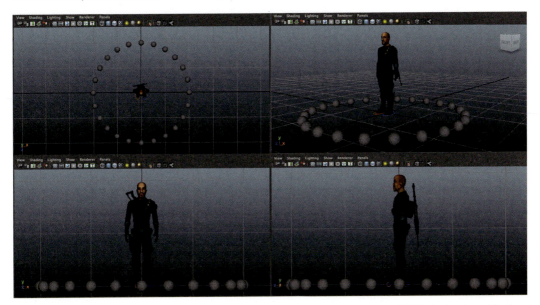

FIG 2.3 Looking at a model in the perspective and three orthographic views. Notice that the orthographic views have no perspective and thus spheres closer to us appear the same size as those that are far away.

Tips and Tricks

This model is from another Focal Press book *Creating 3D Games with Unity and Maya*. That book takes basic Maya instruction and expands it specifically into creating interactive 3D games. After you master this volume – if you're interested in 3D games—that would be a great one to move on to.

What's happening here is that the orthographic views (sometimes called "ortho" for short) are only displaying two of the three dimensions. Take a close look at the XYZ indicator in the ortho View Panels and notice that while two

are easily seen, the third axis – the one coming straight out toward the viewer in any of those panels—is kind of covered. So, in the top View Panel, we are seeing the X and Z axes, but the Y can't be seen. The same for the front (Y and X are visible – Z is not) and side (Y and Z are visible – X is not).

At first blush, this seems like a complete waste of space; it's not how we see the world, so what would be the usefulness here?

Well, there are some real limitations to the perspective View Panel that can actually get in the way of effective understanding of the 3D space. In the real world, our eyes give us some further hints about the world around us that this view does not. First, there tends to be a lot more objects to help us judge distance and the size of an object, but there are other things like depth of field that communicate to our brain where things are in space.

Try this, put your finger up in front of you and focus on that finger. Note what happens to the background – it goes blurry. Alternately, with your finger still out there, focus on the wall behind the finger and note what your finger does (blurry again). This means that if you're holding a marble in front of your face, it may visually be the same size as the moon behind it, but depth of field is letting you know that they aren't next to each other in depth, and thus are not the same size.

In that perspective View Panel, there are no such visual clues. The grid on the ground helps some, but there could be two spheres in space – one that is an inch across and close to the camera, and a second that is a mile across that is very far away from the camera, and with the right camera angle could appear to be next to each other and the same size. In the orthographic views, this would never happen (**Fig. 2.4**). The two spheres are easily seen as their respective sizes and their relative positions.

FIG 2.4 Strange illusion of two spheres with a different size that can appear as the same size in the perspective views, but clearly are not – as can only be seen in the orthographic views.

Now, of course, in the persp View Panel, as soon as the camera was moved from the location in Fig. 2.4, the difference in size and relative location becomes clear. But for beginners, often the camera just isn't moved enough and great confusion ensues. Many times in the first day of the 3D I course, I teach here at UIW, a student will be working on the first project (a primitive character) and will have built nearly the entire model from the persp View Panel, and because they haven't moved the camera, put all the parts in places that made sense from that view, but were actually in all sorts of strange places in digital space. They are horrified to discover that nothing lines up as soon as the four panels become visible, or they actually move the camera.

Consider this other benefit of the orthographic View Panels: When moving objects, the mouse only moves in two dimensions across the screen (up/down and left/right), but we are working in three dimensions. Maya solves this problem by moving objects along what's called the **view plane** in any View Panel. This view plane is a plane that is perpendicular to the camera – which means that in perspective, it will likely be tilted in relation to (or not parallel with) the floor or walls of a room. This means that when a piece of furniture is selected and moved in the persp View Panel, it likely moves up and down (above or beneath the floor) in addition to being shifted around the room.

Alternately, if a piece of furniture that is sitting on the ground is moved in the top View Panel, the furniture is then only being moved in the X and Z directions (*not* in the Y), and thus, it stays right on the ground.

It is for reasons like these that I always recommend to students to work with all four View Panels open. Later, they become comfortable enough with 3D space and camera manipulation that they might do most of their work in just the persp view – but even then, there are times when those orthographic views make for more efficient manipulation.

Back to One View Panel

A couple of final notes about these View Panels. First, when they are split into these four View Panels, any one of the View Panels can take up the full-sized View Panel space by moving the mouse into the space of that View Panel and hitting the Spacebar again.

The space these View Panels take up can be adjusted in all sorts of other ways too. A View Panel can show the Graph Editor (an animation tool) or the Hypershade window (a texturing tool). There are a few preset layouts at the bottom of the Tool Box and highlighted in **Fig. 2.5**. Clicking on any of these will create some layouts that are specialized for different types of tasks. Alternately, if you're having trouble getting back to the regular four panel layout, the top two saved layouts there will do it.

FIG 2.5 Saved layouts at the bottom of the Tool Box.

Tips and Tricks

OK, actually I don't know if this should be a Tips and Tricks or a Warnings and Pitfalls. Figure 2.6 shows something that Maya calls a "Cube Compass." What it is is a collection of buttons that allow the active View Panel to show the scene from a different view (including going directly from perspective to an orthographic front, right, left, top, or bottom and 45° views). It's pretty fun to play with, and a lot of my incoming students quite enjoy using this to change their view (as opposed to splitting to four views). I prefer not to use it, as these same students sometimes get all mixed up because this tool allows the persp View Panel to be turned into a front ortho view (even though it's still labeled as persp). Most long-time 3D artists that I work with don't mess with this tool – they see it as a gimmick, but if it helps you in your workflow (as it does many of my students), then rock on.

FIG 2.6 Maya's love-it-or-hate-it Cube Compass.

Other Notes About the View Panel

There are a few other things to note about any View Panel:

1. By default, the View Panel draws things as wireframe – which means the edges of the polygons are shown, but nothing looks solid. The number 4 on the keyboard (not the number pad) will display the contents of a View Panel as wireframe. The number 5 makes it solid (Smooth Shaded), 6 shows any textures that may be applied in the scene (Smooth Shade with Textures), and 7 shows it with an approximation of the lighting. We'll review this later as it will be important, but as reference this is how the view is changed. Do note that hitting 4, 5, 6, or 7 will apply the display change to whichever View Panel the mouse is within.

2. Figure 2.7 shows the bar across the top of each View Panel. We won't go through every single detail of all these pull-down menus or buttons (the names of each will show up in the Help & Tips line of the interface when the mouse is moved over them). Suffice it to say these separate pull-down menus allow for customization of an individual View Panel. Most of these buttons are available via other pull-down menus as well, but for View Panels often it's easiest to (for instance) turn off the grid by simply toggling these buttons.

FIG 2.7 Custom pull-down menus and buttons at the top of each View Panel that allow for the View Panel to be configured.

3. **Figure 2.8** shows what's called a Hotbox (sometimes also referred to as Marking Menus). The way it is displayed is by pressing and holding the Spacebar. Notice that there are lots and lots of words there that happen to correspond to Maya's pull-down menus. Maya allows for nearly the entire interface (but the View Panels) to be hidden (try hitting Cntrl-Space). But the many options of the interface are available either via keyboard shortcuts or via the Hotbox combinations. When pressing the Spacebar and then clicking right in the middle of the Maya area, Fig. 2.8 will appear, which then allows the user to change the View Panel to some other view (i.e., side orthographic view). Some really old-school Maya users are big fans of Hotboxes and use them with such ferocious speed that it can be hard to track what they've just done. We won't be using many Hotboxes in the tutorials – we'll be accessing commands the old fashioned way: via pull-down menus.

FIG 2.8 Hotbox switching of View Panels.

Tool Box

The Tool Box is a pretty aptly named part of the interface. This includes the most used tools in Maya's arsenal labeled in **Fig. 2.9**.

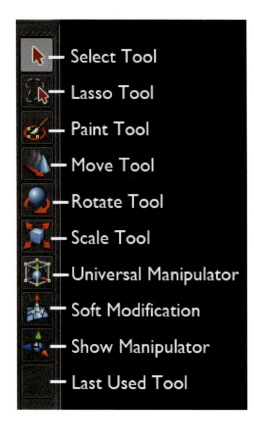

FIG 2.9 Maya's Tool Box.

To understand how these tools work, we need to make something; we'll do this in a mini-tutorial.

Tutorial 2.1 Tool Box Exploration:

Step 1: Choose Create > Polygon Primitives > Interactive Creation.

> **Why?**
>
> By selecting this, it's actually being turned off (the check mark next to it will disappear). We're actually moving a few versions of Maya backward by doing this, but it makes the creation of some objects a little smoother.

Step 2: Create a cube by selecting Create > Polygon Primitives > Cube. This will create a cube sitting right in the middle of the digital space (0,0,0).

Why?

This is what turning off Interactive Creation did. When Maya is told to create a cube, it automatically creates a cube that is one unit wide, by one unit deep, by one unit tall that is sitting right smack dab in the middle of the digital world.

Step 3: In the persp View Panel (move the mouse into that space), hit 5 on the keyboard to draw the cube solid.

Step 4: Click anywhere *besides the cube*. This will deselect the cube.

Step 5: Choose the Select Tool and click on the cube to select it (it will highlight green). Pretty straightforward, eh?

The Move Tool

Step 6: Activate the Move Tool (**Fig. 2.10**).

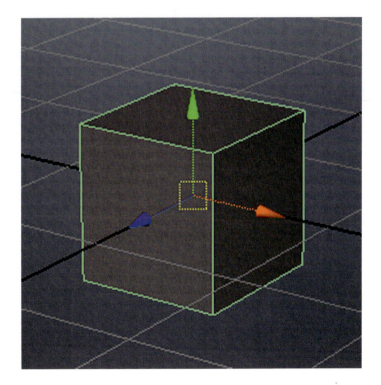

FIG 2.10 A selected object with the Move Tool active.

There is quite a bit happening here that we need to talk about. The first is the important issue of Maya's workflow. An object must be selected first before something can happen to it. Now, we selected it using the Select Tool, but it could also have been selected with the Move Tool directly (or for that matter,

the Rotate or Scale Tools as well). Second, when an object is active and the Move Tool is activated, the **Manipulator** is presented. This manipulator handle is actually four handles in one.

The first is the yellow box in the middle. Clicking and dragging on this handle will move the selected object along the view plane. Some people think of this as a "free move" but it's actually moving along that imaginary plane that is perpendicular to the camera. The other three handles are the three-colored cones. These handles move the active object only along one axis. Clicking and dragging any of these cone handles (or the stem beneath the cone) will first turn the handle yellow and second move the object only along the axis of the handle (red = X axis, blue = Z axis, green = Y axis). Try it.

Last little bit about this tool. Ctrl-clicking on any of the handles will turn that axis off. **Figure 2.11** shows the cube before this is done and after. Note that the center yellow square has changes from being flat to the camera to being flat along the XZ plane. If the object is now moved via the middle yellow box, the object will only move along the X and Z axes. Ctrl-click on the yellow box to turn all the axes back on and have the object move along the view plane once again.

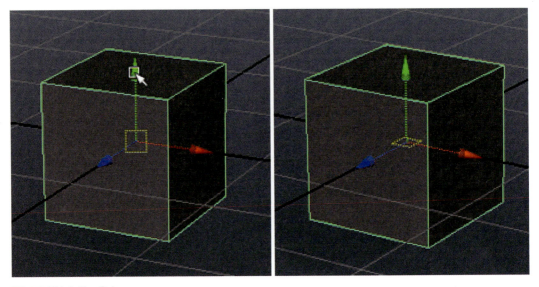

FIG 2.11 With the Move Tool, a single axis can be turned off by Ctrl-clicking the directional handle that you wish to turn off. Ctrl-clicking the center yellow box will activate all axes again.

Step 7: Use the Move Tool and move that cube all over the place. Constrain move it with the directional handles and move it along the view plane with the yellow center handle. Just experiment for a minute.

The Rotate Tool

Step 8: With the cube still selected, activate the Rotate Tool from the Tool Box (**Fig. 2.12**).

FIG 2.12 An active object with the Rotate Tool active.

What's happening here (again) is that there are really four tools – or at least handles in one. Each of the rings in Fig. 2.12 represent an axis around which the active object can be rotated. Drag the yellow circle and the object rotates around the view pane's axis. Dragging the red rotates the object around the X, the green around the Y, and the blue around the Z.

There is actually another handle that's invisible. If you click and drag in the middle of all these handles – but not any one of them, the object can be rotated in all directions; a sort of free rotation.

The Scale Tool

Step 9: Finally, and to carry on with a theme, with the object still selected, choose the Scale Tool from the Tool Box (**Fig. 2.13**).

FIG 2.13 An active object with the Scale Tool chosen.

Again, this has four handles as part of the main manipulator. The yellow cube in the middle allows the object to be scaled in all directions at once. This is important when the proportions of the object need to be maintained. You can guess that the other cubes (or the stems beneath the cubes) allow for constrained scaling: the red cube scales along the X axis, green along the Y, and blue along the Z.

Power of Maya's Selection System

So back to selecting. I know this seems like we're moving backward, I mean we've already looked at the Select Tool and seen how the Move Tool, Rotate Tool, and Scale Tool all will allow objects to be selected. The issue comes in selecting (or deselecting) when the scene has a lot of different objects within it. To understand how it works, follow the following steps:

Step 10: Use the Move Tool to move the cube off the center.
Step 11: Use Create > Polygon Primitives > Cube to create another cube. Again move this to a new location.
Step 12: Repeat the last two steps a few times so that you have six to ten cubes (Fig. 2.14).

FIG 2.14 Multiple cubes. The exact number and placement isn't important. We just want a few cubes that aren't overlapping sitting around.

Lasso Tool

Step 13: Activate the Lasso Tool and simply draw (by clicking and dragging) around a selection of cubes (Fig. 2.15). The results will be multiple objects selected (some highlighting white and one highlighting green).

FIG 2.15 Highlighting with the Lasso Tool (red highlight added on left) and the resulting selected objects (on right).

Tips and Tricks

Ironically, I hardly ever use this tool, especially on objects (although on occasion, it becomes useful for components (more on this later); I just often find it quicker to simply select the objects I want directly. But being able to draw around desired objects is so intuitive, the tool is worth highlighting.

Adjusting Selections

Importantly and powerfully, there are lots of ways to adjust a selection. Maya has one of my favorite paradigms for this; but takes a bit of early experimentation to understand.

Shift Selecting

Step 14: Switch to the Selection Tool. Shift-click on any of the cubes not selected. This will add this cube to the collection of selected objects.

Step 15: Now Shift-click on any cube that *is already selected*. This will remove the cube from the collection of selected objects.

Step 16: Now Shift-drag (called marqueeing) around all the cubes. What will happen is the cubes that are selected will be deselected and those that are not will become selected.

Why?

This is little different than the way most graphic programs work (and most 3D applications as well). Shift-selecting is a double-edged sword that selects and deselects depending on whether the object being clicked on is active or not. This means that selection work can happen quickly. With a quick Shift-marquee, everything that was selected will not be and everything that was not selected is now selected.

Ctrl Selecting

Step 17: Ctrl-click on any cube that was selected. This will deselect it.

Shift-Ctrl Selecting

Step 18: Hold the Shift *and* Ctrl buttons down and marquee select all the cubes. This will add everything to the existing collection of selecting objects.

Why?

So here's the cheat sheet. Shift-clicking or Shift-marqueeing toggles whether an objects is selected or not. Ctrl-clicking or Ctrl-marqueeing *always* removes from the selection. Shift-Cntrl-clicking or Shift-Cntrl-marqueeing always adds to the selection.

Tips and Tricks

Now for the last few steps, we have been using the Select Tool. However, it's important to note that this functionality of selecting (along with Shift, Cntrl, and Shift-Cntrl) also works while the Move, Rotate, or Scale Tools are active.

Objects versus Components

Thus far, we have been working exclusively with cubes. We have been selecting and manipulating the entire cube object. However, it's important to understand that Maya thinks of objects as a sum of parts.

These parts are called **components**. Components actually differ depending on what type of object is being dealt with in Maya. We will talk about the different types of objects more later, but let us look at the component types for the polygon objects we currently have in the scene.

Step 19: Right-click-and-hold on any of the cubes in the scene. A Hotbox will be presented that (among other things) presents the components available for the object. For polygons, these are the useful Edge, Vertex, Face, and UV; and some less used Vertex Face and Multi. Note also that there is also an Object Mode (more on this later).
Step 20: Choose Face (**Fig. 2.16**).

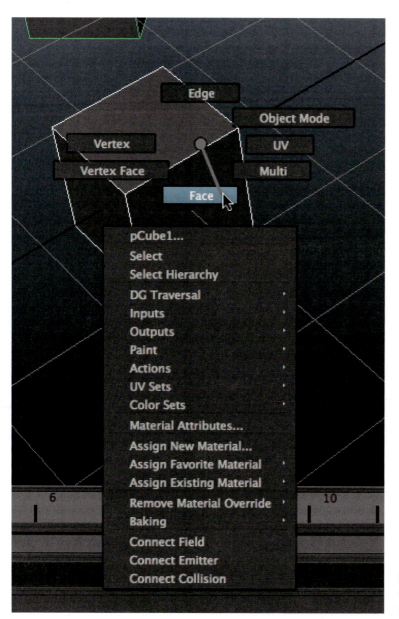

FIG 2.16 Telling Maya that you plan to work with the faces of the form by right-click-holding on an object.

Why?

Here you are telling Maya, "Oi! I want to start manipulating the faces of this object – not the entire object." This is where 3D projects are able to increase dramatically in sophistication – once you can move beyond the primitive forms of a cube or sphere, most any shape is available.

33

Step 20: Swap to the Move Tool, select any of the faces of the cube and use the Manipulator Handles to move that face (**Fig. 2.17**).

FIG 2.17 Once a face is selected, it can be moved, scaled, or rotated.

Paint Selection Tool

The selection paradigm we've looked at previously with all the Shift/Ctrl/Shift-Ctrl combos works for components as well. However, there are some additional tools within the Tool Box that now can come into play.

Step 21: Activate the Paint Selection Tool. Paint across faces on the cube (**Fig. 2.18**).

FIG 2.18 Using the Paint Selection Tool to paint across faces.

Tips and Tricks

Press and hold the B button on the keyboard and click-drag the mouse left and right. A little red circle will appear that dragging the mouse will alter the size of. This will allow for being able to select a whole lot of components at once (with a big brush) or pin-point components (with a small brush).

Warnings and Pitfalls

This tool can be a little finicky. Sometimes, even when in component mode and even when you've defined that the goal is to select faces; when this tool is first activated it defaults to vertex. If this happens, while in the Paint Selection Tool, just right-click on the object again and choose Face (or whatever component type you're after).

Soft Modification Tool

Much more on this tool later, but in the interest of a rundown of the Tool Box we'll look at it here. The Soft Modification Tool allows for a collection of components to be selected and modified quickly. The real benefit of this tool is that the influence of modifications falls off the farther away from the manipulator handle the components are.

> Step 22: Swap to Object Mode. Do this by right-clicking-hold on the cube you've been working with and choose Object Mode from the Hotbox.
> Step 23: Swap to the Selection Tool and marquee around all the cubes. (Which will select all of them. Hit Delete on the keyboard to get rid of them.)

Why?

Cubes are nice for many illustrations, but for things like the Soft Selection Tool that works great for shapes that have a lot of components, the effects can be better illustration on other types of objects.

> Step 24: Choose Create > Polygon Primitives > Sphere. This will create a sphere in the middle of the scene.
> Step 25: Click away from the sphere to deselect it.
> Step 26: Activate the Soft Modification Tool.
> Step 27: Click anywhere on the sphere. It will likely turn completely yellow and a manipulator handle not quite like anything we've seen so far will appear (**Fig. 2.19**).

FIG 2.19 The Soft Modification handles manipulator handles.

> **Why?**
>
> Notice that this manipulator has iconography that represents the Move Tool (cone ends), scale (cube ends), and rotate (light blue circle). This is because, all at once the components within the yellow area can be moved, scaled, or rotated (depending on which part of the manipulator handles are used).

Step 28: Adjust the area of influence by holding the B key down and click-dragging to the left to make it smaller (**Fig. 2.20**).

FIG 2.20 Adjusting the falloff of the Soft Modification Tool.

Step 29: Grab the manipulator handles right in the middle and move this soft selection off to the side (**Fig. 2.21**).

FIG 2.21 Using the Soft Modification Tool to manipulate a collection of components.

Why?

To understand the power of this tool, take a look at **Fig. 2.22**. The left hand of the image shows the effects of the last few steps. See how this deformation is smooth? The right hand image shows how this would look by simply selecting the components and using the Move Tool to move them. It's easy to see that hard edge between the vertices (more than one vertex) that were moved and those that weren't. From here, it would be a real hassle to get that soft falloff that the left side has.

FIG 2.22 Moving components directly (without the Soft Modification Tool).

Universal Manipulator

This is a relatively recent addition to the Maya tool set. As such, there aren't very many old timers who use it. However; if you understand the Move, Rotate, and Scale tools, when this tool is activated, it should become clear what this tool is meant to do: everything.

> Step 30: Back in Object Mode (choose the Move Tool, and then right-click-hold on the cube and choose Object Mode from the Hotbox), select the sphere.

Tips and Tricks

If an object is selected, Maya will highlight it green (or possibly white if there are more than one objects selected). But if Maya still thinks it is selecting a component, the object will display highlighted as light blue.

> Step 31: Activate the Universal Manipulator Tool (**Fig. 2.23**).

FIG 2.23 The Universal Manipulator. Note there are handles to Move, Scale, and Rotate the object.

> ### Why?
>
> It's an interesting tool. The manipulator handles in the middle of the form allow it to be moved; the light blue squares on the corners of the containing cube allow the form to be scaled, and the rotated arrows on the edges of the containing cube allow it to be rotated. It's a fascinating idea and seems like it would be all sorts of handy. It becomes even more powerful when the handles are used in combination with the Shift and Ctrl buttons (Shift-dragging one of the scale blue squares scales in all directions for example). You may find it to be of great help in your own modeling workflow.

Show Manipulator Tool and Last Tool Used

These are the last tool areas of the Tool Box and are two areas we won't cover here. The first, Show Manipulator Tool is very useful in certain corners of the Maya workflow (especially UV mapping); but a little obtuse to explore here, so we'll wait. The second is just an empty space and will change depending on what Maya is doing. What happens is any tool that is used will appear here; so if the user then swaps to the Move Tool for instance, they can quickly swap back to the last tool used by selecting it here in the Tool Box.

Keyboard Shortcuts

Maya's interface is broad and deep. And if you have to click on every single tool used you will be slow and your wrist will be shot at the end of the day. Because of this, Maya has assigned some keyboard shortcuts to these often used tools. The shortcuts move across the keyboard as they move down the Tool Box:

Q: Selection Tool
W: Move Tool
E: Rotate Tool
R: Scale Tool
T: Show Manipulator Tool

Swapping between Move, Rotate, and Scale Tools especially via keyboard shortcuts will save a great deal of time.

Channel Box

The Channel Box is a wealth of information and a spot of incredible manipulation potential. When an object is selected, the Channel Box (**Fig. 2.24**) will display both the nodes that Maya is keeping track of in history (in Fig. 2.24, the polySphere1 is the node that created the sphere) and the relative Transform nodes (the position (Translate), rotation, and scale values).

FIG 2.24 The Channel Box for the selected sphere.

This provides information, but notice all of the input field there. From here, a user can numerically manipulate the objects position, rotation, scale, and visibility. Additionally (depending on the history), this can be used to do things like increase/decrease the number of polygons used to create the form or make other changes to nodes that are created through the creation process.

We will do much with the Channel Box in coming tutorials.

Outliner

The Outliner is an incredibly handy tool that really should be built into Maya's default interface. Figure 2.25 shows the Outliner (the big area on the left) built into the interface using the layout present that the mouse is over. The Outliner is also accessible via Window > Outliner.

What the Outliner *is* is a list of objects and/or nodes in the scene. So for instance, in this case, the Outliner shows the four cameras (persp, top, front, and side) as well as the pSphere visible and selected in the scene. The Outliner will also show other nodes (in this case, the defaultLightSet and defaultObjectSet (more on these later); but is more useful as a list of the objects in the scene and their organization.

FIG 2.25 The Outliner nested in the interface.

Later, we will be grouping things together (this is actually an important part of the construction process) and will be spending a great deal of time naming objects. If any object is double-clicked in the Outliner, it can be renamed. Objects can also be rearranged and parented directly within the Outliner.

When I work, I almost *always* have the Outliner visible; either nested into the interface like in Fig. 2.25 or floating on a second monitor. It provides information about exactly which object is selected, allows objects to be selected by name (by clicking the name of an object in the Outliner), and the ultimate reorganization of objects. It's a critical tool to understanding the scene being built.

Modes

This can be really confusing for new Maya users. We alluded to this earlier, but Maya is such a big program that many of its pull-down menus are not even visible unless we are in the correct **Mode**.

Figure 2.26 shows the top left corner of the interface. This really allows the pull-down menus to show tools relevant to the task at hand. If Animation is the active mode, then all of the pull-down menus right of the Assets pull-down menu will change to show the animation-centric tools. Change this mode drop-down menu to *Polygons*, and suddenly all the pull-down menus right of Assets turn to polygonal modeling menus and tools.

This can be tough for newbies as we've grown accustomed to the top pull-down menus always remaining constant, and it can be frustrating and confusing to be unable to find a pull-down menu that was just there a second ago.

<figure>FIG 2.26 The Modes of Maya.
Changing these will change the
pull-down menus that are visible.</figure>

To help keep this straight, over the course of this book, we use the convention
Mode | Pull-Down Menu > Command. So Animation | Skeleton > Joint Tool
means look for the Skeleton pull-down menu that will only be visible while in
Animation mode (you would have to change the mode to Animation if you're
in some other mode).

Interface Wrap Up

The other areas of the interface (notably, the animation areas, the Layer Editor,
and Masks—and a host of other tools near the Masks) will be covered in other
tutorials. Note that we've completely glossed over the Shelf. The Shelf is a
place to store tools – or rather store the icons of tools. It's on purpose that this
hasn't been covered – and in fact won't be used.

In this book, I will be referring to tools (other than the Move, Scale, Rotate, and
Select Tools) by their pull-down menus. Part of this is for ease of access in a
book form as it's easier to call a tool out by its exact name and location than
to try and describe the icon in the interface. But also, I've found that when
students are able to find the tool by name they begin to connect how Maya is
putting things together. They understand Maya's naming functionalities which
assist in communicating with other artists and they begin to understand more
of what the tool does rather than what it looks like. I'm just not a big fan of
iconography.

Now with this comes a disclaimer. The Shelf area allows for custom shelves to
be created, which can be a great place to store a collection of tools that are a

vital part of your workflow. After you are a master of Maya, you will find the Shelf handy; but for the learning of it, we'll steer clear of the Shelf.

Projects

When creating things in Maya what is really happening is a variety of files are being assembled to create a new asset. What is really more accurate is that a lot of assets are being linked together within a Maya file to create a new project. The difference here is significant: Maya does not actually *import* things like texture files that are used on objects. Rather, it simply links to where that texture file lives on the hard drive. There are a wide variety of files that Maya accesses throughout the production process (everything from shadow maps to cloth caches) that are not contained within the Maya file (called a **scene**).

Because of this, allowing Maya to keep track of where these various assets are is critical. It's really tough to open a scene and find that everything in the scene is completely black because Maya doesn't know where the textures are that it used to create the scene.

To aid in this, Maya uses something called **Projects** to contain all the relevant assets. A Project can contain many Maya scene files that are part of a larger whole. A Maya Project will also act as the container for files that Maya outputs (like renders for instance).

Projects become especially critical when multiple users are working on a Project or (especially important for students in a lab situation) when an artist is working on more than one machine (say their home machine and a school machine for instance). If all the assets are in this Project, Maya can simply be told what the active Project folder is, and suddenly Maya can make all the necessary linkages.

Don't take the Project (creating, setting, storing) lightly. The sooner a student masters the idea of Projects, the smoother their creation process goes.

In the following tutorial, we will create a Project in which we will create one of several of the Projects we will create in this book.

Tutorial 2.2 Setting Projects for "Escaping the Madness"

The first Project we will be tackling in this book is a game level. This will allow us to understand Maya's object creation and basic modification tools. Over the course of the coming chapters, we will model, UV map, texture, light and render the level. Should you have the desire, the model could be taken into your game engine of choice and made interactive.

But, before we start making the very first object the Project needs to be created so as we move from chapter to chapter, from concept to concept, and asset to asset, we can keep things together.

Step 1: Choose File > Project Window (**Fig. 2.27**).

FIG. 2.27 The Project Window.

Tips and Tricks

The Project Window allows us to create new projects and define where they are. Notice that by default it has a bunch of input fields (Scene, Templates, Images, etc.). These are already filled in with names. Generally, these default names work great and I recommend leaving them as is, as this is the paradigm that other artists will likely be working with and if someone ever inherits your Project this will ensure they know where to look for things.

Step 2: Click the New button (top right of the interface).
Step 3: Name the Project in the Current Project input field to `Escaping the Madness`.
Step 4: Click on the folder icon at the end of the Location input field and choose where you want to store (what will become) the new Project folder (**Fig. 2.28**).

FIG 2.28 Project Window ready to fire the creation of the new Project.

Step 5: Click the Accept button. Then go find where you defined the folder to be (**Fig. 2.29**).

FIG 2.29 The results of creating a new Project.

Name	Date Modified	Size	Kind
▶ assets	Today, 5:23 PM	--	Folder
▶ autosave	Today, 5:23 PM	--	Folder
▶ cache	Today, 5:23 PM	--	Folder
▶ clips	Today, 5:23 PM	--	Folder
▶ data	Today, 5:23 PM	--	Folder
▶ images	Today, 5:23 PM	--	Folder
▶ movies	Today, 5:23 PM	--	Folder
▶ particles	Today, 5:23 PM	--	Folder
▶ renderData	Today, 5:23 PM	--	Folder
▶ scenes	Today, 5:23 PM	--	Folder
▶ scripts	Today, 5:23 PM	--	Folder
▶ sound	Today, 5:23 PM	--	Folder
▶ sourceimages	Today, 5:23 PM	--	Folder
workspace.mel	Today, 5:23 PM	4 KB	Maya ...l script

Why?

What has happened here is that Maya has created a new folder called "Escaping the Madness" and populated it with a collection of new folders and a file called workspace.mel. Workspace.mel will keep track of interface changes you make – so if any changes to the interface are made (like nesting the Outliner) – these changes will be remembered the next time you open the Project. The other folders are where we and Maya will store necessary files and assets.

The second important thing that has happened here is that Maya knows that this is the active Project. It means we know where to store things and Maya knows where to find them.

Conclusion

And with that we'll wrap up the chapter. We now have looked at how Maya thinks a bit. We can create and manipulate objects in a very broad sense and have created a Project that will hold our assets.

In the next chapter, we will start roughing out our game level and really get to it.

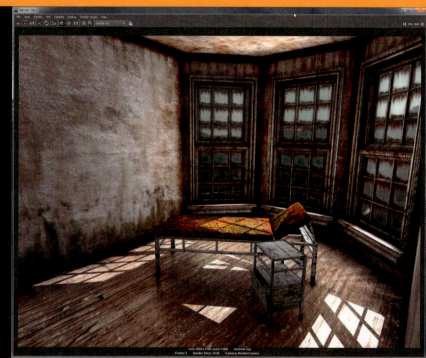

Architectural Modeling

As is true with most all of 3D, there are several ways to accomplish a particular look or shape. In Maya, this is especially true. When you are looking at the mounds of research, you will have done before a project and are trying to plot out how to model a particular shape, there will actually be quite a few methods that will present themselves. Picking which is best for which situation is the key.

In order to efficiently pick the best method, it's important to understand a bit about how 3D software works, and how we see what we see when looking at 3D forms.

The Polygon

Figure 3.1 is a portrait of the star of the 3D show – the **polygon**. The polygon is both the star, and the smallest of players – it is what all forms (that we see) are made of.

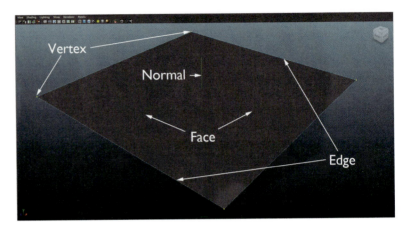

FIG 3.1 The polygon and its parts.

Parts

Polygons have several component parts (which we've referred to in the last chapter). These components are labeled in Fig. 3.1. Let's talk about them for a minute:

Face: This is what we intuitively think of as the polygon. It's the surface that we actually see. While it has a width and height, it has no depth – it's infinitely thin.

Normal: A polygon's normal is simply its front. The simplest way to think of this is that every polygon has a front and a back, and the normal (by default) runs perpendicular to the front of the face. This can be a little abstract until it's seen in action (which we will examine in a little bit); but this becomes very important in situations like game creation because games (in order to draw things faster) don't draw the backs of polygons. So, if the normal of a polygon is facing the wrong way, the polygon isn't seen within a game engine. Normals can be further tough to understand because they aren't shown by default when selecting a component and can be a little obscure to control. Not to worry though; we'll spend some good time talking about them and especially getting them to face the direction they need to.

Edge: A face is surrounded by edges. These edges define the limitations of the polygon and the face. These edges also exist within 3D space, but actually contain no geometry of their own – they simply help describe the geometry of the polygon. When an edge is moved, rotated, or scaled, it changes the shape of the face and thus the polygon.

Vertex: Each edge has a vertex on either end of it. Vertices are one dimensional components that exist in 3D space. When a vertex is moved (one vertex cannot be scaled or rotated), it changes the length of the edges it is a part of, thus changing the shape of the polygons those edges contain. Do note, that a collection of vertices can be rotated or scaled which really is simply moving their relative location to each other.

UVs: These are really less of a "what" and more of a "where." They are a coordinate system that allows Maya (or any 3D program) to know how to attach

a texture to a collection of polygons. They are not particularly modifiable in 3D space – and really need to be handled in 2D space – most particularly in something we call "texture space." Much, much more on this later.

Traits of Polygon

To understand what polygons are and how they work, consider this metaphor. Polygons are like very thin (but very rigidly strong) plates of metal. An individual polygon cannot bend – it is planar. However, multiple polygons can be joined along their edges, and they can indeed bend where they connect.

What this means is that if you take six polygons and attach them to each other, so that they share edges and vertices, you get a cube (**Fig. 3.2**). Increase the number of polygons and the number of places where the shape can bend increases; this means a form can become more and more round as the polygon count increases.

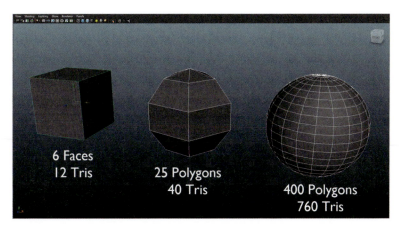

FIG 3.2 Increasing polygon count increases curve possibilities.

But notice that even the seemingly smooth sphere on the far right of Fig. 3.2 is still made of non-bending polygons. Check out the close-up of that sphere shown in **Fig. 3.3** – see the edges of those polygons?

FIG 3.3 Close-up of a smooth sphere and the still non-smooth, rigid polygons.

49

Polycounts

So what does this mean for us? Well, polygons are not only the building blocks of shapes but also the building blocks of the data set that the computer must keep track of for any shape or scene. Especially in situations like games, this data set can be hugely important when considering framerates (the rate—frames in a second—at which the video card is able to display the information of a scene). Too many polygons and the computer simply can't process them, and the video card can't draw them fast enough to allow for any sort of meaningful gameplay.

Now, to be fair, polycount (the number of polygons in a scene) is rarely the most limiting factor of gameplay. Textures and dynamic shadows usually have a bigger influence on that with today's hardware. But get too many polys and even the most robust systems can be ground to a halt in both games and inside of Maya as the scene is being manipulated.

Thus, the age old dilemma – and the craft of good 3D – is to use as many polygons as are needed to describe a form, but no more. How many is too many? The answer is tough and really a moving target. Too many for my machine as I'm writing this may be different for your machine when you read this. Not long ago, a scene with a million polys was way too many to work with and today that's almost a trivial amount.

So the answer is: depends. I know, terribly unsatisfying, but along the way in our tutorials, we will always be keeping our eye on efficient use of polys, so that we can ensure a project that is most useful on the most machines.

Modeling Modes

"Now wait a minute," you may be saying, "I've done some 3D and know that there are things like NURBS and Sub-D surfaces that are 3D forms that aren't polygons, are they?" This can be a bit confusing – especially in Maya. Maya does have a Polygons Mode that allows for the user to create polygons directly; it also has some other modes that are involved in making shapes – particularly the Surfaces Mode which has an entirely alternate collection of tools that also create shapes. It would seem like this indicates that there are other forms besides polygonal.

But here's the deal. When a computer draws a shape and displays it on the monitor, the only shapes it "sees" are polygons. And particularly three-sided polygons called **tris**. All of the modeling techniques in Maya – either polygonal or NURBS or Subdiv Surfaces – are simply ways of creating and manipulating collections of polygons – triangular polygons. The video card sees these triangular polygons (regardless of how they were arranged in Maya's various modeling modes) and displays the form accordingly. The process of converting a model into all tris is called **tessellation** (**Fig. 3.4**).

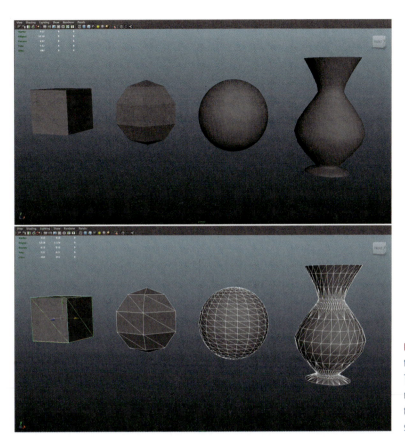

FIG 3.4 All forms in 3D end up as triangular polygons at render time. The top image shows the form as modeled, and the bottom shows the tessellated version as the renderer sees it.

It's for this reason that polygonal modeling has remained a constant reliable choice when tackling modeling challenges. Since the final product is going to end up polygons, creating the forms from easy-to-manipulate polygons often yields the most reliable results at rendering time.

But, it's not always the best solution to finding a form. I'm a huge fan of polygonal modeling, but at the end of the day, polygonal modeling is not as direct as it may seem. Because even the polygons that polygonal modeling creates are tessellated, it still is a bit indirect, and sometimes things like NURBS simply create a better form more quickly. Often, the tessellation issues are easy to manage with other forms of modeling – and in fact, we will be using other forms of modeling throughout the book when they are the more efficient path.

But enough talk. Let's start building stuff.

Escaping the Madness

This is our fictitious game in which you, the player, have been institutionalized because of your insistence on the guilt of a local politician in the recent disappearance of several youth in the community. Your goal is to escape the

sanitarium and prove his guilt. The rub is that you actually are a little crazy and tend to see things much more dire than they really are (**Fig. 3.5**).

FIG 3.5 Finished render of the geometry we'll create in this chapter.

Because of this, the mental hospital that you are currently held at appears to you as run down and abandoned. To you, the walls are crumbling, the rooms are abandoned, the orderlies are all brain sucking drug dealers, the doctors are monstrous sadist scientists, and your fellow patients' inmates in a hellish prison.

Unfortunately, we aren't going to be able to build this game – it's well beyond the scope of this book. However, we will be building a section of the mental hospital you are trying to escape (**Fig. 3.6**).

FIG 3.6 More shots of the final output of this chapter.

In this chapter, we will be creating all of the geometry for one level of the game. Through the course of this tutorial, we will use polygonal and NURBS-based modeling techniques. Since this is a game level, polycount will be important – but this doesn't mean that the forms will be simple. Although the walls, windows, and furniture will appear gray, we should still be able to create sophisticated shapes that help convey the terror of the space (**Fig. 3.7**).

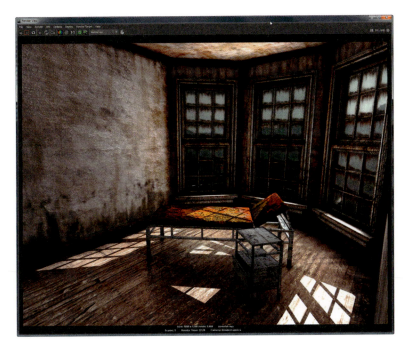

FIG 3.7 Renders of the game level completed in this book.

Gathering Research

Abandoned sanitariums are actually pretty easy to find online. It means that there is a plethora of great research easily seen and assembled. Unfortunately, I don't have the rights to reproduce any in this book, but do a quick Google image search and collect the images that excite or inspire you.

Sometimes, this sort of research collection can be about finding images that assist in understanding architectural structure (how wide are the hallways, what sort of doors are in the facility, what shape are the windows, etc.), but it can also help in defining texture choices (are the walls painted plaster? tile? what color?, etc.). Most importantly, this sort of research can greatly assist in establishing mood.

As I was collecting research for this tutorial, I stopped when I had assembled about 200 images. Take a particular look at image searches using "Beelitz Heilstätten"; there are some great structures in that facility and lots of really beautiful photographs captured by a wide variety of photographers. Generally, the spaces we will be creating are based on the architecture of this facility.

Tutorial 3.1 Architectural Polygonal Game Modeling: Escaping the Madness

Setting the Project

In the last chapter, we finished things up by creating a new Project called "Escaping the Madness." This Maya Project took the form of a folder on your hard drive that included a slew of other folders that defined where certain assets would be stored. This keeps things clear for Maya, so it knows where to find what.

When first sitting down to a machine and getting ready to work on a project always make sure that you are dealing with the right project. Especially if you are a student in a lab situation, it's easy to inherit someone else's settings and thus inherit the project they've defined. If you start creating and saving assets into the wrong Project, paths and connections can be made that will haunt you much later down the line.

> Step 1: Set the Project. Do this by selecting File > Set Project.
> Step 2: In the dialog box that next appears, be sure to navigate to the Escaping the Madness folder, and when inside that folder (or with that folder selected), hit the Set button.

Why?

Setting the Project in this way let's Maya know where the parent project folder is, and thus all the children folders that will enable Maya to know where the relevant files are.

Warnings and Pitfalls

Even when I'm working at home, when I sit down and launch Maya, I always set the Project before opening anything. Similarly, I never open a Maya file by simply double-clicking it in the OS. I always set the Project, and then once I'm sure Maya understands what the Project is, I use the File > Open to open the file I'm working with.

Saving a New Scene

> Step 3: Create a new Maya scene via File > New Scene.

Why?

Scenes are what people usually think of as Maya files. Maya can keep one or many scenes within the Project's "scenes" folder.

Step 4: Save the scene with File > Save Scene. This will open a dialog box similar to **Fig. 3.8**. Notice that the "Look in": input field that Maya has automatically taken us to the "scenes" folder inside the "Escaping the Madness" project folder. Name the file `ETM_Hallway` and click the Save button.

FIG 3.8 Saving a file. Note that this is a chance to double-check that your Project is set correctly.

Warnings and Pitfalls

If you are not taken to the *scenes* folder, stop. It means that Maya does not understand the Project yet and doesn't know where things should be stored. Go back and try setting the Project again (Steps 1 and 2). If this still doesn't work, there may have been an error in how you created the Project – so recreate the Project (last chapter). If you save this file in some other place besides the location, Maya thinks its scene files should be your future paths of textures and other things will be absolute and thus you'll never be able to share this file with someone else or open it on another machine without everything breaking.

Why?

So, why are we saving when there is nothing in the scene? First, this gives you a chance to double-check that the Project is set right. If Maya takes you to any other place but the scenes folder you know something is wrong. Second, saving often is just a fact of life when using Maya. Maya's a great application – but crashes are not unusual and getting into the habit of saving often is critical to minimizing lost time.

Laying the Foundation

Now it's time to start making geometry. Before we do so, it's worthwhile to point out that we may be doing things a little differently than Maya's default settings.

For instance, in the last chapter, we did some mini-tutorials in which we turned off Interactive Creation (Create > Interactive Creation). What this does is that instead of dragging out an object into existence (which is how Maya works by default these days), it creates an object at (0,0,0) in world space and usually at a *size* of 1.

Problems with Scale

Units in Maya can be a little tough to work with. By default, Maya is working in centimeters (although we'll change this in a minute). However, it can be a little difficult seeing exactly what the size of an object is.

Here's why. In the Channel Box, the information provided for a selected object is Translate (X, Y, & Z), Rotate (X, Y, & Z), and Scale (X, Y, & Z). Notice that it's Scale and not size. What this is referring to is the scale of the object since it was created. This means that an object that was created as 20 feet wide by 20 feet deep by 20 feet tall will show up in the Channel Box as Scale X, Y, & Z = 1. Ironically, an object that was created as 1 foot, by 1 foot, by 1 foot, will also show up as Scale X, Y, & Z = 1. See the problem?

It's for this reason that I like creating objects that are 1 unit in size as that matches the scale settings. Then, if the object is scaled five times as big, to 5 feet, the Scale settings in the Channel Box will also show 5. It gives us a quicker look at what the size of an object actually is.

To be fair as soon as components are altered (moving vertices or faces), the Scale setting in the Channel Box becomes completely inaccurate since at that point we are reshaping the object – not scaling it. But, for early roughs I like keeping the Channel Box as relevant as I can as long as I can – it just makes initial work go faster.

Changing Units

Step 5: Change the units to feet. Do this by selecting Window > Settings/ Preferences > Preferences. In the Categories column, select Settings. Then, in the Working Units section change the "Linear": setting to *foot*. Click the Save button.

Why?

In a game model, this units setting is not all that important. Maya will export the file according to the unit setting defined in the exporter (so the absolute size could be tweaked there). However, if later you end up using any physics in Maya, the real size of objects matters (an object will appear to fall off a shelf to the floor much different if Maya thinks the shelf is 3 feet off the floor than if Maya thinks it is 3 miles off the floor). So, it's worthwhile to keep things clean from the beginning.

Saving Incrementally

Incremental saves are absolutely one of the most beautiful and important parts of Maya's structure. What it does is each time you save in Maya, a copy of the last saved version is placed in a folder called Incremental Save before saving

and overwriting your file. This means that you have a linear history of every save you make within Maya.

Seems overly complex now, but every single semester I have taught, someone has come in with a Maya scene file that is listed as 0 KB; it's empty – gone. We're never quite sure what causes this or what corrupts the file. What we are sure of is that if the student has been using incremental saves, he has lost time for sure – but only the time since his last save; he doesn't have to start over.

It just takes a second to tell Maya to incrementally save the files, but can save countless hours in the disastrous occasion of corrupted files.

> Step 6: Choose File > Save **Scene** (Options). Click the *Incremental Save* option, and click the Save Scene button.

Tips and Tricks

From now on a quick Ctrl-S or Command-S will save the scene and do it incrementally. Do this often – not just when it's called out in the tutorial. Save often. Save often. Save often.

Roughing Out the Scene

If you have drawing or painting experience, you are probably quite familiar with this idea. With very broad strokes, we are going to construct the bones of the scene. Some of these bones may be altered and even deleted later, but they help establish scale and make sure the size of walls, doors, and rooms are appropriate.

Creating Hall Floor

> Step 7: Choose Create > Polygon Primitives > Plane. This will create a 1 × 1 units (feet) plane in the middle of the scene.

Why?

With the default settings, Maya would make you draw the shape; but since we have Interactive Creation turned off, it automatically creates the 1 × 1 plane.

> Step 8: Adjust the Scale of the plane to yield a plane that is 8' wide by 100' long. To do this, with the plane selected make sure the Channels Box is visible and change the Scale X input to 8 and the Scale Z to 100.

Why?

This is going to be the size of the main hallway. It's important to note that changing the Scale X and Scale Z values to 8 and 100, respectively, does not guarantee in all cases that an object is then 8 × 100; however, because we created this plane at 1 × 1, scaling it to 8 and 100 times, its 1 unit does indeed yield an 8' × 100' plane.

Tips and Tricks

If the Channel Box is not visible for some reason, you can toggle its visibility by clicking in the very top right corner of the Maya 2012 interface (right beneath the close button on a PC).

Step 9: Keep the polycount low by ensuring that the plane is one polygon. Do this in the Channel Box editor, by clicking on the polyPlane1 (to expand it) under the INPUTS section. Make sure the Subdivision Width and Subdivision Height both read 1 (**Fig. 3.9**).

FIG 3.9 Final Channel Box settings for the hallway polygon plane (notice the name of the object in yours will be polyPlane1).

Why?

In most cases, having the much more dense default of 10 polygons by 10 polygons would be fine. However, because this is a game model, we want to be ever mindful of keeping the data set small. Part of this effort is wrangling the polycount. If the hall is one big long plane, one polygon will do it. A total of 100 polygons will do it as well, but add lots of unnecessary information for video cards to draw.

Step 10: Rename the plane to ETM_HallwayFloor. There are several ways to do this, but my favorite is via the Outliner (Window > Outliner). There, double-click the pPlane1 object to rename and enter ETM_HallwayFloor.

Step 11: Hit 5 on the keyboard to show the plane as a solid shape (**Fig. 3.10**).

FIG 3.10 Hallway completed.

Roughing Out the Walls

Step 12: Create a new cube that will become a wall. Do this via Create > Polygon Primitives > Cube. This will create a 1 × 1 × 1 cube sitting at 0,0,0 in the scene.

Adjusting the Manipulator

By default, the manipulator of an object is at the geometric center. This is a logical place to put it, but because the manipulator handle is the point around which the object rotates or scales, having it smack dab in the middle can cause problems in many situations.

For one example, consider a door. Most doors do not rotate around the middle of the door – but rather rotate on hinges on one of its edges. For doors, we want to definitely have the manipulator handle not in the middle of the door. Another example is the walls we are building. When we created the cube, it is sitting halfway through the floor. In order to get this cube scaled to the right size, we would need to scale it in Y, which means that it would grow up *and* down as it's scaling from the manipulators location (in the middle). It would be much easier if the manipulator was at the bottom of the cube, so that as the cube was scaled, it would only grow up. Having a manipulator for the wall on the bottom will also allow for the wall to be snapped to the hallway floor.

Step 13: Hit the spacebar to shift to a four-View Panel layout. With the cube still selected, move the mouse over each View Panel and hit f while in each panel to frame that cube (or my tech editor pointed out Shift-f will do the same thing).

Step 14: Switch to the Move Tool (w is the keyboard shortcut) to see where the cube's manipulator handle is (right in the middle of the cube).

Step 15: In the front View Panel, hold the d key down on the keyboard. Notice that the manipulator changes to look something like Fig. 3.11. This shows that the manipulator handle is ready to be moved (or otherwise manipulated).

FIG 3.11 Holding the d key down will activate the ability to move the manipulator.

Step 16: Still holding the d key down, press and hold the v key (snap to vertex). Now grab the green line of the current manipulator and drag downward toward the bottom of the cube. The manipulator should snap to the bottom. Release both the d and v buttons.

Why?

Lots of things happening here. First, there is the finger gymnastics of holding down the two keys at once, but that is a critical step. Holding the d key down tells Maya that the manipulator is to be moved. Holding the v key tells it to snap to the nearest vertex. By dragging the green line of the manipulator, we move the manipulator down only in y – it does not slide off to the sides of the cube but remains right in the bottom middle of the cube.

Warnings and Pitfalls

There is often the tendency for new Maya users to always grab the middle of the manipulator (the yellow square) when trying to move things. This is intuitive, but it means that the object being grabbed can move in any direction. So for instance, in this case, if the manipulator (even while holding d and v down) is grabbed by the yellow square, it will snap to one of the corners of the cube and not stay in the middle – this is because the yellow square means it can move in all directions and will move in all directions toward the nearest vertex.

Scaling and Positioning the Walls with Snapping

Step 17: Snap the wall to the floor's level using the Move Tool by holding the x key down (snap to grid) and grabbing the manipulator's Y-axis handle (the green one which will highlight to yellow once grabbed) and drag up. The cube will snap to be sitting right on the floor (**Fig. 3.12**).

FIG 3.12 Using Snap to Grid to move the cube up to sit on the floor.

Why?

It looks like we are snapping to the floor; in actuality, holding x down simply snaps to the grid. Because the floor is sitting at Y = 0 (on the grid), by snapping to the grid, we make sure that the cube is sitting right on the floor. Alternatively, the v key could have been held down as well while moving the cube up in Y, and it would have moved up to the next level of vertices visible in the scene – which also would have been the floor. Either way would work.

Step 18: Snap the wall to the edge of the floor. Still with the Move Tool activated hold v down (to snap to vertex) and grab the X handle of the manipulator (red) and move the cube to the edge of the floor (**Fig. 3.13**).

Warnings and Pitfalls

My tech editor reminded me that you must have one of the corners (vertices) of the floor visible in the persp View Panel in order for snap to vertex to work. So, you may need to dolly back to make sure you can see a vertex of the floor to snap to.

FIG 3.13 Snapping the cube to the edge of the hallway floor.

Step 19: Resize the wall to be 6 inches thick (0.5'), 10 feet tall, and 100 feet long. This can either be done via the Scale Tool or in the Channel Box editor by entering .5, 10, and 100 in the Scale X, Y, and Z input fields (**Fig. 3.14**).

FIG 3.14 Results of resizing the wall with appropriately placed manipulator.

> **Why?**
>
> Because the axis of the cube is at the bottom center, when the scale settings are changed the wall grows up and out and fits to the floor.

Step 20: Rename the wall to `ETM_HallWallEast`.

Duplicating

Generally using Copy/Paste in Maya is a bad idea. The node-based structure of Maya means that there are just some goofy things that happen with Copy/Paste.

Alternatively, Maya has a Duplicate Tool (Edit > Duplicate) and a sister tool – Duplicate Special – that do some great things.

Step 21: Duplicate ETM_HallWallEast. With ETM_HallWallEast selected, hit Ctrl+d, or select Edit > Duplicate.

Why?

It will look like nothing has happened because the new duplicate wall is sitting in exactly the same place; but look at the Outliner and there is a new object – ETM_HallWallEast1.

Step 22: Snap the new wall to the other side of the hallway. Do this by making sure that ETM_HallWallEast1 is selected in the Outliner, then using the Move Tool and holding v down, move (and snap) the wall to the other side of the wall (Fig. 3.15).

FIG 3.15 Duplicated wall snapped to other side of the hallway.

Tips and Tricks

Remember that when snapping to the other side, only grab the X handle (red) of the manipulator.

Step 23: Rename this new wall ETM_HallWallWest.

Why?

So, why a plane for the floor, but cubes for the walls? It's because the walls are going to have shapes cut out of them for doorways and we want to make sure that those doorways have a relief to them.

Boolean

Boolean functions can be tremendously powerful and tremendously problematic. The basic idea of Booleans is that one object can be subtracted from another (or added, or the intersections of two objects found). The powerful part about it is that it can be fairly intuitive to look at two shapes and think, "ok, so this object will be cut from that one." The problem is that you lose control of some of the topology of the form that this Boolean creates. Boolean functions will often create polygons with many more than four sides that sometimes need some reconstruction.

However, having said this, in many situations, like cutting out doorways that are square, it can be a very handy tool that works quickly and efficiently. The idea for the next few steps will be to cut holes out of the walls we've just created that will lead into other rooms that we will create in the future.

Step 24: Create a cube that is 3' feet wide, 6'9" (6.75') tall, and 1' deep. Because the hallway is running in the Z direction, this means the Channel Box should read Scale X = 1, Scale Y = 6.75, and Scale Z = 3.

Step 25: Adjust the manipulator to be at the bottom center of the cube and then snap the cube up to match the floor. Finally, snap it, so that it penetrates the ETM_HallWallWest approximately as shown in **Fig. 3.16**.

FIG 3.16 Creating and placing the cube that will cut out the door. Note that both the wall and new cube are selected for illustration's sake.

> **Why?**
>
> Note that the new cube completely penetrates the wall. It needs to in order to create a hole that goes completely through the wall. This is the reason why this new cube was 1' thick – so that it would indeed be deep enough to make it through the wall.

Step 26: Select ETM_HallWallWest and then Shift-select the new cube (the order is important).

Step 27: Perform the Boolean operation. Do this by selecting Polygons|Mesh > Booleans > Difference. The results should show up like **Fig. 3.17**.

FIG 3.17 Results of the Boolean Difference.

Tips and Tricks

Notice that the result of this procedure is a pretty messy Outliner. Suddenly, ETM_HallWallWest and the cube we made appear to be just empty groups and there is a new object probably called polySurface1. This is due to History being active, and the objects used to create the new polySurface1 are still around – more specifically, the nodes of those objects are still around. We will clean that up in a bit (as well as rename things), but for now don't sweat the messy Outliner.

Step 28: Repeat this process (from Steps 24–27) to create six more doorways along what was ETM_HallWallWest (**Fig. 3.18**).

FIG 3.18 Further Boolean Difference functions to create other doorways.

Tips and Tricks

Note that to speed things up, create one cube for the door hole, and then before using it for a Boolean, duplicate it and move this new duplicate to where you want the next hole to be. Then, after working the Boolean magic on one doorway, there is no need to create the next door hole from scratch as it already exists.

Step 29: Repeat for the other side of the hallway, only this time work with door holes that are 3 feet wide and 8.5 feet tall (these will largely be open portals – no doors). We only need three; roughly place them as shown in **Fig. 3.19**.

FIG 3.19 Creating doorways for the east wall.

Step 30: Cleanup. Delete the history (Edit > Delete All by Type > History). Then, rename the walls back to ETM_HallWallWest and ETM_HallWallEast. Finally, use your newfound skills to move the manipulator to a place that makes sense for these new walls (probably bottom middle).

Why?

Why do we need to move the manipulator again? Well, when the results of Boolean operations are new objects. These new objects, by default, have their manipulator at 0,0,0 in world space. So, even though the walls were once well organized in regards to their manipulators, those walls are gone, and in their place are these new walls with holes in them; so, we have to do a bit of reorganizing again.

Component Level Editing

Thus far, most of the work we have done is on an object level. We've been moving and scaling entire objects, which is great as long as the only shapes in the scene are cubes, spheres, or other primitive forms.

Sooner or later, projects will need to move beyond just simple forms and require more complex (and interesting) shapes. Turns out, most any form is

possible within Maya, but to get sophisticated forms (like human forms – or in this case, non-square rooms) we need to be able to manipulate the parts of the object to change not just the size but the *shape*.

Remember in past chapters, we talked about some of the **components** of 3D forms within Maya: faces, edges, vertices, and normals. In modeling, the faces, edges, and vertices will be of particular interest and use. For a refresher on swapping between objects and components, check out Chapter 2.

Building a Room

Step 31: Create a room that is 12' wide, 12' deep, and 10' tall. Do this by creating a polygon cube (Create > Polygon Primitives > Cube) and in the Channel Box change the Scale X = 12, Scale Y = 10, and Scale Z = 12.

> **Why?**
>
> So after spending all that time creating separate walls for the hall, here we are creating a room with a box. What gives? Fair question. The reality is that either could work – especially for game levels. However, when there are multiple rooms, often building only the inside of the room – especially if that's all the player will see can yield nice benefits. First, it spares the unneeded polygons on the back sides of the walls that would never be seen. Second, when baking lighting into the scene, the UV set can be much easier to manage and light separately if each room is independent of the walls in the next room. Ultimately, the biggest reason to do it differently this time is to show new modeling techniques. When building your own model, you can certainly choose to build rooms/walls either way.

Step 32: Move the new cube off to the side somewhere where it is easy to work with. The absolute location is unimportant.

Extruding Polygons

Extruding a polygon face is one of the most effective ways to manipulate (and grow) a form. The name of this tool is fairly indicative of what it does. When a polygon is selected and Polygons|Edit Mesh > Extrude is activated, the selected polygon can be moved out away from where it once resided on the object. Importantly, new polygons are made around the edges of the extruded polygon, so the form remains contiguous. Take a look at it in use.

Step 33: Right-click on the object and choose Face from the Hotbox that pops up. On one of the shorter ends, select a face by clicking on it. Choose Polygons|Edit Mesh > Extrude.

> **Why?**
>
> Notice that the manipulator immediately changes to a strange looking hither-to-fore unseen form. It actually has handles that allow this extruded face to be moved (the cones), scaled (the cubes), and rotated (the blue circle).

Step 34: Pull the new face out. With the new manipulator handles, grab the Move Z handle (the blue cone), and pull the face out to approximate Fig. 3.20.

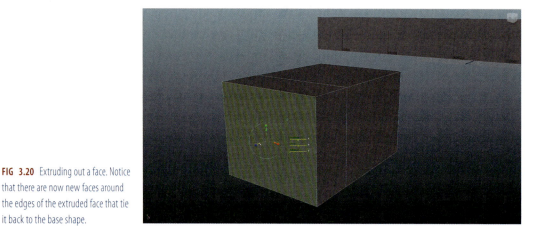

FIG 3.20 Extruding out a face. Notice that there are now new faces around the edges of the extruded face that tie it back to the base shape.

Step 35: Scale the new face down. Still within the same Extrude manipulator tool, scale the face in X by click-dragging on the Scale X handle (the red cube). Just eyeball it for now to look similar to Fig. 3.21.

FIG 3.21 Scaling an extruded face.

Tips and Tricks

We are translating and scaling all within the same tool here and all within the Extrude function. However, do note that after a face is extruded, it can be selected at any time and moved, scaled, or rotated using the regular Move, Scale, and Rotate tools.

Step 36: Create a door frame. Select the face on the opposite side of this new extrusion. Again, choose Polygons|Edit Mesh > Extrude. This time, however, do not use the Move handles, instead use the Scale X and Scale Y handles (Fig. 3.22) to scale this new face down right in place.

FIG 3.22 Scaling extruded face.

Step 37: Delete the face. Hit Delete or Backspace on the keyboard to get rid of this polygon and the one below it (**Fig. 3.23**).

FIG 3.23 Deleted faces. Leaving the polygons we are interested in.

Why?

Sometimes extruding faces is a means to an end. In this case, extruding the face provides the polygons we need to sculpt the doorway. Later, we'll use this same technique to provide the geometry needed to create window reliefs.

Step 38: Adjust the doorway geometry to look more like a door. Do this by first swapping to Vertex Mode (right-click on the object and choose Vertex from the Hotbox menu). With the Move Tool, select the two vertices shown in Fig. 3.24 and snap them down to the bottom of the room (hold v down while dragging the Y (green) handle).

FIG 3.24 Adjusting vertices to find shape of doorway.

Step 39: Create windows. Do this by swinging around to the other side (the three-sided wall) and select the faces shown in **Fig. 3.25**. Remember to this you need to swap to Faces Mode.

FIG 3.25 Selecting the walls that will become windows.

Step 40: Make sure the faces will extrude independently. To do this, select Polygons|Edit Mesh > Keep Faces Together (make sure it's turned off (without the check)).

Step 41: Use the Extrude Tool (and the scale handles of the Extrude manipulator) to create shapes like shown in **Fig. 3.26**.

FIG 3.26 Extruding windows.

Tips and Tricks

Note that even though there is only one manipulator handle, when this handle is manipulated, all three faces adjust.

Step 42: Give the windows depth. With these faces still selected, again choose Polygons|Edit Mesh > Extrude and pull this new extrusion back (the blue handle) a bit to give the windows a relief (**Fig. 3.27**).

FIG 3.27 Creating depth for the windows via a second extrusion of the same faces.

Tips and Tricks

Notice that this time you should be using the move handles – not the scale handles of the Extrude manipulator.

Step 43: Turn these into window holes. To do this, simply delete the faces selected (Fig. 3.28).

FIG 3.28 Making the window faces into holes. This is the view from inside the room.

Organizing Rooms

Step 44: Prepare to attach the room to the ETM_HallWallWest by deleting the face on the outside of the hall wall (Fig. 3.29).

FIG 3.29 Deleted outer face of ETM_HallWallWest.

Why?

The idea here is that this part of the wall will never be seen. The walls seen on the insides of the rooms are contained in these room objects. So, the face on the outside wall of the hall just gets in the way.

Step 45: Further prepare by maneuvering the room object's manipulator to the middle front edge of the doorway (**Fig. 3.30**). Do this in steps: first snap to vertex and move the manipulator only in Y to snap to the bottom of the room. Then, snap to vertex and move only in X to snap to the front of the room.

FIG 3.30 Preparing to place the room by getting the manipulator into a good place.

Why?

The idea here is to have the manipulator placed in a location that facilitates snapping. Having the manipulator on the front edge of the room will allow us to snap this part to the edge of the door relief.

Step 46: Move the room into place so it snaps right up against the second doorway (**Fig. 3.31**). Do this by holding v down and with the Move Tool snapping to one of the bottom corners of the door relief. You may need to rotate the room into place.

FIG 3.31 Snapping the room to the doorway.

Why?

Notice that at this point the doorway of the room is much bigger than the doorway of the hallway (yours may be smaller). Not to worry – we knew this was going to happen as in earlier steps we were just roughing out the shape to get the geometry we needed. We'll tweak it into place in a minute. But in this step, we have made the important step of lining up the inside wall of the room to the edge of the doorway.

Tips and Tricks

You can sometimes "help" the snap tools by moving the mouse to the exact vertex you are wanting your selection to snap to. Notice in Fig. 3.31 that the mouse is sitting on the bottom right corner of the hall's door relief. Even though I'm only moving the room in X, if the mouse moves over that vertex on the doorway while I'm moving it, Maya will know, "Oh, so he wants me to snap (in X) to the level of *this* vertex."

Tips and Tricks

Notice that sometimes it's just easier to see what's happening in wireframe (hit 4 on the keyboard). Alternately, sometimes the orthographic views will be the best way to understand where the object is in 3D space.

Step 47: Adjust the room's doorway to match the hall's. Do this in Edge Mode (right-click the room object and choose Edge from the Hotbox). Again, use Snap to Vertex (hold v) to snap each edge of the room to the corresponding edge of the hall's doorway (**Fig. 3.32**).

FIG 3.32 Adjusting (in Edge Mode) the edges of the room to match the hallway. Be sure to snap to vertex to make this match exact.

Step 48: Duplicate and place the new room two doors down. To do this, swap to Object Mode and move the room's manipulator handle to the bottom corner of the door. Use Edit > Duplicate and then use Snap to Vertex and move the new room down two doors, snapping to the corner of the doorway (**Fig. 3.33**).

FIG 3.33 Duplicating the old room to create a new room with smart snapping.

Why?

Yes, it's true it would be better to have created the windows that fill the holes of this room first. And later, you may choose to actually delete this second room in favor of a completed grouped room once the windows are created and placed. But continuing with the idea of utilizing Maya's snapping tools to place objects, it made sense to show the method here.

Step 49: Adjust the hall floor by moving the edges, so that they close the gap between the hall and the rooms (**Fig. 3.34**).

FIG 3.34 With a quick Snap to Vertex, we can clean up holes to make objects match perfectly.

Creating Non-Cubic Shaped Rooms

So with the methodology we have created so far, the cube has been the central building block. This is actually a good method for a fairly astounding number of forms; but sometimes an alternative primitive can be used to create forms much faster.

For instance, in the research of Beelitz Heilstätten, there is a very interesting "arch room" that looks to be a big gymnasium in an octagonal shape. This could definitely be hewn out of a cube, but we could much more easily build it using part of a cylinder and part of a sphere, and assembling the two together.

Step 50: Create the octagonal base of the room with a cylinder. To do this, choose Create > Polygon Primitives > Cylinder. Move the cylinder away from the middle of the scene to a place where it's easier to evaluate. In the Channel Box, under INPUTS expand the node named polyCylinder1. There, change the Subdivisions Axis to 8 (**Fig. 3.35**).

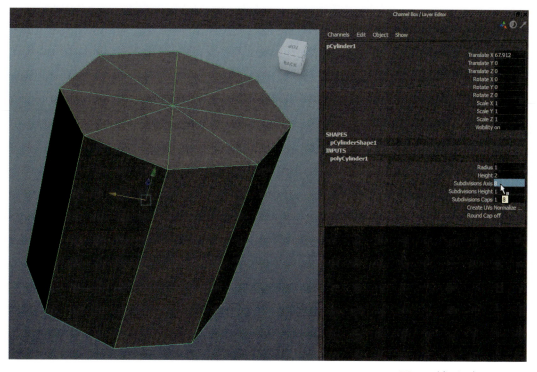

FIG 3.35 Adjusting the parameters of a primitive cylinder to create the base of our octagonal room.

Why?

This is part of the power of those polygon primitives. The parameters of the shape can be changed, and thus, the primitive can be reshaped.

Warnings and Pitfalls

Note that being able to reshape the primitive is dependent on this polyCylinder1 node being available as part of the shape's history. This means that when history is deleted, this node disappears and is no longer editable via its INPUT parameters.

Step 51: Remove the roof. Do this by swapping to Faces Mode and deleting the polygons that make up the top of the cylinder. This will turn the cylinder into a sort of cup (**Fig. 3.36**).

FIG 3.36 Making way for a new roof.

Step 52: Create the dome for the roof. Start by creating a polygon sphere (Create > Polygon Primitives > Sphere). Move the sphere over to near the cylinder. With the sphere selected, look in the Channel Box and under the INPUTS section, expand the polySphere1 node and change the Subdivisions Axis setting to 8 (to match the number of walls in the lower room). Now, in Faces Mode, select and delete all the faces beneath the sphere's equator (**Fig. 3.37**).

FIG 3.37 Creating the polygon sphere (or half sphere) that will become the dome of the room's ceiling.

Step 53: Line the dome roof up with the room. Do this by switching back out to Object Mode (right-click on the sphere and select Object Mode in the Hotbox). Swap to the Move Tool and move the manipulator (hold d) of the dome to any of the corners (remember to Snap to Vertex). Then, using the Move Tool (be sure to release d), grab the manipulator by the middle yellow square, and move the dome up to snap into place atop the cylinder (**Fig. 3.38**).

FIG 3.38 Snapping the dome into place.

Step 54: Combine the meshes into one form. Select the bottom cylinder, then shift-select the half sphere (or the other way around), and choose Polygons|Mesh > Combine.

> **Why?**
>
> Technically, we could leave the roof and walls separate. There are a couple of benefits to combining them. When meshes are combined, Maya thinks of them as one object. Likewise, game engines see it as one object and thus reduce the draw calls. Further, when there is one object (and especially after we get the ceiling and walls merged—more on this in a moment—), the UV mapping – deciding how texture is applied to a surface – gets a little easier.

Step 55: Merge the vertices between the walls and ceiling. Try this experiment: click on one of the vertices that are at the bottom of the sphere, but not at the top of the cylinder (don't marquee around it – just click it). Now move it up and see that there are actually two vertices sitting atop one another – not one vertex merged from the two shapes

(**Fig. 3.39**). To fix this, first undo the experiment, then marquee select around all the vertices along the seam of the two shapes. Now choose Polygons|Edit Mesh > Merge.

FIG 3.39 Simply combining meshes doesn't actually merge vertices. To fix this use Polygons|Edit Mesh > Merge.

Step 56: Scale the room to taste and place it in the scene as seen in **Fig. 3.40**. Be sure to use either Modify > Center Pivot or manually move the Manipulator into a more logical location before starting in on scaling things. Note that in Fig. 3.40, the room has also been rotated 22.5° (along the Y), so that a flat wall meets up with the hallway.

FIG 3.40 Finished rough of large gym space.

Step 57: Name the rooms. The naming mechanism is arbitrary at this point. But naming is important to do as you go along.

Step 58: Finish the homework challenges for room shapes. In the homework of this chapter, include several finished rooms (available at the

support website www.GettingStartedIn3D.com). All of these rooms use the techniques we've covered thus far. Give 'em a shot! The results are shown in **Figs. 3.41–3.43.**

FIG 3.41 Rooms blocked out using the currently known techniques.

FIG 3.42 Large chunks of architecture are quickly built with the techniques discussed above.

FIG 3.43 Check out close-ups of these rooms in the homework section.

Conclusion

Using simple polygonal modeling techniques, the shape of a game level (or any set design really) can begin to come into form quickly. Of course, it's still a very boring form; it doesn't have the level of detail that makes a game experience immersive or a TV/movie/animated short set compelling or believable – this comes later.

However, I always counsel students to rough out all their rooms first using methods similar to this. If they are creating an animated short, it gives them a quick look at whether or not they have the appropriate acting spaces created. For games, a roughed version like this provides the perfect start to a game prototype and is the version that we first put in a game engine to run around in and see if the scale and scope of the level is what was envisioned.

Tutorial 3.2 Prop Polygonal Game Modeling: Escaping the Madness

We've got a good start with the roughed out versions of the space. However, things are simply too blocky without necessary *stuff*. In this tutorial, we will expand on the techniques, we have built to begin to create beds, gurneys, chairs, and other props that will be placed around the scene to make it look like people once lived here.

Creating an End Table

Figure 3.44 shows the results of the next few steps. It might not look like it at first glance, but we are actually just extending skills we already have – particularly with regards to extruding polygons.

FIG 3.44 Finished table.

We are going to construct this form out of three forms actually. The first will be the drawer compartment area, the second will be the drawer, and the third will be the frame that surrounds the drawer and its compartment. After, we construct these two forms we will use the Combine technique we looked at earlier to make it one mesh and thus reduce the number of objects to keep track of and the number of draw calls if this ends up in a game engine.

> Step 1: Create a new Maya scene. Save whatever scene is currently open (if there is anything in it), and then choose File > New Scene. Save it as `ETM_Furniture_SmallTable`.

Why?

We could build this right within the hallway scene; but this will allow us to explore working with the import functionalities of Maya.

> Step 2: Create and scale a new cube to approximate **Fig. 3.45**. Do this in Object Mode with the Scale Tool.

FIG 3.45 Roughing out the general shape of the main drawer compartment.

Step 3: Start to create the drawer cavern with the Extrude Tool. Select the front face (in Face Mode) and choose Polygons|Edit Polygons > Extrude. This time, click on one of the cube handles of the Extrude Tool and notice that the middle of the manipulator turns to a light blue cube. Click and drag on that cube and the extruded face will scale in all directions at once – creating a face that pulls away evenly from its old size (**Fig. 3.46**).

FIG 3.46 Scaling in all directions at once with the Extrude Tool.

Step 4: Finish the drawer cavern with a second extrusion into the cube. Again, choose Polygons > Edit Polygons > Extrude and this time use the Extrude tools' move handles (cones) to move this new extrusion back into the cube (**Fig. 3.47**).

FIG 3.47 Extruding into the form to create the cavern.

Step 5: Create the drawer from a new cube, using the Extrude Tool. Check out the sequence of screenshots shown in **Fig. 3.48** for how I constructed it.

FIG 3.48 *Continued*

FIG 3.48 *Continued*

FIG 3.48 Creating the drawer.

Why?

Why make the drawer separately? Well, the idea is to make these pieces of furniture look pretty beat up…we don't want a lot of things to look very neat – like how a drawer fits. By building it separately, we can easily plug the drawer into the compartment and very easily make it look broken or partly opened.

Step 6: Move the drawer into place. The key here is to make the drawer offset – not perfect (**Fig. 3.49**).

FIG 3.49 Drawer compartment and drawer.

Constructing the Frame

Now that we have the drawer area done we can build the frame around it. This will provide some important opportunities to look at adding geometry needed to create the forms desired.

Starting with a cube doesn't mean that the form has to stay a cube. Already, cubes have had holes dropped out of them and new forms built off of them. Sometimes, more refined extrusions need to be made. To get these, new geometry needs to be formed to allow for new faces to be extruded.

> Step 6: Create a cube and resize it to be slightly bigger than the drawer compartment. Make sure it is also fairly flat (**Fig. 3.50**).

FIG 3.50 Top of small table built from rescaled cube.

> **Why?**
>
> Notice that we are just "eyeballing" the forms. This is fine for our purposes here. Getting too caught up getting the exact size would just slow down the learning process. The point is to see the general tools and their application. Later, if the shape isn't just right, you can always move vertices around to get the form closer to the desired shape or proportions.

Insert Edge Loop Tool

This is a powerful tool that allows new geometry to be inserted between loops of edges. In our case, our "loops" are pretty straight; but this tool will still be useful. Remember though that this tool is also powerful for non-linear shapes (like organic ones) where new geometry is needed to better define a shape.

> Step 7: Add geometry to extend the legs from. To do this, make sure the object is selected and choose Polygons|Edit Mesh > Insert Edge Loop Tool.

Click and drag on one of the edges to create a new loop of edges (and thus new polygons (**Fig. 3.51**)).

FIG 3.51 Using the Insert Edge Loop Tool to create new geometry.

Why?

So what just happened here? By "inserting an edge loop," we have a new loop of edges. This splits the faces the edge loops cut through into two faces. These new faces can be extruded into forms that would not have otherwise been easy to accomplish with the current skill set.

Step 8: Add further geometry with additional loops. Again, activate the Insert Edge Loop Tool and create further loops parallel and perpendicular to the first edge loop (**Fig. 3.52**).

FIG 3.52 Inserting additional edge loops.

Why?

Take a look at this new shape and notice that there are now squares on each of the corners of the shape. These are the faces that we will use to extrude out the legs.

Tips and Tricks

Notice that the way the Insert Edge Loop Tool works is a loop is created perpendicular to the edge clicked. So to get the edges shown in Fig. 3.52, some of the edges were created along the same side, but the next two have to be created by clicking on one of the edge perpendicular to the first.

Step 9: Select the faces that will become the legs. Do this by rotating your view to below the cube. Select the faces shown in **Fig. 3.53** (select one and then shift-select each of the others).

FIG 3.53 Selecting the faces that will be the legs.

Step 10: Extrude the legs down to the ground. Polygons|Edit Mesh > Extrude (**Fig. 3.54**).

FIG 3.54 Extruding down the legs.

Cut Faces Tool

The Insert Edge Loop Tool is one way to insert new geometry. The Cut Faces Tool also creates new geometry, but is much more linear in its approach. Think of this tool as a sort of laser that slices though the entire object. Because of this, it will be important that the tool is used in a non-perspective view.

> Step 11: Create new geometry to create further cross braces. First, make sure to view the object in the Front or Side View Panel (either will work). Select the frame shape (in Object Mode). Activate the Cut Faces Tool (Polygons|Edit Mesh > Cut Faces Tool). Hold the Shift key down (to constrain the cut) and drag from left to right on the screen to approximate the cut shown in Fig. 3.55. Repeat for a second cut.

FIG 3.55 Using the Cut Faces Tool to add new geometry.

Why?

It's tough to show the Cut Faces Tool in action with a screenshot. What happens when the Cut Faces Tool is used – is a flickering line (a straight line through the whole screen) will appear to show where the cut will be made. This line rotates around the place where the mouse is clicked. Holding the Shift key down will make sure it snaps to 45° increments (including flat). When the mouse is released, the "laser" cuts all the way though the object selected. This means that (unlike the Insert Edge Loop Tool), the first click is really important – as moving the mouse only rotates the cut. So click wisely.

Bridge

The Bridge Tool is a relative newcomer to Maya, but is a really handy one. What it does is allow for components to be bridged together by new polygons. In this case, it will be used to connect the new geometry made on the legs.

Step 12: Select the faces to bridge. In Face Mode, select two faces that face each other on the inside of any two legs (**Fig. 3.56**).

FIG 3.56 Selecting the faces to be bridged.

Step 13: Connect the legs with the Bridge Tool. Choose Polygons|Edit Mesh > Bridge (Options). In the Bridge Options window, change the Divisions setting to 0. Click the Bridge button (**Fig. 3.57**).

FIG 3.57 Bridging together two faces.

> **Why?**
>
> The default setting for Divisions for the Bridge Tool is (strangely) 5. What this would mean is that (with the default settings), the two faces would be bridged together, but there would be five edge loops around the new shape created. Obviously, there is no need for this amount of geometry, so setting the Division setting to 0 simply bridges the two selected faces by creating new faces that join the edges.

Step 14: Repeat the bridging process to connect all sides (**Fig. 3.58**).

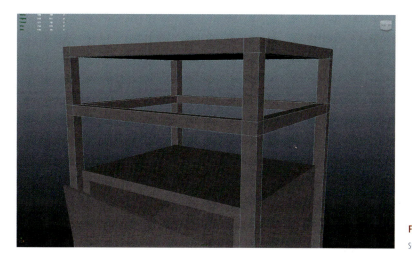

FIG 3.58 Bridging across all the supports.

Tips and Tricks

G is the keyboard shortcut to repeat the last used tool. So, if the last thing done was to use the Bridge Tool, two new faces can be selected, g hit (the faces are bridged), then rotated around, two more faces selected, g hit, etc. Makes for quick work.

Step 15: Add other details using techniques you know. **Figure 3.59** shows the results of a bit of extra tweaking including some extrusions and simple Booleans.

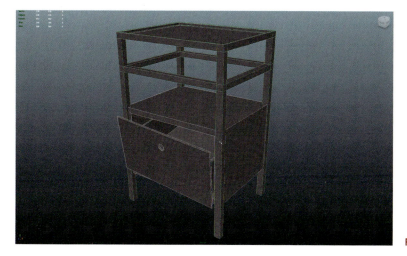

FIG 3.59 Finished table.

Step 16: Combine into one mesh. Select all the parts in Object Mode and choose Polygons|Mesh > Combine.

Step 17: Delete history. Edit > Delete All by Type > History.

> **Why?**
>
> In creating this form, quite a bit of history has been created. Each time, the Insert Edge Loop Tool was used a new node appeared attached to the object. Each Bridge, each Extrude, and the Combine all add nodes to the forms – and they all end up on the final combined form. By deleting history, we keep the data set related to this form small and get rid of any phantom nodes that might be floating around in the Outliner.

Step 18: Name the object `ETM_Furniture_SmallTable` in the Outliner.
Step 19: Move the ETM_Furniture_SmallTable's manipulator to be at the bottom of the legs. Remember do this by holding d and v down (d to move the manipulator, v to snap to vertex) and pull the manipulator down by the green post to snap to the bottom of the legs (**Fig. 3.60**).

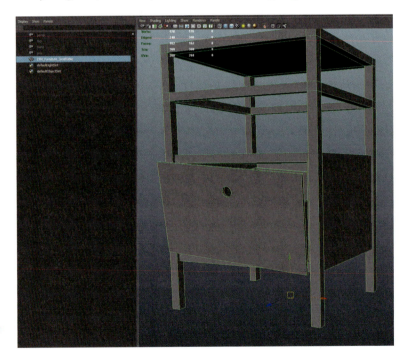

FIG 3.60 Manipulator moved to the bottom of the shape.

> **Why?**
>
> Thus far, the shape has been created by eyeballing it into shape. The absolute size of this one object could well be bigger than the entire set built in the earlier tutorials – or could be way, way too small. By moving the axis into this spot at the bottom center of the form, it is ready to be placed in the set and scaled easily.

Step 19: Save the file (File > Save).

Modeling Examination Table/Gurney

Building upon the techniques already covered, building an examination table will allow for exploration of some new techniques that will help make the models not quite so crisp and blocky. The focus here will be to get rid of those sharp edges that cubes have.

Step 20: Create a new file and immediately save it as ETM_Furniture_ ExamTable.

Step 21: Using the techniques covered in the previous steps create the frame for the bed (**Fig. 3.61**).

FIG 3.61 *Continued*

FIG 3.61 *Continued*

Step 22: Create a rough mattress from a cube. Create a polygonal cube and scale it roughly as shown in **Fig. 3.62**.

FIG 3.62 Roughing out the mattress with a polygonal cube.

Bevel

The Bevel Tool can be tremendously helpful for broad stroke situations (big areas like making this cube into a softer cushion). It can also be of real help in much tighter situations like making the edges of a table not razor sharp as two big faces come together.

What the Bevel Tool does is insert additional edges and faces to a selected edge (or object), offsets these new subdivisions, and scales them. The result is

a much rounder corner. In the following steps, we use it to make a much softer cushion.

Step 23: Select the edges around the top of the new mattress cube (**Fig. 3.63**).

FIG 3.63 Selected edges to be beveled.

Step 24: Bevel these edges. Do this by selecting Polygons|Edit Mesh > Bevel (Options). In the Bevel Options window, set the Width to 0.5 and the Segments to 4. Hit the Apply button. If the results are desirable (**Fig. 3.64**), close the Bevel Options window. If not, move the mouse over the View Panel and hit Ctrl-z to undo. Adjust the settings in the Bevel Options window and hit Apply again until happy with the results.

FIG 3.64 Results of the Bevel Tool.

Why?

This is a very broad bevel. Immediately though, you can see the four segments lead to four new rings of edges that are each offset to create a nice-rounded shape. For games, this is a great way to work as it gives the shape a more rounded form without dramatically increasing its polycount.

Tips and Tricks

The Apply button mechanism is a really nice way to tweak the sometimes esoteric results of Maya's options windows. In the case of the Bevel Tool, if the Bevel button is clicked, the bevel is performed and the Bevel Options window is closed. Conversely, using the Apply button lets you see the results of the settings you've chosen, but keeps the Bevel Options window open to tweak if need be. Just be sure to move the mouse over the View Panels and undo if you plan to adjust settings.

Step 25: Duplicate this cushion and move it up to the head of the bed (**Fig. 3.65**).

FIG 3.65 Second cushion being maneuvered.

Step 26: Reshape the cushion to be shorter. Do this by selecting the vertices at the top of the form and using the Move Tool to slide them down to make a shorter cushion (**Fig. 3.66**).

FIG 3.66 Left side shows the results when the vertices are *moved*. The right side shows the incorrect results of scaling the form.

Warnings and Pitfalls

It seems like we should be able to simply scale the top cushion down to size. The problem is that scaling literally moves all the vertices in relationship to each other, so that they are closer together. The screenshot on the right side of Fig. 3.66 shows the results of scaling the object. See how the top and bottom edges (as if laying on the table) of the cushion have been collapsed? This is why moving the vertices to change the shape creates a form that is more desirable as it keeps the curved shape.

Step 27: Position the top cushion shape to be reclined. The easiest way to do this is to move its manipulator to the bottom front edge of the shape, then with this new axis of rotation, use the Rotate Tool to rotate the shape up (**Fig. 3.67**). Add further details as desired (i.e., brace to hold up cushion).

FIG 3.67 Finished bed.

Step 28: Combine, delete history, rename, move manipulator, and save. Select all the shapes in the scene, choose Polygons|Mesh > Combine. Then, choose Edit > Delete All by Type > History. Move the object's manipulator to sit at the bottom center of the shape (where the feet would touch the floor). Finally, rename the new form to `ETM_Furniture_ExamTable` and save the file.

Conclusion

And with that we will leave architectural polygonal modeling. Of course, there are lots of other forms to be made within this game level; but with the techniques covered in the last few tutorials, most any shape that can be found in the research can be built.

This won't be the last we see of these polygonal tools though. In the next chapter, the exploration of polygonal tools will continue as they are used to create much more sophisticated forms for organic characters.

For now though, check out the homework and see what further shapes can be built with the current techniques. Place the furniture into the scene to make the space look like people were once there.

In the next tutorial, NURBS will be the technique of exploration. NURBS is just another way of achieving forms and it happens to work very well for certain types of shapes.

Tutorial 3.3 NURBS Modeling in Architecture

NURBS stands for Non-Uniform Rational B-Splines. This is of little importance except to notice that the core building component of NURBS surfaces are

splines. Splines (at its simplest) are curves. These curves can be used to create surfaces that appear solid.

The use of NURBS in modeling has risen and fallen in popularity over the years. For a while, it looked like there was going to be a serious movement to do all character modeling in NURBS. NURBS are great at creating smooth organic forms. They have a little more indirect method of manipulating the shape (more about control vertices, hulls, etc. later), and as time has gone on, the more direct methods of polygonal modeling – where a modeler is able to directly select a vertex and move it – have reemerged as the favorite of most modelers – especially game modelers.

However, having said all that, there is certainly a time and a place for NURBS modeling techniques. NURBS modeling techniques will allow for polygonal shapes to be the final output so can still be a great tool for certain forms (like the bathtub to be created and shown in **Fig. 3.68**).

FIG 3.68 Finished bathtub built using NURBS modeling techniques.

Step 1: Create a new Maya Scene and immediately save it as `ETM_Furniture_Bathtub`.

Curves (Splines)

So we've already established that NURBS are the results of splines. What this means is that creating the splines that create the NURBS surfaces is critical.

Maya allows for several ways of creating (and editing) curves. CV (Control Vertex), EP (Edit Point), and more recently Bezier Curves. In Maya books of the past, I've written extensively about how to work with Maya's CV Curve Tool – which used to be my favorite. But finally, Maya has caught up with the rest of the 3D world and finally allows for the creation of curves using Bezier curves.

If you have any experience with Illustrator – or even Photoshop, you have had occasion to work with the Bezier curve paradigm. Bezier curves are defined

with anchor points that have Bezier handles that control how the curve comes in and goes out of that anchor point.

There are several keys to working with Bezier points in Maya:

1. Create Bezier points in orthographic views. A curve that is flat (sharing at least one dimension) will make for lots of important possibilities.
2. When Using the Bezier Curve Tool, clicking and releasing puts a Bezier anchor down with no handles. This means the curve will come in and out of that point linearly – making sharp angles.
3. Remember that with Maya's Bezier Curve Tool, it's often easier to place the points needed and then go back in and refine them when the curve is done.
4. The Bezier Curve Tool curiously also acts as the Edit Bezier Curve Tool (although it isn't called that). This is handled a bit differently than most other tools are handled in Maya.

Step 2: In the front View Panel, create a curve that begins and ends on the Y-axis. Do this by first Create > Bezier Curve Tool. With the tool activated, hold the x down (snap to grid), and click-and-release on the world's Y-axis (indicated by the thickest vertical black line). Continue through the other points shown in **Fig. 3.69** by clicking and dragging each time to produce an anchor point with Bezier handles. Do this until point 7 in Fig. 3.69. There, again hold the x key down and click release on the Y axis. Hit Enter to exit the tool.

FIG 3.69 Creating the curve that will become the bathtub.

Step 3: Edit the curve as needed with the Bezier Curve Tool. With the curve selected activate the Bezier Curve Tool (Create > Bezier Curve Tool (Options)). The options for the tool will appear across the left side of the interface (**Fig. 3.70**). Now any of the Bezier anchors or Bezier handles can be selected and adjusted as needed. Be sure to exit the tool when done by activating any other tool (like the Move Tool).

Tips and Tricks

Maya handles the Bezier curves a little differently than most other applications. However, the basic ideas of a key combined with a mouse click is the same. For instance, Ctrl-left-click-drag will reset the handles on an anchor (add handles if the anchor has none). It takes a little bit of playing with, but ultimately, this allows for any curve to be achieved.

Surfaces

The curves that are created in Maya have no geometry of their own. This means that if we asked Maya to render or draw what has been created, the scene would show up black – empty. Curves by themselves are pretty useless.

Curves really should be thought of as construction objects; objects that can be used to create other objects. In this case, the curves will be used to create NURBS surfaces.

NURBS surfaces can be built from multiple curves (which we'll look at in a bit), but in this case, this curve will be rotated around an axis leaving a surface in its wake.

Step 4: Create a revolved surface. Select the curve and choose Surfaces|Surfaces > Revolve. The default settings will yield a form like **Fig. 3.71**.

FIG 3.71 Results of a revolved curve.

Why?

What has happened here is that the curve has rotated 180° around its manipulator. Because we created the curve starting and stopping on the Y-axis, the manipulator of the curve happens to be on the inside edge of the curve. It doesn't have to be though. For instance, if the desired shape had a big hole in the bottom, the curve could have been started and stopped off of the Y-axis; or before revolving, if the curve's axis was moved away from its default setting (on the Y-axis), the outcome would have been much different.

Tips and Tricks

Now if you open the options of the Revolve (Surfaces|Surfaces > Revolve (Options)), you will see that there is the ability to output directly to polygons. In some cases, this is a good way to work; but in this case, we are going to hold off for a while. This will allow us to work with the new NURBS surface for a bit and see the power of NURBS forms.

Step 5: Adjust the surface via its Control Vertices. To do this, right-click on the surface and choose Control Vertex from the Hotbox. Suddenly, there will be lots of little pink squares floating just off the surface (these are Control Vertices (CVs for short)). With the Move Tool active, marquee around the CVs shown in **Fig. 3.72** and move them along one axis to lengthen the shape.

FIG 3.72 Adjusting NURBS surface by moving its Control Vertices.

Step 6: Further sculpt the CVs to taste. Do this with the Move Tool and by marqueeing groups of CVs to find the form of the tub you are after. I ended up with **Fig. 3.73**.

FIG 3.73 Finished tub shape sans legs.

Step 7: Delete history and delete the curve.

Why?

Before deleting the history, the curve is still tied to the surface. This can be very useful if the profile of the tub needs to be adjusted. The curve itself has CVs that, if adjusted, would change the very shape of the tub. However, because the two are tied together, if the curve is deleted, the tub itself will also delete.

Tips and Tricks

In some cases, it's nice to keep that curve around (or curves if working with a surface that requires multiple curves). In those cases, it's still good to get the curves out of the way. This can be done by grouping the curves together(Ctrl-g) and hiding (Ctrl-h) the group. Or in the Layers Editor (beneath the Channel Box), new Layers can be created and their visibility turned off by clicking the V box.

Step 8: Convert the NURBS surface to polygons. Do this by selecting the tub and choosing Modify > Convert > NURBS to Polygons (Options). Change the Tessellation method: to Control Points. Hit the Tessellate button. Move the new object created off to the side (Fig. 3.74).

FIG 3.74 Converted NURBS surface to polygon shape.

Why?

"Now wait a minute !" you may be saying. "It looks to me like we're moving backward. This new shape looks worse than what we just created." And you'd be right. So why are we changing to a polygonal shape anyway?

Well, in some cases we wouldn't want to. For instance, if this were a high-poly scene (not a game scene), there may not be any reason to swap from a NURBS surface. However, since this will eventually go in a game engine, we need to be able see what the shape will really be like in game – which will be polygonal. Further, the tubs in all the research have those very straight legs which will be more easily achievable via a polygonal shape. Thus, now is the time. Not to worry though, in the coming steps we will "up-rez" the shape to give it more polygons so we get back to the curvilinear tub shape.

Smooth

OK, so this actually isn't a NURBS surface tool – it's a polygonal tool but stick with me for a minute here. What Smooth does (Polygons|Mesh > Smooth) is take each polygon and subdivide it into four and bend each of those new polygons in relation to the others. It turns a cube into a sphere (or more into a sphere anyway). In this case, we can take the ultra-low poly tub and convert it into a higher polygon – but smoother shape.

> Step 9: Smooth the polygonal mesh. Select Polygons|Mesh > Smooth (Options). Change the Divisions setting to 2. Hit the Smooth button (**Fig. 3.75**).

FIG 3.75 The results of the Smooth function.

Why?

So the number of divisions refers to how many times it's going to subdivide each polygon in the shape. This means that this can quickly get out of hand and suddenly you could end up with a mesh that is so dense it's impossible to edit. Further, the mesh that the Smooth function creates often has very inefficient polygons (more than needed to describe the shape). So, while the Smooth Tool seems to be a magical make-everything-sexy-and-curvilinear-tool, it can also be the diabolical make-a-mesh-too-dense-to-use-especially-in-games-tool.

> Step 10: Optimize by deleting unneeded edge loops. To do this, select an edge and ctrl-right-click-hold and select Edge Loop Utilities > To Edge Loop and Delete (**Fig. 3.76**). Look for areas where there are many loops defining a collection of geometry that could be defined with fewer. My final solution can be seen in **Fig. 3.77**. Yours may vary.

FIG 3.76 Deleting unnecessary geometry with the To Edge Loop and Delete.

FIG 3.77 Results of deleting unnecessary edge loops.

Why?

The idea here is that there are too many divisions – a problem with the Smooth Tool. There are a lot of equally distanced edge loops, but not all of them are needed. By taking a minute to optimize, the form will be easier to manipulate now during modeling and make other things like UV mapping easier.

Tips and Tricks

The key here is to delete edges and see if the resulting shape is acceptable. Sometimes you will pick an edge to delete that changes the shape of the form in the wrong ways. Undo and pick another.

Step 11: Use polygonal modeling tools (i.e., Extrude) to extrude out legs and otherwise adjust the form.

Step 12: Cleanup. Delete all history. Delete the NURBS tub, move the manipulator of the tub to the bottom floor. Rename the object to `ETM_Furniture_Bathtub`. Save.

NURBS for Trim

So using NURBS can be a great way to start creating shapes with a rounded form (bathtubs, toilets, vases, wine glasses, etc.); but it ironically can also be used to make some very interesting linear elements too. One of my favorite uses of NURBS processes is for trim pieces – door trim, floor boards, crown molding, picture frames, etc.

The process is a little different than the previous steps. It starts with a curve that is the profile of the trim, but then that curve is placed in each corner to define the path that the NURBS Loft surface will take. The results are some very beautiful trim pieces.

Step 13: Create a new file and save it as ETM_Hallway_DoorTrim.
Step 14: Create a cross section of door trim. Using the Bezier Curve Tool and in the top View Panel, draw a curve that represents what you would see if you cut a piece of trim and looked directly at its profile (**Fig. 3.78**). Think of this as curve #1.

FIG 3.78 Trim Curve.

Why?

Why the top View Panel? It doesn't really matter actually – as long as it is one of the orthographic View Panels that the curve is drawn in.

Tips and Tricks

If you have ever shopped for trim at Home Depot or Lowes you have seen these sorts of curves. They are how the stores differentiate the trim on the signs at the bottom of the bins that hold pieces of trim. If you are unfamiliar with what these curves look like, just copy Fig. 3.78 or Google "door trim profile."

Warnings and Pitfalls

It's best to make sure this curve is closed. There are two ways to do this: First, when using the Bezier Curve Tool and after placing the last anchor, hold Cntrl-Shift-Left-Click on the first anchor point. Or, after the last anchor is placed, hit Enter to leave the tool and choose Surfaces|Edit Curves > Open/Close Curve.

Step 15: Move the curve's manipulator to the inside corner of the curve – the corner that will be against the wall and on the door side.
Step 16: Rotate the curve 45°, so that it roughly matches **Fig. 3.79**. Remember you can do this in the Channel Box by changing the Rotate Z to 45 (or –45 either will work) or by swapping to the Rotate Tool and holding the j key down (to snap to 15° increments).

FIG 3.79 Rotated curve.

Why?

Eventually, there will be four of these curves – one for each corner of the doorway. If the curves remain flat, the trim will loft into a shape that has flat (as in flat as a piece of paper) parts as the surface attempts to go from a curve with no height (the curve is flat) to another with no height. Rotating by 45° will ensure that the lofted surface has a constant width.

Step 17: Duplicate (Ctrl-d) curve #1 and move the new curve #2 straight up in Y (**Fig. 3.80**).

FIG 3.80 Duplicated and moved curve.

Tips and Tricks

If, when moving the curve up in Y, the x key is held down, the curve's new location will be snapped to the grid. This can make lining all the curves up a bit easier.

Step 18: Duplicate curve #2, slide it (curve #3) over and rotate another 90°, so that it mirrors curve #2 (**Fig. 3.81**).

FIG 3.81 Duplicated and moved curve #3.

113

Step 19: Duplicate curve #3 and move it (curve #4) straight down, so that it is at the same level as curve #1 (**Fig. 3.82**).

FIG 3.82 Last curve in place.

Step 20: Loft the curves into a polygonal shape. Do this by first selecting the curves in order (select curve #1, Shift-select curve #2, Shift-select curve #3, and Shift-select curve #4). Then, choose Surfaces|Surfaces > Loft (Options). Change the Surface Degree: to Linear. Change the Output Geometry: to Polygons. Change the Tessellation Method: to Control Points. Hit Loft (**Fig. 3.83**).

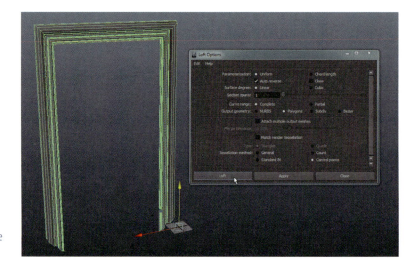

FIG 3.83 Lofted surface – note the results are a polygon form.

Why?

Lots of things to talk about here. First, the order things are selected in is important to Maya. It tells it in what order to run as it lofts the shape. Surface Degree: Linear means that Maya takes the shortest path between curves. Output Geometry: Polygons means we get a polygonal shape (not a NURBS surface) as a result of the process – this makes editing things like the bottom of the trim easier. Tessellation Method: Control Points mean that a polygonal vertex is placed at each place that a NURBS Control Vertex would have been. This creates the leanest and cleanest geometry (all quads).

Step 21: Delete the history (Edit > Delete All by Type > History). Delete the curves.

Why?

We want to separate the lofted form from the curves to be able to quickly and efficiently manipulate the form without getting entangled in the curves. We can still do all the editing, we are going to need to do with just the polygonal shape.

Step 22: Flatten the bottom of the trim. This can be done several ways; for now, select all the vertices that are on the bottom of the door and in the very top of the interface, toward the right side look for three input fields titled X, Y, and Z. These represent "Absolute Values." Enter 0 and hit Enter in the Y input field (**Fig. 3.84**).

FIG 3.84 Using the Absolute Values to flatten the vertices at the bottom of the trim.

Step 23: Cleanup. Delete all history. Move the manipulator to the bottom of the trim object. Name it `ETM_Hallway_DoorTrim`. Save.

Import

Thus far, we have been creating assets in separate Maya scene files. This has the benefit of keeping the scene clean as each form is built. But there comes a time when these assets need to be consolidated. Maya makes this pretty easy with the File > Import; however, there is a bit of cleanup that has to happen along the way.

Step 24: Open ETM_Hallway.

Step 25: Choose File > Import.

Step 26: In the Import window, choose any of the assets created in other scenes. I am going to choose the ETM_Hallway_DoorTrim file. Click the Import button.

Step 27: Rename the newly imported asset in the Outliner. Note that when it comes in, the name becomes really long – unnecessarily long as it shows the name of the file the object came from and the object itself (**Fig. 3.85**). In this case, shorten the name of the object to ETM_Hallway_DoorTrim.

FIG 3.85 Results of Import – a name that's way, way too long.

Step 28: Resize or reshape as appropriate. In my case, I needed to move the trim, so that it actually was at a door to start. Then, I needed to move the vertices (of the corners), so that the trim matched the doorway. Notice I didn't scale; I moved the vertices to match the shape of the door (**Fig. 3.86**).

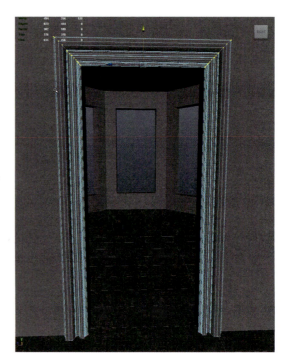

FIG 3.86 Placed and adjusted door trim.

Step 29: Repeat with other assets modeled (**Fig. 3.87**).

FIG 3.87 Additional placed assets.

Conclusion

There is certainly more to model and populate before this game level is done. Be sure to check out the Homework section for new challenges or pick shapes in the research that you want to place in the spaces created to help tell the story that took place here.

The key is that now you have the tools to create most any shape you would see in the research. Part of the final modeling mastery is deciding what technique to use where. Don't be afraid to abandon a technique if it isn't producing the form you're after and trying another. These failed experiments can be invaluable learning experiences.

In the next chapter, we will take the modeling techniques further – much further and create much more complicated, interesting, and sophisticated organic shapes.

Homework

1. Populate the rest of the rooms with props and furniture found in your research.
2. Give windows a shot. Could they come from the same techniques as the doors?
3. Try vases, glasses, light fixtures, etc… How could you use the techniques used in the bath tub to build these?

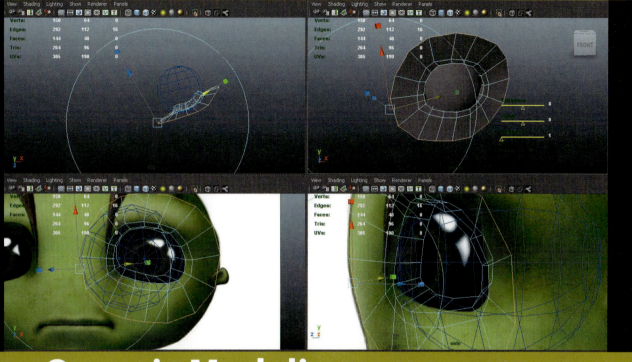

Organic Modeling

Modeling architectural assets is a great way to start learning about modeling. Architectural things like walls and furniture are all man made. This means that many of these sorts of assets are simple in form – often linear and inorganic.

Organic modeling, while using many of the same *tools* as architectural modeling, is a whole other ball game and as such often needs a new collection of *techniques*. In this chapter, we will be looking at organic polygonal modeling techniques specifically through the lens of organic modeling.

In this chapter, we will look at creating assets for two different applications. The first is a game character model. Game characters are great places to start as they are limited in the number of polygons they should contain. Too many polys and any game engine get bogged down. Although this limitation may seem like a problem at first glance, it's of benefit for the learning process as the data set is smaller and allows a more bite-sized collection of techniques to be explored.

Once you know the basics of character modeling – as realized in game characters – you will actually have the necessary knowledge to tackle higher resolution assets. Be sure to check out the homework to see the challenge of a

high-poly character bust. This will be a character that would hold up in film or TV. The number of polygons are higher, the detail deeper, and the techniques slightly different.

Tutorial 4.1 Game Character Modeling

As discussed before, game engines must render (or draw) everything on the screen many times a second (generally at least 30 frames per second is demanded by most gamers). In order to render this quickly, the game engine has to have a reasonable collection of assets to work with. Too many polygons, too many textures, textures that are too big, and lighting schemes that are too complex will drag down a game's frame rate.

How many polygons are too many is actually a pretty complex question. Part of it depends on what platform the game will appear on (Xbox 360 and PS3 can push a 15,000 poly character without blinking – while that's a pretty good workout for a Wii or a iOS/Android device). Part of it depends on how many characters will be on the screen at a time (if there is one character and one enemy, a high polycount is no problem; but if there are hordes of baddies coming after you, each of those bad guys will need to be fairly efficient). And part of it depends on the complexity of the environment (both in polycount and textures).

For this project, we will give ourselves a fairly arbitrary self-defined limit of 15,000 tris (triangular polygons needed to render). In the process, the final form can and will be sophisticated and interesting. A low polycount is not a limitation – but rather a construct to work within.

The character we will be building was designed and modeled by Jake Green – a talented animation artist (and former student of mine) who is currently working at the Los Alamos National Laboratory. For more of his work, check out www.JakeGreenAnimation.com.

Some Notes

A few quick notes before beginning. First, a good-looking character model begins with a good-looking character design. Really, there is very little technical prowess than can compensate for poor design. This is why Jake did the design; he's a character designer while I am not. Don't be afraid of getting your design from a friend or colleague who has solid character design skills.

Second, this tutorial makes use of assets called **Character Style Sheets**. These are front and side drawings of the character to be modeled. But they are more than just sketches – they are really draftings that work out some of the architecture of the character. The model will be created right over the top of these drawings, and so their accuracy – and specifically their accuracy in relationship to each other (front and side) is critical. The work of lining these has been done for you in this case (downloadable on the support website at http://www.GettingStartedin3D.com). However, knowing how to prepare style sheets is important. Be sure to check out Appendix A: Preparing Character Style Sheets.

Getting Started

Step 1: Create a new Project. Remember, to do this, use File > Project Window. Name the new Project `Game_Character`.

Step 2: Make a new scene and save it. Save it as Game_Character. This will save the file Game_Character.mb into the scenes folder of the Game_Character Project.

Step 3: Place the prepared character style sheets within your project. To do this, go to http://www.GettingStartedin3D.com and go to the Tutorials & Support section and to the Chapter 4 thread. There, download the file under the link "Prepared Character Style Sheets." Unzip the archive (which will contain two files – GameCharacterStyleSheetFront.jpg and GameCharacterStyleSheetSide.jpg) and move these two files into your Project's sourceimages folder.

Image Planes and Setting Up to Work

Image planes are so useful; they almost feel like cheating. They are really just images that are placed in orthographic views (although they can be placed in perspective views – their usefulness there is limited) that provide a reference over which polygons can be created and shaped. It's kind of like tracing with polygons.

With the prepared style sheets that are now in your sourceimages folder, we can create these guide images and build over the top of them.

Step 4: If the View Panel is not already split, move the mouse over the View Panel and hit the space bar to split into four views.

Step 5: Import the front style sheet drawing. Do this in the front View Panel. Choose View > Image Plane > Import Image (**Fig. 4.1**). This will open a new dialog box that should take you to the sourceimages folder where the style sheets have been placed. Choose GameCharacterStyleSheetFront.jpg and hit Open.

FIG 4.1 Importing an image plane. Note that it uses a pull-down menu that is *inside* a particular View Panel.

Step 6: Import the side style sheet drawing. Do this one in the side View Panel. In that View Panel, choose View > Image Plane > Import Image. This time in the Open dialog box, choose GameCharacterStyleSheetSide.jpg and hit Open.

Why?

The results of the last two steps should appear like **Fig. 4.2**. Notice that in the front and side View Panels, the two sketches appear, and they also appear in the persp View Panel. Notice also that if they are in the middle of the persp view then these planes would intersect the geometry we need to build. In the following steps, we will need to move these planes around in space. But to move them takes a unique collection of steps because they are image planes (not geometry in the scene).

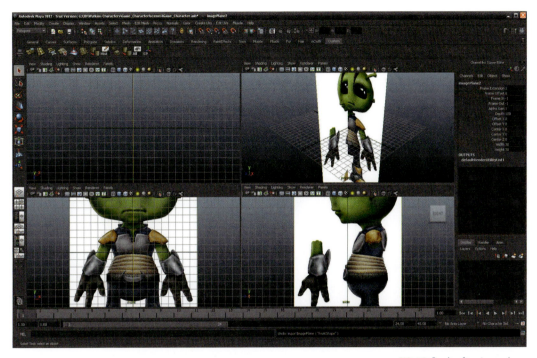

FIG 4.2 Results of two image planes being placed.

Step 7: Access the imagePlane attributes for the front View Panel and move the image plane back in Z. To do this, in the front View Panel, choose View > Select Camera. This will show attributes of the camera in the Attributes Editor (to the far right of the interface). There, look for the imagePlane1 tab and click it. Look for the Placement Extras section and expand it (if needed). In the Center input fields, change the settings to read 0, 0, −50 (**Fig. 4.3**).

Why?

Think of an image plane as a plane attached to a camera. This is why accessing the attributes of the image plane is done by adjusting the attributes of the front camera. Within the front camera's nodes, the imagePlane1 tab shows the attributes of the image plane attached to the camera. Predictably, the Placement Extras section allows for adjustments of the image plane. The Center set of input fields isn't labeled, but the three input fields are for X, Y, and Z. By default these will be 0, 0, 0, but entering −50 in the Z input field pushes the image 50 units back in Z (as can be seen in Fig. 4.3).

The critical (and useful) thing here is to notice that although the plane has slid back 50 units in the persp View Panel, it hasn't gotten any smaller in the front orthographic View Panel. It still serves the same purpose as an image to build polygons over, but won't be in the way of the polygons to be built.

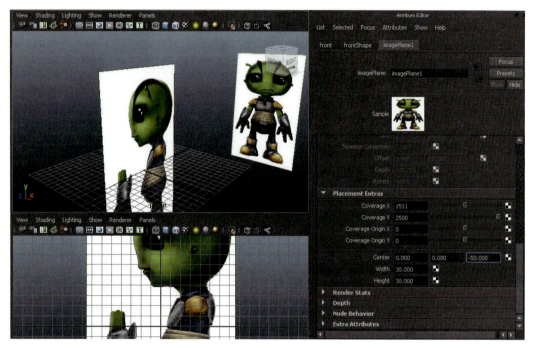

FIG 4.3 Adjusting the placement (in Z) of the image plane that is in the front View Panel.

Step 8: Hide the image plane for all the views except the front View Panel. Still within the Attribute Editor and within the imagePlane1 tab, click the Display: `looking through camera` radio button.

> **Why?**
>
> Even though the plane is moved back in space, it is still an unnecessary clutter in the persp View Panel. By turning on "looking through camera," we make the image plane *only* visible in the front View Panel.

Step 9: Repeat for the side View Panel. So again, in the side View Panel, choose View > Select Camera. In the Attributes Editor, select imagePlane1. In the Placement Extras section, this time enter −50, 0, 0 in the Center input fields. Finally click the looking through camera radio button.

> **Why?**
>
> Same idea, only this time the image plane is being shifted −50 units in X not Z.

Step 10: Hide the grids. Do this using Display > Grid (turn the check mark off).

Why?

The grid can be very helpful in some situations or a real pain in others. This is one of those times when it needs to go away and clean up the interface.

Step 11: Keep track of the polycount. Do this via Display > Heads Up Display > Poly Count.

Why?

We're in game-land right now, and keeping our polycount low is critical. It's tough to keep the polycount low if we don't know what the polycount is. The Heads Up Display can present (at all times) how many polys we have created. As soon as Poly Count is turned on, information on the model will appear in the top left corner of the View Panel.

Tips and Tricks

The Poly Count part of the HUD (Heads Up Display) can seem a little tricky at first. Notice that the numbers will change depending on how much of the model is visible and if an object is selected or not.

Getting Started on the Eye

Step 12: Create the eyeball. Do this by creating a polygonal sphere (Create > Polygon Primitives > Sphere). Rotate it 90 in X (probably most easily done in the Channel Box). Scale it and move it, so it appears like **Fig. 4.4**.

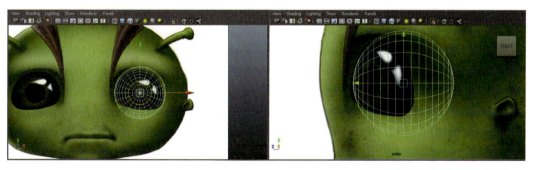

FIG 4.4 Creating the basis of the eye.

Why?

Starting with the eye seems strange, but this one piece of anatomy that will help inform a lot of the steps coming up. Be really sure to be organizing the eye in both the front and side View Panels.

Display Layers

Display layers allow a user to hide and show collections of assets en masse. Additionally, it allows for a collection of objects to be locked down or become unselectable. At its core, display layers are an organizational tool.

Step 13: Create a layer to store the eye. In the bottom right corner of the interface should be the Layer Editor with three tabs (Display, Render, and Anim; Fig. 4.5). If this is not visible, click the Show or Hide the Channel Box/ Layer Editor button in the top right corner of the interface. Select the eyeball sphere, and in the Layers Editor under the Display tab, choose Layers > Create Layer from Selected.

FIG 4.5 Top of the Layer Editor.

Why?

This does two things at once. First, it creates a new layer, and second, it adds the eyeball to it.

Step 14: Reference the layer. In the Layer Editor, there is a new layer1. Between the name of the layer and a box with a V in it, there is an empty box. Click that box twice until an R (for "reference") appears within it.

Why?

A layer that is referenced is a layer that is visible, solid, but not selectable. Note that the first time when this area is clicked, a T appears. T is for Template and allows an object to be non-selectable as well, but will always display as a salmon-colored wireframe.

In both cases, the idea is that there may be elements that need to be in the scene to help in further creation (scale references, etc.). Or there are objects that are finished and you don't want to accidentally select or alter them. Getting them on a layer that is either a Template or Reference makes sure they are set aside and not messed with.

Tips and Tricks

Although we aren't going to mess with it here, the button on the far left there with the V is for visibility. Toggling the V will toggle the visibility of the layer.

Create Polygon Tool

Thus, so far we have generally altered polygons that already existed as part of primitive forms. Polygons have been split, cut, and extruded. These are great tools, but there are other ways of getting geometry to work with. The Create Polygon Tool is pretty self-explanatory: it allows for a polygon to be created by allowing the user to click three (or more) times where the vertices of the polygon should be.

> Step 15: Create the first polygon via the Create Polygon Tool. Activate Polygons|Mesh > Create Polygon Tool. Then, in the front View Panel, click four times (**Fig. 4.6**) once for where each of four vertices should be. Hit Enter when through to exit the tool.

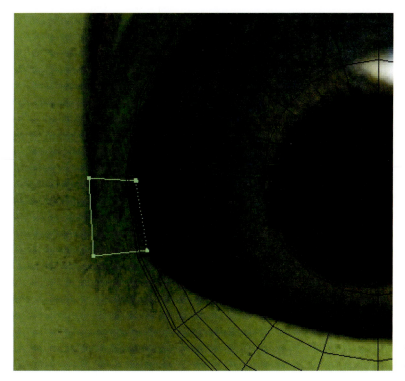

FIG 4.6 Using the Create Polygon Tool to create the first polygon of what will become this game character.

Extruding Around the Eye

Using the Extrude Tool should be fairly familiar by now. In Chapter 3, faces were extruded to create everything from new walls to chunks of furniture. It turns out that the Extrude Tool can be used for more than just extruding faces – it can be used on edges too.

This will be the strategy employed here. Selecting and extruding edges will allow the single polygon just created to be extended into more complex forms.

127

Step 16: Select the top edge of the polygon in preparation of extruding. Remember to do this, right-click-hold on the polygon and select Edge from the Hotbox to get into Edge Mode. Then, select the top edge of the polygon.

Step 17: Extrude the edge to create a new polygon. Select Polygons|Edit Mesh > Extrude. Use the Move handles to move the extruded edge away to create the new polygon (**Fig. 4.7**).

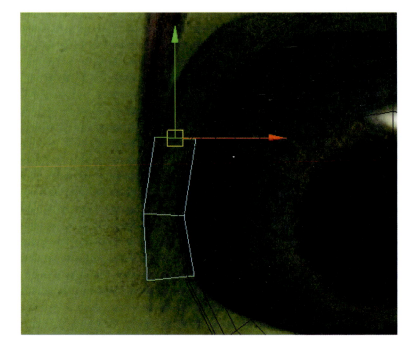

FIG 4.7 Extruding out an edge to create a new polygon.

Step 18: Repeat, and extrude, but make sure that in addition to moving the new edge up use the rotation handles (blue circle) to rotate the edge as well (**Fig. 4.8**).

Why?

Good topology is always important. It is especially critical with characters. The muscles around an eye are largely circular – they surround the eye. By rotating the edges of this first loop of polygons (so that the edges all point toward the middle of the eye), we can lay the ground work needed for effective topology to come.

Step 19: Repeat all the way around the eye. For each extrusion, remember to both move and rotate the edge (**Fig. 4.9**). Be sure to match the line of the eyelid as it touches the eye.

FIG 4.8 Extruding, but also taking the time to rotate the edge.

FIG 4.9 Continuing all the way around the eye with extruded edges.

Merge to Center

We have looked at all sorts of ways to increase the amount of geometry we have (extrusions, cuts, etc.). Sometimes, however, what is needed is a consolidation of elements or components. In this case, we need to close off the loop of polygons we have begun. To do this, we will need to merge vertices together.

129

There are a couple of merge tools available in the Maya of today. The Merge to Center is often a great choice when there are pairs of vertices that need to be merged regardless of how far apart they are.

Step 20: Merge pairs of vertices together to close-up the polygon loop. Do this by selecting pairs of vertices (like shown in the left image of **Fig. 4.10**) and then selecting Polygons|Edit Polygons > Merge to Center. The result will appear like the right image in Fig. 4.10.

FIG 4.10 Using Merge to Center to combine two vertices into one.

Step 21: Repeat for the other pair of vertices.

Finding the Shape of the Eye

From the front view, we now have a good shape for the eye. However, take a look at this ring of polygons in the top or perspective view and you'll see that it is sitting right in the middle of the eyeball, which is not where it should be.

Part of the reason for creating the eyeball first is that it will give us a quick way to make sure that the shape of the polygons that are the eyelid (the ring of polys we just created) are correct. In the next few steps, we will start to manipulate this collection of polygons into a three-dimensional representation of the eyelid.

Step 22: Move all the vertices to the front of the eye. Select the entire object and use the Move Tool to move these flat polygons, so that they are in front of the eyeball.

Step 23: Move pairs of vertices up to match the sketch and the eyeball. This takes a few steps. Make sure you are using a four-view layout (hit the Spacebar) and in the front View Panel, select a *pair* of vertices. Then, in the side View Panel, move the vertices only along the Z axis, so that they match the sketch (**Fig. 4.11**).

FIG 4.11 Moving vertices into place in three dimensions.

Why?

It's important that these vertices are moved only in the Z axis as there was great care in organizing them in the front view. Should you start moving them around in other directions besides just Z, suddenly the vertices wouldn't match the front sketch any more.

Step 24: For the moment, make the eyeball invisible. Do this by clicking the V button in the Display Layers Editor for layer1.

Why?

In a perfect world, the character style sheets will line up perfectly in the front and side and will work out perfectly with the sphere that is the eyeball. In the real world, it's very difficult to make drawings that work perfectly in this way. As the vertices have been moved back to match the sketch, you've undoubtedly found that there is quite a bit of eyeball penetration going on there. We are going to fix some of that in a minute, but in the meantime, it can be a bit distracting. Hiding the eyeball for a moment will allow for focus to remain on the shape of the geometry for a moment.

Step 25: Adjust the outermost ring of vertices to match more closely the geometry of the face as it moves out from the eye (**Fig. 4.12**).

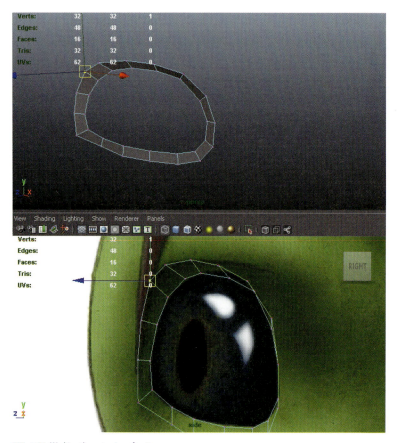

FIG 4.12 Working the outer ring of vertices.

Step 26: Adjust to the eyeball. First, make sure the eyeball is visible (do this in the Display Layer Editor by clicking the button where the V was until the V returns and the eyeball is again visible). Then, again – by selecting pairs of vertices – move the pairs out, so that the inner most ring of vertices are on the surface of the eyeball (**Fig. 4.13**).

Thickness for the Eyelid

Step 27: Give the eyelid thickness. Switch to Edge Mode and then double-click on any of the inner edges (this will select a ring of edges that selects all the inner edges). Use the Move Tool to slide this selection out off the eyeball just a bit. Now select Polygons|Edit Mesh > Extrude and pull the new extrusion back, so that it matches the eyeball's surface once again (**Fig. 4.14**).

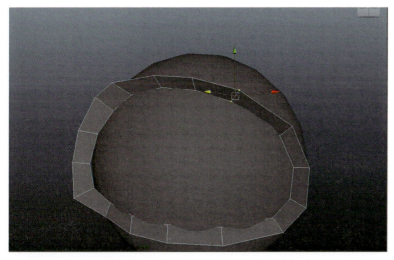

FIG 4.13 Moving vertices to match eyeball.

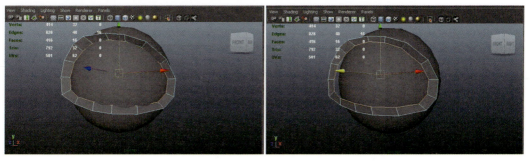

FIG 4.14 Adding thickness to the eyelid by moving the edge away from the eye (left) and extruding back to meet the eyeball (right).

Why?

Creating the initial geometry right up against the eye gives us the right shape. However, it also produces eyelids that are paper thin. By pulling that edge off the eye – we have the right shape of that inner ring of edges, but then extruding back provides "meat" to the eyelid.

Step 28: Reduce the number of polys in the eyeball. Do this by unreferencing the eyeball layer (clicking the R button in the Display Layers Editor) and selecting the eyeball itself. Then, in the Channel Box, expand the INPUTS section and click the polysphere1 node. There, enter `12` in the Subdivision Axis input field and `8` in the Subdivisions Height input field (**Fig. 4.15**).

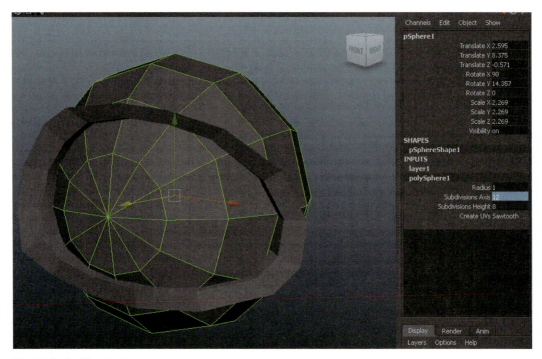

FIG 4.15 Results of decreasing the geometry in the eyeball.

Why?

Having a densely constructed eyeball was of great use when creating the form that would surround that eyeball. But at the end of the day, there is little need to spend so much of the poly budget on the eyeball. So once the eyelid shape has been achieved, we can reclaim some of that budget by reducing the amount of geometry in that eye.

Step 29: Soften the edge normals. Still with the eyeball selected, choose Polygons|Normals > Soften Edge (**Fig. 4.16**).

Why?

Similar to faces, edges have normal as well that help define the front of the edge. A hard edge normal leaves a very crisp edge – which is sometimes just what is desired. But softening that edge normal can make a shape where the edges of faces are harder to distinguish – and thus the shape appears smoother. After the sphere's polys were reduced, the eye appears very faceted. Softening all the edge normals for the object (using Soften Edge when the entire object is selected) will appear to smooth the entire form, but not increase the polycount at all. This technique will be used quite frequently in game modeling.

FIG 4.16 Softening edge normals.

Expanding the Geometry

Step 30: Extrude out new geometry. On the geometry, that is the alien's face (not the eyeball), switch to Edge Mode and double-click one of the edges on the outside of the shape. Use Polygons|Edit Mesh > Extrude and then use the Move handles of the Extrude Tool to pull the new extrusion out (Fig. 4.17).

FIG 4.17 Creating new geometry with an edge extrude.

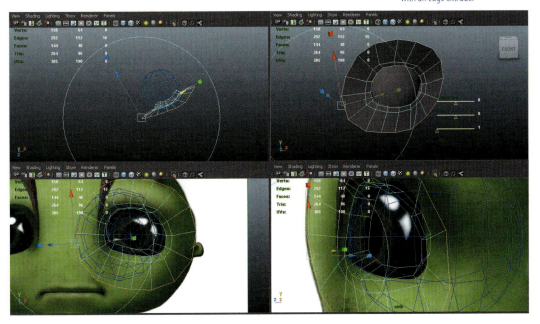

Step 31: Tweak new geometry into place. This can be done either in Edge Mode or Vertex Mode. The idea is to take a moment and start moving these new components, so that they match the side and front image planes. As you tweak, be sure to check the persp View Panel to see if the shape is coming together as desired.

Step 32: Extrude out another ring of faces. Again, do this by swapping to Edge Mode and double-clicking one of the outside edges to select the outer ring of edges. Use Polygons|Edit Mesh > Extrude and pull out the new ring of edges (**Fig. 4.18**).

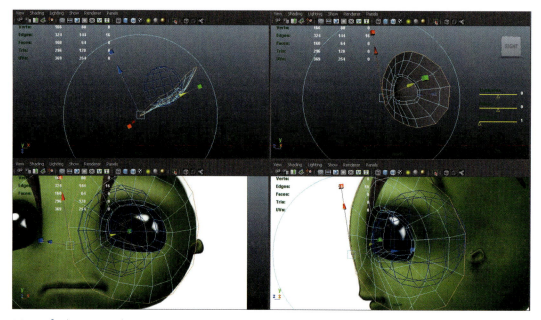

FIG 4.18 Creating a new extrusion.

Step 33: Tweak as needed but snap the inner edges to the middle of the face. In the front view, take a look, and by this point, there will be geometry that passes over the middle of the face. Switch to Vertex Mode and select vertices that have crossed over the middle of the face. Double-click the Move Tool, and in the Tool Settings window that will appear, look for the Move Snap Settings section. Turn off Retain Component Spacing. Now, in the front View Panel, hold x down (snapping to grid) and move the vertices in X. Snap them to the middle of the face (**Fig. 4.19**).

Why?

Lots happening here. Because the character is largely symmetrical, much time will be saved by modeling only half the form and mirroring that later. But to make this work right, the center of the mesh needs to be clean – it must have a clean axis of symmetry. This is why the vertices need to be snapped clean on the center.

Retain Component Spacing is the default setting for the Move Tool. It means that if a collection of vertices (for example) are selected, as they are moved – particularly as they are snapped) – Maya will retain their relative location to each other. This means that, by default, Maya snaps the selection's manipulator (not each individual component) to grid or vertex or whatever. By turning off Retain Component Spacing, when a group of components are snapped, they abandon their relative spacing, and, in this case, all snap to the next X grid line.

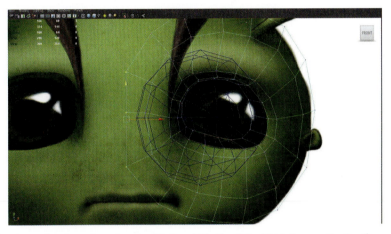

FIG 4.19 Snapping vertices to the center of the face with the Move Tool and Retain Component Spacing off.

Creating Dynamic Mirrored Geometry

Getting started modeling is fine, but it can be a little disconcerting always building just half of the form. Eventually, when one half of the form is complete, Maya can mirror the geometry, so that there is one complete form. However, for now, we only want to have to build one half of the shape.

Mirror Geometry is actually a function in Maya – but it is fairly inflexible. Instead, we will make use of **instances** to create a dynamic copy of the half we are modeling. This instance of the model will be a mirrored version of the current geometry, and as changes are made to one side, they will be replicated on the other.

Step 34: In Object Mode, select the mesh of the face. If you have not moved the object, its manipulator should be sitting at 0, 0, 0.
Step 35: Duplicate an instance. Choose Edit > Duplicate Special (Options). In Geometry Type, click Instance. Under Scale, change the values to −1, 1, 1 (**Fig. 4.20**). Hit Duplicate Special.

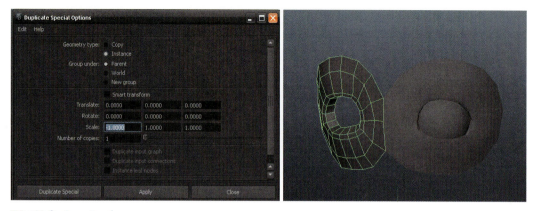

FIG 4.20 Creating a mirrored copy using Duplicate Special.

Why?

Instances are not actually copies of geometry. They are simply showing another object again. So by making sure to click Instance, the new duplicate will be just another display of the geometry built, which means that when the vertices on the original are adjusted on the left side, they are adjusted on the right as well.

Remember that most of the time you see three input fields in a row (as there appears next to Scale in the Duplicate Special dialog box), it really represents X, Y, and Z. So changing the first input field means to make the duplicate be −1 in Scale X. As an object is scaled smaller and smaller in any direction (in this case X), it gets closer and closer to 0. Pushing a scale past 0 into the negative direction means the form "grows" out the opposite (mirrored) direction.

Tweaking and Duplicating the Eye

Step 36: Duplicate the eyeball and move it over to fill the other eye hole. Notice in **Fig. 4.21** that the eyeballs have also been rotated a little to point outward as the character's form demands.

FIG 4.21 Duplicated and rotated eyeballs.

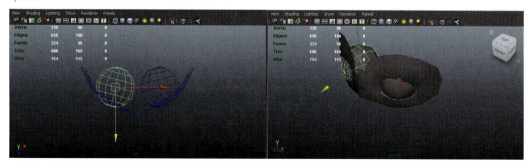

Constructing the Mouth

The methodology behind the mouth is much the same as the eye. The difference is that for the mouth, only one half of the mouth is created (it will be mirrored). But the basic idea of (1) creating a polygon, (2) extruding the edge to create a ring of polygons, and then (3) extruding the outer edges to build out the form remains.

Step 37: Use the Polygons|Mesh > Create Polygon Tool to create a new polygon for the start of the mouth. Remember to do this in the Front View Panel (Fig. 4.22).

FIG 4.22 Creating the start of the mouth with the Create Polygon Tool.

Step 38: Select and extrude the edge on the right side. Keep extruding (be sure to also be rotating) to get around the mouth shape (Fig. 4.23).

FIG 4.23 Extruding edges out to create the basis of the mouth.

Step 39: Clean up the vertices that will be on the axis of symmetry. Swap to Vertex Mode, and using the Move Tool, hold the x key down and move/snap the vertices to the middle of the face (**Fig. 4.24**).

FIG 4.24 Snapping the center vertices into place.

Step 40: Move vertices to match the side image plane. Select each of the new vertices in the front View Panel, and then in the side View Panel, move each vertex in Z only to match where that vertex should be (**Fig. 4.25**).

FIG 4.25 Adjusting new vertices in the side View Panel.

Why?

We carefully placed the geometry in the front View Panel as it needs to be – however, all that new geometry is flat. This step allows for moving our flat lips into three-dimensional forms.

Step 41: Extrude new geometry for the lips. This is done by selecting the edges that are on the outside ring of the lips – but *do not* select the edges that are on the far left (along the mirrored axis). Then use the Extrude Tool to extrude out this new geometry (**Fig. 4.26**).

FIG 4.26 Extruding out new geometry.

Why?

Because we are only doing half of the face, there shouldn't be any additional geometry to emerge along the center of the face. We just cleaned up that seam, and new geometry would only need to be deleted later.

Step 42: Tweak the vertices along the top of the mouth to match those along the bottom of the eye area geometry. Select each vertex, and then using the Move Tool and holding v down (snapping to vertex), move the vertex up to a corresponding vertex in the geometry describing the eye area (**Fig. 4.27**).

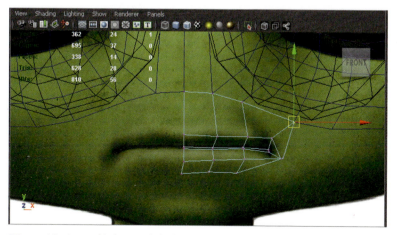

FIG 4.27 Adjusting top of the lip to match the bottom of the eye area.

> **Why?**
>
> In a few steps, the object that is now the lips will be combined with the object that is now the "mask" surrounding the eyes. To make sure that this union goes well, getting the topology to line up now will pay dividends later.

Step 43: Extrude out added geometry across the bottom of the mouth. Do this by manually selecting the edges that are not now butted up against the upper eye region geometry and using the Extrude Tool to extrude them out to begin working through the chin and mandible area (**Fig. 4.28**).

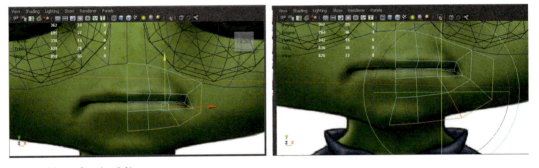

FIG 4.28 Selecting free edges (left) and extruding them out to expand the region of the face (right).

Step 44: Extrude again and tweak. Create some further geometry by repeating the last step. Be sure to be adjusting the new vertices in both the front and side View Panels as you go to get that form right (**Fig. 4.29**).

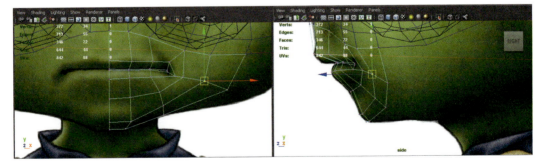

FIG 4.29 Additional extrusions.

Mandible Construction

Although this character is not going to have a lot of facial animation, creating topology that will allow for this sort of animation is good practice. One of Jake's real strengths in his characters is effective topology; and in the next few images, he uses one of my favorite techniques to construct that jaw bone

(mandible), by creating a sort of ribbon of geometry that runs back to create the basic form. This creates a natural flow of geometry that at once effectively describes the form and allows for facial animation.

Step 45: Select the two edges shown in the left image of **Fig. 4.30** and use the Extrude Tool to extrude back a couple of times as can be seen in the right image of Fig. 4.30. The idea is to extrude back toward the edge of the eye region geometry. Be sure to be tweaking these new vertices in front and side View Panels to get the right shape.

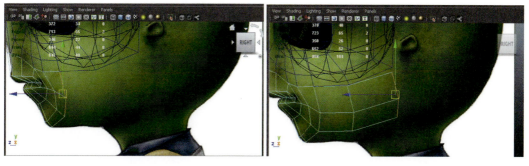

FIG 4.30 Creating the start of the jaw by extruding a very particular collection of edges.

Step 46: Clean up the seam where the mouth/jaw region meets the eye geometry (**Fig. 4.31**). Again, the best way to do this is by selecting a vertex and then using the Move Tool and hold v down to snap the vertices to match.

FIG 4.31 A clean connection between the two shapes.

Combining

Step 47: Combine the mouth mesh and the eye area mesh into one form. In Object Mode, select each of the two meshes we've created. Choose Polygons|Mesh > Combine.

> **Why?**
>
> Even though the two may be aligned well, they are still two separate meshes. Combining makes them one. However, note that although they are now one mesh, where there were two vertices (along the seam where they meet), there are still two vertices where there should be one. Combining makes Maya think of the shape as one, but it doesn't automatically merge the vertices that are atop each other.

Step 48: Merge the vertices that were along the seam. Marquee select each of the vertices shown in **Fig. 4.32** (the vertices along the seam). Choose Polygons|Edit Mesh > Merge.

FIG 4.32 Marquee-selecting vertices along the seam.

> **Why?**
>
> The Merge Tool is a bit different than the Merge to Center. If – in this situation – Merge to Center would have been used, all the vertices would have snapped and merged to a single location. Instead, the regular Merge Tool tells each selected vertex to look around itself to see if there are any other selected vertices that are within a certain distance of itself (the default threshold setting is 0.01) – and if they are, to merge with it. This means that each of the pairs of vertices merge to each other but leave the next pair alone to do their own pairing and merging.

Step 49: Soften the normal along the former seam. For that matter, go ahead and soften all the edges by choosing Polygons > Normals > Soften Edge.

Step 50: Delete the old instance of the right side of the face (if necessary), and create another mirrored instance. Remember to do this, select the mesh that is the left side of the face and choose Edit > Duplicate Special with Instance checked and −1 for the Scale X value (**Fig. 4.33**).

FIG 4.33 Mirrored shape. Starting to take shape, no?

Building Back

Step 51: Continue extruding back to continue forming the cranium. Select the edges of the face but do not include the edges along the center of the face or the edges that are along the bottom of the jaw. Extrude back a couple more extrusions to form back to behind the ear (**Fig. 4.34**). Be sure to be shaping the form by moving the new vertices as you go.

FIG 4.34 Continuing to shape back across the head.

Step 52: Extrude a strip down across the back of the head. Select a collection of three edges (left image of **Fig. 4.35**). Extrude just these back.

FIG 4.35 Beginning to construct the back of the head with a selective extrusion.

Why?

We have a lot of polygons now; and there is little need for all of them to describe the back of the head. By extruding this strip of polys down the back of the head, we can lay the groundwork for the back corner of the head but still keep the polycount manageable.

Step 53: Continue extruding back down the head. In **Fig. 4.36**, notice the results of several extrusions. Notice that there are about as many extrusions down as there are horizontal edges of the side of the face. Also note that we aren't doing a lot of sculpting at this point – just creating the needed geometry (Fig. 4.36).

FIG 4.36 Extruding needed geometry across the back of the head.

Step 54: Clean up the seam. Using the Move Tool, snap the vertices to close-up the hole of the back corner (**Fig. 4.37**).

FIG 4.37 Closing up (visually) the back corner of the head by snapping (moving) the vertices to match.

Step 55: Merge the vertices. Marquee select a broad swath of vertices (**Fig. 4.38**) that includes all the vertices of the seam. Use Polygons|Edit Mesh > Merge.

FIG 4.38 Making sure that recently snapped vertices are merged – note the broad selection that is taken care of in the Merge Tool.

> **Why?**
>
> Remember that the Merge Tool looks around each selected vertex to find if there are any other vertices within a certain distance of itself and only merges those. Because of this, a very broad selection of vertices can be selected as seen in Fig. 4.38, but if the model is big enough (and thus the vertices far enough apart), only the vertices that are right on top of each other will be merged.

Sculpt Geometry Tool

Throughout the history of 3D animation, the promise of a sort of virtual clay has continually raised its head. The most recent incarnations of this idea that have stayed with the industry are Mudbox and ZBrush, which are indeed some incredibly powerful tools – especially with their ability to output to Normal maps.

However, inside of Maya, there remain some virtual sculpting tools that are reasonably effective tools for maneuvering or massaging geometry around. One of these tools is the Sculpt Geometry Tool.

This tool is actually many tools in one. It allows geometry to be pushed, pulled, stretched, and smoothed. It works on the paradigm of a paint brush that crawls across a surface that when clicked and dragged will affect the geometry.

Some notes about this tool: first, always make sure that when activating it to activate the options (Polygons|Mesh > Sculpt Geometry Tool Options). The options of this tool are what make it powerful. Second, pressing and holding the b button and then left-click-dragging allows for the size of the brush (a red circle on the mesh) to be resized bigger or smaller. Finally, the best way to understand this tool is to use it. I could talk about it forever, or you could use it for 2 minutes and have a better understanding. Let's give it a go.

> Step 56: In Object Mode, select the alien's head and then select Polygons|Mesh > Sculpt Geometry Tool (Options).
> Step 57: Use the Relax Operation and paint over the new corner of the head to relax the polygons to a more uniform mesh configuration (**Fig. 4.39**). Do this by first going to the Sculpt Parameters section of the Tool Settings and activating the Relax Operation (fourth blue sphere over in the Operations line). Then in the persp View Panel, hold b down and scale your brush to approximate Fig. 4.39 and click-drag to relax the area.

Tips and Tricks

Remember that for most tools – including the Sculpt Geometry Tool, as the mouse is moved over a tool or function/operation within the tool, the name of the tool will show up in the very bottom left of the interface. So although the iconography of the Operations of Relax, Smooth, Push, and Pull are reasonably effective, you can be sure by checking out the short help line.

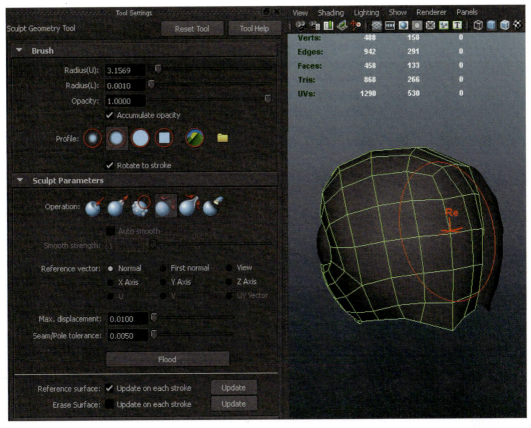

FIG 4.39 Using the Sculpt Geometry Tool's Relax operation to better distribute the mesh.

Why?

Relaxing needs to have a brush that is a little bigger, so that it can sample a good swath of vertices. What relaxing will do is it will redistribute the vertices to create a more equally distributed poly mesh. Although polygons don't all need to be the same size in a mesh, distributing the information that describes a form (the polygons) across that form more evenly prevents unwanted tucks and bands that occur when a ribbon of very small polygons is right next to a ribbon of big polygons. It's pretty obvious once this tool gets going how it helps the shape feel more rounded and organic.

Soft Modification Tool

Because we're on the topic of sculpting tools within Maya, let's look at another one. The Soft Modification Tool is a bit like a magnet tool. A part of the mesh can be clicked and then moved, scaled, or rotated, but instead of just moving an individual polygon, a group of components will be affected with the influence falling off over distance.

Once a rough mesh is laid out, this can be a much more efficient way of nudging forms into shape without requiring the adjustment of every single component in the area. This is a surprisingly useful tool and is very deep in the variations of its functionality. However, in this case, we will look at the most basic implementation of simply clicking on the mesh and moving a bit of the mesh around.

To access the Soft Modification Tool, look at the Tool Box at the far left of the interface (Fig. 4.40).

Step 58: Select the alien's head in Object Mode.

Step 59: Nudge the back of the head down toward the neck with the Soft Modification Tool. With the Soft Modification Tool activated, click on the back of the head. Notice that it will turn red, yellow, and black. Pressing and holding b and left-click-dragging will make the influence bigger or smaller. Resize it to approximate what's shown in Fig. 4.41 and using the Move handles, slide the soft selection to the top of the neck.

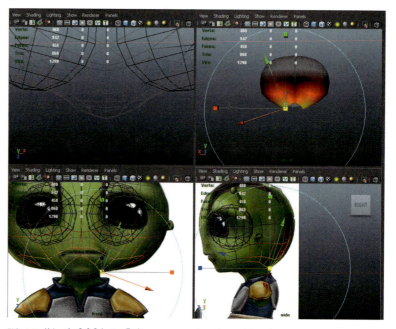

FIG 4.40 Activating the Soft Modification Tool.

FIG 4.41 Using the Soft Selection Tool to maneuver and tweak a mesh into place.

Tips and Tricks

The default size of the Soft Selection Tool's influence can be a little weird. If, when the mesh is first clicked with the Soft Selection Tool, it appears completely yellow, this means the selection is so big as if it includes the entire mesh. Hold b down and left-click-drag to the left for quite a while until a big yellow circle appears and finally starts to get smaller than the mesh.

Warnings and Pitfalls

Depending on if the mesh has history on it, the Soft Modification Tool will leave an S floating around. This is meant to be a selection that can be tweaked (even animated) later. However, for now, this "s" is just in the way. If this S appears and stays after the Soft Modification Tool is exited, select the mesh (with something besides the Soft Modification Tool) and choose Edit > Delete by Type > History.

Step 60: Clean the seam. Especially across the back of the head where we have been using the Sculpt Geometry Tool and the Soft Modification Tool, select the vertices that should be right down the center of the head (along the axis of symmetry). Using the Move Tool and holding x (snap to grid), move the vertices in just x to snap them to the middle (**Fig. 4.42**).

FIG 4.42 Snapping vertices across the back of the head (those that might have gotten inadvertently moved in the previous steps) to the axis of symmetry.

Tips and Tricks

Remember that they all snap to the middle because we have Retain Component Spacing turned off in the Tool Settings for the Move Tool.

Building to the Neck

The head is starting to take shape. But to build the body, we will prepare by closing off the shape of the head. This provides us faces across the bottom of the head, which we will use to construct a circular collection of edges to build the body from.

Step 61: Begin to close off the bottom of the head by extruding the chin edges toward the back of the head. Notice that in **Fig. 4.43**, each of the extrusions corresponds to a vertex along the jaw line (and the back of the head) that this strip will need to eventually merge to.

FIG 4.43 Beginning to extrude to complete the bottom of the head.

Append to Polygon Tool

This is really a sort of sister tool to the Create Polygon Tool. Its purpose is basically to create a new polygon that utilizes edges that already exist.

Step 62: Use Append to Polygon to close off the gaps between the new chin strap of polygons and the bottom of the head. To do this, in Object Mode, select the alien's head. Then choose Polygons|Edit Mesh > Append to Polygon Tool. To use the tool, click on any of the edges that are open. Little purple arrows will appear to show the direction of the new polygon that will be built. Click on each of these in turn (**Fig. 4.44**) and watch the polygon fill in. Hit Enter when the polygon is created. Seal up all the bottom of the head in this way.

FIG 4.44 Using the Append to Polygon Tool to fill in the gaps.

Interactive Split Tool

The Interactive Split Tool does just what it says. It allows for polygons to be split. The difference is that this tool allows for a string of cuts to be made across several surfaces that may not be in a loop or a straight line. It can be great for custom topology.

Step 63: Create the groundwork of a round neck by using the Interactive Split Tool to make a cut as seen in **Fig. 4.45**. The way this tool works is that as an edge or vertex is clicked, an orange line appears to show the proposed path of the split. So Fig. 4.45 shows five clicks – four on the edges and one on a vertex. Hit Enter when done.

FIG 4.45 Using the Interactive Split Tool to lay groundwork of a diagonal polygon.

Step 64: Collapse two edges with the Merge to Center tool. The two edges are highlighted in **Fig. 4.46** (left). Select one edge and choose Polygons|Edit Mesh > Merge to Center. Repeat on the second edge. The results are also in Fig. 4.46 (right).

FIG 4.46 Collapsing edges with the Merge to Center Tool.

Step 65: Repeat the process for the back corner shown in **Fig. 4.47**.

FIG 4.47 Creating a more circular band of polygons to extrude the neck out of.

> ### Why?
>
> The benefits of these processes may be a little opaque right now. But look at Fig. 4.47 and see the band of polygons that these steps have created? The band is far more circular than we had earlier that will allow the neck to be built from a much more appropriate shape.

Step 66: Delete the faces on the bottom of the head – the area where the neck will emerge (**Fig. 4.48**).

FIG 4.48 Deleted faces providing a good ring of edges to extrude the neck out of.

Step 67: Construct the neck down to the top of the shoulders. This is done with a bit of tweaking and several extrusions. **Figure 4.49** shows how the neck was constructed by selecting the inner edge of the faces we just meticulously constructed and extruding down three times. Be sure to be sculpting the new vertices into place as the neck grows down.

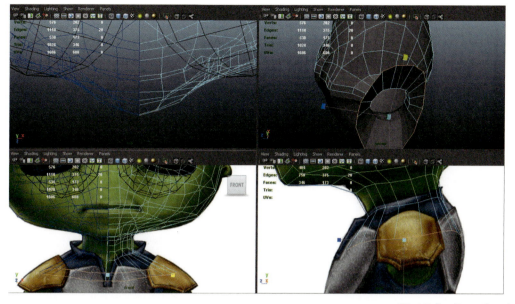

FIG 4.49 Roughing out the neck.

Tips and Tricks

As these new extrusions take shape – and as the new geometry is moved into place – be sure to make use of the new tools at your disposal. The Soft Modification Tool can be used to nudge groups of components into place. Don't forget that the Sculpt Geometry Tool can be used to smooth areas that have begun to appear too chunky. Finally, be sure to clean up the seam along the middle axis of symmetry.

Step 68: Refine the lips. Using the Insert Edge Loop Tool, create a new loop of edges through the middle of the lips to create some more "meat" to the shape (**Fig. 4.50**). Tweak the new geometry into shape.

FIG 4.50 Rounding out the lips.

155

Why?

Often working with a rough pass to knock out the general shape allows for proportions to be quickly found and the general shape discovered. This often helps new artists to keep from getting bogged down in the drudgery of any one area. The idea is to make sure to get back to those spots and add detail as needed.

Modeling the Torso

Now that the head has been refined, it's time to move down the figure and work on the torso. The long-term plan here is to model the torso without arms, and then go back and add that detail later.

In the following steps, we will rough out the torso by extruding new edges, cutting needed geometry from existing extrusions, and extruding out garment details.

Step 69: Add groundwork of collar. Do this (**Fig. 4.51**) by using the Interactive Split Tool to make a new cut that will become the inside of the collar.

FIG 4.51 Using the Interactive Split Tool to rough out the collar.

Step 70: Extrude the bottom edge of the form down to rough out the top of the torso (**Fig. 4.52**). This is done with three extrusions that go down to the top of the belt. Notice that the rough shape goes out to where the arms connect to the torso, but do not include the arms themselves.
Step 71: Add additional detail for the collar and chest plate. Do this with the Interactive Split Tool (**Fig. 4.53**).
Step 72: Extrude down to create the belly region. This is done with a series of extrusions – all by extruding the bottom ring of edges. Do note that some of the extrusions will slide down the form, and some will need to go straight out to create the stepped surface in the design (**Fig. 4.54**).

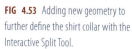

FIG 4.52 Roughing out the torso shape.

FIG 4.53 Adding new geometry to further define the shirt collar with the Interactive Split Tool.

FIG 4.54 Creating the belly.

Tips and Tricks

Sometimes moving edges – particularly straight out of new extrusions is most easily not done with the Extrude Tool, but with the Move or Scale Tool. To use this method, use the Extrude Tool from the pull-down menu to create an extrusion, but then before grabbing any of the Extrude Tools handles, swap to the Move Tool (or Scale Tool) and move that new extrusion straight out in Z (or whatever axis). The difference here is that the edge is being moved in World Space and not along the edge's normal.

Step 73: Continue extruding down to include the belt and clean the axis of symmetry (**Fig. 4.55**).

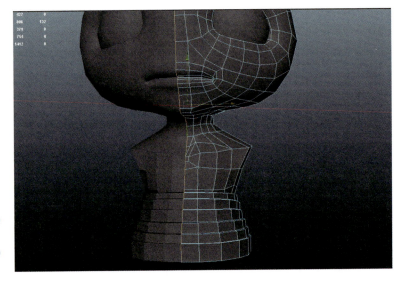

FIG 4.55 Extruding down to include the belt – and then making sure that the axis of symmetry is clean (snap to grid with the Move Tool).

Adding Detail to Torso and Shirt

Step 74: Arrange or add geometry to the torso to allow for a selection as shown in **Fig. 4.56**. This selection corresponds to the shirt and breast plate.

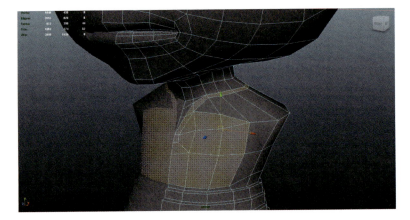

FIG 4.56 Selection needed to add new dimension to shirt and breast plate.

Why?

Again, the idea we've been working with is to rough out the general shape and then make necessary cuts to allow for the geometry needed to add new detail. In this case, the breast plate and collar will work best as extruded geometry – but the basic shape needs to be laid out first.

Step 75: Extrude out the beginnings of the breast plate and collar (**Fig. 4.57**).

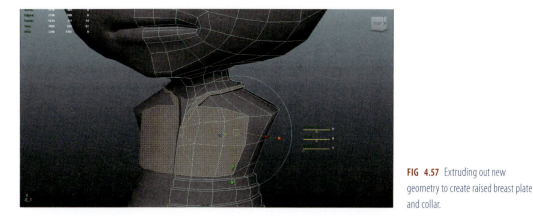

FIG 4.57 Extruding out new geometry to create raised breast plate and collar.

Step 76: Clean the seam. With this extrusion comes new polygons around the edge of the extrusion. This includes some right along the middle of the chest – which we don't want. Select those (**Fig. 4.58**, left) and delete them. Then, snap the vertices across the middle of the chest back to the center (Fig. 4.58, right).

FIG 4.58 Cleaning up unwanted geometry from the extrusion steps.

Step 77: Adjust the new geometry to match the style sheets (**Fig. 4.59**).
Step 78: Refine the collar. **Figure 4.60** shows the refined collar. The methods used were mostly tweaking existing geometry, although if new geometry is needed, be sure to extrude it out (for instance – getting the collar above the breast plate).
Step 79: Use Harden Edges to make desired forms crisper. Select the edges shown in **Fig. 4.61** and choose Polygons|Normals > Harden Edge.

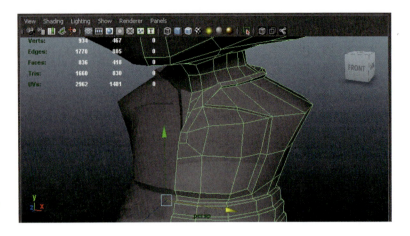

FIG 4.59 Maneuvering new geometry to match the style sheets.

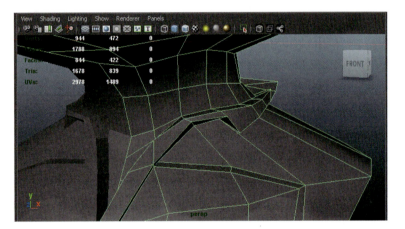

FIG 4.60 Refining the collar.

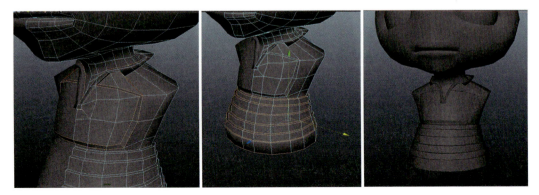

FIG 4.61 Using Harden Edge Tool to sharpen edges.

Why?

We have looked at the Soften Edge Tool in the past to make the edges of a form not be so faceted. That tool made the individual faces less obvious. This Harden Edge Tool is just the opposite but can certainly be used to our advantage here. In this case, it helps with non-organic costume pieces (armor, etc.) and makes these edges crisper.

Crotch

The point of this methodology of constructing the crotch is to again create a ring of edge that can be used to create another piece of anatomy (the leg). To do this, we will extrude down and create a strip of polygons that run across the bottom of the crotch.

Step 80: Continue extruding down to the widest part of the hips (**Fig. 4.62**).

FIG **4.62** Extruding down to fill out the hips and prepare for the leg.

Step 81: Extrude both the front three edges and the back three edges. Be sure to extrude them down and inward toward the center of the bottom of the crotch (**Fig. 4.63**).

FIG **4.63** Getting started on the crotch.

Step 82: Extrude both again and then merge the two together. **Figure 4.64** shows the result of another extrusion and then the Merge to Center to close-up each pair of vertices.

FIG 4.64 Closing up the bottom of the crotch with an added extrusion and Merge to Center.

Step 83: Add geometry as need to provide a leg start that is 10 edges. In **Fig. 4.65**, this was done with the Insert Edge Loop Tool. Be sure to adjust the geometry to provide a rounded shape for the leg and make sure that all this new geometry matches the style sheets.

FIG 4.65 Creating the start of the leg by adding geometry and arranging ring into rounded shape.

Legs

Step 84: Create a rough version of the leg. Do this by selecting the ring of edges for the leg and extruding them down to the top of the boot (**Fig. 4.66**).

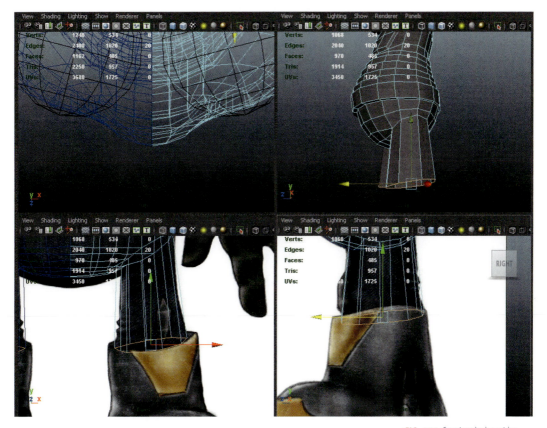

FIG 4.66 Creating the leg with a quick extrude.

Why?

This time, the extrusion is a little different than has been used in the past. In past steps, extruding down was in much smaller chunks with a lot of the geometry being roughed out as we went. In this case, a slightly different technique is being used: a quick extrusion down will cover the entire leg (to the boot anyway), and then we will go back and refine this shape with additional edge loops.

Step 85: Add geometry and sculpt to create leg detail. This is done by using the Insert Edge Loop to place new loops of edges where there are changes in the shape of the leg. Then these new edges are scaled to create the folds of the pants or other modifications across the shape of that leg (**Fig. 4.67**).

FIG 4.67 Inserting edge loops and then adjusting those loops to refine the leg.

Step 86: Create the boot without the toe. Figure 4.68 shows this done with a couple of extra extrusions of the edges that were the bottom of the leg down to where the heel touches the ground. Notice that in Fig. 4.68, the Append to Polygon Tool is activated to close off that bottom of the shape.

FIG 4.68 Boot created without a toe. Note that the bottom of the heel is closed off with the Append to Polygon Tool making sure the new geometry is all quadrangles (four-sided polygons).

Step 87: Create the foot of the boot. Do this by selecting the faces across the front of the boot shape currently built and extrude out a couple of times to create that foot shape (Fig. 4.69).

FIG 4.69 Foot shape of boot extruded out.

Step 88: Finish boot shape. To taste, add edge loops and sculpt the existing geometry into a form that is pleasing in persp and matches the style sheets (Fig. 4.70).

FIG 4.70 Finished off boot.

Arms

The process of extruding out the arms uses almost identical techniques to what we've used. Take a close look at **Fig. 4.71** though. The selected faces are the faces that we will delete to leave a ring of edges that the arm will be built from. The important idea is the number of faces (and edges) this will yield. If this was a single face, we would be stuck with a square-shaped arm and have to insert all sorts of edge loops to get any good shape. The nine polygons shown in Fig. 4.71 are carefully created and chosen, so we have a good number of edges to keep the arm round.

FIG 4.71 The area the arm will be built off of. Added edges highlighted.

Step 89: Delete the faces shown in Fig. 4.71.

Why?

We could extrude those faces instead of deleting them and extruding the edges. Sometimes it's just a preference of how you prefer to use the Extrude Tool; in this case, we have the added benefit of being able to create the geometry specifically needed for the fingers when we get down to that spot of the hand – and not be stuck with the faces here at the top of the arm.

Step 90: Extrude out the arm ring of edges to rough out the shape of the arm (**Fig. 4.72**).

FIG 4.72 Extruding out the arm.

Why?

As with the boot, these quick extrusions get us down to a place where the shape is going to adjust abruptly (the armor on the forearm). Taking a moment to get down to those spots and then tweaking the geometry makes getting the shape of the forearm armor a bit easier to handle.

Step 91: Extrude down to include the palm, but not the fingers of the hand (**Fig. 4.73**).

Step 92: Add geometry and sculpt the new geometry to refine the arm (**Fig. 4.74**).

FIG 4.73 Extruding down to the hand (but not the fingers).

FIG 4.74 Refining the arm.

Hands

Step 93: Close off the bottom of the arm. Do this with the Append to Polygon Tool. Match the topology as shown in **Fig. 4.75**.

FIG 4.75 Creating the geometry needed for the fingers by closing off the ring of edges at the bottom of the arm.

Step 94: Allow for finger roundness with additional geometry. Gain this geometry with the Interactive Split Tool and make a cut similar to **Fig. 4.76**.

FIG 4.76 New cuts to allow for finger shape.

Step 95: Extrude out the middle finger. Select the faces shown in **Fig. 4.77** and extrude down a shape that approximates the middle finger.

FIG 4.77 The start of the middle finger.

Step 96: Use remaining geometry to create new fingers. This is done using the same techniques as before: rough out the finger, and then go back in and insert edge loops as needed to create the bumps and joints that are part of the hand's anatomy (**Fig. 4.78**).

FIG 4.78 Hand completed.

Why?

I know, that's a big jump between steps. However, the key to getting a good shape in the hand is having a good palm with the necessary geometry to build the shape off of; and you have that. After that, it's just about extruding and tweaking. Have a go.

Details and Armor

The remaining parts are creating using techniques already covered. Generally, this consists of making cuts (via the Interactive Split Tool) to lay the groundwork of a piece of armor and then extruding that geometry out. The next few steps are short bursts to flesh out the details of the form.

FIG 4.79 The forearm armor via extrusions.

Step 97: Create the forearm armor (**Fig. 4.79**).

Step 98: Further refine the forearm armor as per the style sheets (**Fig. 4.80**).

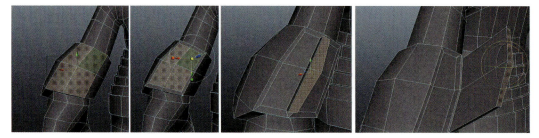

FIG 4.80 Completing the forearm armor.

170

Step 99: Hit any other armor indicated in the style sheets (or that you desire to add to the form).

Step 100: Add head ridges. Do this by arranging the topology needed across the top of the head (**Fig. 4.81**) and this time by simply moving an edge up to create the ridge rather than extruding.

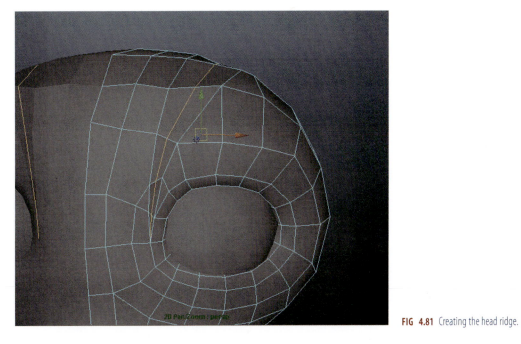

FIG **4.81** Creating the head ridge.

Step 101: Harden edges along head ridges (**Fig. 4.82**).

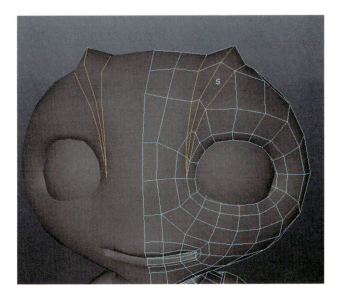

FIG **4.82** Visually highlighting the head ridges with hardened edges.

171

Ears and Antennae

Ears can be tricky. Luckily this character has fairly simple ears that are created with a few simple extrusions.

Step 102: Create initial shape of the ear extrusion with a series of extrusions (**Fig. 4.83**).

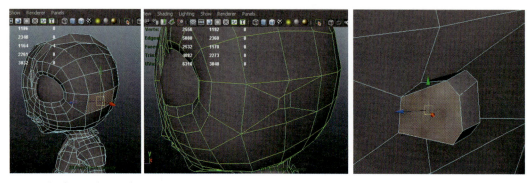

FIG 4.83 Roughing out the ear with a few extrusions.

Step 103: Finish the ear. This is done with a quick extrude into the ear, and then a few added edge loops around the ear base to better define the connection between the ear and the head (**Fig. 4.84**).

FIG 4.84 Finishing off the ear with Extrude and Insert Edge Loop.

Step 104: Create antennae. Do this with a series of extrusions (**Fig. 4.85**). Shape to match.

FIG 4.85 Creating the antennae.

Belt Buckle

The belt buckle is an interesting problem. In theory, this belt buckle could be created from geometry extruded off the belt but with great difficulty. Instead, in this case, we will model the belt buckle separately, and simply attach it with Maya's Combine.

Step 105: Create the basic shape of the buckle. This is done starting out with a cube rotated 45 degrees in Z and then extruding the face on the outside several times to get the correct shape (Fig. 4.86).

FIG 4.86 Creating the shape of the belt buckle. Notice this is a separate shape.

Warnings and Pitfalls

Be sure to clean the axis of symmetry for this new belt buckle as the ultimate plan is to mirror this shape as well.

Mirror Geometry

The Mirror Geometry Tool is one of the last tools to use in the character modeling process (if the character is symmetrical). What this tool does is take any mesh and creates a mirrored copy of it. More importantly, it merges the vertices along the mirror axis, which is why we've been very careful to keep that axis clean.

> Step 106: Delete the instance. Do this by selecting the right side (the character's right) of the body (which is a separate object) and delete it.

Why?

This new belt buckle that we've been forming looks great, but notice that it doesn't automatically mirror as the other shapes have as we've extruded them off the alien mesh. To get a mirrored belt buckle, we need to make it a part of the alien's body first.

> Step 107: Combine the body to the belt buckle. Do this by selecting the alien's body, then shift-selecting the buckle and choose Polygons|Mesh > Combine.

Why?

Remember that Combine makes Maya think of this mesh as one. This means that when this mesh is mirrored, it will include a mirrored belt buckle.

> Step 108: Delete History. Edit > Delete All by Type > History.

Why?

Before any big step (like Mirror Geometry), I like to try and get rid of any history that may cause trouble. By deleting history, we keep the file size small and allow Maya to forget all of the hundreds of nodes it has accumulated along the way as we've created this form.

> Step 109: Mirror Geometry. Simply select the one alien mesh and choose Polygons|Mesh > Mirror Geometry.

Step 110: Soften the middle edge. Double-click the middle edge – the edge along the mirror axis – and choose Polygons|Normals > Soften Edge (**Fig. 4.87**).

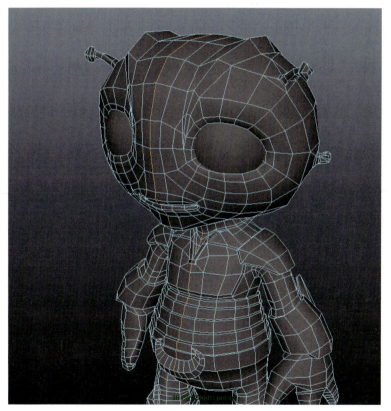

FIG 4.87 Softening out the hard edge in the middle of the form.

Why?

Mirror Geometry does a lot of great things. It makes the other half of the form and cleans up the vertices along the middle by merging them together. However, it doesn't soften the edge of this newly merged center. Softening makes the character look whole again without a crease down its center.

Conclusion

And there he is (Fig. 4.88). Ready to be UV mapped, rigged, skinned, and animated. We'll get to all of that in time; but for now enjoy the completed project and sculpt any tweaks you need.

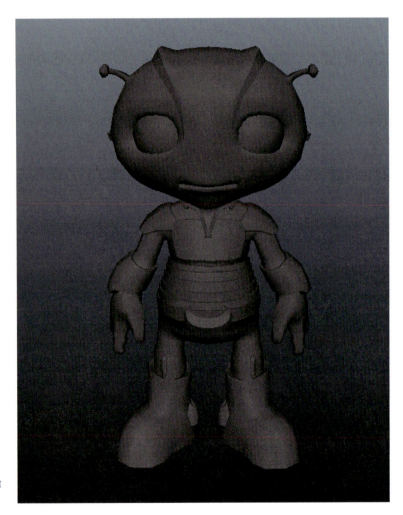

FIG 4.88 Finished modeled (but not textured) game character.

In this tutorial, we've covered a huge amount of ground and discussed a great many techniques. With these techniques, you have the tools to construct most any form (check out the homework).

But enough of modeling. It is but the first step of a long journey. In the coming chapters, we will add visual detail to the character by adding needed texture, but before that we need to look at how to get the texture to lay across the surfaces – UV Mapping, here we come.

Homework

Figure 4.89 shows the one single homework assignment for this chapter. Again, it is a character design by the talented Jake Green (http://www .jakegreenanimation.com).

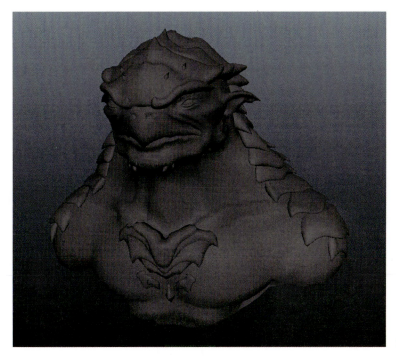

FIG 4.89 High poly mesh.

Believe it or not, this mesh was created using the same techniques used to create this game character – just at a much higher resolution.

The screenshots for this construction process are all contained on the support website (http://www.GettingStartedin3D.com). It's a significant project, but completing it will help solidify the techniques covered in this chapter.

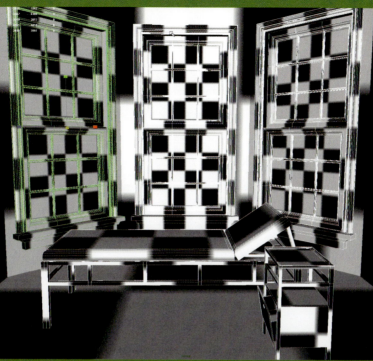

UVs and UV Layout

So now we have our objects. The tools of polygons and NURBS have been explored, and engaging shapes have taken form. Now what?

Well, the gray plastic shapes we have been creating must be getting kind of old to look at. I always get a bit depressed when I have spent too long in the modeling realm – I need color! And indeed, texturing the shapes created will start to really bring these forms out of the depressing realms of gray and into a colorful world of life.

If we were just slapping a simple color on the objects, we could do that now. However, these forms will have much more life if there is a texture that lays across the geometry. In our hallways, the floors should look like there is some tile or wood on them, the walls have peeling plaster, and the doors – rotting wood. Our little alien character needs to have some parts of his form look like green skin, and other parts appear to have clothing. To do this, we need to be able to manage what parts of a texture are applied to what parts of a polygon mesh.

UVs

So what are UVs? Well, actually – they are a "where" – they are a coordinate system across the surface of polygons (think latitude and longitude across a globe). What this coordinate system does is allow a texture to be "pinned" to the surface, so that the pixels of a texture know where on the surface to stick to.

Understanding what UVs are and being able to manipulate them is incredibly powerful and allows any image to define the surface of a 3D form. It allows the same collection of polygons to appear as a bowling ball, a marble, or a ball of yarn.

Unfortunately, this power to manipulate UV is not a trivial task and can be very counterintuitive. It's not impossible of course – but getting your mind around how UVs work will take a bit of effort.

UV Texture Editor

The mechanism that Maya has provided to work with UVs is the UV Texture Editor. You can bring this tool up via Window > UV Texture Editor (**Fig. 5.1**).

FIG 5.1 UV Texture Editor with a cube's default UVs displayed.

Maneuvering with UV Space

Moving within the UV Texture Editor space is consistent with other Maya tools. Alt-RMB will allow the "camera" viewing this space to move close or farther away. Alt-MMB or Alt-LMB will allow you to pan across the space.

UV Texture Editor Interface

There are really a lot more tools available here than we are going to actually use in our tutorials, but here are the core ideas: All of the icons across the top of the interface (and below the pull-down menus) are simply shortcuts to commands available via the pull-down menus. The biggest work area below that will show four quadrants, but only the top right quadrant will (at this point and by default) include any UVs or texture information. So for instance, in Fig. 5.1, there is a dark gray swatch in that top right quadrant that represents the color of the lambert1 material that is the default gray assigned to the new objects in Maya.

The upside-down T shape seen within that quadrant is the default UV for a primitive cube. Think of this shape as the cube if it were unfolded and laid out in 2D space. Each of the squares there represents a face of the cube.

Selecting Components

Right-click-holding on any components of the UV Texture Editor will pull up a Hotbox that allows the user to define what type of component they wish to select for manipulation (Fig. 5.2). These should look familiar as they are the components of polygonal objects that we have been using in past tutorials. The big difference here is that we are dealing in UV space – *not* 3D space, and so only UVs can actually be manipulated here (moved, scaled, or rotated). The other components such as faces, edges, or vertices can be selected here (and they will highlight in the View Panels (3D space) as well), but they cannot be manipulated within the UV Texture Editor.

FIG 5.2 Hotbox within the UV Texture Editor to define what type of component is to be selected.

181

Tips and Tricks

Note that while components other than UVs cannot be manipulated in this UV space, simply being able to select components in a 2D paradigm like this can be very handy. Once a mesh is laid out and flattened into a 2D form, some faces will be much easier to find and select here than they would be in 3D space if they are in tight spots or covered by other faces.

Shells

A critical idea of UVs is the concept of **shells**. The shape shown in Fig. 5.1 is one shell. Think of shells as unbroken collections of polygons where each of the shared edges between polygons have been (and this is the metaphor Maya uses too) sewn together.

These shells can be a little difficult to see visually. Two "patches" of polygons can be laying right next to each other with their edges lined up perfectly and still not be a shell. It all depends on whether or not those aligned edges are sewn together.

The power of a shell is that when an individual UV is selected, if the user uses Cntrl-Right-Click-Hold, a Hotbox will appear (**Fig. 5.3**), that when "To Shell" is selected, the selection will expand out to the edges of a given patch of sewn together UVs. Splitting and sewing these edges together into usable shells is a big part of effective UV planning and manipulation. A shell of UVs will ensure that a texture crawls across that collection of polygons without breaks or seams.

FIG 5.3 Cntrl-Right Click-Hold will allow for a single UV selected to expand out to the edge of a collection of UVs that have been sewn together.

UV Maps, Snapshots, and the Purpose for It All

So what's the point of all this? Why are we worried about UVs, and what will they eventually be used for? Well, consider **Fig. 5.4**. On the right are the UVs laid out for the complex high-polygon form given as homework in past chapters. All the

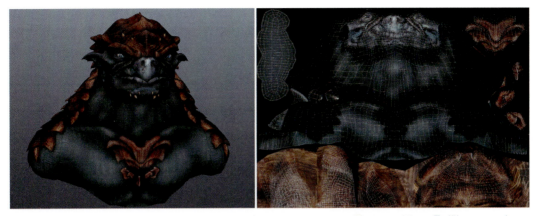

FIG 5.4 The UV map was used to determine how to paint the texture map.

polygons of the form are represented in that **snapshot** of the UV space. Beneath it is a painting of the texture to be applied to those polygons (the painting was done in Photoshop). By knowing where the polygons are that represent the collar bones (for instance), the colored texture can be created to allow for shadowing, or changes in color, bump, or specularity. By having the UVs laid out, and a snapshot of those UVs accessible in other applications, we can determine exactly which chunk of texture information goes where on the polygon mesh.

Having good UV maps is the first step for having well-textured objects. Without them, it is impossible to get the texture to go where it needs to be on the form.

The key will be understanding how to manipulate UVs and create them if they don't exist. There will be some new ideas around the idea of sewing up edges to create new shells, but manipulating UVs will be fairly straight forward (they can be moved, scaled, or rotated in the same way as any other component in Maya). Creating new UVs will be the newest idea.

Projections

The way new UVs are created is through an idea called projections. Although not entirely accurate, an easy way to think about this is as though a texture were being projected onto a surface. This projection will create UVs that are distributed so as to allow a texture to sit across the projected upon polygons.

It turns out there are other sorts of projections where this metaphor breaks down. Cylindrical projections, spherical projections, etc. are much more like wrapping a texture around an object with a blanket; but the core idea of using a projection to create and space UVs to allow a texture to appear undistorted on a surface remains.

Don't worry, it will make a bit more sense when it is seen in action.

Getting to It

Through years of teaching these seemingly opaque topics, I've found that often the easiest way to explain how it works is to simply illustrate the concepts through showing them in action. So without too much

other "theory" discussion, let's get our hands dirty and working through UV layout.

Tutorial 5.1 UV Layout for Architecture and Level Design

It's a fairly gross generalization to say that all architecture is square. Not every room is a cube – but lots are. Because of this, the architecture of our game level from "Escaping the Madness" will be a great place to get going. Cubes are simple shapes that make the illustration of UV manipulation much easier to see.

FIG 5.5 Base room to be UV mapped – the results of earlier tutorials.

Step 1: Open and isolate the room to UV. In the course of this tutorial, we will be UV mapping the results of some earlier tutorials. Namely, the room shown in **Fig. 5.5** was created a few chapters ago and will provide several interesting challenges and illustration opportunities. If you have your own version of this room, go ahead and open it, or if you'd prefer to use the exact same assets at the tutorials use, download it at http://www .GettingStartedin3D.com. Look under the Tutorials & Support files in the Chapter 5 thread. The file we'll be using is called Hallway_Chapter5UV_ Start.mb. If you wish to use this one, download it, unzip it, place it within your project file's *scenes* folder, and then open it in Maya (File > Open).

Step 2: Open and examine the current UV set. Do this by first selecting the wall shape and then opening the UV Texture Editor (Window > UV Texture Editor). It should actually look just like Fig. 5.1.

Why?

This room clearly isn't a cube – yet the UV layout looks like it is: there are six faces. What you are seeing there is the UVs that existed when this room was first created – as a cube (Maya's primitives have UVs already created and assigned). If you'll remember back when we were modeling this room, the new walls were created using some extrude functions. These extrude functions create new geometry – and this new geometry has no UVs. Thus, here, we are about to create UVs for the new polygons we created in the modeling steps and adjust the old UVs that are extant on some of the faces.

Dummy Material

It will be important that we know that the amount of texture space we are assigning to any particular polygon is consistent with the actual size of the polygon. We wouldn't want a 2-inch chunk of the wall to have as much texture as an 8' × 8' chunk of the floor; the biggest objects should have the most texture space (or pixels) to define it.

This can be tricky to find though. One easy way to do this is use a well-distributed texture (like checkerboards) that can be slapped on polygons and as the UVs are created or edited, it will be easy to see whether the checkers on one part of the mesh are bigger or smaller than on others. If the checkers are the same size everywhere on the form, then the relative size of the UVs in texture space matches the relative size of the geometry in 3D space.

So for now, we will create a dummy checkerboard material that we will change out later (in the next chapter).

Step 3: Create a dummy material to illustrate UV space distribution. To do this, right-click on the walls shape and choose Assign New Material.
Step 4: Make the new material a Lambert. When you choose Assign a New Material, a dialog box similar to **Fig. 5.6** will appear. We will spend a lot more time working through the details of materials and shader types later. For now, we'll create the simplest and fastest rendering material type – a Lambert. Just click on the Lambert button.
Step 5: Define a checker pattern for the color attribute of the material. After the last step, the Attribute Editor should automatically pop up and look like **Fig. 5.7**. At the far end of the Color slider is a little checkerboard square – click this to tell Maya to use an image to define the color. Note that this does not make the color a checkerboard automatically (despite what the button looks like). A new window called the Create Render Node will pop up. Click on the Checkerboard button there.

FIG 5.6 Picking the type of new material to create.

FIG 5.7 Using the Attribute Editor to use an image to define the color of this new material.

Warnings and Pitfalls

If the Attribute Editor does not automatically fire up, before clicking on anything else, just click on the Show or Hide the Attribute Editor button in the top right corner of the interface.

Why?

This actually isn't an image – it's a procedural texture. This means it's a mathematically dynamically created texture. The difference right now is not important, but it's worthwhile to point out that later we will actually be using images to define the color of a material.

Step 6: Make sure the new material is visible on the wall shape. To do this move the mouse over your persp View Panel and hit 6 (Shaded with Texture) (**Fig. 5.8**).

FIG 5.8 Results of new material with checkerboard as the color.

Why?

There's a lot to talk about here. First, note that in the UV Texture Editor, this new checkerboard pattern appears in the top right quadrant (which makes the existing UVs a little tough to see (we'll fix this in a minute). Second, in the View Panel, there seems to be a really weird thing happening in that some of the faces have the checkers on them and some do not. What gives? Well, remember that the original cube had UVs (that are represented in the UV Texture Editor), but the new faces that were extruded did not. Without UVs, Maya does not know how to attach the material to the polygons – so it doesn't. What you're seeing there is that the faces that were the original faces of the cube have texture – the new faces don't. We need to add them.

187

Automatic Mapping

Anytime software claims to do something "automatically" be afraid – or at least highly skeptical. However, Maya's Automatic Mapping does indeed have some uses. At its core, Automatic Mapping is the idea of multiple projections being projected onto a surface from many different angles (by default – six – a projection for each face of a cube). This means that for cubic shapes, this can be a very efficient tool (rather than doing six individual projections). For things like square buildings, this can be a very quick way of getting good UVs. For things like our room (with its angled walls), it can be useful for some things but not so great for others.

Step 7: Use Automatic Projection to create UVs for the entire wall object. Do this by selecting the wall object and choosing Polygons|Create UVs > Automatic Mapping (**Fig. 5.9**).

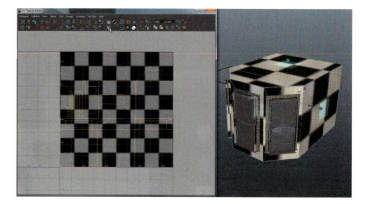

FIG 5.9 Results of Automatic Mapping with the default settings (six projections).

Why?

Take a close look at 5.9 and you'll see that there are really six light blue/teal squares that appear to be laid on each side of the form; these are the projections. The manipulator handle has also changed to the kind that allows for Movement, Scale, and Rotation. What this is doing is giving you the option of adjusting the projection here within 3D space. For now, don't mess with them – we'll adjust the new UVs in the UV Texture Editor instead.

Notice that what this step did was make sure that all the faces of the wall shape now have checkers on them. This is a good start, although it will definitely have a few problems that we'll need to solve.

Notice also that in the UV Texture Editor, now the upside down T is gone and has been replaced by a collection of faces that correspond (generally) to the shape of the faces of the room.

There are some problems though – but to see and understand the problems, we'll need to do a few more adjustments.

Step 8: Dim the texture to make the UVs more visible. Do this in the UV Texture Editor via Image > Dim Image (as can be seen in Fig. 5.9).

Step 9: Resize the checkers to be much smaller across the surface. Do this in the UV Texture Editor. First Right-click-hold and choose UV. Marquee select around all the UVs (all the shapes in the UV Texture Editor at this point). Hit r on the keyboard to swap to the Scale Tool, and scale uniformly in both directions by clicking and dragging on the yellow square in the middle of the manipulator handle. Scale out quite a bit – and well beyond the bounds of the top right quadrant, so that the checkers become much smaller on the wall in the View Panels (**Fig. 5.10**).

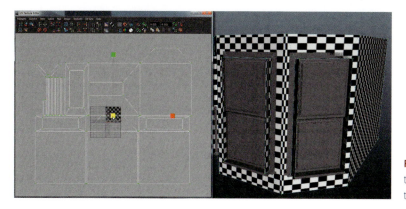

FIG 5.10 Resizing the UVs, so that the texture tiles across the surface thus creating much smaller checkers.

Why?

There are actually several ways to make the checkers smaller on the surface of the polygons – but this is my favorite and the fastest. What we are after here is a smaller checker that will allow us to see a few things. First, it will let us see whether the actual size of the checkers is accurate from wall to wall; and second, will let us see whether we do indeed have square checkers. If the size of the checkers from wall to wall matches, we know that the relative size is correct and each wall is getting the correct amount of texture space. If the checkers are square, we know that there isn't distortion happening in texture space. Conversely, as you can see in the diagonal walls, if the checkers are not square, it means there is distortion, and it needs to be corrected.

Planar Mapping

Flat shapes – like this diagonal wall that has malformed checkers – are perfect candidates for another form of UV Projection – Planar Mapping. This will project UVs straight onto a surface; and although Planar Mapping is a terrible choice for curvilinear forms (like characters), it's perfect for a flat wall like this.

Step 10: Select the faces of the diagonal wall (**Fig. 5.11**). Do this in the View Panel.

FIG 5.11 Selecting the offending polygons. Notice that they also select in the UV Texture Editor.

Step 11: Use Planar Projection to project the texture anew in a more accurate way. Do this by selecting Polygons|Create UVs > Planar Mapping (Options). In the options window, look for the Fit Project To Area and click on Best Plane. Finally click on Project. The results will appear like **Fig. 5.12**.

FIG 5.12 Results of a Planar Mapping using Best Plane.

Step 12: Resize the new projection to make consistent sized square checkers. Do this in the UV Texture Editor by using the new visible projection manipulator handles to scale the projection (the hollow squares). Scale the projection to get the squares to the right size and make sure they are square (**Fig. 5.13**).

FIG 5.13 Scaling a projection to make square checkers that are the right size, so that the UVs are appropriate for the size and shape of the polygons they are representing.

Tips and Tricks

Note that there is also a "Keep Image width/height ratio" option within the Planar Map dialog box. This will automatically keep the relative proportions of the projection constant, so the checkers will be square to begin with.

FIG 5.14 With the projections finished, the inside of the room will make your head hurt. But should show well-distributed UVs via well-distributed and equally sized checkers.

Step 13: Repeat the planar projection process for any other malformed faces. This will probably mean the other diagonal wall and the recessed faces for the windows of those walls (**Fig 5.14**).

Sewing and Moving and Sewing UV Edges

We are in a good place, but aren't done yet. Take a look at the UV Texture Editor and things will look a mess. There will likely be lines everywhere and it will be difficult to see which wall is where – and what is a floor, what is a ceiling, and what is a wall (makes it pretty tough to effectively paint a texture).

FIG 5.15 Selecting a single edge in the View Panel will highlight that same edge twice in the UV Texture Editor as it is part of two different UV shells.

Additionally, there are going to be seams everywhere. Seams are where one shell doesn't line up with another. **Figure 5.15** illustrates this problem (which you can replicate yourself). Select a corner edge and take a look at what highlights (Fig. 5.15 augments the selection in red for visibilities sake). One edge selected in 3D space highlights two edges in UV space. What really is happening is that the same edge is part of two different UV shells.

The problem here is that the two shells are nowhere near each other. This means that if we were to try and paint the texture, it would be very tough to get a believable corner as the wallpaper, or bullet hole, or dirt we painted on the edge of one shell would be very difficult to line up with the wallpaper, bullet hole, or dirt of another. But if we could make this shared edge a single edge – a part of the same shell – the texture would crawl from one wall to the next seamlessly.

Maya provides some very easy to use tools to make this happen.

> Step 14: Move and sew the shells of the diagonal walls together. To do this, select the edge shown in Fig. 5.15 in the View Panel (this will show the edge highlighted twice in the UV Texture Editor). Then, within the UV Texture Editor, choose Polygons > Move and Sew UV Edges (**Fig. 5.16**).

FIG 5.16 Results of a Move and Sew UV Edges.

Why?

So what will happen here is one shell will move up to the location of the other, and the UV edges will be sewn together to make one new larger UV shell.

Step 15: To make things a bit more easily visible, in the UV Texture Editor, select any one UV of the new shell and Cntrl-right-click-hold and choose To Shell to select out the shell and move the shell away, so it's not in the jumble of other UVs.

Step 16: Repeat for other diagonal wall, so that all the walls that house windows are sewn to one UV shell (Fig. 5.17).

FIG 5.17 Single shell for windowed walls.

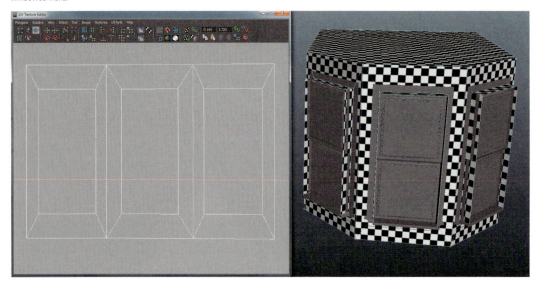

FIG 5.18 Single shell that includes all the walls but the wall with the doorway.

Step 17: Repeat for two walls on either end of the windowed walls (Fig. 5.18).

Why?

Unwrapping a 3D closed shape will always have at least one seam. Part of the challenge of UV layout is deciding where those seams are tolerable. In this case, we want the walls and corners that are visible as the player enters the room to be seamless, so that they make the best impact. For now, we will leave the final wall – the wall with the door – separate. This means that there will be seams at the corners of that wall, but hopefully with some effective texturing, we can minimize the visual impact.

Step 18: If needed, rotate the UV shell for the wall with the door. You may not need to do this, but in my version, the automatic mapping yielded a UV mapping of the wall with the door as a sideways UV set. To fix this, simply select the shell and use the Rotate Selected UVs Counter Clockwise (highlighted in **Fig. 5.19**) to rotate the wall so it stands straight.

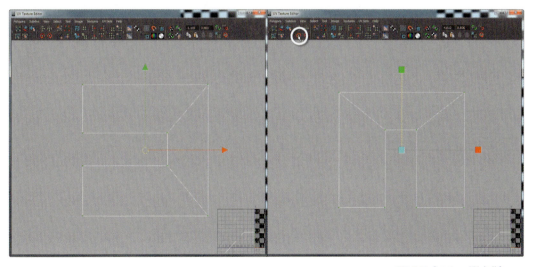

FIG 5.19 Rotating a UV shell for ease of painting later.

Step 19: Map and adjust any other faces that need it. This will probably include the relief polygons of the windows. Similarly, give everything a careful look once more to make sure that the checkers are indeed square and the same size everywhere. If they aren't, in the UV Texture Editor, select offending shells and scale the shell appropriately.

UV Snapshots

Just having UVs laid out is of little value without a good texture. To paint a good texture, we need to know where the UVs are in texture space. To do this, we need to arrange our UVs, so that they all exist within that top right quadrant of the UV Texture Editor, and then create a UV snapshot that will show the shells we have painstakingly made, so that later (in the next chapter) we can paint the texture we want.

> Step 20: Scale and move all the UV shells, so that they fit within the top right quadrant. In the UV Texture Editor, marquee select *all* the UVs. Scale them to fit inside the top right quadrant (the one with the checkers). Our biggest shell is the shell that includes the windowed walls, so use that as a guide. Move the shells, so that they fit within the quadrant (**Fig. 5.20**).

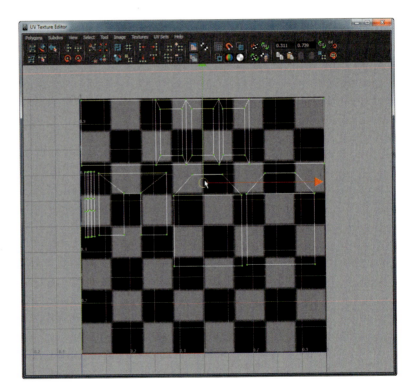

FIG 5.20 Scaled and positioned UV shells.

Why?

Of critical importance here is that we maintain the proportions of each shell in relationship to each other. To do this, always make sure you are scaling all the shells together; that way they can all get smaller, but they get smaller together and one shell doesn't start getting more or less texture space than it should.

Cut UV Edges

So here's the problem: The UVs are laid out and they all fit within the top right quadrant. However, there is a lot of that quadrant that is empty; this UV layout isn't a very efficient use of texture space. What this means in a game situation is that we are paying the price (in video card overhead) for a texture, but only using a bit of its overall space. It's like buying a Ferrari and then only driving it 20 mph.

FIG 5.21 Cutting a UV edge to create two UV shells from one.

To make better use of the texture space, we'll cut some faces off of existing shells (particularly the windowed wall shell) and recombine those faces elsewhere. This will allow us to resize all the shells larger and make better use of the UV space.

Step 21: Cut a wall away from the windowed wall shell. In the UV Texture Editor, select the edge shown in **Fig. 5.21**. Choose Polygons > Cut UV Edges. Select the bottom right UV of the far right wall and expand to shell – it will select only the one wall that is its own shell now.

Step 22: Move this new shell (of one wall) away from the shell it used to be a part of.

Step 23: Sew this wall up to the wall with the doorway. To do this select the edge (in the UV Texture Editor) that is shared between the two walls and choose Polygons > Move and Sew UVs (**Fig. 5.22**).

197

FIG 5.22 Sewing up two other walls.

Tips and Tricks

Sometimes even with a dimmed image, it can be tough to see the UVs. You can hide the texture all together by deactivating Image > Display Image.

Step 24: Scale and move all the UV shells to better fit within the quadrant (**Fig. 5.23**).

Saving Out UV Snapshot

Now we are finally ready to output the UV snapshot. Part of the technical concern here is determining how big of a snapshot to make. Much of this will depend on the final delivery of this game. If it is going to be on a large PC, we could be working with huge textures. However, if this is destined for an iPhone or Android device, we simply can't push that many large textures.

Most game engines will allow textures to be downsampled before build. Although this isn't ideal, it's acceptable; so for this situation, we will be creating a large 2048 × 2048 texture that we will paint on top of.

FIG 5.23 Scaled and positioned shells to make best use of UV space.

Step 25: Export the UV Snapshot. In the View Panel, swap to Object mode and select the walls shape. Back in the UV Texture Editor, select Polygons > UV Snapshot. In the resulting dialog box, be sure to change the File Name to `ETM_RoomWest1UVS`. Change the Size X and Size Y to `2048`. Hit OK (**Fig. 5.24**).

FIG 5.24 Exporting a UV Snapshot.

Wrapping Up

The other shapes in this scene (the windows, the window panes, and even the furniture) are also largely squares. Use the techniques we've covered so far to UV these shapes as well (**Fig. 5.25**).

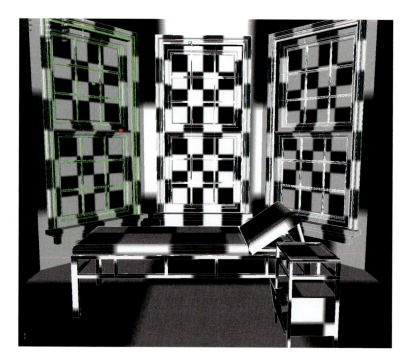

FIG 5.25 UV layout complete for the room.

A few notes as you tackle the other shapes:

1. Often, using Automatic Mapping works best with objects that are not rotated in world space. For the furniture pieces, consider rotating them back to square before starting with an Automatic Mapping Projection.
2. Optimize as you go. Through the modeling process – especially for game models – it's good to delete faces that simply will never be seen. For

instance, the polygons at the bottom of the legs are highly unlikely to be seen unless you plan to knock the furniture over. If you discover that this sort of geometry is still around when doing UV layouts, delete them. Often they are taking up valuable texture space.

3. Some highly detailed shapes (like the windows) have a lot of indentions, but these will be mostly covered in grime. Further, when baked, they will likely use an ambient occlusion pass that will further darken these sorts of spaces. Because of this, there is not a whole lot of reason to spend a lot of time unfolding all those UVs. In my version, I just used a planar projection on the entire window.

4. Remember that it's easier to UV map one object and then duplicate it than it is to re-UV a bunch of identical objects. For the windows, consider UV mapping one, then deleting the versions that aren't UV mapped, and simply duplicate the mapped one into place.

5. Remember to export UV Snapshots for each object as you go along.

6. The solutions I chose are available on the support site (http://www .GettingStartedIn3D.com/) in the Tutorials& Support Files section.

Conclusion

So there this room is. It's laid out in all of its checkered glory. Of course there is lots and lots to do here before this space is done – namely texture and lighting and detail geometry (floorboards anyone?); but now, with a good UV layout, we are ready to create the texture assets to make this space come together.

Tutorial 5.2 Organic Form UV Layouts

Architecture is a great way to start to understand the ideas behind UV mapping. But, as in modeling, organic forms present some new and unique challenges. However, the concepts are the same: we're trying to find ways to unwrap the poly meshes, so that we know where all the polys are and can define exactly how a texture is applied to that surface.

In the previous tutorial, we did a lot of automatic mapping and planar projections. For organic forms, we need to use some sister tools that are much more efficient for the curvilinear shapes of these forms.

For this tutorial, we will be UV mapping the mesh of the alien that we created in Chapter 4. So open that file (**Fig. 5.26**) and let's get started.

The Head

We'll start with the head. With the head, we will get to explore several important ideas surrounding organic forms. First, we will take some time to make sure the head has UVs and then do a sort of rough unwrapping of those UVs. Then, using this rough wrapping, we'll refine the layout to allow for a better use of UV space to make sure the front of the face gets plenty of texture (as that's presumably the part of the head we are most interested in).

201

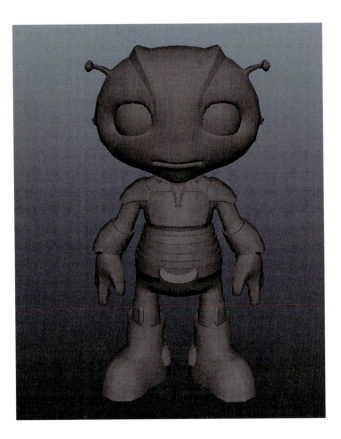

FIG 5.26 The character we modeled before, that we will now UV map.

Step 1: Select the faces that are the head (Fig. 5.27).

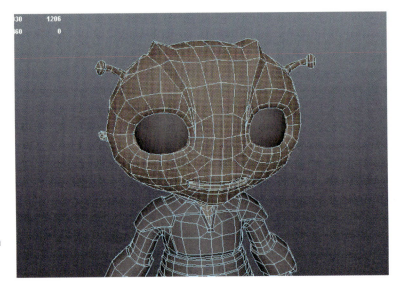

FIG 5.27 Selecting the faces that are the head. Notice that the selection goes down the neck to where it hits the collar.

Cylindrical Mapping

Step 2: Create a cylindrical projection. Do this by choosing Polygons|Create UVs > Cylindrical Mapping (**Fig. 5.28**).

FIG 5.28 Cylindrical mapping.

Step 3: Open the UV Texture Editor and look at the messy results (**Fig. 5.29**). Move these newly projected UVs off to the side where they will be easier to work with.

FIG 5.29 The faces of the head are UVed; but they are pretty useless as is.

Step 4: Separate the mouth as a separate UV shell. The easiest way to do this is double-click on an edge at the front of the oral cavity that is just inside the lips (**Fig. 5.30**). This will select a ring of edges. In the UV Texture Editor, choose Polygons > Cut UV Edges.

FIG 5.30 Selecting a ring of edges to Cut UV Edges along that will separate the mouth from the head.

Smooth UVs

The Smooth UVs Tool is a relatively recent addition to Maya but is so useful in organic shape UV layouts. It actually has several parts to it; the most interesting for us right now though is the Unfold function of it. What it will allow us to do

is unfold this jumble of UVs that we currently have. The Smooth UVs Tool is most easily accessed within the UV Texture Editor as shown in **Fig. 5.31**.

FIG 5.31 Selecting the Smooth UVs tool from the UV Texture Editor.

Step 5: Unfold the UVs of the head. Do this by selecting any one UV of the head in the UV Texture Editor and then expanding to its shell. Next activate the Smooth UVs Tool and watch for two little yellow boxes with the words Unfold and Relax in them. Click and drag to the right on the word Unfold and watch as the UVs *unfold*, so that all the faces become visible (**Fig. 5.32**).

FIG 5.32 Unfolding a shell using the Smooth UVs Unfold function.

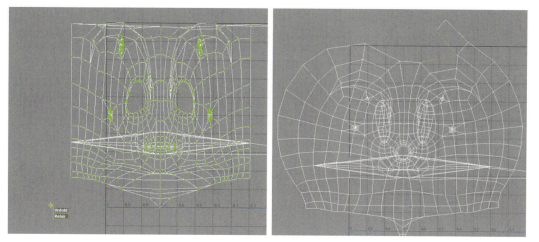

Warnings and Pitfalls

Depending on the topology of your project, you may end up seeing strange flaps sticking out of your shape (as can be seen in Fig. 5.32 on the right side). If this happens, just use Move and Sew UV Edges to get them back into place.

Step 6: Repeat for the oral cavity. Do this by first selecting the faces that are the oral cavity (probably most easily done in the View Panel) and then in the UV Texture Editor Cntrl-right-click and select To UV to convert the selection from a group of faces to UVs. Then (still in the UV Texture Editor) move this collection of UVs away so they can more easily be worked with. Use the same Smooth UVs Unfold functionality to unfold the faces.

> **Why?**
>
> Don't get too worked up over the oral cavity. It's unlikely we will see much of this shape, so working with the oral cavity at all is just about making sure those polygons and UVs are accounted for.

Step 7: Use Automatic Mapping and Sew UVs to create and assemble UVs for the antennae. Do this by first selecting the faces that are the antennae. Choose Polygons|Create UVs > Automatic Mapping. In the UV Texture Editor, move this new projection down away from the other UVs so they can easily be worked with. Next, start selecting edges and using Move and Sew UV Edges to reassemble the shells together (**Fig. 5.33**).

FIG 5.33 Selecting faces (far left). The results of Automatic Mapping (center) and finally reassembling with Move and Sew UV Edges (right).

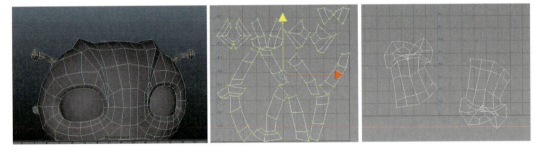

> **Why?**
>
> The idea here is to use UV mapping to get several projections going on those antennae, so that all the UV faces are laid out flat. Then, reassembling with Move and Sew UV Edges gets it back to a near seamless state (there will be one seam for sure). At the end of this process, you will have imperfect UV shells (there are overlapping UVs for instance that we'll work out in a minute); but these new shells are much more accurate than they were when they were part of the big head shell.

Warnings and Pitfalls

Make sure that as you are Move and Sewing UV Edges, that you do not re-sew the antennae back onto the head. As you select each edge, make sure you know where the other edge shows up at – and if it's back up on the head, don't sew it. Instead select another and sew, so that the antennae remain independent of the head.

Step 8: Use the Smooth UVs Tool's Unfold option to unfold these antennae into a better shell (**Fig. 5.34**).

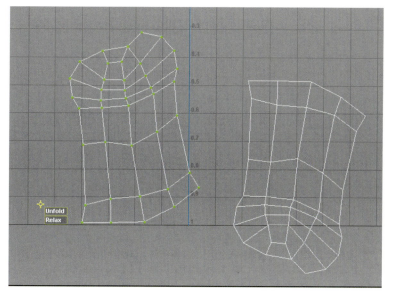

FIG 5.34 Unfolding (via Smooth UVs) the antenna shells.

Refining the Face Region

We've got a good start, but by unfolding the entire head at once, the region of the face very easily becomes scrunched up together as Maya attempts to fit all the UVs of the whole head into one shell. Sometimes, taking an unwrapped shell like this and unfolding certain sections will allow for a better distribution of UVs and allow for less deformed texture across key areas like a character's face.

Step 9: Select just the faces (polygons) of the character's face. A nice way to do this is to select all the faces of the head in the UV Texture Editor, and then in the View Panel, Cntrl-marquee across the polygons that are not desired (the back of the head) as seen in **Fig. 5.35**.

Step 10: Re-project the UVs for these faces using Polygons|Create UVs > Cylindrical Mapping.

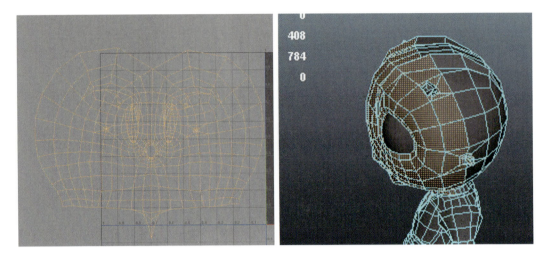

FIG 5.35 Using the UV Texture Editor in concert with the View Panel can allow for rapid selection of appropriate faces.

Why?

I know, we've already projected these polygons with a cylindrical map. The difference here is that we are creating a cylindrical projection for just the face this time (not the whole head). This will give us a smaller and cleaner shell that will unfold more cleanly.

Step 11: Clean up the new projection. Watch for strange flaps that this projection may cause. Additionally watch for areas like down the front of the neck that may end up split. **Figure 5.36** shows a selection of edges that are all to be sewn together (Polygons > Move and Sew UV Edges) to create a unified UV shell.

FIG 5.36 Cleaning up the results of the cylindrical projection.

Step 12: Unfold – via Smooth UVs – this new face UV shell (**Fig. 5.37**).

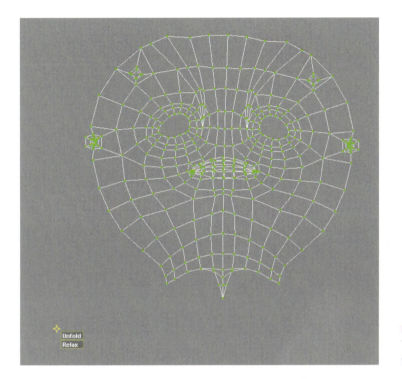

FIG 5.37 Using the Smooth UVs Tool's Unfold function to further refine the face UV shell.

Step 13: Create a new shell as a strip to represent the top and middle of the back of the head. We'll get this off of the old projections. **Figure 5.38**

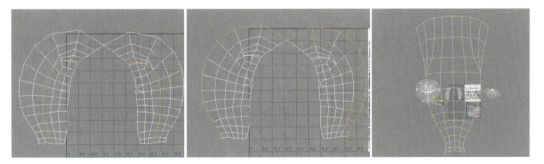

FIG 5.38 Creating a new shell to represent the top and back of the head.

Why?

The idea here is to try and make sure our seams are not across the middle of the back of the head. In this case, we have those ridges that make for a good seam location. Getting the center top and back of the head into one strip as a UV shell will ensure that the texture still holds up well when we see the back of the character (which could be often in a third person game).

(left) shows the edges that need to be selected and then cut (Polygons > Cut UV Edges). Next, select the outer edges (Fig. 5.38, center) and Move and Sew UV Edges to make a new shell. Finally, Fig. 5.38 (right) shows this new shell after using the Smooth UVs Tool's Unfold functionality.

Step 14: Scale this new shell, so that it matches the top of the face shell and attach them together with Move and Sew UV Edges (**Fig. 5.39**).

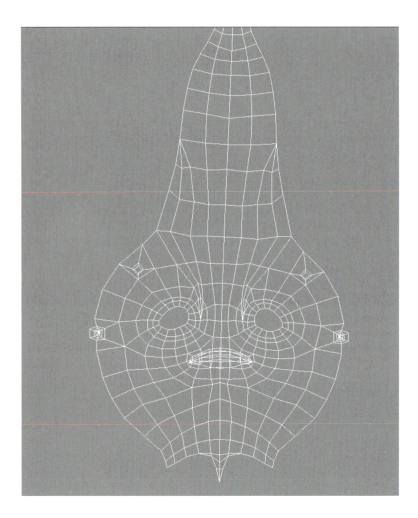

FIG 5.39 Face shell that now includes the shell that was the top and back of the head.

Step 15: Reattach the remaining head shells. To do this select the remaining shells of the side of the head and scale them, so that their edges are similar in size to the extant face shell. Then attach them to the face shell with Move and Sew UV Edges (**Fig. 5.40**).

Step 16: Take one more pass at Smoothing the UVs (with the Unfold).

Step 17: Finally, scale and position the antennae and oral cavity shells. For now, just eyeball them in scale, but rotate them around so they make

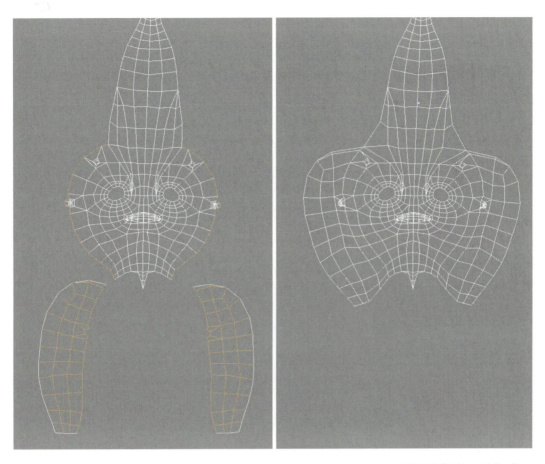

FIG 5.40 Finishing up the head by reattaching remaining UVs.

Tips and Tricks

Notice that the selection shown in Fig. 5.40 (left) is pretty liberal (it's not limited to just the edges that are to be sewn together). This is OK actually as the other edges that are selected there are already sewn together; so they will have no effect on the final shell once Move and Sew UV Edges is used. Sometimes a sloppy selection like this can save a lot of time and yield the same results as if a very careful selection of edges were made.

sense to you (as you're going to be painting this stuff later). Notice that the oral cavity in Fig. 5.41 is stuck inside the empty space of the character's left eye.

Step 18: Create a checkered Lambert for the character. As we did in the last tutorial, in the View Panel, right-click-hold on the character and choose Assign New Material. Create a Lambert, and then in the Attribute

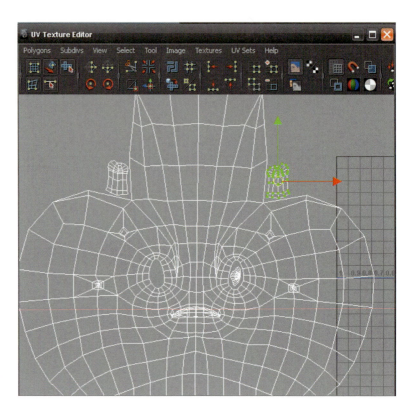

FIG 5.41 Bringing the other head parts together. Notice they are not sewn together but are placed where they will be easy to identify.

Editor, click the checker button next to the Color channel and choose Checker.

Half the Work, Twice the Results

Notice that for the next big collection of steps, we will only be working on one side of the alien (his left side). Because this creature is symmetrical, it will allow us to UV once and then duplicate the UVed side. What this will also allow us to do is overlap some UVs (so both hands exist in the same UV space – just mirrored versions on top of each other), so that we are able to use more of the texture space on the forms.

Armor Pieces

The armor pieces are unique shapes that could be tackled in a lot of different ways. But a quick and easy method for smaller elements like this is the method where UVs are created with Automatic Mapping, and then the exploded shells reassembled.

Step 19: Select the faces that are the shoulder pads and the belt buckle.
Step 20: Polygons|Create UVs > Automatic Mapping (**Fig. 5.42**). Move this new projection to a good place to work with them within the UV Texture Editor.

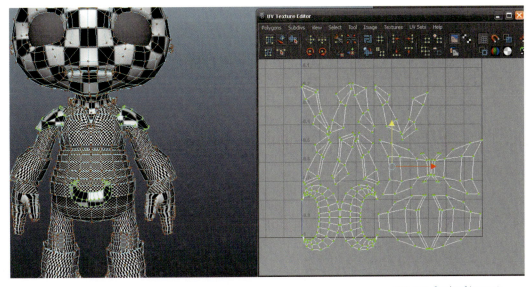

FIG 5.42 Results of Automatic Mapping. Now we can put it all back together.

Step 21: Assemble and unfold. Use the Move and Sew UV Edges to reassemble the armor parts. Remember not to sew the edges of the armor back onto the body. When the pieces are all assembled again, use the Unfold function of the Smooth UVs Tool to unfold the shells (**Fig. 5.43**).

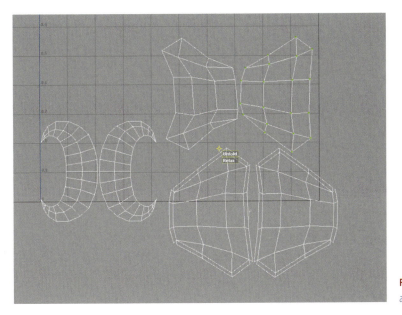

FIG 5.43 Assembled and unfolded armor shells.

The Belt and More Cylindrical Mapping

We have used Cylindrical Mapping to quickly create some UVs for the face. But this tool can be used for more accurate mapping as well. Specifically, we can make sure that the projection wraps clear around a cylindrical object (like the belt).

Step 22: In the View Panels, select the faces that are the belt.
Step 23: Choose Polygons|Create UVs > Cylindrical Mapping. Although this projection is still active, activate the Channels Box and change the Projection Horizontal Sweep to 360 (**Fig. 5.44**).

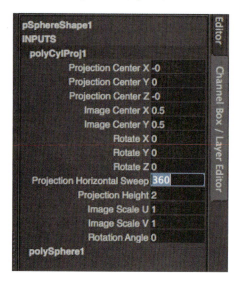

FIG 5.44 Adjusting the Cylindrical Mapping projection to wrap clear around the object.

Step 24: In the UV Texture Editor, move this new projection out to a place to work with it and use the Smooth UVs Unfold to unfold the projection.
Step 25: Repeat this process for the cummerbund part of the belt. Select the polygons and use Cylindrical Mapping with a 360 Projection Horizontal Sweep to create the UVs for the area. Then Unfold with the Smooth UVs Tool (**Fig. 5.45**).

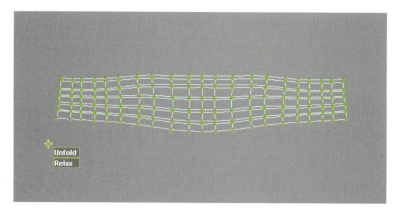

FIG 5.45 Creating the shell for the top of the belt – the cummerbund area.

214

Cylindrical Mapping Revisited

We've made extensive use of Cylindrical Mapping, but haven't yet really made extensive use of some graphical manipulations of these sorts of projections. When Cylindrical Mappings are first activated, there are some manipulators that appear in the View Panel that can be used to visually adjust how that projection is applied to the selected polygons. Unfortunately these manipulator handles can be very tough to see on your own screen, even tougher to see in print, and almost impossible to discern when there is a high contrast checkerboard material beneath it. So, consider **Fig. 5.46** where we'll try and break down how these handles work.

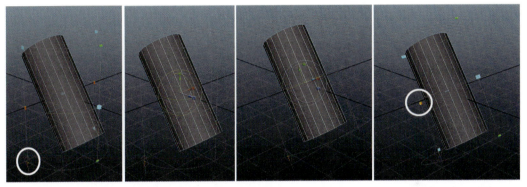

FIG 5.46 Using the manipulator handles of the Cylindrical Mapping Tool to create a projection that is closer to the orientation of a diagonal collection of polygons.

In Fig. 5.46 (left), you can see the manipulators as they appear immediately after Polygons|Create UVs > Cylindrical Mapping. On the far left, a small red T is highlighted. When this is clicked, the manipulator handles will turn into the traditional manipulator handles that show the projection can be moved, scaled, or rotated. This is important as the default position of a cylindrical projection is straight up and down – but sometimes the polygons, the projection is meant to map, are diagonal. Once this T is clicked, the projection can be rotated (as it is in the next two shots) to align with the rotation of the polygons it is mapping. When the T is clicked again, new handles appear that allow the projections Projection Horizontal Sweep settings to be manually adjusted (in this case, wrapped completely around the shape, 360°).

Being able to manually control the projection becomes all sorts of important for things like arms, legs, or other collections of polygons in those sorts of areas.

Step 26: Use this new understanding of the Cylindrical Mapping Tool for areas like wrist armor (**Fig. 5.47**). Remember to select the faces, activate the projection with Polygons|Create UVs > Cylindrical Mapping, and then use the manipulator handles to rotate the projection into place to effectively wrap the shape. Don't forget to use the Smooth UVs Unfold Tool.

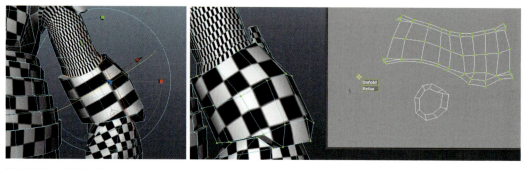

FIG 5.47 Using Cylindrical Mapping to effectively wrap the wrist armor.

Step 27: Repeat for shapes like the arms, legs, and chest (**Fig. 5.48**).

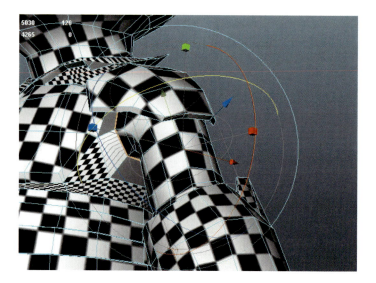

FIG 5.48 Mapping the arms or legs.

The Boot

Ah feet. Always and interesting challenge. You actually already know of the tools needed for this though. Not to fear.

Step 28: UV Map the boot. Do this with three projections: two cylindrical (**Fig. 5.49**, left and center) and one planar (Fig. 5.49, right).

Chests, Backs, and Planar Mapping

There are a few other areas where a quick Planar Mapping will do just the trick. These have to be done with caution as they are a seductive way to get UVs quick, but the results can quickly be very distorted. However, there are some shapes (like the chest plate and the armor on the alien's back) where a quick planar map will be perfect.

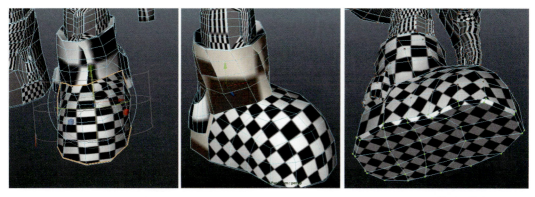

FIG 5.49 Mapping the boot.

Step 26: Select the faces of the chest plate and use Polygons|Create UVs > Planar Mapping (Options). Be sure that Best Plane is checked for the Fit Projection To setting and hit Project. In the UV Texture Editor, move the new projection to a new place and use the Unfold of the Smooth UVs Tool (Fig. 5.50).

FIG 5.50 Working through the breast plate with a quick planar projection.

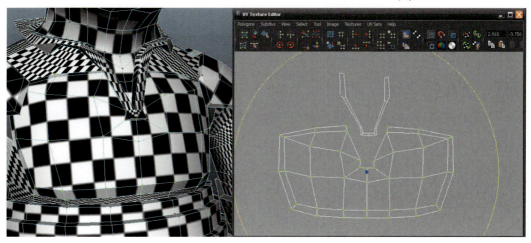

Step 27: Repeat for the back armor (Fig. 5.51).

Hands

The hands can be overly complicated. My personal favorite technique is to do the hands with just a couple of Planar Projects and then make heavy use of the Smooth UVs Unfold functionality.

Step 29: UV Map the hands. Do this by selecting the faces of the hand that are the palm and Planar Map them. Then do the same for the top of the hand. Be sure both of these projections are in a good place to see them in the UV Texture Editor and use the Smooth UVs Unfold to unfold them into a usable shell (Fig. 5.52).

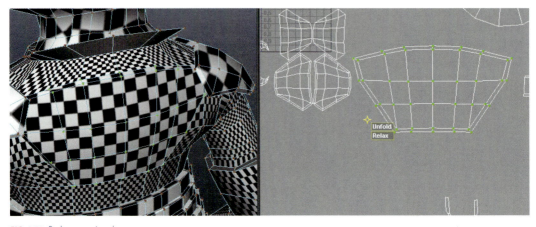

FIG 5.51 Back armor using planar mapping.

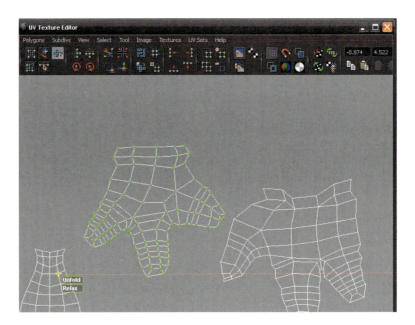

FIG 5.52 Mapping the hands with two planar projections.

Misc. Cleanup

Step 30: Make sure all of one half of the alien is mapped. At this point, you will likely have loads of shells scattered hither and yon throughout your UV Texture Editor. The nice thing about this is that the top right quadrant will have any faces that have not been mapped yet.

Step 31: Scale your shells, so that the checkers are the same size everywhere – except for the head – it can be bigger than the rest.

> **Why?**
>
> The head will be very important to the visual impact of the character. Because of this, a common technique in gaming is to cheat the head UVs and allow them to be bigger than usual, so that they take up more texture space – and thus, the texture is sharper across the face (which is the first place we look at a character).

Mirroring

Now that we have half of the mesh UVed; we can duplicate this finished side and not have to manually re-UV the entire other half.

Step 32: Select all the faces on the right side of the character and delete them (**Fig. 5.53**).

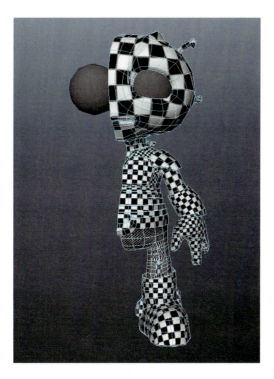

FIG 5.53 Deleting the right side of the character (the non-UVed side).

Step 33: With one half of the character selected, choose Polygons|Mesh > Mirror Geometry (Options). Change the Mirror Direction to be –X and click mirror (**Fig. 5.54**).

Step 34: Flip the head shell. To do this, in the View Panel, select any one UV on the head. Then in the UV Texture Editor, expand this one UV to the shell (which should show up right on top of the one half of the head shell).

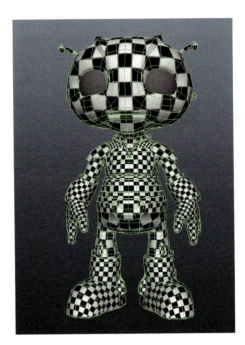

FIG 5.54 Mirrored mesh – notice that the checkers are all mirrored as well.

Why?

Take a look in the UV Texture Editor. Go to Image > Shade UVs. The way this tool works is UV faces that are facing forward (the direction of the face normal) will show up blue. Those facing away will display as pink. For now all of the shells will show up a dark purple (blue on top of pink).
What this means is that the Mirror Geometry left the UVs right where they were but are mirrored (and thus facing the opposite direction of the originals. In some cases, this is fine; we want it to be that way for things like the arms, boots, and hands where we will be happy to pick up that extra texture space). But in other places (like the chest plate that goes across the middle of the chest and the head), a mirrored texture would look very strange. In places like that, we want to be sure and make those UVs not laying on top of each other, but mirrored and facing the right way.

Use the Move Tool to move the shell away from the other (it will be pink). Next choose Polygons > Flip (Options). Make sure the Direction is set to Horizontal and hit the Apply and Close button.

Why?

This will flip the shell, so that it is the mirrored version of what it was. It will turn blue as it is now facing forward.

Step 35: Maneuver this new shell, so that it aligns with the shell of the left side of the face (Fig. 5.55).

Step 36: Select all of the edges right along the center of the mirrored axis and choose Polygons > Move and Sew UV Edges to seal the two sides into one shell.

FIG 5.55 Maneuvering the right side shell into position.

Step 37: Repeat this process for any place where a mirrored texture would be obvious. This would include the belt, the cummerbund, the chest plate, back plate, and crotch (Fig. 5.56).

Scale and Organize

Step 38: Scale the head shell, so that it fills a quadrant vertically (be sure to scale in all directions at once).

Why?

Remember we are going to allow the head to have a lot of texture space. Because it's the biggest, positioning it first will help in the organization puzzle that is to come.

Warnings and Pitfalls

Now that we've spent all this time creating well-built UV shells, it is critical that when scaling shells that you *always* use the middle yellow box to scale in X and Y together.

FIG 5.56 Mirrored UV shells for belt, cummerbund, breast plate, and back plate. Notice that this also cut the belt and cummerbunds into two strips to allow for easier organization of shells.

Step 39: Scale all the other shells at once and begin to maneuver them into place around the head. If you find that the shells won't fit, select them all and scale them all at the same time to maintain the relative size to each other (Fig. 5.57).

Warnings and Pitfalls

Be sure all of the shells fit within the top right quadrant. Be careful that the mirrored versions stay together but that these UV shells do not overlap any other shells.

Step 40: Delete all your history (Edit > Delete All by Type > History).

Why?

Along the way you will have amassed an amazing amount of history in the form of projections. Deleting the history will keep your scene clean.

FIG 5.57 Assembling the puzzle that is the UV set up for the alien.

Step 41: Make a UV Snapshot of the alien's UV layout. You might name it something like `AlienUVSnapshot`.

Conclusion

Pretty intense, eh? This sort of task seems pretty thankless at first. All you have left after hours of work is a weird checkered alien that doesn't appear all that different than what the alien looked like when you started. But, under the hood, you've got the UV layout that is going to allow for sophisticated texture painting.

What's Next

Well now that we have UV maps created for the game level and our character, we can get going on creating the textures that will finally get us out of this grey plastic (or checkerboard) hell. Yay!

In the next chapter, we will start painting textures to bring the surfaces to life. The most fun is yet to come!

Homework

1. Layout the UVs for the rest of the game level.
2. Layout the UVs for the high-rez challenge from the last chapters.

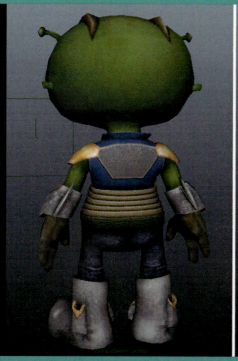
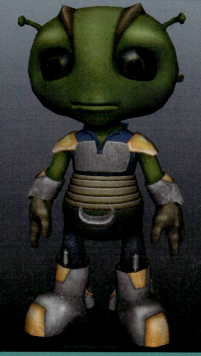

Material Creation and Texture Painting

Gray plastic is getting really old. So far we've created some great looking forms and taken some extensive time to do the hard work of good UV layouts. Now we get to reap the benefits of that hard work and start texturing our surfaces to bring some real life to the scenes.

Nomenclature

There is some nomenclature here that we should cover before we go too far. People will often talk of "texturing" their objects or scene. What the artist usually means is that he plans to add color or other visual surface properties to his collection of polygons. But this usually is done through three different things: textures, materials, and shaders.

Textures are images. A texture can be used to define the color of an object, or other things like where the object is shiny (via a specular map), or how bumpy a surface will appear (via a bump, normal, or displacement map). Maya is pretty tolerant as to what format it will accept textures in. Tiffs, jpgs, pngs,

or even Photoshop files will work in most cases (although certain rendering engines don't like some formats – Mental Ray dislikes Photoshop for instance). This means that textures can be painted in a lot of different places. For our purposes, we will be painting our textures in Photoshop, although our final output will be a tiff.

Textures by themselves are pretty useless though. In order for them to be assembled (one texture for color, one for bump, etc.), Maya uses the idea of creating **Materials**. These materials are what are actually applied to the mesh. A material can be reused on multiple objects or a single object can have multiple materials assigned to different polygon selections.

Materials can be of several types. These different types are called **Shaders**. A shader is really the cumulative result of textures within materials and will include the final visual product like whether the surface appears shiny, reflective, transparent, etc. Shaders can exist outside and independent of materials in some cases – but generally (and for our purposes in this volume), we will be using Materials of various Shader types to define surfaces.

To better understand how all this fits together, let's look at Maya's methodology for creating and managing materials – the **Hypershade**.

The Hypershade

The Hypershade (accessible via Window > Rendering Editors > Hypershade) has several general areas that are important to understand (Fig. 6.1).

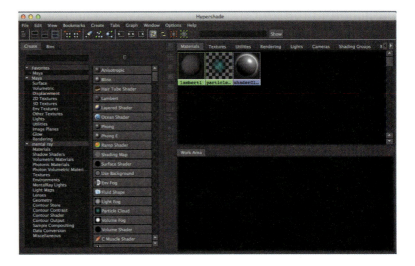

FIG 6.1 The Hypershade.

Typical of Maya, this window is dense with tools and options. The general areas that are important to us are these:

Create Area: This is the area on the far left of the window. The Create tab signals the area. Beneath this tab is a list of different types of shaders that are available for different types of rendering engines. When any of the shaders beneath the rendering engines (Maya or Mental ray) are selected, the column next to it will present some buttons that are specific shader types. When a particular shader type is clicked, a material of that type will be created and show up in the Materials area.

Hypershade Top Tabs: I know – dumb name, but it's what Maya officially calls them. What this is talking about is the area that is represented in Fig. 6.1 by the Materials tab. I like to think of this area as a sort of shelf. Beneath each tab, the user can see what materials have been created (and stored) in relationship to the scene created. Notice there are also other tabs for things like Textures. Again, the idea here is that when the Texture tab is clicked, you can see what Textures have been linked to materials in the scene.

Work Area: This area – directly beneath the shelves that hold the materials or textures allows for materials to be constructed or modified. By middle-mouse-dragging a material or texture from the space above down to the work area – that node (material or texture) will be represented and can be graphed to show how the material is put together or how the texture is tied to certain materials.

For an example of how all these work together, try this:

Step 1: Open the last saved version of the Escaping the Madness game level.
Step 2: Open the Hypershade.
Step 3: Middle-mouse-drag the checkerboard material (probably called lambert2) from the Materials area down into the work area.
Step 4: Within the Hypershade, choose Graph > Input and Output Connections (Fig. 6.2).

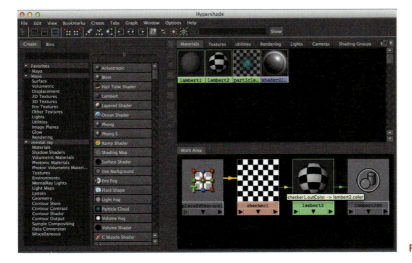

FIG 6.2 Graphing a material.

What's happening here is the material (lambert2) and the textures that define it (checker1) are laid out with arrows indicating how these various nodes are connected. If the mouse is moved over the arrows that connect the nodes and left there for a second – a little yellow hint box will pop up (as it has in Fig. 6.2 with the mouse hidden for clarity) that shows which attribute is coming out of one node (checker1.outColor in 6.2) and into what attribute of the next (lambert2.color). So in Fig. 6.2, the color of the checker1 node is defining the color attribute of the material lambert2.

Creating and Applying Materials

In the last chapter, out of necessity, we took a quick look at creating a new material. There are a few ways to create and apply textures: In the Hypershade, a new material is creating by clicking one of the shader type buttons (Anisotropic, Blinn, Hair Tube Shader, Lambert, Layered Shader, etc.). When this is done, a new material will be created and show up in the Materials tab.

This material can then be applied to an object by middle-mouse-dragging it from the Hypershade to the object in the View Panel, or by selecting an object (or objects) in the View Panel and then in the Hypershade right-clicking on the material and choosing Assign Material to Selection, or by right-clicking on an object in the View Panel and choosing Assign Existing Material > Name of Material from the Hotbox.

Alternately, in the View Panels, right-clicking on an object and choosing Assign New Material will bring up a window that looks just like the left part of the Hypershade (the Create area) that allows you to create a new material. Once you pick a type of material to make, Maya creates the new material and automatically assigns it to the object.

There are lots of ways of connecting nodes within the Hypershade. But some of the easiest ways to adjust materials is through the Attribute Editor. If any node is double-clicked in the Hypershade, the attributes of that node will appear in the Attribute Editor, where they can be easily edited. Remember that in the last chapter, we assigned the checkerboard texture to our newly created material via the Attribute Editor.

But enough talk. The best way to see how all this fits together is by creating some materials. Even more fun will be making materials that are tied to textures to make the scene feel much more "real."

Tutorial 6.1 Game Level and Architectural Texturing

We will start off by creating the textures for the room we UV mapped in the last chapter. There are fewer surfaces there and it will be easier to see the direct correlation between how the textures are built and their usage and placement in the space.

Remember that before working on creating textures, you must have a well laid out UV map and a UV Snapshot of that layout. Remember from the last chapter that this UV Snapshot will (by default) be saved within the images folder of the Project folder.

Walls

Step 1: Set your Project. Remember to do this, choose File > Set Project . . . and then navigate to the Escaping the Madness folder.

Why?

Why are we bringing this up again? There is a very critical thing to remember about textures: Maya doesn't actually *import* any of the texture files into the .mb scene – rather it links to these files. This means that keeping your textures and keeping track of where those textures are is important. It's why having a properly set Project is critical in Maya. If the texture files move or if Maya doesn't understand where they are stored – all the materials you created using those textures will break and likely render as solid black.

Step 2: Ensure that you have a UV Snapshot of the wall object. To check this, if you followed the last chapters tutorials, this UV Snapshot should be within the images folder of your Project file and be named ETM_RoomWest1UVS. If it is not there, repeat the steps of outputting a UV Snapshot: In Maya, select the walls shape, then in the UV Texture Editor select Polygons > UV Snapshot. The resolution we used in the last chapter was 2048 × 2048.

Tips and Tricks

You can certainly use your own UV layout for this step or you can grab the .mb file Hallway_Chapter5UV_End.mb off the support website (http://www.GettingStartedIn3D.com).

Texture Resources

We're going to call what we're about to do "painting textures," but in reality we are going to be doing photo assemblage with Photoshop. There may be some of you out there reading this book that are incredible enough illustrators to really paint (digitally or traditionally) the textures for things like walls – and in fact, depending on the style of a game or scene, a painted look can be a very interesting choice. But, for our purposes, we will be using photographs of surfaces to create our custom textures.

Ideally, you go out and take your own photographs to use as source material. However, in a pinch and for mockups and educational exercises like this, there are some online resources that are very effective. My personal favorite

is CG Textures (http://www.cgtextures.com). This site requires an account – which just takes a minute to set up; but most of the assets are free and it can be an incredibly quick and effective source for photos.

As per the license agreement on the site: "One or more textures on this map have been created with images from CGTextures.com. These images may not be redistributed by default. Please visit www.cgtextures.com for more information."

In the course of this tutorial, I will be using several textures from CG Textures. I'll be calling out which textures I used – and you can go grab the exact textures as well; or feel free to grab similar textures to make the surface your own.

Photoshop Preparation

Before we can start effectively painting textures, we need to a bit of adjustment to our UV Snapshot.

> Step 3: Prepare the UV Snapshot. Do this by opening the UV Snapshot in Photoshop (ETM_roomWest1UVs if you followed the past tutorials). In the Layers palette, Cntrl-click Layer 0. Choose Edit > Stroke. In the Stroke dialog box, change the width to `5 px` and change the color to a solid black. Hit OK.

Why?

Some of the steps here might seem to be invisible. When the file is first opened, you'll see just the hint of the UVs in this snapshot. This is because the UV lines are laid out with a very, very thin line and with such a big image (2048 × 2048) it's just tough to see them. Cntrl-clicking selects the content of Layer 0 and then we are stroking that selection by five pixels with black which makes the UV Snapshot much easier to see. When it's easier to see, it's easier to know where textures are being placed.

> Step 4: Rename Layer 0 to `UV Snapshot`. Do this in the Layers palette by double-clicking the words Layer 0.
> Step 5: Save the file as ETM_RoomWest1Raw.psd. Save this in the images folder of your project file.

Why?

I usually like to keep two copies of my textures: a raw multi-layered version that I can go back and adjust easily and a flattened version that I actually use as a texture in my Maya materials. Just to keep things clean, I like to keep my raw versions with the UV snapshots from which they came (in the images folder), and then later, when I save out the flattened version, I'll save that to the source images folder – where Maya will expect to find texture files for materials.

Step 6: Find and download a plaster base image from CG Textures. The plaster base image I used is linked to at www.GettingStartedIn3D.com in the Tutorials & Support Files under the Chapter 6 topic. Note that in this case, I am using one of the "tiled" textures. Open this file in Photoshop and copy its content to the ETM_RoomWest1Raw file.

Tips and Tricks

Notice that in CG Textures, some textures are listed as "Tiled." This means that the texture will repeat without yielding unsightly seams. Generally, these are best to use for repeating base textures. You're not limited to those that are tiled, however – be sure to check out Appendix B for details on how to make your own seamless textures.

Step 7: Use the Free Transform tool (Edit > Free Transform) to resize the texture, so that it is an appropriate size on the wall (**Fig. 6.3**). Again, holding Shift will maintain the proportions of the selection as it is resized.

FIG 6.3 Pasted texture laid beneath the UV Snapshot layer.

231

Why?

The size of this texture is just a guess. In all reality, it's pretty tough to know how that texture will look to scale until it's actually applied to the Maya scene. Generally, tiled textures are meant to be tiled and usually are not going to fill the entire surface with one copy.

Step 8: Duplicate the texture enough times to fill the wall (**Fig. 6.4**).

FIG 6.4 Duplicated tile to fill the wall.

Tips and Tricks

Remember that using the Move Tool while holding the Alt (or Option on a Mac) key will duplicate the layer as it is moved. Remember to snap the tiles together.

Why?

So there are some strange things that you may notice now. First, the texture is going off the right end of the wall in my screenshot. This is OK as there is no other UVs to the right and so that overlap won't cause any problems. The second issue to notice is that even though the texture is seamless (there are no hard lines), you can definitely begin to pick out a pattern. This really is an issue and is undesirable (unless dealing with things like ceramic tiles). But don't sweat it now. When we start layering textures, most of this repeating stuff will be toned down.

Step 9: Merge all the copies to one layer. In the Layers Palette, select all the many duplicates of this plaster base image and choose Layer > Merge Layers.

Step 10: Duplicate this merged layer to cover the other wall.

Step 11: Duplicate plaster base for the ceiling. In my UV snapshot, this is the shape in the bottom left. If you're unclear which is which in yours, just open your scene in Maya, select the faces you're after, and then in the UV Texture Editor look at which are highlighted. At this point, there should be plaster base for all the walls and the ceiling (Fig. 6.5).

FIG 6.5 Plaster base laid out for all surfaces but the floor.

Step 12: Rename the layers to `Ceiling Base`, `Wall 1 Base`, and `Wall 2 Base`. If you're unfamiliar with Photoshop, you can do this by double-clicking the name of a layer and then typing the new name.

Why?

We're about to get complicated in this texture – we're going to have a whole lot of layers. Keeping track of which layer is critical both to your own workflow and efficacy thereof, but also to peace among your team mates if someone else inherits parts of a project. It's very frustrating and incredibly time consuming to try and sort through another artists unlabeled work.

Step 13: Find, download, and place a floor base. I'm using a worn wood floor (again, the specific link is listed at the support website). After placing, be sure to label the layer as `Floor Base` (**Fig. 6.6**).

FIG 6.6 Floor base in place.

Trying It On for Size

So we have a good guess on the size of the texture base images. But, before we go too far with starting to make this texture not appear like a tiled boring space, let's get it into the Maya scene and see how it's looking. There may need to be adjustments.

Saving Out a Flattened Texture

We want to keep this multi-layered raw version of the texture (it's pretty rough at this point), but it'll save time if we have a flattened, smaller image (like a jpg) to use in Maya.

> Step 14: Save the file.
> Step 15: Hide the UV Snapshot layer (click off the eye icon in the Layers Palette).

> **Why?**
>
> Being able to see the UVs in Photoshop is important for us, but we don't want those lines to be baked into the texture that we bring back into Maya. Hiding this layer makes sure we just have the color information and not the map we used to determine it.

> Step 16: Use File > Save for Web & Devices to output a jpg. In the Save for Web & Devices dialog, change the Preset to JPEG High and click the Save button. When prompted, choose to save the file (rename it to `ETM_RoomWest1Color.jpg`) in the sourceimages folder of your project.

> **Why?**
>
> Sourceimages. This folder is important. This is a folder that Maya will always reference files from (remember that the Character Style Sheets were placed here).
>
> Why the new name? Well, this is the first of several textures we will be using over the course of these tutorials. Naming is important, and labeling this texture as a color texture helps keep things straight.

Creating the Wall Material

Time to get back into Maya. Here, we'll create a new material just for the wall shape and use our rough painting as the color texture map and see how the size of the textures hold up.

> Step 17: Create a new wall material. Do this by opening the Hypershade. In the Create Area, click the Lambert button. This will create a new material (probably called lambert3) that will show up in both the Materials tab and the Work area. Double-click this new material, and it should show up in the Attribute Editor as well. Rename the material to `Wall_Mat` (**Fig. 6.7**).

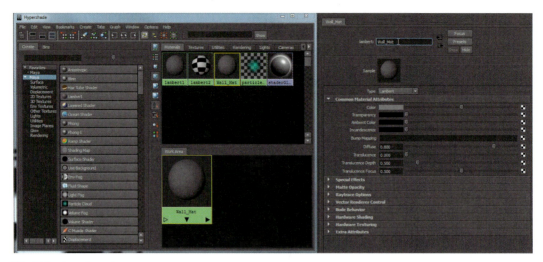

FIG 6.7 Creating and preparing to edit a new material: Wall_Mat.

Why?

Naming materials matter. It doesn't take long to name the material (I always like to include _Mat on my materials as it always lets me know that that node is a material) and can be big dividends when assigning materials by name (as in right-clicking on an object and choosing Assign Existing Material from the Hotbox).

Tips and Tricks

There are several ways to make new materials. Remember that this could also have been done by right-clicking on the wall object itself and choosing Assign New Material from the Hotbox. Then you could carry on with the following steps in the same way, but the material would have already been applied. For now though, I'm after a familiarity with the Hypershade, so we're building the new material there.

Step 18: Tell Maya that we plan to use an image to define the color of this material. To do this, in the Attribute Editor, on the Color line, click the little checkerboard button to tell Maya to create a Render Node. Now, in the Create Render Node window click the File button.

Why?

This should feel vaguely familiar. Remember that when we were creating the dummy material (with all the checkers), we followed this same technique, but instead of choosing File, we used the procedural checkerboard. In this case, by choosing File, we are telling Maya that the color attribute of Wall_Mat will be defined by a bitmapped image. Now, we just need to define which image to use.

Step 19: Use our painted texture as the color image. After the last step, the Attribute Editor should have swapped to show the attributes of the newly created file node that it created. There, look for the Image Name input field and click the folder icon on the far right. Maya will open a dialog box that *should* go to the sourceimages folder of the project file. Choose the painted image we saved there (ETM_RoomWest1Color.jpg). The results should look like Fig. 6.8.

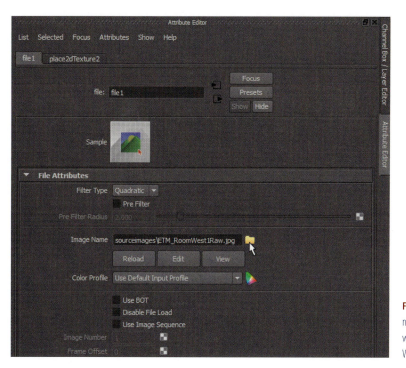

FIG 6.8 Results of filling the file node with our image – which in turn will define the color attribute of the Wall_Mat.

Warnings and Pitfalls

If, when you click the folder icon to define the image to use Maya does not take you directly to the sourceimages of your project file – STOP – it means your project isn't set quite right. It is critical – especially if you ever plan to open this scene on another machine that Maya understands a relative path (not an absolute path) to the texture. Go back and reset your project (File > Set Project) and reopen your file . . . then repeat the last few steps.

Step 20: Apply this material to the wall shape. To do this, middle-mouse-drag the Wall_Mat from the Hypershade onto the walls of the room (Fig. 6.9).

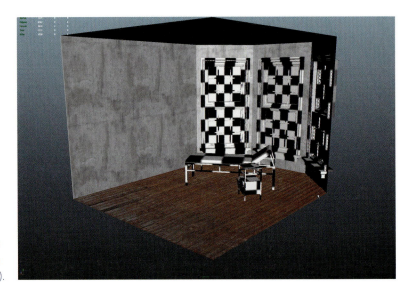

FIG 6.9 Applied material (note this screenshot is viewing the scene with Backface Culling turned on for clarity).

Tips and Tricks

Backface Culling is having Maya only show the front sides of faces. For games, this is really an important idea as most game engines only show the front side of any face. In construction, it can also be of great help as it can let you see into a room from the outside. To turn on Backface Culling, go to the View Panel and choose Shading > Backface Culling. If the room still looks solid from the outside, but transparent from the inside, select the walls and choose Polygon|Normals > Reverse to swap the direction the polygons are facing.

Why?

There it is. Some things are working well; the wall base seems to be a reasonable texture size, but the floor feels a bit big to me. Your results may vary depending on the textures you chose. Make note of what needs to be changed, so you can make the necessary adjustments back in Photoshop.

Step 21: Save the scene in Maya and go back to Photoshop.

Layering Textures

Step 22: Make any size adjustments you noted after placing the texture in Maya. If there needs to be extra copies of a texture to help fill space out, make them.

Step 23: Find and download a good "leaking" texture. Figure. 6.10 shows the result of the leaking texture I used from CG Texture (and linked to on the supporting website). The key to this nicely prepared decal is that it

already has an alpha channel, so it lays right over the plaster. Note that this dripping decal has been duplicated many tips and is laid everywhere leaks would actually occur.

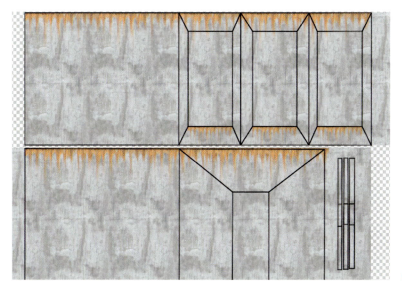

FIG 6.10 Drips.

Why?

This is really a fun texture to do this with. One of the things I really like about CG Textures is that many of the textures are prepared like this, so they can just be dropped right into place. However, there are lots of other ways for layers to work besides just laying one on top of another . . .

Step 24: Find and download an interesting rust texture. The one I used is linked to on the website. Again, the exact texture isn't important; but within CG Textures do a quick search on "rust" and plenty of interesting options will come up.

Tips and Tricks

The idea here will be to overlay a big rust texture over the top of the each entire wall. So grabbing a few variations of any of the rust pages will give you a few more options for variation.

Step 25: Copy, paste, and scale (via Free Transform), a couple of the rust textures, so that they cover your entire plaster surfaces (walls and ceiling). Make sure these layers are on top of all the layers but the UV Snapshot layer. Be sure to label them (I used Ceiling `Rust Overlay, Wall 2 Rust Overlay, Wall 1 Rust Overlay`). The strange results will look something like **Fig. 6.11**.

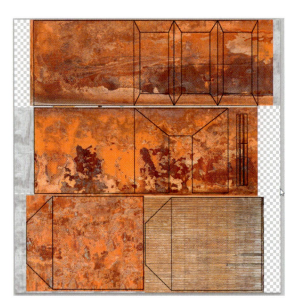

FIG 6.11 The rust layers.

Why?

"Whoa!" I can hear you saying, "it was making sense until now, but what's going on there?" I know, it looks strange here; just laying another image over the top seems to negate all the work we did earlier. But hang tight, being able to blend these layers together will yield interesting results in just a few steps.

Step 26: Change the Blending Mode from Normal to Soft Light for each layer. Do this in the Layers palette of Photoshop. The Blend Mode is the drop down menu in the top left of the palette. The results will appear like **Fig. 6.12.**

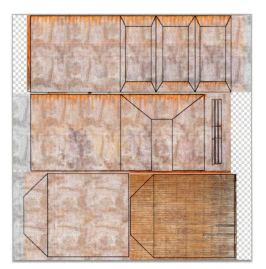

FIG 6.12 Soft Light blending.

Why?

Blending Mode allows you to tell Photoshop how to blend the selected layer with the layers beneath it. There are different modes to use at different times. Sometimes Multiply is the best solution; but when there is a fairly dark overlay (like this rust image), then Soft Light does just the trick.

Step 27: If desired, adjust the saturation or levels of the rust overlays. My rust textures are turning the whole room a little orange for my taste. But by selecting each of those rust overlay layers and adjusting the Hue/Saturation (Image > Adjustments > Hue/Saturation) and specifically turning the Saturation value down, I can still get the surface disturbance without the overwhelming orange color (**Fig. 6.13**).

FIG 6.13 Adjusted saturation levels of overlay layers.

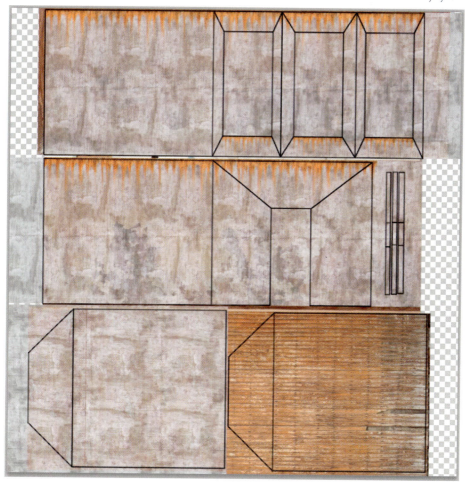

Step 28: Repeat this process to taste using varieties of textures to dirty corners and break up surfaces until you are happy with the result. My final output looks like **Fig. 6.14**.

FIG 6.14 Finished dirtied, layered texture.

Updating the Texture

Step 29: In Photoshop, save the file (File > Save). Remember this will save the raw Photoshop version in the images folder.

Step 30: Hide the UV Snapshot layer and save out the jpg version to the sourceimages folder (again using File > Save for Web and Devices). Be sure to overwrite the old version.

Step 31: Back in Maya, open the Hypershade and graph the Wall_Mat. Do this by selecting Wall_Mat in the Materials tab and selecting Graph > Input and Output Connections (**Fig. 6.15**).

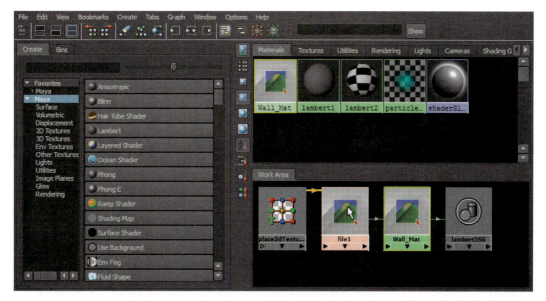

Step 32: Double-click on the file1 node. This will open the attributes of this node in the Attribute Editor.

FIG 6.15 Graphing the input and output connections of the Wall_Mat.

Why?

This file1 is the node that contains the color texture – the texture we have been working. This is the quickest way to access this node – which we need to in order to update the texture.

Step 33: In the Attribute Editor, have Maya go ahead and recheck the texture file by clicking the Reload button (**Fig. 6.16**).

FIG 6.16 Updated texture within Maya.

Step 34: Adjust, add, or remove elements to taste. Bouncing back and forth between Maya and Photoshop will allow the space to become increasingly refined until you get just the look you're after.

Expanding the Concepts

Those are the core ideas for the color maps of most architectural efforts. Go ahead and use these ideas to create the color maps for the rest of the room.

Step 35: Create materials and custom textures for the rest of the elements in this room (**Fig. 6.17**). Leave off the glass of the windows for now – we'll get to that in a bit.

FIG 6.17 Finished color textures for the entire room.

Ambient Occlusion for Texturing

Ambient Occlusion (AO) – for our purposes – is the concept of ambient lighting being occluded (or left out) of certain areas. AO has only recently begun to really assert itself into the 3D artist's consciousness as the computing power to calculate it has just in the last few years become possible. The way I like to think of AO is visual dirt that collects in corners.

AO can be calculated at render time, but will quickly add significantly to the time it takes to render a scene – which (for animation sake) can add many hours to rendering time. In a game situation, while AO is available, it is often splotchy and also takes a toll on real-time rendering times as well.

Luckily, AO can be "baked" into a texture. Basically, the core concept is to have the rendering engine calculate what the AO would be and output that to an image. Then, we'll use that image and lay it down as a layer on our textures

and get a real-time result that will give a scene dirt and dimension without additional rendering horsepower being spent.

Here's the process: we'll create a new type of surface shader that will include directions for Maya to render AO. Then using Maya's Mental Ray engine, we'll render objects using the AO and have Maya write that AO darkness to an image. Then, we'll use that image in Photoshop to apply it permanently to our texture.

Because we're using Mental Ray, if you have not activated this rendering engine with your Maya install you will need to do so. It's pretty quick and easy, just go to Windows > Settings/Preferences > Plugins Manager . . . There, look for the plugin called Mayatomr.mll (that's Maya to Mental Ray) and click both Loaded and Auto Load check boxes. Then click Close.

> Step 36: In Maya, save the scene. We're about to mess a lot of things up, and it will be important that you have this one saved.
>
> Step 37: Use File > Save As . . . to save a copy of the scene as ETM_AO_Pass (or something like that).

Why?

This is a safety precaution. We're about to change a bunch of materials and want to make sure that the version in which we have all of our basic materials created is not lost. By saving and then saving a new version of the file, we help protect against accidental overwrites.

> Step 38: Create a new surface shader. Do this in the Hypershade by selecting Create > Materials > Surface Shader.
>
> Step 39: Create an AO texture node. Again, in the Hypershade, choose Create > Mental Ray Textures > mib_amb_occlusion.

Tips and Tricks

Notice that we are creating materials and textures by using the drop down menus. It turns out this can also be done via the Create area lists and buttons. Using the drop down menu in the Hypershade just makes it easier to follow along within a tutorial.

> Step 40: Connect these two new nodes in the Work Area. To do this, Cntrl-middle-mouse drag from the bottom right arrow of the AO (mib_amb_occlusion1) node to the bottom left arrow of the surfaceShader1 node (**Fig. 6.18**). This connects the output of the AO node to the input of the surface shader node. A green arrow will appear showing the connection.

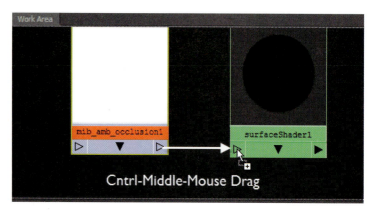

FIG 6.18 Connecting the AO to the surface shader.

Cntrl-Middle-Mouse Drag

Why?

This sort of connecting nodes is what the Hypershade is really good at. In fact, any nodes (like color textures and materials) can be connected here in this sort of way. The biggest issue to keep in mind is Maya has lots of freaky ways to connect these nodes (like Cntrl-middle-mouse drag); and it sometimes takes a bit of getting used to (and even experimenting) to get the nodes connected like you want.

Step 41: Adjust the AO node. Double-click the mib_amb_occlusion1 node in the Hypershade, and then in the Attribute Editor change the Samples setting to 256. Additionally, change the Max Distance setting to 50 and the Falloff to 1.

Why?

The number of samples will determine how smooth the final AO pass appears. Sometimes a rougher AO pass (with fewer samples) is a stylistic choice, and sometimes you want to leave this low for early rendering passes. For now though, since this is a simple scene without too many polygons, we can turn up the number of samples from the start.

The other numbers are the results of some trial and error. They have to do with how far out the AO looks for other surfaces when it's checking for corners and how far out to draw the dark spots. Part of the weirdness of tutorials is somehow these numbers seem to appear instantly – but the reality is I tweaked them up and down until I found the numbers I liked.

Tips and Tricks

If you're using your own scene, you may need to tweak these values as they are based upon the size of the room.

Step 42: Change the render settings to render with Mental Ray. Go to Window > Rendering Editors > Render Settings. Change the Render Using setting to Mental Ray. Click the Quality Tab and change the Quality Presets to Production. Click Close.

Why?

Our AO node only works with Mental Ray as the rendering engine.

Step 43: Apply the new surface shader to the wall shape by middle-mouse-dragging it from the Hypershade to the object. Repeat this for any of the other objects in the room (including the window panes – which probably don't have a material yet). This will turn everything black. You may want to swap to wireframe node (hit 4 on the keyboard) to be able to make out where you are in the space.

Step 44: Render. To do this, choose Rendering|Render > Render Current Frame. The Render View window will open, and Maya and your computer will chug away to draw an image that finally will look similar to **Fig. 6.19**.

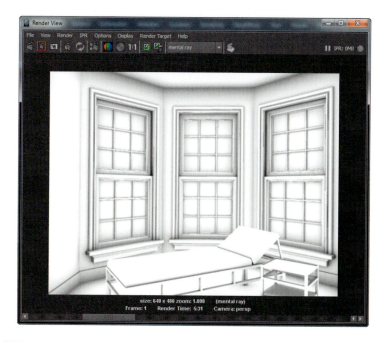

FIG 6.19 Rendering results of the surface shader using AO.

Why?

Pretty strange, eh? Suddenly, the space looks like a ghostly clean hospital room. What's interesting there though is that any place where two surfaces come together into a corner, there is darkness painted in. Now, we just need to capture that in our textures.

Baking the AO

Baking can mean a few things in 3D animation. Animation can be baked, lighting can be baked, and AO can be baked. The core idea to take something that is computationally heavy and reduce it down to a smaller data set that becomes an easy to compute attribute in Maya. So for animation, baking would take the computationally heavy inverse kinematics calculations and convert this to simple rotation keyframes for joints. For AO, this means calculating the AO and painting the AO onto the texture.

Baking is fairly easy, but does take a while to compute. When rendering a scene, Maya only has to draw what the camera sees. But in baking, Maya is computing every polygon of a surface. This can make testing and tweaking settings pretty rough and slow, but usually the increase in rendering time – or the visual impact in our case – makes the time spent here worthwhile.

Step 42: Bake the AO with a test pass. To bake objects, select them (in this case select all the objects in the scene by marqueeing around them), and then choose Rendering|Lighting/Shading > Batch Bake (mental ray) (Options). Here, adjust the following settings – Bake To: Texture, Bake Optimization: Multiple Objects, and click the Use Bake Set Override checkbox. This will make a lot of other options active in the lower sections. Change the following: Color Mode: Occlusion, Occlusion Rays: 16, Occlusion Falloff: 10. X Resolution: 1024, Y Resolution: 1024. Click Convert and Close and go take a break.

> ### Why?
>
> Most of the settings here are self-explanatory. We are baking an Occlusion pass with a very low number of rays (16) to get a rough idea of whether our falloff (10) is a good one. We are baking to a tiff that is 1024 × 1024. Some of your textures may be bigger or smaller than that (my walls are 2048 × 2048). But since this is just a darkening corner layer, a 1024 × 1024 map can be used and scaled up without much degradation in final output.

Step 43: Tweak if needed and rebake. Take a look at the output, and if the dark spots are to your liking, undo (Cntrl-z) and rebake with higher quality settings. Do this by turning up the Occusion Rays setting to 256 and again hitting Convert and Close. If the darkened regions are too far or two narrow, adjust the Occlusion Falloff settings, and then rebake with the low Occlusion Rays (16) setting. The final results will look something like **Fig. 6.20**.

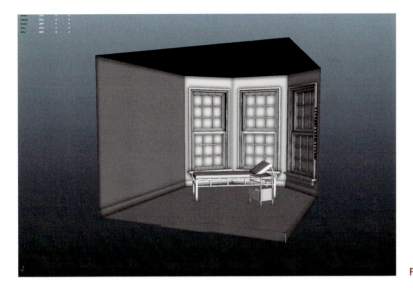

FIG 6.20 Baked AO pass.

Step 44: Track down the baked textures (**Fig. 6.21**). They will be within your project file in the path: Escaping the Madness/renderData/mentalray/lightMap. Open these files in Photoshop.

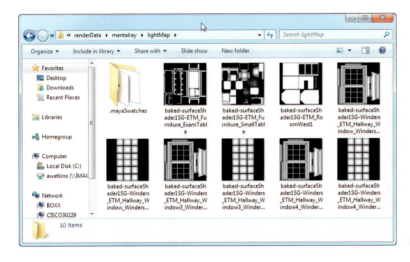

FIG 6.21 AO-baked textures.

Why?

Since we have well laid out UVs (that don't overlap), Maya has a clear place to paint the AO to. These baked textures have horrific names, but don't worry, we're soon to simply copy and paste them into our extant textures.

Step 45: Apply the AO pass to the color textures in Photoshop. To do this, start with the baked texture and Select > Select All. Copy it (Edit > Copy), then open the raw version of your textures (the base color), and paste it

(Edit > Paste). Make sure this new layer is labeled AO Pass and make sure it is the top layer – but still beneath the UV Snapshot layer. Change the Blending Mode to Multiply (**Fig. 6.22**).

FIG 6.22 Applying the AO pass to a texture. The image on the left is the base color texture and the image on the right has the AO layer applied.

Why?

Makes a quick difference, eh? Multiply Blending will use the AO Layer's dark parts to darken the layers beneath it, but essentially ignore the white parts. The net result will be a darkening of all the corners of the textured form.

Step 46: Save out the AO+color version (Save For Web & Devices) and replace the old version of the texture. Back in Maya, Open the original (non-AO) version of the scene. Reload this new texture (**Fig. 6.23**).

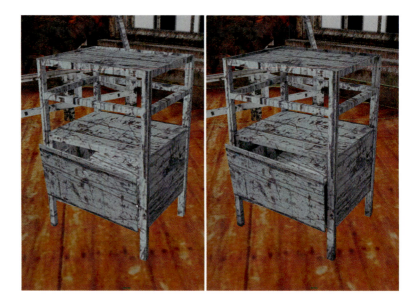

FIG 6.23 Before and after of a texture with the AO-baked layer applied.

Step 47: Repeat for all other objects in the room (**Fig. 6.24**).

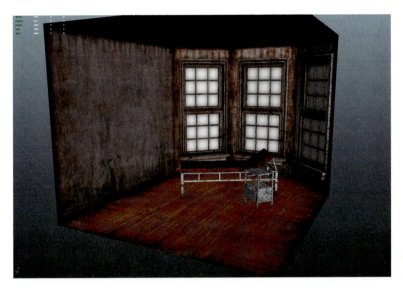

FIG 6.24 All other objects with AO pass applied.

> **Why?**
>
> A lot of the dirt in corners were created and applied during the texturing process. However, this AO pass always pushes things a bit further. It grounds objects so they look like they are really sitting on the ground and helps to give other objects increased visual volume and form definition.

Beyond Color

So far we've built some pretty sophisticated color maps to define the surfaces of the shapes in our room. But materials in Maya can be more than just color – so very much more.

As you've probably guessed from the multitude of options available in the Attribute Editor whenever dealing with a material, there are lots of other attributes that can be defined. Covering all of them is outside of the scope of this book, but in the coming steps, we will look at two of them that are particularly useful: Transparency and Bump Mapping.

Transparency

Transparency maps can do some very sophisticated things. When any material is selected and opened in the Attribute Editor, the entire material can be made transparent by simply sliding the Transparency slider to the right. However, this has limited efficacy in our situations as the windows in that dirty of a room should have collected some grime on the window panes as well. They're old which should mean that the panes of glass are neither clean nor totally transparent. With a transparency texture map, we can define what parts of the window panes are transparent, which are completely opaque and what is somewhere in between.

Now, there are several ways to approach transparency maps. Maya works pretty well with Photoshop documents and can read alpha channels and other built in attributes of a .psd file so that one file can define lots of attributes of a material. However, for illustration sake on how materials are put together, in this tutorial, we are going to create a separate color and transparency maps and tie them in as discreet chains of nodes.

But first, we need to create a quick color texture for the window panes. For this, we'll use a slightly different method than we have in the past. Namely, we'll be using the AO pass, as the foundation for our texture. The reason for this has to do with the topology of the window glass pane.

When I modeled the panes, they were built with single polygon planes and put within the window shape. The benefit is that it was a quick solution to have an object for the glass; the drawback is that it would be very tough to try and pick out where each of the transoms and mullions (the wood between the panes) go, and where to place the dirt or other collected grime.

Luckily, the AO pass of these panes (shown in **Fig. 6.25**) shows us exactly where the individual panes would be. This provides us a great template upon which to build our color map.

A basic idea to remember about these separate transparency maps is that Maya will interpret black pixels as transparent and white pixels as opaque. Gray pixels will render as semi-transparent. With this paradigm in mind, we can create a custom map that defines exactly what's opaque and what is transparent.

FIG 6.25 AO pass that provides important information on where individual panes of glass would be.

Step 48: Open the baked AO texture and then grab some grime materials off of CG Textures and lay in the grime that would be on the individual window panes. Do this in Photoshop (of course) and be sure to keep these grime layers un-flattened (**Fig. 6.26**). Save this to the images folder as `ETM_WindowPanesRaw.psd`.

FIG **6.26** Rough color map.

Step 49: Use File > Save for Web & Devices to save out a `ETM_WindowPanesColor.jpg` image to the sourceimages folder.
Step 50: In Maya, create a new ETM_WindowsPane_Mat material and use your newly outputted file to define the color (**Fig. 6.27**).

FIG **6.27** Results of flat color map.

Why?

Well, it's creepy alright, but it's too creepy – and there's no transparency. We really need to have some of that window be at least a little bit transparent. Thus, the need to create a custom transparency map.

Step 51: Use Adjustment Layers to create in inversed black and white version of the color map. Do this within Photoshop by going to Layer > New Adjustment Layer > Black & White. Move this layer to the top of your layers in the Layers Palette. Then, go to Layer > New Adjustment Layer > Invert. Again, make sure this is the top of the layers. The results will be a creepy but effective **Fig. 6.28**. Save the file (the raw version) and then use File > Save for Web & Devices and save out a new `ETM_WindowsPaneTransparency.jpg` to the sourceimages folder.

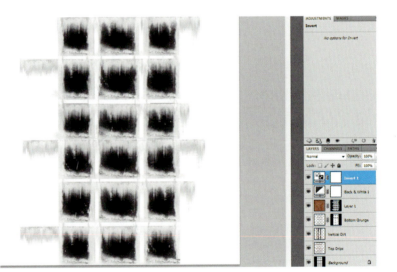

FIG 6.28 Results of two adjustment layers.

Why?

Adjustment Layers are non-destructive methods to getting broad adjustments to your Photoshop file. For us, this is a perfect use of them as it keeps our color versions within the raw version of the texture. That way, if we decide to change anything, we still have the color information and can simply turn off the Adjustment Layers when it's time to save out the .jpg color texture for Maya and then reactivate them for a new transparency texture.

Step 52: Implement this new transparency map. Do this in Maya.
Open the Hypershade and double-click the ETM_WindowsPane_Mat
icon in the Materials tab to open the material in the Attribute Editor.
Click the checker button at the end of the Transparency line and choose
File from the Create Render Node window. Then, populate that new file
node (again in the Attribute Editor) with our newly exported
ETM_WindowsPaneTransparency.jpg file.

Why?

It seems like we should be set. In fact if you take a look at the material
in the Hypershade it should look something like **Fig. 6.29** and indicates
that there is indeed transparency on the material. But yet, in the View
Panel, everything looks the same . . . what's up? Well, Maya is trying
to make sure that the scene draws as quickly as possible in the View
Panels so as to no slow the creation process down. Because of this, it
often ignores certain attributes of materials. We need to tell Maya to
draw more than that.

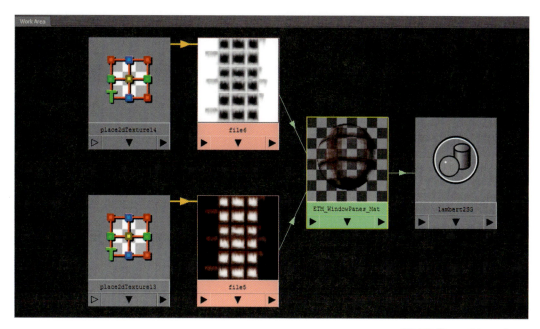

FIG 6.29 The material network
using a color map and a separate
transparency map.

Step 53: Tell Maya to draw the transparency channel. There are a couple of
ways to do this. The quickest (but most intensive on your video card) is to
choose in the persp View Panel Renderer > Viewport 2.0 (**Fig. 6.30**).

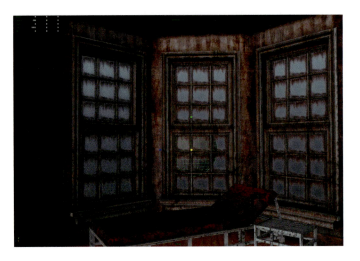

FIG 6.30 Using Viewport 2.0 to see transparency. Note the new sphere is just to show that the panes are indeed transparent.

Tips and Tricks

An alternate way to do this is per material and done in the Attribute Editor. Look for the Hardware Texturing section and change the Textured Channel setting to Combined Textures. The results will be more blurry, but will be easier on the video card. If you have a small or old video card, this is probably the best choice for you.

Bump Mapping

Bump mapping is an incredibly useful tool to make geometry look like it has more detail than it really has. Traditionally, bump textures were gray scale images in which Maya interpreted white pixels as raised, and black pixels as recessed. More recently, normal maps have come into vogue which do much the same thing but allow for visual distortion in more than just the straight direction off the face's normal.

Normal maps can be a bit more opaque to work with, but the results are undeniably better. The problem is that you really can't paint a normal map directly, but there are some excellent tools to create very nice normal maps from a color map that produces some very nice results.

My favorite is a tool called Crazy Bump (www.CrazyBump.com). It's a fairly inexpensive tool ($49 for students, $99 for personal use, and $299 for professional, and includes a free trial) that is really the most painless way to generate and control normal maps that I have seen. If you don't have it, take a moment to download and install it (it's cross platform).

We aren't going to spend a lot of time here learning how to use Crazy Bump (this is a Maya book after all), but don't be intimidated. It's a quick tool to use and the sliders make for quick and easy adjustments to dial in the look you're after . . . the next few steps are a very quick overview (**Fig. 6.31**).

FIG 6.31 Crazy Bump introduction interface.

Step 54: Open a color map in Crazy Bump to convert to a normal map. Using Crazy Bump, click the Open button (labeled as "Click this button to begin"). In the next window, click the Open Photograph from File button and navigate to any of the color textures in your sourceimages folder (I'll be using the color map from the gurney).

Step 55: In the next window, take your best guess as to which looks better. Often it doesn't matter which you choose (as this can be adjusted later), but basically the idea is to determine in this dialog whether to raise lighter pixels or lower them.

Step 56: Dial the detail recognition in to get the look you're after. Figure 6.32 shows my best guesses on the first pass. Remember, we can come back and edit these setting later, for now, give it a close look and best guess. I find that most every color texture I convert to a normal map requires at least one or two trips back into Crazy Bump to get just right.

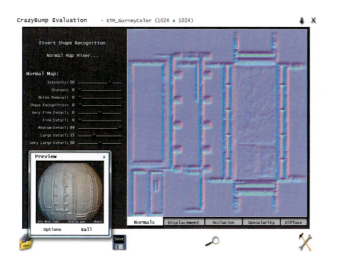

FIG 6.32 Dialing in the settings for the normal map.

Step 57: Save to a file. When ready, click the Save button and choose Save Normals to File . . . from the popup menu. Save the file as ETM_GurneyNormals in the sourceimages folder. Don't close Crazy Bump.

Step 58: Apply the new normals map to the Bump Mapping channel for your material in Maya. To do this, select the material in the Hypershade by double-clicking it. Then in the Attribute Editor, apply the normals map the same way we did the color or transparency maps. With Viewport 2.0 active, the results should be immediate (**Fig. 6.33**).

FIG 6.33 Results of Crazy Bump.

Step 59: Evaluate, adjust, reload. Evaluate visually in Maya. In Crazy Bump, adjust the settings and resave over the same normal texture. Back in Maya, reload the Bump Mapping file, repeat.

Step 60: Repeat for other objects in the room (**Fig. 6.34**).

FIG 6.34 Finished normal maps for the room.

Tips and Tricks

It's sometimes difficult to tell from far away like this, what the final result in the level will be. It's even more complex because the results will change quite a bit once the scene is lit. Generally though, gentler is better – especially when it comes to the Intensity setting. The default is a very high 50, when often closer to 5 will yield the most believable results.

Conclusion

And with that we will leave the texturing part of our room. There still are some very important parts of shading our scene that we haven't talked about – most importantly adjusting the shader type. So far, we have created only Lambert materials, which are always matte materials without any gloss. There are plenty of other types of materials, and some that will be of great use to us in this scene. But most of these other shader types are very reliant on lighting, so we will wait to tweak those in the lighting chapter.

So let's use the techniques used thus far to work on an organic shape.

Tutorial 6.2 Textures for Organic Forms

In the last tutorial, we assembled textures almost exclusively through image manipulation. We started with textures, and then mixed, matched, and blended them to get a new and unique look that was more than any of the individual source textures.

In this chapter, we will be texturing the little alien we began in past tutorials. This is the work of Jake Green (www.JakeGreenAnimation.com) and he has a much more illustrative style. In this tutorial, we will often be utilizing the techniques covered in the last chapter, but generally, the techniques will be much more illustrative here; we will literally be painting many of the textures in to indicate surface attributes (like specular highlights, and AO darkening). This direct manipulation and painting of textures can really be a fun way to get just the look you're after without being totally beholden to the textures you can find online or take photographs of.

Preparation

Step 1: Make sure your project is set, the Alien file is open and that you have a snapshot of the alien's UVs. If you've been following along, use your own or if you'd like to match the screenshots of this tutorial exactly, the starting and finishing state of this character are available on the support website (http://www.GettingStartedIn3D.com).

Step 2: Open the UV Snapshot in Photoshop. If you are using the tutorial files, this is the file GameCharacterOutUV.iff in the images folder. Save it as `GameCharacterRaw.psd` back into the images folder.

Step 3: Prepare the image so the UVs can be clearly seen. Cntrl-click on the Layer 0 and choose Edit > Stroke. Enter 3 for the Width and change the color to white. Create a new layer and fill it with black. Label the UVs as `UV Snapshot` and the black layer as `Background`.

Why?

Yes, the colors here are a little different than the last time. It's largely personal preference – some people like the white UV lines, others black, and others change them depending on the planned texture beneath it. In this case, the screenshots make use of white UVs on top of a black image, so we'll use that here to match. The key will be to always make sure that the Background is the bottom most layer and the UV Snapshot layer is the top most.

Step 4: Lay in the base green for the screen. Do this by creating a new layer and then choose Edit > Fill and pick a nice alien-esque green (**Fig. 6.35**).

FIG 6.35 Laying in the green basis of the skin.

Step 5: Break up the green field with blended layers. Do this by first finding a nice noisy texture from CG Textures (or elsewhere). Download it, copy and paste it into the GameCharacterRaw file. Be sure this new layer is on top of the green skin base layer and change the Blend Mode to Soft Light (or to taste – there are various Blend Modes that could be used here (**Fig. 6.36**)).

FIG 6.36 Breaking up the green with a noise layer using Soft Light for blending.

Step 6: Limit the green texture to the face. We'll do this with a Layer Mask. Start by using the Lasso Tool to roughly select the UV faces that represent the aliens face. Then, in the Layers Palette, click the Add Layer Mask button to the green layer. The results should look like **Fig. 6.37**.

Layer 21

FIG 6.37 The results of a Layer Mask (the inset shows what the layer should appear like in the Layers Palette).

Why?

Don't' worry about all the brown. For now, it will provide a nice way to break up the other textures we are going to lay down. The core idea here is to work non-destructively and Layer Masks are a great way to do this. From here on out, you can select the Layer Mask and when you paint with black, it will mask out the area, and return it when you paint with white.

Step 7: Use the Layer Mask to return the green to other parts of the UVs where skin should be showing. A nice way to do this quickly but effectively is to use the Lasso to roughly select around an area of UV faces and then use the paint brush to paint the Layer Mask in white . . . the green skin will reappear (**Fig. 6.38**).

FIG 6.38 Painting back in skin areas by painting on the Layer Mask.

Step 8: Paint in other head details. The method here is to make sure to create a new layer for each big color change (like the brown ridges across the head) and make sure the layer is beneath the noise layer and above the skin layer. Then paint the desired color (**Fig. 6.39**).

FIG 6.39 Painting new color layers that are still beneath the noise material.

Tips and Tricks

Sometimes when painting specific areas like this, it can really help to first select the area using the Lasso Tool – or the Polygonal Lasso Tool as it will keep the texture clean.

Faux AO

In the last tutorial, we looked at having Maya calculate AO for us that we then placed into the texture. There are, however, other ways to accomplish this same look. Jake frequently uses an interesting form of fake AO that produces a quick and effective result without the need for baking.

Step 9: Add AO to the outside of the ridges. Do this by selecting the layer(s) that contain the brown ridges. Choose Layer > Layer Styles > Drop Shadow . . . Change the Distance setting to 0, turn the Spread up (try around 20%), and adjust the opacity to taste (**Fig. 6.40**). Do not click OK yet . . . we need to activate other Layer Styles yet.

FIG 6.40 Settings for the Drop Shadow Layer Style.

Why?

This Drop Shadow without an offset will make a sort of halo of diffuse black around the brown stripes. This will simulate AO on the head at the edge where the ridges rise off the head.

Step 10: Activate Inner Shadow to add faux AO to the brown areas. The suggested settings are shown in **Fig. 6.41**.

FIG 6.41 Adding faux AO to the inside of the brown stripes.

Step 11: Activate Inner Glow. The suggested settings are in **Fig. 6.42**.

Step 12: Paint in additional highlights and faux AO. Do this by creating a new layer and then using the Paint Brush tool with very low opacity/ flow (set these at the very top of the Photoshop interface), gently brush in additional details to represent places where the light would be caught (i.e., top of the brows) or AO would appear (**Fig. 6.43**).

FIG 6.42 Further sculpting with painting using Layer Styles.

FIG 6.43 Painting in AO and highlights.

Tips and Tricks

Be patient. It's much better to paint in too delicately in the early passes with very low opacity painting than to make the character look clownish with too heavy handed light and dark strokes. Remember, the character shouldn't look painted.

Step 13: Repeat steps 8–12 for areas like the hand. Remember the trick of the fake AO using Layer Styles. The final results should look like **Fig. 6.44**.

FIG 6.44 Laying out hands with additional colors and faux AO.

Textures as Painting Basis

Going back to the techniques examined in the last tutorial, let's use some textures download from CG Textures (or taken yourself) with Layer Masks to create the texture of several parts of the costume.

Step 14: Use the texture/Layer Mask technique with a metallic texture for the chest and back plates (**Fig. 6.45**). Remember the basic idea here is to copy and paste into the scene a base texture, then use the Lasso Tool to select around the area of the UV faces this texture should be applied to and click the Add Layer Mask button in the Layers palette.

FIG 6.45 Chest and back plate.

Step 15: Continue for things like the shirt. Use a base texture with a Layer Mask to keep the texture confined. Then, go in and gently paint in highlights and AO as desired (**Fig. 6.46**).

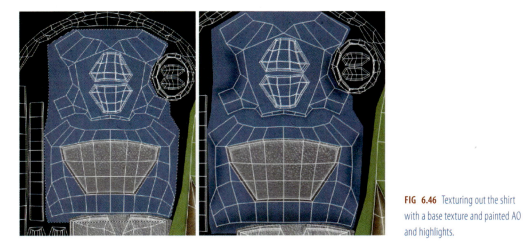

FIG 6.46 Texturing out the shirt with a base texture and painted AO and highlights.

Step 16: Repeat for boots and belts. **Figures 6.47–6.50** show screenshots along the way. All are using the same techniques laid out in this tutorial.

FIG 6.47 Start of the boots.

FIG 6.48 Finished boots with highlights.

FIG 6.49 Cummerbund and belt.

FIG 6.50 Pants. Notice the painted highlights, shadows, and folds.

Step 16: Save the multi-layered image (**Fig. 6.51**). Remember this is probably saved in your images folder.

FIG 6.51 Final multi-layered textures.

Step 17: Use File > Save for Web & Devices to save out a `GameCharacterColor.jpg` version of the texture to the sourceimages folder.

Implementing into Maya

Step 18: Back in Maya, create a new Lambert material for the alien. This time, try right-clicking on the alien and choosing Assign New Material . . . This will apply the new material to the alien and should open the material in the Attribute Editor.

Step 19: Name the material `Alien_Mat`.

Step 20: Define the color channel to use the newly saved GameCharacterColor.jpg (**Fig. 6.52**).

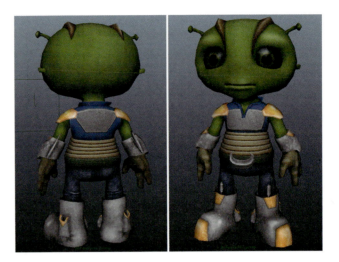

FIG. 6.52 Finished alien texture.

Conclusion

There is still work to be done on the alien. The eyes need to be completed (hint – try pulling the eyes off the character style sheet for a start), and there is more history that could be done. Think of ways that you can tell a story with the textures that the little alien has on his clothes, skin, and armor.

But the techniques are all laid out now, so you have the tools at your disposal to begin to realize your vision of the narrative.

Wrapping Up and Moving On

Texturing is an important part of a 3D project. It's critical to beginning to make spaces look like someone has been in it and making characters look like they lived before we saw them. But texturing is at its most effective when it ties into its sister techniques – lighting.

Any surface attribute on a texture is heavily dependent on the light that is shown upon it. Great modeling and texturing work can be completely ruined with shoddy lighting. And even mediocre modeling can start to look like a million bucks with a clever lighting scheme. In the next chapter, we will start looking at Maya's lighting and rendering mechanisms. We'll explore the actual instruments and then look at how to use them in our set. Finally, we will look at some character lighting strategies.

Homework

1. Finish the eyeballs of alien.
2. Add further narrative to the alien by altering his texture to let us know where the alien comes from and what he does for a living.
3. Texture the high poly mesh given as challenges in past chapters.
4. Use the techniques covered in this chapter to finish out the textures for Escaping the Madness. Be sure to give each room a clear purpose.

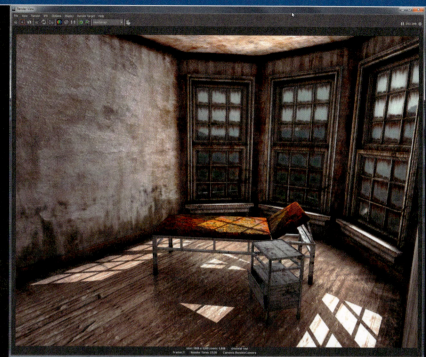

Lighting and Rendering

How to cover issues of texture, lighting, and rendering is always a tough pedagogical nut to crack. All three are intricately tied together. A red apple, when lit with green light, will render gray/brown. Small green highlights in a texture will absolutely glow if the scene is lit with that same green light. But none of these relationships will be well understood until the setup is rendered. Texturing, lighting, and rendering must work hand in hand with a very fluid two-way work flow in order to be effective.

In the last chapter, we worked on the basics of texturing. We created Lambert shaders that we were able to use images to define the color, transparency, and bump on. In this chapter, we will continue to explore shader creation a bit as we look at different material types that will exhibit different characteristics.

But the real focus will be on Maya's lighting scheme. We are going to talk through the basic ideas of Maya's lighting instruments and the core editable characteristics of those instruments. After this, we'll look at how lighting works with Maya Software and Mental Ray rendering engines. Once we understand the differences here, we can start lighting our room and render with a couple of different lighting schemes and rendering solutions. Finally, we'll look at lighting a character to best show off the character's form.

Tips and Tricks

A quick note about nomenclature. "Light" can mean a lot of different things. It can be what is given off by a light source. It can mean the light source itself. It can be a verb. For this reason, we'll be using an old theater device in which the actual light source is always referred to as the "lighting instrument" – or just "instrument." When the word "light" is used, we'll be referring to the emissions of that instrument.

Maya's Lighting Instruments

The lighting instruments in Maya, in many ways, mimic the way lighting sources work in the real world, but usually not exactly. The best way to illustrate this is through a mini-tutorial in which we will place lighting instruments and then start tweaking settings to see how the things work.

But first a few general notes. When a light is created in Maya, a little gizmo will show up in the scene to represent the lighting instrument (**Fig. 7.1**). This gizmo gives a visual hint as to which type of lighting instrument has been placed. In all cases, the gizmo itself can be moved and rotated using Maya's standard Move and Rotate Tools. In some cases (like the Directional Light and the Spot Light (among others)), the gizmo can also be scaled. Although remember that scaling these gizmos doesn't always actually change the light that the instrument is emitting, it's largely a cosmetic tool to make the gizmos easier to see.

FIG 7.1 A point light gizmo immediately after creation.

The next thing to note is that often light gizmos will make use of additional manipulator handles that can greatly assist in aiming instruments. We haven't used the Show Manipulator Tool much so far, but it is always available in the Tool Box, and this tool is the ninth icon down (just beneath

the Soft Modification Tool). With some lighting instruments (like the Spot Light shown in **Fig. 7.2**), when the Show Manipulator Tool is activated, two sets of manipulator handles will appear. One allows for the movement of the lighting instrument itself, and the second moves the target that the instrument is pointed at. Moving this second manipulator target can be a great way to quickly get the instrument pointing in the direction it should be.

FIG 7.2 Second set of manipulator handles made visible for the Spotlight when the Show Manipulator Handles Tool is activated.

Lastly, note that in Fig. 7.2, there is a little blue icon beneath the light gizmo. This is actually a switch that when clicked will provide additional handles on the light gizmo that allows for certain attributes to be tweaked. Each time it's clicked, a different set of attributes for the instrument will be shown. Most of these attributes can be adjusted within the Attribute Editor (which is how we'll do it); however, some artists find that they prefer to work with the visual representations this allows for.

Tutorial 7.1 Lighting Instrument Exploration

In this tutorial, we won't have any finished product to show; but it will be important to see how the different lighting instruments function in Maya. If you'd like to run through it with me, then there are benefits to working with the lights. However, you could also just read along and look at the images for a good understanding of how the different instruments work.

Step 1: Set up a quick scene to illustrate the lighting (**Fig. 7.3**). Basically, it's a plane, the size of the default grid, and some cylinders placed in a circle. The cylinders are all sitting on the plane.

FIG 7.3 Lighting setup.

Step 2: Establish render settings to use Maya Software. Choose Window > Rendering Editors > Render Settings. There, make sure Render using: Maya Software. Click on the Maya Software tab and change Quality: Production. Click the Close button.

> **Why?**
>
> For our purposes here, Maya Software is going to be the fastest output – which will be great for our exploration purposes here. Setting the Quality to Production will change a whole lot of settings automatically – which will simplify things for now, but give us good-looking output to make a good comparison.

Point Light

Point Lights are like suspended light bulbs. The light that comes from these instruments come from a single point in space and shoots out in all directions. They can be a great way to get started with a lighting scheme as they throw a lot of light all at once.

Step 3: Create and position a Point Light. To do this, choose Create > Lights > Point Light. This will create the instrument at 0, 0, 0 in world space. Use the Move Tool to move it up in Y to match **Fig. 7.4** (approximately).

FIG 7.4 Positioned Point Light.

Step 4: Render the scene. **Figure 7.5** shows the mouse over the Render the Current Frame button and the results of the render.

FIG 7.5 First rendering using default settings for a Point Light.

Depth Map Shadows

Depth Map Shadows are the simplest and quickest rendering of shadows. By default, Maya doesn't render any shadows – as it's always looking, by default, to provide the quickest rendering solution. Depth Map Shadows, essentially, are maps that paint where the light is blocked.

Within Maya Software's renderings, light from a source will shoot out as a linear ray from the instrument and die when it hits a surface. Areas behind the struck surface receive none of the light from this source. Depth Map Shadows are simply black textures that lay across surfaces. The benefit to these are that they render very fast (in comparison to other types of shadows like Raytraced); the drawback is that they aren't very realistic right out of the box. They are usually unnecessarily stark and can be blocky if the resolution of the shadow map is too low. Often, with a little tweaking though, some of these drawbacks can be overcome.

Step 5: Activate Depth Map Shadows. To do this, select the Point Light and look to the Attribute Editor (remember Cntrl + A will toggle the Attribute Editor if it is not open). Look for the Shadows section and expand it. Click the Use Depth Map Shadows checkbox. Render (**Fig. 7.6**).

FIG 7.6 Same light with shadows
activated. Note this is rendered at a
higher resolution for print purposes.

Step 6: Soften the shadow maps. Do this still within the Attribute Editor.
Still within the Shadows section of the Point Light, change the Filter Size
to 6. Render (Fig. 7.7).

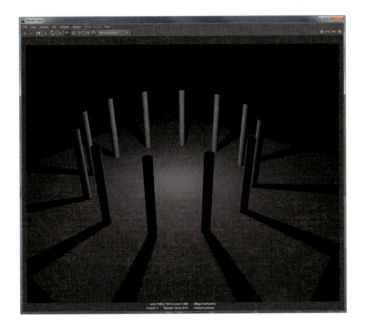

FIG 7.7 Using a Filter Size of 6
makes for much softer shadows.

Why?

In this situation, think of "Filter" just like the Gaussian Blur in Photoshop. It takes the shadow map and runs a blur filter over it which softens the resulting shadows.

Decay Rate

Decay Rate refers to how the light falls off as it gets farther from the source. Step into your back yard and shine a flashlight at the moon, and it won't get brighter, the light simply spreads and diffuses before it ever reaches the moon.

In Maya, we can tell light to behave in much the same way. There are several Decay Rate settings for Maya – some more realistic than others. They are Linear, Quadratic, and Cubic. Linear is the fastest rendering and Cubic is the slowest. Cubic is the most like how real light works, but it is often difficult to see the difference in a rendering – so I almost always use Linear.

> Step 7: Activate a Linear Decay Rate for the instrument. This is still done in the Attribute Editor up near the top in the Point Light Attribute area. Render (**Fig. 7.8**).

FIG 7.8 Rendering with Decay Rate of Linear.

Why?

Pretty dark, huh? Now that the light isn't throwing forever, it gets pretty dark in the scene. When activating the Decay Rate, it becomes important to adjust the instrument's Intensity.

> Step 8: Change the Point Light's Intensity to 5. This is still within the Attribute Editor, in the Point Light Attribute area. Render (**Fig. 7.9**).

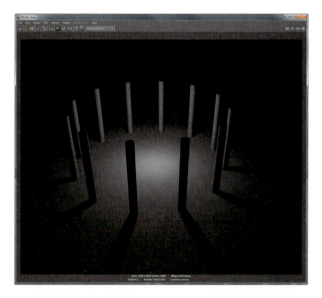

FIG 7.9 Render with Point Light using an Intensity of 5 with a Decay Rate of Linear.

Why?

As you can guess by looking at the Attribute Editor, there are still a plethora of other options that can be tweaked. But keeping with this very broad look at light types, let's move on to see some other options.

Spot Light

Spot Lights are instruments that also emit from a single source, but instead of throwing light in every direction, these instruments throw light in a cone along the direction it is pointing. This means that the light rays from this light type splay outward from a central point.

Step 9: Change the light's Type to Spot Light. Do this within the Attribute Editor (**Fig. 7.10**).

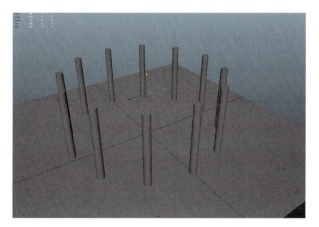

FIG 7.10 A Spot Light.

Tips and Tricks

Note that in this case, we simply changed the type of light – this means we keep some of the other settings we've already set (Shadows, etc. – although notice that Decay Rate will be reset to None). However, remember that a Spot Light can also be created from scratch via Create > Lights > Spot Light.

Step 10: Change the persp View Panel to display in Viewport 2.0. Do this via the Renderer pull-down menu.
Step 11: Change to Use All Lights. Do this by either selecting Lighting > Use All Lights within the View Panel or by letting the mouse hover over the persp View Panel and hitting 7 on the keyboard.

Why?

Both of these last two steps are aimed at providing a real-time preview of what the lighting *might* look like on render. Don't trust it – it's notoriously inaccurate, but it can still provide a good idea of things like where an instrument is actually illuminating.

One note about this Viewport 2.0 though: it's heavily reliant on the particulars of your video card. It is almost always useful when working with lights, but your screen may differ a little from my screenshots.

Step 12: Use the Rotate Tool and Move Tool to move the Spot Light up in space and aim it down toward the set (**Fig. 7.11**). Render (**Fig. 7.12**).

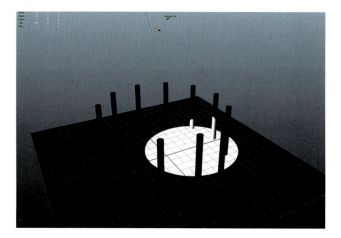

FIG 7.11 Using the Move and Rotate Tools to position and aim the instrument.

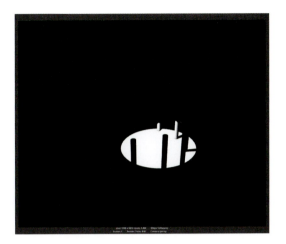

FIG 7.12 Render of the Spot Light as positioned in Fig. 7.11.

Step 13: Reactivate Linear Decay Rate and increase the Intensity to taste. Do frequent renders to get a more natural look.

Why?

Unfortunately, you will probably find that no matter what the settings are for the Intensity and Decay Rate, the results will still appear overly harsh. This is because the instrument is just too focused. Let's look at some other things to adjust for Maya's Spot Lights.

Tips and Tricks

On my machine, with my video card, the View Panel can be a little goofy when using Viewport 2.0. For some reasons, it can just stop working or drawing accurately. If this happens to you (you make a change to the lighting, and things just don't look right in the View Panel), it can essentially be reset by changing Renderer > High Quality Rendering and then back to Renderer > Viewport 2.0. Heck, you might find that the High Quality Rendering gives you a good enough preview.

Cone Angle and Penumbra Angle

Within the Attribute Editor – specific to Spot Lights are some new settings: Cone Angle and Penumbra Angle. These are meant to mimic how real-lighting instruments work. The Cone Angle is pretty intuitive; there is a visual cone on the instruments gizmo that indicates how wide the angle of the light is that emerges from the source. The Penumbra Angle might be a little more new to you.

The basics of this are that a real-theater lighting instrument actually has a series of lenses. These lenses focus the light coming from the bulb. By moving the lenses closer and farther away from one another, the light that strikes a surface will change in how crisp the edge is. Highly focused light gives razor

281

sharp edges to where the light falls off, whereas unfocused provides a gentle falloff to the edge of the light. Of course, there are times for both looks, but knowing how to dial the edge's softness up or down is important.

Step 14: For experiments sake, change the settings on the Spot Light to Intensity: 20 (this may need to be tweaked depending on your scene's size), Decay Rate: Linear, Cone Angle: 45, and Penumbra Angle: 0. Render (**Fig. 7.13**).

FIG 7.13 A 45° Cone Angle with a 0 Penumbra Angle.

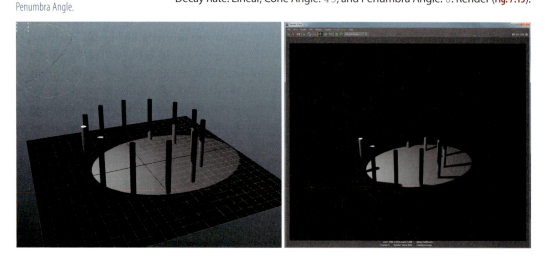

Step 15: Now, adjust the Penumbra to a non-zero value (I'm using 10). Notice in the View Panel, the edge will soften, and then when the scene is rendered, likewise the edge of the light will be soft (**Fig. 7.14**).

FIG 7.14 All the same settings but with a Penumbra Angle setting of 10.

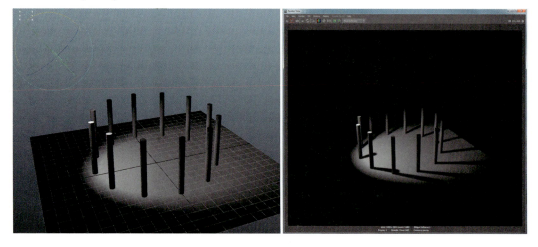

Directional Light

Directional Lights are best thought of as sunlight. What a Directional Light does is throw light infinitely far from infinitely far away (there is no Decay

setting). The light that comes off of a Directional Light comes in parallel rays (not from a single point in space like the Point Light and Spot Light).

Step 16: Change the instrument type to Directional Light. Do this in the Attribute Editor by changing the Type to Directional Light.
Step 17: Move the instrument to the center of the circle of columns (Fig. 7.15).

FIG 7.15 Moving the light to the middle of the cylinders.

Why?

This is really for some illustrative purposes. The location of the actual gizmo doesn't matter, and this will help show why.

Step 18: Take a render (Fig. 7.16).

FIG 7.16 Render of the results of a Directional Light.

Why?

Lots and lots to see here. First, notice that the Directional Light gizmo is in the center of the ring of cylinders, but that the outside of the cylinders *behind* the instrument are lit. Regardless of where the actual instrument is placed, the light still comes from infinitely far away.

Second, notice that the shadows are different than the past lights. See how the shadows are all running parallel to each other? This is because the light coming from a Directional Light is coming in parallel rays.

Third, upon a closer look, the shadows are looking a little dirty. Take a look at Fig. 7.17 and look at the highlighted areas. Now this render has the Filter setting reduced back to 1 (from the 6 your scene is probably using). But it helps show how the shadow map really does have a resolution – and a small one (512) by default. With the Spot Light, or even Point Light, this 512 resolution is spread out over a much smaller area and is harder to see the actual pixels of the map. But with a Directional Light, suddenly, the shadow map is spread out over every object in the scene and the low resolution begins to pop a bit more. So for Directional Lights – when using Depth Shadow Maps, some adjustments need to be made.

FIG 7.17 Using the default Depth Map Shadow resolution of 512, the low resolution begins to be very visible when using the Directional Light.

Step 19: Increase the Depth Map Shadow resolution to make a cleaner shadow. Do this in the Attribute Editor. First, change the Filter setting back to 1, then try turning up the Resolution setting (in the Depth Map Shadow Attribute section) to 1024 and render. Try 2048 and render. Finally, give 4096 a shot and render (Fig. 7.18).

FIG 7.18 Same Directional Light rendered using a 4096 Depth Map Shadow.

Why?

So, sure enough, the shadow has gotten crisper and cleaner – much more like what the sun would actually do. But, notice that the rendering time also increased along the way. Bigger Depth Map Shadow resolutions mean bigger chunks of data that need to be calculated, and thus the rendering time goes up. It's a balancing act (as is much of rendering) to track down what setting looks the best but doesn't kill the clock with excessive rendering times.

Area Lights

If you have experience with real-lighting instruments, Area Lights are most like light boxes. In 3D, think of Area Lights as light emitting planes – they produce a very diffuse and soft light. Area Lights definitely have a hot spot middle, and the light emerges from the center of the instrument in a conical shape. But they are much more diffuse than any of the other light types.

Step 20: Change our demo light to Type: Area Light. Reactivate Decay: Linear and change its intensity to 80. Move it to approximate **Fig. 7.19** and render.

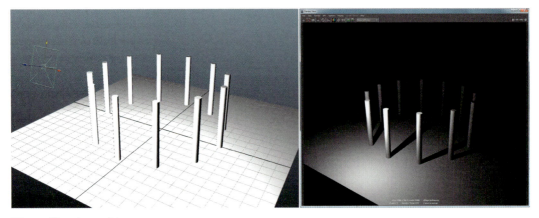

FIG 7.19 Effects of an area light.

Why?

So notice that first of all we entered a value for Intensity that was higher than the slider initially indicated we could. This is true for lots of places in Maya (you can turn the amp to "11"!), and it's needed sometimes for things like the diffuse Area Light. Notice how the light is very soft, has a falloff, and the shadows radiate out (not parallel).

Volume Lights

Volume Lights are interesting instruments. They are perhaps the easiest to control but most unrealistic instruments in the tool chest. The basic idea is this: a volume (sphere, box, cylinder, or cone) is drawn around the center of the instrument. Light from this point source emanates outward to the edges of the volume shape. No light escapes the volume.

This means that the effects of a light can be definitively seen in the View Panel, as the volume shape can be scaled up or down. The light decreases in intensity from the center point to the edge of the volume. Check out **Fig. 7.20** and see how the sphere is slightly larger than the ring of columns and how the light from this instrument stops right there.

Step 21: Change the demo light to Type: Volume Light. Change its intensity to 5. Move and Scale the instrument to the middle of the ring of cylinders and render (Fig. 7.20). Try experimenting with the size and type of volume and taking multiple renders.

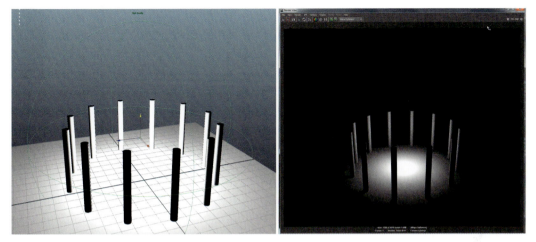

FIG 7.20 Volume Light. Illumination only takes place within the gizmo's volume shape.

Ambient Light

Ambient Light is the last light type, and we aren't going to mess with this one much. Ambient Light can be an unhealthy crutch (although it sure has its place in some Mental Ray setups (which we'll talk about)). What it does is produce light from everywhere and nowhere. Students too often look at a scene and say, "Shoot. It's too dark – my lighting setup hasn't produced enough light. I know! I'll throw an Ambient Light in there." This is *almost* always a bad idea. In real life, light comes from some place; it always has a source. Now this light bounces off of surfaces and we sometimes refer to this bounced light as "ambient," but it came from an instrument of some type (a light bulb, or the sun, or a computer screen, etc.). Because of this, it's important that if a scene is too dim, take some time to make intelligent and thoughtful choices to either mimic this bounced light or set up a rendering engine solution (Mental Ray and Final Gather for instance), which will calculate the bounced light and produce the extra ambient lighting.

Tutorial 7.2

So now let's let the rubber hit the road. Now that we've explored the lighting instruments themselves, let's take a look at them in a real-world situation.

In this tutorial, we will be lighting the room from Escaping the Madness that we have been working on. It provides some interesting challenges and opportunities. Namely, it provides a scene with a window, a wooden floor, furniture, and dirty walls. This will make for a really interestingly lit scene.

For this tutorial, we will be lighting the scene as though it is day time (day time is actually more difficult to light than night time), and this will provide us many opportunities to use quite a few lighting instrument solutions.

Step 1: Open the last available version of the room. If you'd like, you can download mine at http://www.GettingStartedin3D.com/ and download the starting file from the Tutorial & Support Files section.

Step 2: Start by creating the sun. We will assume that the windows are facing the west as the sun as in the late afternoon. Create a sunlight by creating a Directional Light (Create > Lights > Directional Light).

Step 3: Move the Directional Light, so that it is outside of the window and aim it down so that it will shine through the windows (**Fig. 7.21**). Depending on the size of your scene, you may also need to scale the Directional Light (really just scaling the gizmo that represents the instrument). A render will yield a pretty unimpressive figure (**Fig. 7.22**).

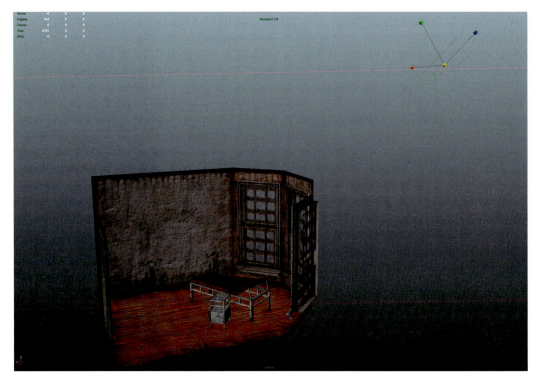

FIG 7.21 Positioning, scaling, and rotating the Directional Light that will act as the sun.

Why?

Yes, much of this is cosmetic. The only alteration here that really matters is the direction the light is pointing in. The positioning and scaling of the gizmo just makes things a little more intuitive when viewing the lighting scheme in the View Panels.

FIG 7.22 Rendering of the current lighting setup.

Why?

We have a sun alright, but the sun is behaving in weird ways. Remember that the default settings for any new instrument in Maya will not have any shadows activated. We need to make some tweaks to this instrument to get it looking right.

Step 4: Activate Depth Map Shadows and change the resolution to 4096. Render.

Why?

Well, let's start with the render – or lack of render actually. If you render the scene now with a camera inside the room, the room will be black. The reason is that because shadows are being cast from this light, all the light rays are being stopped by the walls and windows. We need to get the light to pass through those window panes.

Step 5: Make the window panes not cast shadows. Do this by first selecting the window pane object. Then, in the Attribute Editor, look for the shape node (this will be NameOfObjectShape (in the case of the version on the supporting website it will be named

289

Winders_ETM_Hallway_Window_GlassShape)). There expand the Render Stats section and turn off the Cast Shadows option (Fig. 7.23). Do this for all the window panes. Render (Fig. 7.24).

FIG 7.23 Turning off the window's ability to cast shadows – which means the light will pass right through the pane.

Why?

With an object not casting shadows, light rays will be able to pass right through the object. The render will show that the transoms and mullions (wood between the panes) are still casting shadows, but the glass itself is allowing the light through.

FIG 7.24 Rendering with window panes not casting shadows.

Step 6: Provide illumination from windows. Do this by creating an Area Light, scaling it and positioning it to be just inside a window (do just one for now (**Fig. 7.25**)).

FIG 7.25 Positioning Area Light for emission from windows.

Why?

We're doing a bit of trickery here. Later, we will actually have Maya do some light bouncing calculations for us, but for now we are manually adding some light to help indicate other sources of illumination besides the straight sunlight. In reality, the sun has very directional light, but there is still quite a bit of light that comes in from every window of a room – not just those facing the sun. This area light helps to mimic this light and will provide some extra illumination around the emissive windows.

Step 7: Adjust the Area Light settings to include Depth Map Shadows (Resolution = 512, Filter = 6). Also, adjust the intensity to 0.6 (**Fig. 7.26**). Render.

FIG 7.26 Results of adjusted settings for Area Light.

Step 8: Duplicate this Area Light and place appropriate for each of the other windows. Render (**Fig. 7.27**).

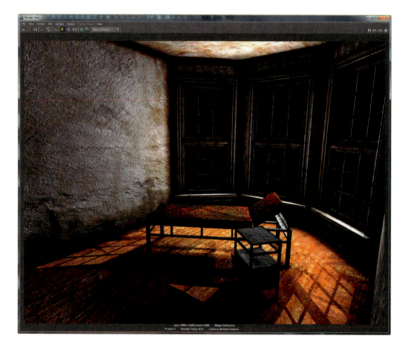

FIG 7.27 Duplicated Window Area Lights.

Mental Ray

The default rendering engine in Maya is Maya Software. This is a reasonably fast rendering engine that works with fairly simple physics models of light behavior. Some of this behavior becomes clear in renderings like Fig. 7.27 in which you can see all sorts of light streaming in, but yet, big chunks of the scene is still really dark. This is because the light hits a surface and dies, when in the real world, light bounces off of most non-black surfaces and provides further illumination to surfaces around it. And here's where Maya Software immediately begins to show some of its restrictions.

Maya does include other rendering engines, however, and one of them handles issues like bounced light quite well. Mental Ray is another rendering engine that Maya allows access to that includes a powerful tool called Final

Gather. Final Gather creates what are called stochastic samples along surfaces that sample (or look) around themselves to see what other surfaces are close. If it sees a surface close to it, it gathers the color information off that surface and tints the texture around the stochastic sample to represent the bounced light that that second surface would have provided. The net result is the look of bounced light.

So for us, this is perfect. We have only one light source – the sun – in this scene (although we are cheating a bit with the Area Lights in the windows), that we want to have bounce all over the room to provide further secondary illumination.

Now, because Mental Ray is a different rendering engine there are some things that we'll need to adjust to make the renderings look right. The light instruments we've currently placed will likely prove too intense once the bounced light is calculated. The settings for transparency will need to be adjusted for our windows. And most importantly, our rendering times will be much longer (there's just more calculations going on). But the results are generally worth the extra work and rendering times.

Before we start looking at adjustments that need to be made, make sure Maya is set up to utilize Mental Ray. To do this, chose Windows > Settings/Preferences > Plug-in Manager. Look for the Mayatomr.mll and make sure it is checked in both the Loaded and Auto load columns.

> Step 9: Turn on Mental Ray and Final Gather. Do this by choosing Render Settings (Window > Rendering Editors > Render Settings). Change Render Using: Mental Ray. Then, click on the Features tab, and in the Secondary Effects area, tick on the Final Gather option. Click the Close button. Render (**Fig. 7.28**).

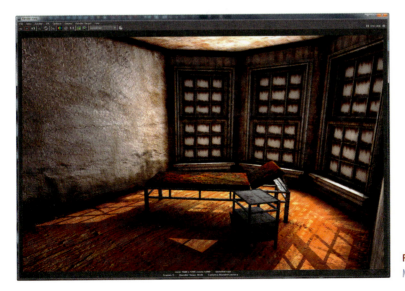

FIG 7.28 Initial render with Mental Ray.

Step 10: Tweak light intensities. This is largely a personal preference and
will take some tweaking and lots of rendering. What I did was turn my
Directional Light's intensity up to 1.5 (it is the sun after all and should be
pretty intense) and turned my window lights down to 0.25 (**Fig. 7.29**).

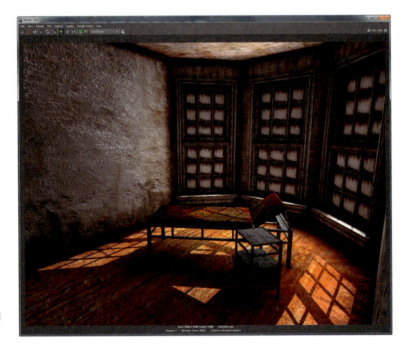

FIG 7.29 Renderings with adjusted lighting intensities.

Step 11: Fix the transparency. Transparency works a little different with
Mental Ray – the shaders have to be constructed just a little bit differently.
To make the window panes transparent again select the material attached
to them (do this either in the Hypershade or by clicking one of the window
panes, and in the Attribute Editor, look for the tab that represents the
material). Scroll down to the Raytrace Options section and turn the Shadow
Attenuation to 0.

Step 12: Add an Ambient Light. Do this with Create > Lights > Ambient
Light. Move the Ambient Light into the center of the room and change the
Intensity to 0.25. Render (**Fig. 7.30**).

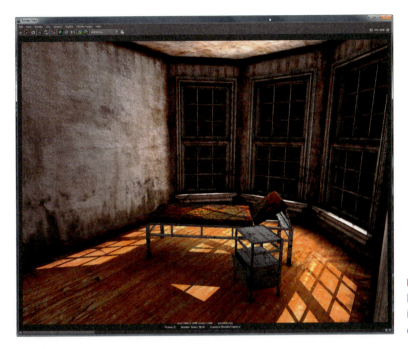

Why?

Yes, usually Ambient Lights are a lazy man's way of lighting a room. But when using Final Gather, an Ambient Light can be a great way to make sure that all the surfaces in the room initially have some illumination for the stochastic samples to pick up. While an Ambient Light can easily simply wash out an entire scene and ruin any sense of depth, a very low intensity (like our 0.25) Ambient Light can provide added lighting flexibility but keep the visual depth.

Cycs

Getting dangerously close, huh? The lighting on the walls and floor is looking quite good; but those windows – even though they are transparent – just look dead. The reason, of course is that we are looking out the windows into the depths of the 3D wasteland. They are transparent, but there is nothing to see out there – so Maya/Mental Ray render it as black.

To fix this, we'll employ an old theater trick. A cyclorama is the backdrop that sits on the back end of a stage that often has a slight curve. It gives the illusion (albeit kind of stylized and corny) of added depth. In 3D, we can do the same thing.

This will take a few steps. First, we will model the cyc, texture it, and then make sure it doesn't get in the way of the lighting scheme we've already set up.

295

Step 13: Model a cyc. This can be done several ways, but let's look at a slightly different method here than we've used in the past. Start by creating a Bezier curve in the top View Panel to roughly mimic **Fig. 7.31**. Duplicate this curve and move it above the original, so there are two curves to define the bottom and top of the cyc. Select both and choose Surfaces|Surfaces > Loft (Options). Make sure the options match **Fig. 7.32**. The results are shown in **Fig. 7.33**. Name this object Cyc.

FIG 7.31 The Bezier curve that will become the cyc. Notice this is done with three anchors.

FIG 7.32 Loft Options for the Loft that creates the cyc geometry.

FIG 7.33 Lofting results.

Why?

Now this cyc is really a little weird, but works well for this tutorial. In reality, the cyc should really be built so that all the rooms on this side of the sanitorium could look out and see it. But we're building it so that it can only be seen out of this one room that we are currently working on. That's OK for now, but be aware that one unbroken cyc is usually preferable for all the windows of one side of a building.

Step 14: Create a new Lambert material to apply to the cyc. Do this by either creating a new material in the Hypershade or by right-clicking on the cyc and choosing Create New Material from the Hotbox. Name this new material `Cyc_Mat`.

Step 15: Find a panoramic picture to use as the base color map. A quick Google search using "countryside panorama" yields a huge collection of different options. Download the one you want and save it to your sourceimages folder.

Why?

Searching for panorama's usually provides those long images that work best for cycs. This will provide the best chance of getting a cyc that doesn't have a skewed image on it.

Step 16: Back in Maya, apply this newly found panoramic image as the color map in the color channel of the Cyc_Mat. The results will look something like Fig. 7.34.

FIG 7.34 Applied panoramic image as the color map for the Cyc_Mat. Clearly, it's upside down and needs some tweaking.

Step 17: Rotate, scale, and position the cyc as needed (Fig. 7.35). Be sure to take a look at what you can see inside the room.

FIG 7.35 Positioned cyc.

Tips and Tricks

It's really important to check inside the room to see how the cyc holds up. It's likely that it will need to be bigger than you anticipate, so that it holds up when you are in the room looking out the window at various angles.

Step 18: Make the cyc not cast shadows. Remember that to do this, select the object, then in the Attribute Editor, find the shape node, and look for the Render Stats section. Turn off the Casts Shadow check box.

Why?

If this big cyc object was casting shadows, it would block our sunlight. This cyc needs to be really independent of all the lighting in the scene as the photograph appears lit already.

Step 19: Make the cyc self-lit or rather independent of the lights. We'll do this by adjusting the Cyc_Mat. Open the Hypershade, select Cyc_Mat in the Materials tab and choose Graph > Input and Output Connections which will graph the material in the Work area. We want to use this same color map as the ambient color map. To do this, right-click the arrow at the bottom-right of the file12 (or whatever number yours is) node and choose outColor > outColor from the Hotbox that appears. Then, right-click on the arrow at the bottom-left of the Cyc_Mat node and choose ambient-Color from that Hotbox. There will appear to be little difference in the Hypershade. But a render will yield an outside well lit (**Fig. 7.36**).

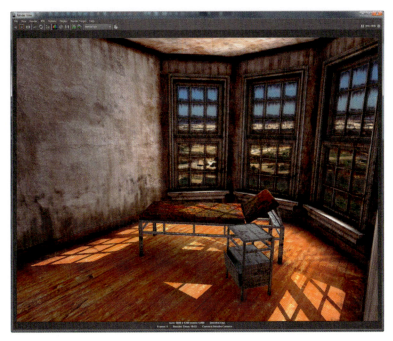

FIG 7.36 Cyc_Mat with activated ambient color channel.

Why?

The idea of an ambient color channel is the color of an object regardless of the lighting. By using the same image to define both the color (which we can see easily in the View Panel) and the ambient color, we ensure the surface to be independent of the lighting scheme of the scene.

Step 20: Clean up. Delete all history, and delete the curves used to create the cyc. Ensure that all the new elements have been appropriately named.

Step 21: Tweak lighting settings or texture settings as desired. I always find that once I get everything in, I need to make some adjustments – tweak a light here, change the color of a texture there, or even swap out entire textures. A few minutes of adjustments can really change the ambiance of a scene (**Fig. 7.37**).

FIG 7.37 Tweaked scene.

Shader Types

So far, the scene is looking pretty good. So far it's also true that we've been using one type of Shader for all the objects – Lambert. A Lambert Shader is a good one to start with as it renders quickly and has little specialty attribute to worry about. However, there comes a time when different surfaces should have different characteristics beside changes in color.

There are actually quite a few other Shader types within Maya: Anisotropic, Phong, Phong E, and Blinn to name a few. The biggest difference (for us at this level) between these Shader types and Lambert are specular highlights and reflections.

In 3D-land, specular highlights are the little gloss highlights that smooth surfaces have. In the real world, specular highlights are really bits of reflection. The sharpness of this reflection helps define the difference between the plastic on your mouse, the plastic of your keyboard, and the surface of a metal ball bearing.

Changing a Shader type from a Lambert to something like a Blinn (for instance) is fairly simple and will take something like our metal side table and make it look much more like metal. However, as always there are tweaks and changes that must be made to the material after its type is changed. Let's look at how to do this over the next few steps.

Step 22: Change the shader type of the Walls_Mat and name it again. The easiest way to do this is select the walls, and then in the Attribute Editor go to the tab that is the material. There, the Type can be changed to Phong (or whatever). Notice that when this is done though, it renames the material. Be sure to rename the material to something like Walls_Mat. Take a quick render to view the disastrous results (**Fig. 7.38**).

FIG 7.38 Default Phong shader on the walls.

Why?

Phong, Phone E, and Blinn are three shader types that add specular highlights to a material. However, it also automatically turns on reflections. This suddenly means everything in the scene looks like it was made of tinfoil. The effect isn't as bad in Fig. 7.38 as it could be because of the normal map that is applied (which breaks up the reflection); however, it's still clear that something isn't right.

What we really want to have is a little bit of reflection/specularity on the floor (it's made of wood), but there really should be none on the walls. If the walls and floor were different objects, each could have a different Shader type (a Lambert on the walls and a Phong on the ground for instance) and that would solve the problem. For us here, in our game level, we are working on fewer objects and fewer materials to keep the draw calls low. Luckily, we can keep one material for the walls and floor – but tell that material where to be reflective and where to be matte. We'll define what parts are reflective in the same way we define what parts have what color – with a texture map.

301

Step 23: Create a Specular Map for the walls. Do this in Photoshop by opening a version of the color map (this could be the raw version in your images folder or ETM_RoomWest1Color). In Photoshop, select all the parts of the image that are not the floor and fill them with black (you could manually paint this, or use Edit > Fill after the non-floor parts are selected). The resulting image should look like **Fig. 7.39**. Save it as ETM_RoomWest1Specular.

FIG 7.39 Specular map for walls.

Step 24: Use the new ETM_RoomWest1Specular texture map to define the Specular Color. To do this, open the Wall_Mat in the Attribute Editor (do this by either double-clicking the material in the Hypershade or tracking down the Wall_Mat node in the Attribute Editor after selecting the walls). Expand the Specular Shading section. In the Specular Color channel, import the specular map (click the checker button and create a File render node). Take a render (**Fig. 7.40**).

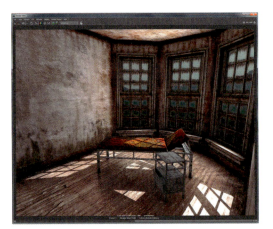

FIG 7.40 Render using a specular map to have a reflective floor but matte walls.

Why?

So the question here is, why does this work? The trick is not worrying about turning off specularity, but simply telling the color of the specular highlight to be black in certain places. The net result is that the walls again appear matte while the floor which has a non-black color in the Specular map renders with its specular in-tact.

Notice that the specular map just left the color of the floor as is. We could have made the floor area pure white for the most specularity, but we don't want things to look too clean, so keeping some color information there helps to break things up.

Tips and Tricks

For further control, you can use this same map to define the reflectivity as well.

Step 25: Adjust the other objects in the scene to use alternate shaders as desired. Be sure to remember to use Specular maps to define what parts of objects should have reflectivity/specularity and which parts should be more matte. My solution is shown in Fig. 7.41.

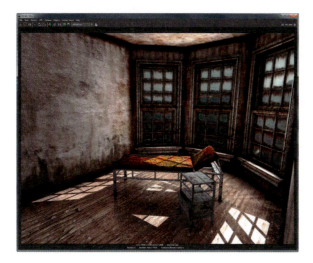

FIG 7.41 Additional shaders adjusted.

Tips and Tricks

The differences between Phong, Phone E, and Blinn can sometimes be a bit difficult to discern. Often the differences are internal to the code and there are just a few situations in which the results show this difference. Blinn tends to render a little faster, whereas Phong tends to have crisper specular results. But don't sweat the details on this.

> **Warnings and Pitfalls**
>
> For some reason, while writing this tutorial, when bouncing back and forth between the scene and the Hypershade, I got a lot of crashes (especially when closing the Hypershade). I would suggest, after any changes you make in the Hypershade, save before closing it down.

Preparing for Final Render

Up to now, we've been rendering with the default quality settings in Mental Ray. Although my screen shots show a large render (1600 × 1200) so that the images would look better in print, you've likely been rendering at the default 640 × 480 resolution. This is good, as it ensures a faster rendering time (Mental Ray can take a long time to render). However, as your lighting scheme begins to take shape, there comes a time when you're ready for a higher quality, or larger sized render.

To do this, we'll need to make a few tweaks in the Render Settings. Now, we aren't going to make an exhaustive analysis of the Render Settings window – there's the built in documentation for that. But we will look at a few critical parts of it. Note that we will revisit this window later when we are deep into animation as being able to control this area is an important part of the animation process.

One final warning though. Students often rush to get high-quality renders and turn these settings up way too early in the process (while they are still finding the lighting scheme that works). We are about to explode our rendering times – easily doubling the time it will take to output an image. Hold off in turning these settings up until you're reasonably sure you're ready for a final render.

> Step 26: Open the Render Settings dialog box (Windows > Rendering Editors > Render Settings).
> Step 27: Define the resolution. Under the Common tab, scroll down to get to the Image Size section. There you can change the default resolution if needed. There are a number of Presets there to help plug in the appropriate numbers for things like HD television resolutions. However, you can manually enter resolution sizes if you need a render for something like print. For now, just for exploration sake, go ahead and enter Width = 1600 and Height = 1200.

> **Why?**
>
> These are really just arbitrary values, but they will create an image that is big enough to let you see the detail of the texture and lighting. You may wish to render with these settings to see if there are any big errors that jump out at you.

> Step 28: Adjust the Quality settings. Do this under the Quality tab. Change the Preset to Production. This preset will unfortunately deactivate Final

Gather, so flip it back on by going to the Indirect Lighting tab and checking the Final Gather box. Render (**Fig. 7.42**).

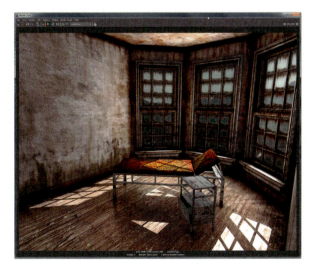

FIG 7.42 Render with new quality and size settings.

Why?

This is an area that gets more and more complicated with each new release of Maya – and gets further complicated with Mental Ray. Here, the presets are of immense value – and likely all you'll need to mess with at this point.

Step 29: Adjust as needed. If the new rendering ends up showing flaws that you couldn't see, go ahead and fix them. For instance, in mine, I found that the Directional Light's shadow resolution was still too low so I increased it. The final render is at **Fig. 7.43**.

FIG 7.43 Final rendered high-resolution shot.

Conclusion

Lighting takes some time. It takes time to set up and takes time to render. Unfortunately, really good lighting takes a lot of small tweaks, then long render times. But don't sell yourself short. Great-looking models are often completely decimated by poor lighting.

There are of course lots of advanced techniques that can assist in speeding this process up (rendering in passes, light linking, etc.); but before seeking these techniques out, getting a good grip on the core concepts – by practicing on "straight ahead" lighting – can still yield good looking results.

Tutorial 7.3 Character Lighting

It seems like lighting should be lighting. In reality, there are some techniques that are specific to set designs, and others that work better for characters. Often, in a project, the set will be lit one way, the character another, and then the set will use a different rendering engine than the characters that sit within the space. If rendering proves to be your area of primary interest, there are lots of fascinating techniques that await you.

However, we need to start with the basics. In this chapter, we will be looking at how to light a character. We will be lighting the alien we have created so far since we have him handy, and he presents some interesting challenges with his round body.

The techniques we will be using are loosely based on a pioneering lighting designer named Stanley McCandless. His important book, *A Method of Lighting the Stage,* was an important one in shaping lighting theory in American theater. Although his ideas have fallen out of vogue in many corners of theater today, his methods are still incredibly valuable in the relatively new medium of virtual lighting.

As a crude explanation of the idea, McCandless works with a Key Light that acts as the primary light source (the sun, or the overhead light bulb, etc.). In 3D, this creates very harsh shadows that leave big chunks of the character in complete blackness. McCandless' theory calls for a collection of warm-colored fill lights coming from the general direction of the Key Light. This helps diversify the colors of the character – and in particular can bring out skin tones in people. Then, a collection of cool-colored fill lights are used to light the dark side of the character. These cool-colored lights help provide illumination to the character, so that there are no black shadows, but still keep the side of the character that is away from the obvious Key Light to appear darker.

Let's put it into practice and see if we can see better how it works.

Scene Setup

Step 1: Set your project and open the alien character from past tutorials.

Step 2: Set up the scene. To get a good idea of how this character is going to be lit, he needs to be placed on a floor. Move the character up so that he's standing on the grid, then create a plane and place it beneath his feet (Fig. 7.44).

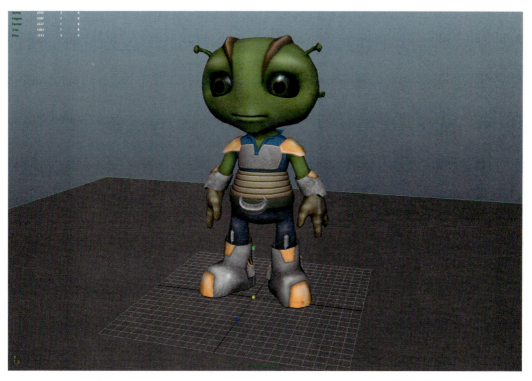

FIG 7.44 Set up scene.

Key Light

A Key Light is the primary light source of a lighting scheme. If you've done any studio photography, you are familiar with a three-light system, and if you're not, you have undoubtedly noticed that for outdoor or indoor scenes, there is usually a primary light source that tends to dictate the shadows and brightest parts of a space.

Step 3: Create a Directional Light and position it to light the characters face. The idea is that the instrument needs to be higher than the character and pointed down. The rough position I chose is shown in Fig. 7.45.

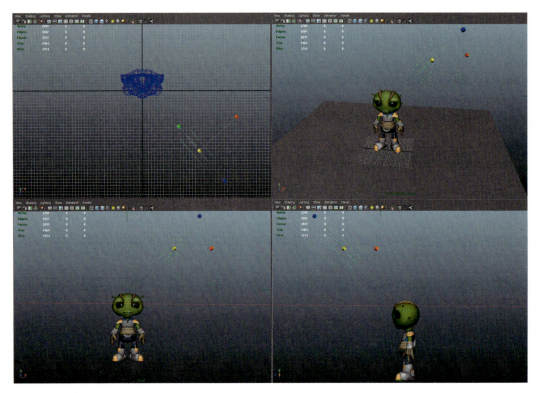

FIG 7.45 Key Light position.

Why?

In this case, we're using a Directional Light for a couple of reasons. First, there are less variables to have to mess with (no decay or cone angles needed). Second, it's fairly easy to see where these lights are pointing. Both of these make for an easier tutorial following experience.

However, ultimately, this might not be the best case for all lighting situations. For instance, if this character were inside a building, these Directional Lights illumination would be blocked by the building as soon as their shadows were activated (although this could be fixed with a bunch of light linking). Still, this technique would be just as valid if the Directional Lights we are going to build were Spot Lights, or Area Lights, or even Point Lights.

Step 4: Adjust the Directional Light's attribute. Activate Depth Map Shadows and change the Resolution to `2048`. Change the Filter to `4`. Rename the Directional Light to `Key_Light`. Take a render (**Fig. 7.46**).

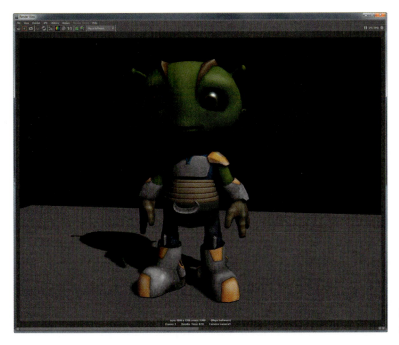

FIG 7.46 Render with one light source.

Why?

These are preemptive things that we know we need to adjust. The light needs to cast shadows, and since it is a Directional Light, we need to have a high Resolution setting. Finally, the Filter takes a little of the edge off the shadows that will be too crisp right out of the box.

Warm Side Fill Lights

Figure 7.46 shows a strange render. There's light alright, but an entire half of his face and body just disappears in black shadows. There are probably situations in which this would be what was wanted, but not for this lovable guy. We can now start filling in with fill lights. We'll start with the warm side.

Step 5: Duplicate the Key_Light and rename it `Warm_Fill_Light`.
Step 6: In the top View Panel, activate the Show Manipulator Tool (activated in **Fig. 7.47**). There will appear two manipulation handles (one for the instrument itself and one for the target point). Move the target handle, so that it sits in the middle of the alien. Then move the instrument a little bit around the alien.

FIG 7.47 Using the Show Manipulator Tool to position a light.

Why?

This Show Manipulator method is a great way to work with Maya's light instruments. When activated, as the instrument moves, it automatically turns to stay focused on the subject.

Step 7: Adjust the attribute of Warm_Fill_Light. Again, do this in the Attribute Editor. Turn the intensity down to 0.3 and change the color to an amber color that very roughly matches **Fig. 7.48**.

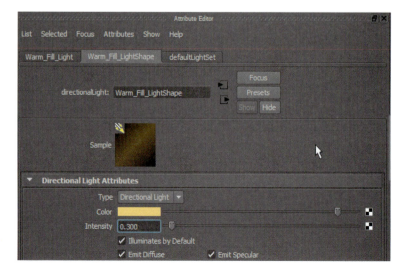

FIG 7.48 Adjusting attribute of the Warm_Fill_Light.

Why?

The fill lights should never be as intense as the Key Light – there will be more of them and we want to make sure they don't overwhelm the effect of the Key Light.

The exact color there isn't terribly important. It should be toward the yellow end of the color spectrum (warm colors), but we may end up changing this later anyway.

Step 8: Duplicate and position 4 more copies of Warm_Fill_Light and position them roughly like **Fig. 7.49**.

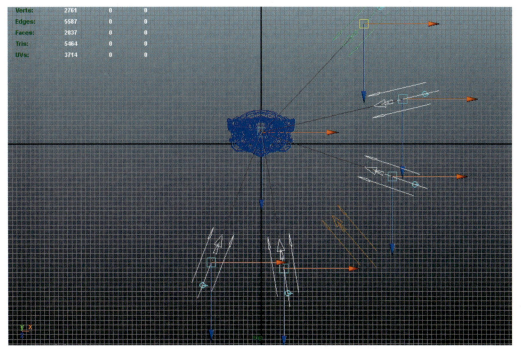

FIG 7.49 More Warm_Fill_Lights. Notice there is one light there that is not selected – that's the Key Light.

Tips and Tricks

So notice that there are lights on both sides (radially) of the Key_Light. These warm fill lights should all generally feel like they are coming from the Key Light's direction.

Cool Side Fill Lights

If you took a render at this point, the image would look something like **Fig. 7.50**. It's warmer alright, and there is some nice filling in that is happening. However, the dark side of the alien is still too dark.

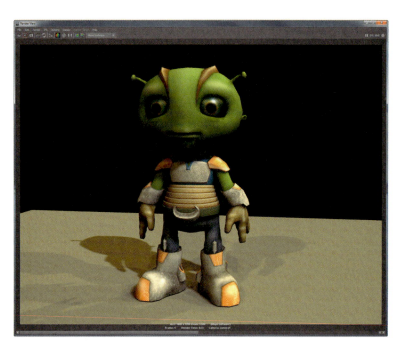

FIG 7.50 Lit with warm side fill lights.

We don't want to keep duplicating these warm fill lights though. If we do, the character will end up totally evenly lit, and the forms of the character will be lost. Enter our cool side fill lights. These will provide illumination to the dark side of the alien, but because they are a different color, we'll still see where the Key Light is coming from – but still be able to see the form of the dark side of the character.

> Step 9: Create the cool side fill lights. To do this, duplicate any one of the Warm_Fill_Lights. Rename it `Cool_Fill_Light` and change the color to a desaturate blue (**Fig. 7.51**).

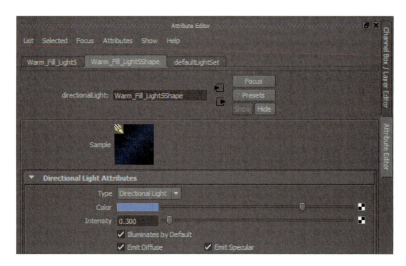

FIG 7.51 Cool side fill light settings.

Step 10: Fill out the cool side. Do this by moving the new Cool_Fill_Light, and then duplicating it four more times and positioning each of these to match Fig. 7.52.

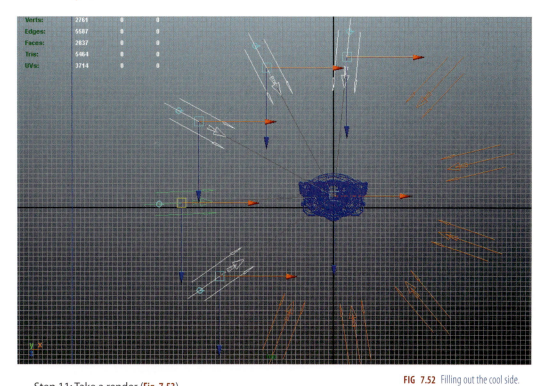

FIG 7.52 Filling out the cool side.

Step 11: Take a render (Fig. 7.53).

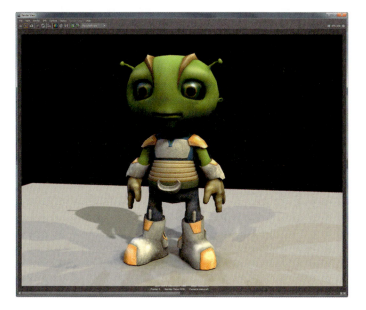

FIG 7.53 Render with warm and cool side fill lights (one ring anyway).

Why?

Starting to get a little closer, no? there are still some areas (like under the chin) that are way too dark, but you can start to see the other side of the face finally.

Step 12: Fill out the fill light setup. To do this, in the Outliner, select all the Fill_Lights (both warm and cool). Group them (cntrl - G). Duplicate this group and slide it down to near the floor level. For each of the instruments in this new lower ring, select the instrument with the Show Manipualtor Tool and move the target up so that it is again on the alien's face (**Fig. 7.54**).

FIG 7.54 New ring of fill lights.

Step 13: Make the floor not cast shadows. Do this by selecting the floor plane and then in the Attribute Editor go to the shape node and look for the Render Stats section. Click off the Casts Shadows checkbox. Render (**Fig. 7.55**).

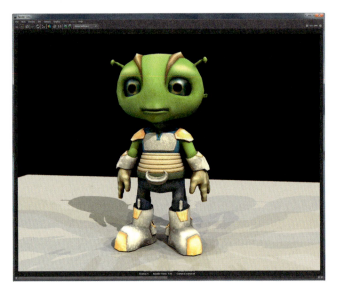

FIG 7.55 Rendered with second set of fill lights. He's starting to get a bit blown out.

314

Why?

OK, so this is a little bit of a cheat that becomes necessary with our Directional Light setup. If those Directional Lights are pointed up to any degree, it means that the light is coming from below the floor (remember Directional Light illumination comes from infinitely far away and casts an infinite distance). This means that the floor would simply stop all the light from this new ring of fill lights. Telling the floor to not cast shadows means the light can now make it up to the alien.

The problem now is that he's beginning to get a bit blown out. There are too many instruments throwing too much light. We need to adjust.

Group Adjustments

There are some funny quirks to adjusting more than one light at a time in Maya. If you have multiple instruments selected and then make a change in the Attribute Editor (say, change the Intensity); you'd think that the intensity of all the selected instruments would be changed – but alas, that won't happen. Using this method, Maya will simply change the intensity of the last selected instrument.

However, there are ways around this…namely the Channels Box Editor.

> Step 14: Batch adjust the intensity of all the fill lights. Start to do this by going to the Outliner and selecting all the fill lights (everything with Fill_ Light in its name – both warm and cool side in both rings). In the Channel Box Editor, look for the Intensity input field within the SHAPES and change the setting from 0.3 to 0.1. Render (**Fig. 7.56**).

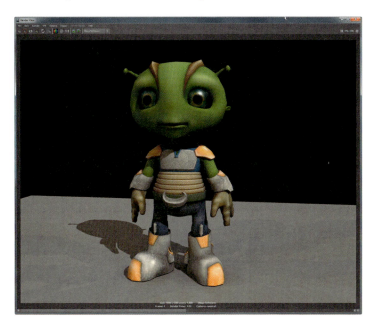

FIG 7.56 Adjusted fill intensities.

315

Why?

This Channel Box trick may seem a little weird. After all, when all those lights are selected, the Channel Box still only shows the name of the last instrument selected. But you'll notice that when the Intensity setting is changed, there is an immediate difference in the scene.

Step 15: Tweak as desired. Now that there are the instruments to fill out the illumination, and you know how to batch adjust things like the intensity, you can turn the fill lights up or down as desired. My final tweaked solution (which included turning the cool side's intensity up just a bit, and adding just a bit of green to the Key Light to bring out the green in the skin) is shown in **Fig. 7.57**.

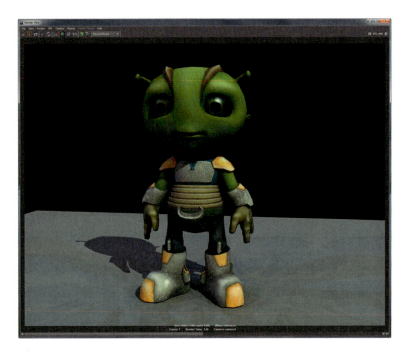

FIG 7.57 Further group tweaks.

Conclusion

So much more fun can be had here. But hopefully this quick look at McCandless' ideas shows how the form of the character can be highlighted while still maintaining a clear sense of where the light is coming from.

And with that we're going to move on from lighting and rendering. We'll visit it again briefly when we animate, but for now we've got the basics covered. Lighting is one of my favorite parts of 3D, and we've barely scratched the surface. Exciting tools like Global Illumination and Image Based Lighting didn't even get touched here, but can make for some really nice outputs.

However, now that you know how Maya's lights work, if lighting is your interest, you can further explore and develop your own look.

Homework

1. Light the room for night time. Remember, there needs to be a light source modeled, and don't forget to make that modeled light source not cast shadows, so the actual Maya lighting instrument that gets placed inside the geometry doesn't have all its light stopped when it starts casting shadows.

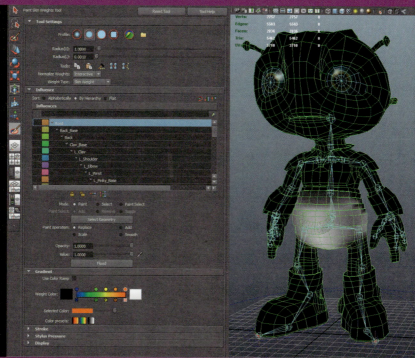

Character Rigging and Skinning

We've traveled a long way. We've created geometry, UVed that geometry, created materials to make the geometry look like it is a variety of materials, and even lit it to give it extra form and depth. All of this is important – and without it we can't get to what's next: animation.

At the end of the day, animation is what brings this digital world to life. Whether it's in games, TV, or movies, the most lucrative part of 3D that has the broadest appeal is the animation. The last two chapters of this book are devoted to this pursuit. This chapter will be focused on creating the puppet or the controls to allow for animation, while Chapter 9 will actually be involved with making things move.

Turns out, any object can move in Maya. Any object can have keyframes set, and the scale, position, or rotation change over time. But the most dynamic animation happens when a character moves, specifically when a single mesh (like the alien) deforms to give the illusion of muscles and bones giving the shape form and moving it in space.

Maya is probably not the best modeler out there. It isn't even my favorite for creating materials. Its lighting tools are limited by its rendering engine. But in animation, it is really among the industry leaders, particularly in character animation. Although there are certainly other packages in this space (SoftImage for one), when talking to character animators, chances are they are using Maya to bring their characters to life.

Deformation Objects and Joints

Part of the reason for this is Maya's robust and reliable collections of **deformation objects**. Deformation objects are tools that deform a collection of geometry. Of particular interest to us is the **joint**.

In anatomical terms, think of joints as the point where two bones meet. This was originally a fairly new way to think of character deformation objects. Most 3D software created *bones*. But Maya creates joints: it focuses on the point of movement. When multiple joints are strung together (one as a child of the next), Maya creates a visual representation of this connection as a bone; but the focus is still on the joints.

What happens is that joints are given an influence over vertices near them, and as the joint rotates, it deforms the vertices it has influence over. This process of defining which vertices are manipulated by which joints is called **skinning**. Creating the joints themselves and building handles to manipulate those joints is referred to as **rigging**. Both are critical of course, but they are really separate processes. In this chapter, we will work with both. First, we will create the skeleton for the character and will then rig it with some basic handles that will allow us to manipulate the joints easier. Once this is done, we will skin the character to make the joints deform the mesh in a believable and pleasing way.

Joint Behavior

Joints and the way they interact with polygons have some specific peculiarities that are important to understand. Consider the following mini-tutorial to get a better idea of how it all works:

Step 1: In Maya, create a new file.
Step 2: Maximize one of the orthographic View Panels (move the mouse over top, side, or front and hit the space bar).
Step 3: Activate the Joint Tool (Animation|Skeleton > Joint Tool).
Step 4: Click and release anywhere in the View Panel to create a joint (**Fig. 8.1**, left).
Step 5: Click again a couple of times in a couple of different places to create new joints as part of a joint chain (Fig. 8.1, center).

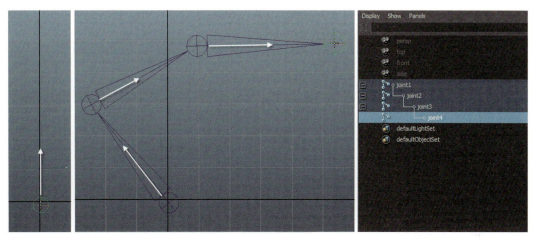

FIG 8.1 Each click of the joint tool will make a new joint that is the child of the preceding joint. The preceding joint will automatically orient toward the new child.

There are several things to notice about this:

1. When a joint is first created, its orientation is straight up and down – it is *oriented* standing straight up (the white arrows in Fig. 8.1 indicate the joint's orientation or the direction the joint is pointing).
2. While still in the Joint Tool, if other joints are created, the joint before the new joint automatically orients to point at this new joint (this is good).
3. When these new joints are created, they are also automatically created as children of the joint before it (Fig. 8.1, right).
4. Generally – although not always – creating joints is best done in non-perspective views (top, front, or side). It just makes sure that this auto-orienting happens predictably.
5. When creating joints with the Joint Tool, when you click, the joint is created, but if you click drag, you can create and move the joint into place before it is actually placed.
6. When in the Joint Tool, hitting Enter exits you from the tool and ends the joint chain.
7. Maya 2012 seems to have introduced a bug when creating joints in these orthographic views. When in a four-view setup, when creating a joint, the joint isn't actually painted until the mouse is released. This is an icky bug, but if you maximize the View Panel, the joint appears as soon as you click.

There are some other eccentricities to this tool that we'll be talking about in the coming tutorials, but if you understand these basic ideas, we can get things going.

Joints as a Deformation Object

Joints, by themselves, are pretty useless. If they don't have any geometry to deform, they don't even show up in a render. What this means is that a joint's efficacy is heavily tied to the geometry it is deforming. Consider the

following example: Fig. 8.2 shows a simple joint chain (e.g., a basic finger). The left most image is the joint chain alone. The middle image is the joint chain tied to a cylinder that is one subdivision tall (one ring of vertical polygons goes from the bottom of the cylinder to the top). The right most image is the same structure, but tied to a cylinder with many subdivisions along its height.

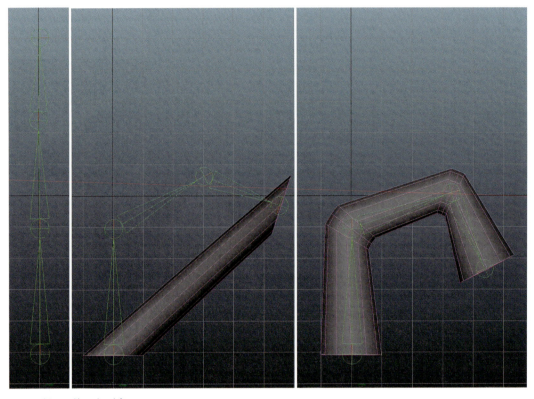

FIG 8.2 Joints and how they deform differing topology.

Remember that polygons don't bend. The only way a mesh deforms is along the vertices or edges where polygons meet. In the center image, there simply aren't any places for the shape to bend – the unyielding polygons go from bottom to top. On the other hand, the shape on the right side has loads of places to bend, and therefore, the joints are able to affect a new form.

Sometimes, this means that when creating joints, you may notice that you don't have enough places for your mesh to deform. If this is the case, you'll need to insert some additional geometry (perhaps through something like the Insert Edge Loop Tool). Generally, the alien's topology is in good shape; but in your own creation, always keep this in mind.

Tutorial 8.1 Joint Chain for the Alien

This alien was modeled as a game model. This means that the polygon count was an important part of the design and construction. However, if you take a look at the model provided on the support website, you'll notice that around the elbows and knees (for example), there are rings of polygons that allow for good deformation.

As you follow this tutorial, take a look before you get too far to see if you need to add additional geometry to the areas where a joint is going to be deforming the mesh. If you'd like, you may want to use the version provided on the website – although your own version would be great as well.

Step 1: Set your project and open the alien character.
Step 2: Position the character, so that it sits on the floor. The easiest way to do this is to first move the axis of the character to the bottom of his boots (hold d and v down together to move the axis and snap it to a vertex). Next, hold x down (to snap to grid) and move the character up, so that his feet are sitting on the ground grid.

Why?

This is largely cosmetic. It just becomes easier to see how everything fits together when the character is standing on the ground. It's unlikely that he was modeled standing on the ground. Also, later, when bringing this character into a game engine, this can help head off some other issues in character placement.

Step 3: Clean up the history and transformations. Do this by first choosing Edit > Delete All by Type > History. Then, select the body of the alien and choose Modify > Freeze Transformations. Repeat this for the eyes.

Why?

This is not cosmetic. It's pretty important to actually have a mesh that is devoid of all history when getting ready to do any rigging or skinning. Deforming a mesh can be a processor intensive procedure, and if there is other history on the mesh, Maya has to recalculate all those history nodes for every tweak to a skinned joint. Having a straight chunk of geometry cuts way down on the amount of calculations Maya has to do and helps to stave off unintended hiccups along the way.

Root Joint

Ultimately, we need to have a skeleton in which all the joints are connected. Importantly, there need to be one joint that is the ruler of them all. We will

call this master joint the Root joint. Generally, the theory here is to have the Root joint be at the center of weight for a character – which is generally about halfway between the belly button and the bottom of the crotch.

It will be important that this Root joint has a very clean orientation – that it isn't oriented toward any particular joint and is set to be rotated at 0, 0, 0 in the world space. To do this, we need to place a joint and then exit the Joint Tool.

Step 4: In the side View Panel, place a joint and exit the Joint Tool. Remember to activate the Joint Tool and go to Animation|Skeleton > Joint Tool. Place a joint by clicking. Exit the tool by hitting the Enter key (Fig. 8.3). In the Outliner, rename the joint to Root.

FIG 8.3 Placing the Root joint.

Why?

Placing this joint in the side View Panel does some things for us. This character is largely symmetrical, and so, we will only need to create one-half of the character's joints and then mirror those joints. By placing joints (like the Root joint – that will be right in the middle of the character) in the side View Panel, we know that it is sitting at X = 0 – in the middle of the character.

Legs

Later, to animate the legs, we will be using a method called inverse kinematics (IK). We'll talk much more about what this means later – but for now, it's important that we create the legs, so that each of the joints are at an angle (don't create them in a straight line).

Step 5: Still in the side View Panel, create five joints for the hip, knee, ankle, ball, and toe (**Fig. 8.4**). This time when using the Joint Tool, simply click and release for the placement of each joint and hit the Enter key after creating the last joint (the toe; Fig. 8.4). Label them as L_Hip, L_Knee, L_Ankle, L_Ball, and L_Toe.

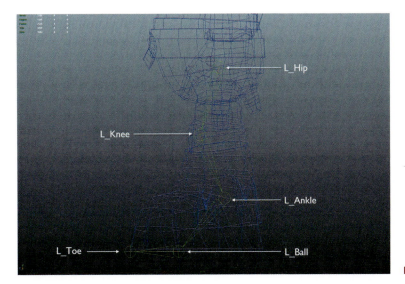

FIG 8.4 Creating the leg joints.

Why?

Special note that the knee is bent. If the hip, knee, and ankle are all in a straight vertical line, there will be real problems later when we set up the IK rig. For the hip, knee, and ankle joints, the idea is to place the joints in the middle of the leg or where the actual physical joint would be on a real person. However, for the ball and toe, we are placing the joint where the ball and toe of the foot actually would touch the ground.

The naming here is important. "L_" of course stands for "left." If we effectively name one side of the skeleton we are creating, when we mirror it later, Maya will do some quick and effective renaming for us that will include replacing all the L_ with R_.

Also, notice that if you look at any of the other views, this new joint chain is going to look really strange, as it will appear to come out of the bottom of the character's crotch. Not to worry, we'll fix that in a minute.

Step 6: Position the leg joints (move only). In the front View Panel, select the L_Hip joint and use the Move Tool to slide the hip over, so that it sits where it should be for the leg (**Fig. 8.5**).

FIG 8.5 Moving the leg joints.

Step 7: Rotate the leg joints. First, select L_Hip if it is not selected. Then we want to make a few changes to how the Rotate Tool works: double-click the Rotate Tool, and the Tool Settings window will appear (probably to the left of the interface). Here, under the Rotate Settings area, change the Rotate Mode to World. This will change the rotation handle, so that it is flat in world space instead of rotated as the joint was. Now, rotate the L_Hip joint along the Y axis (grab only the green circle of the handle) and rotate the chain, so that it is set within the leg. This is most easily done from the persp View Panel (**Fig. 8.6**).

FIG 8.6 Rotating the leg appropriately.

Why?

There's a lot going on here. We haven't messed with the Tool Settings much; but as you can see, it allows us to determine from what axis we are rotating things from (local, which is the default, or global, which is what we're doing here). The Move Tool by default is moving objects in global space (no matter how the object is oriented, the manipulator handles still match the global coordinates). However, by default, the Rotate Tool rotates its handles to match the rotation of the selected object. In this case, it would be a complex collection of rotations to get the leg rotated right if the handles were rotated to match the rotation of the L_Hip joint. By swapping the way the Rotate Tool works, we can quickly get it oriented in the appropriate direction.

Step 8: Reset the Rotation Tool by clicking the Reset Tool button in the Tool Settings window.

Step 9: Adjust the L_Toe joint to reach the end of the toe. First, select the L_Toe joint. To move this toe and keep it in line with the ball, we'll adjust how the Move Tool works as well: double-click the Move Tool to open the Tool Settings windows. In the Move Settings section, change the Move Axis to Local. This will rotate the Move Tool handle, so that it is rotated as the joint chain is. Move the joint along the X axis, so that it sits right where the toe of the boot touches the ground (**Fig. 8.7**).

FIG 8.7 Using the altered Move Tool to move the L_Toe joint, so that it matches where the toe touches the ground.

Why?

When we first made the leg joints, we were doing it in the orthographic side view. This would have worked fine if the character toes were facing straight forward, but because this character's feet are pointed outward, we need to adjust its position slightly to make sure the toe is actually where we planned on it being.

Step 10: Reset the Move Tool by clicking the Reset Tool button in the Tool Settings window.

Step 11: Freeze Transformations for the leg joints. Select L_Hip and choose Modify > Freeze Transformations.

Why?

This will do a couple of important things for us. First, it will make sure that the rotation values for all the leg joints are indeed at 0, 0, 0. Second, it will make sure that the hip joint (which we rotated with the altered Rotate Tool) will orient to point to the knee (this will be important to the IK calculations later). The core idea here is that joints can be *moved* without a problem; but it's best to have the rotation values always be 0, 0, 0. This will make it easy to get the characters joints back into place if we start rotating them in animation later.

Step 12: Make the leg joints a child of Root. To do this, in the Outliner, middle-mouse-drag the L_Hip joint onto the Root joint.

Why?

We created this leg chain independently of the root. Making it a child of the root will create a new bone that connects the two and make sure that the leg is indeed a part of the master skeleton for this character.

It's important to note that we could have created the Root and then just continued down to the leg; but this would have meant that the Root was oriented toward that left leg – and not remained oriented straight. By creating the leg chain, and making it a child of the Root, we keep the rotation of the Root pristine.

Tips and Tricks

Note that there is another joint that could be used here that you will read about called a Pelvic Girdle. The Pelvic Girdle is a joint that goes beneath the Root that has two children: each of the hips. This allows for the hips to be moved and animated without affecting the upper body. For high-poly characters built for TV or film, I prefer to have this joint. But for a game character, we want to keep the joint count low (deformation objects are expensive to a game engine), so we will leave it out.

IK vs. FK

Kinematics is the study of motion without regards to force. In animation, kinematics basically refers to "how am I going to control how this thing moves." Specifically, kinematics generally refers to character joint positioning. There are two ways of positioning joints: **Forward Kinematics** and **Inverse Kinematics**.

Forward Kinematics (FK) works by *rotating* a lot of joints. If a character is reaching up to grab a glass, FK would have the animator rotating the shoulder, then the elbow, and then perhaps the wrist to get the character into position. The nice part of this is that this rotation of joints causes the arm to move in continuous arcs, which is how our bodies move. The bad part is that there ends up being a lot of tweaking to get that arm into the right spot, so that the hand meets the glass.

Inverse Kinematics (IK) works by *moving* a target and then having Maya to calculate the rotation of a joint chain to allow it to point at that target. This is a more indirect method of rotating joints and can be very useful. In situations like walks, this means that a target could be placed where the foot hits the ground, and then as the character is moved up and down or front and back, the joints in the leg are continually rotating to allow that foot to stay on the ground. The problem with IK is that it can lead to very robotic movement as an animated target takes the most direct path between poses.

So which is better? Well, both of them are. It's kind of like asking if a hammer or a screw driver is a better tool; it depends on the task at hand. For the upper body, I prefer to pose and animate using FK for things like walks and gestures. It makes much more fluid and believable motion. But for the legs, IK is a more effective tool. It allows for all sorts of quick poses as the body can be moved, but the feet stay planted. Although there may be other preferences on the upper body (some folks like to animate the upper body at times with IK), there is really no debate about the lower body – IK is the way to go.

For us, this means we need to set up IK chains in the leg. We are doing it now, so that we only have to do it once. If the left leg is set up well with complete IK chains, when the left leg joints are mirrored, the IK mechanisms will be mirrored as well.

In the next few steps, we're going to set up more IK handles than it would seem we need. This is partly to lay the groundwork for a later foot roll rig.

> Step 13: Create an IK chain between the L_Hip and L_Ankle. To do this, choose Animation|Skeleton > IK Handle Tool. To use the tool, in a View Panel, click on the L_Hip joint to start the IK chain and then click second time on the L_Ankle joint (**Fig. 8.8**). Rename the new ikHandle that will appear in the Outliner to `L_AnkleIK`.

FIG 8.8 Creating an IK chain with the IK Handle Tool.

Why?

This will create a bunch of new gizmos on the screen. Notice that there is a new handle down on the ankle (for some fun, use the Move Tool to grab that handle and move it around to see IK in action – but be sure to undo(Cntrl + z) to get it back into position). This is the actual IK handle. Notice that there are other green lines to show how the IK chain is built and which joints are involved in the chain.

> Step 14: Create an IK chain between L_Ankle and L_Ball. Again, activate the IK Handle Tool and then click once on the L_Ankle and second time on L_Ball. Rename the new ikHandle to `L_BallIK` (**Fig. 8.9**).

FIG 8.9 Second IK chain between ankle and ball.

Why?

I know, this seems really strange to have an IK chain between just two joints. What it will eventually allow us to do is change the rotation of the foot. It's all part of a rig that will allow us to control how the foot rolls.

Step 15: Create one more IK chain between the L_Ball and L_Toe. Rename the ikHandle to `L_ToeIK` (**Fig. 8.10**).

FIG 8.10 Final IK chain between ball and toe.

Mirror

With the left leg done and labeled correctly, we can use a great tool in Maya to quickly build the other side.

331

Step 16: Mirror the left leg joints. Do this by selecting the L_Hip joint and then choosing Animation|Skeleton > Mirror Joint (Options). There, change the Mirror across setting to YZ and change Search for: L_ and Replace with: R_ (**Fig. 8.11**).

FIG 8.11 The Mirror Joint Options window.

Why?

The Mirror across option is defining which plane to mirror across – which in this case would be a plane that ran along the Y and Z axis. The Search for/Replace with mechanism is a naming help. It simply looks at each of the joints and associated handles and with the mirrored version, replaces any "L_" with "R_." The ultimate result will be a complete right leg with all its IK handles intact and everything labeled correctly. I love this tool.

Upper Body

Now that when the lower body's joints are placed, we can move to the upper body. We have some work left to do in the lower body – especially in regards to handles to control it, but we'll still get all the joints into place.

Step 17: In the side view, create a spinal column. Do this by creating six joints for Back_Base, Back, Clav_Base, Neck, Head, and an extra joint for the head to point toward (**Fig. 8.12**).

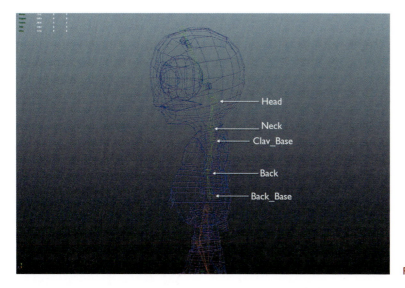

FIG 8.12 Spinal column.

Why?

We build this from the side to make sure that the spine is right in the middle of the body. The number of joints is low for a couple of reasons: First, this is a game character, and too many joints slow down the performance of the game. Second, this is a pretty round and short character, so there will not need to be that much deformation along the back.

The placement of these joints isn't absolute. Some important things to consider though: the Head joint should be placed where the spinal column would connect to the skull (it's sometimes a little hard to tell with a character like this where this would be – but in more humanoid characters, this is a critical placement). Neck should be at the base of the neck. Clav_Base will be the joint we build the clavicle bones (collar bones) from, so it needs to be up where the arms will branch.

Step 18: Delete the last joint on the top of the head.

Why?

This joint is really there to make sure that the Head joint (down by the base of the skull) is oriented correctly. However, it won't actually affect any vertices, so ditch it.

Arms

Creating the arms can sometimes be a little tricky if the character isn't modeled in a true T-pose (arms straight out to the side). There are all sorts of interesting techniques to placing the joints in the arms. One of my old

students taught some adjunct classes for us and demonstrated a great technique in which he ripped the polygons of the arm off the body, rotated them straight to build the joints, and then rotated that arm chain into place. For us, we will be exploring a few other functions of the Joint Tool to get the character's arms into place.

Of particular interest to us is that the Joint Tool allows already created joints to be positioned by middle-mouse-dragging them. This means that a joint can be placed in one View Panel by clicking and releasing, and then in another View Panel, the joint can be moved into a better position by middle-mouse-dragging it. This means you needn't exit the Joint Tool, and it keeps the joints auto-orienting to the next joint's position.

The next important idea is that the Joint Tool will allow new joint chains to be built off of extant joints. To do this, you just need to select the Joint Tool and make the first click on a joint that already exists. Click after that build new joints as children of the first clicked joint.

Step 19: Create and position the L_Clav joint. Start this in the front View Panel by activating the Joint Tool and first clicking on the Clav_Base joint. Then click where the L_Clav joint should be (**Fig. 8.13**). Do NOT hit Enter or otherwise select another tool.

FIG 8.13 L_Clav placement in the front View Panel (we still need to adjust its position in other View Panels).

Step 20: While still in the Joint Tool, adjust the position of this new L_Clav in the side View Panel. Swap to the side View Panel, and middle-mouse-drag the joint (**Fig. 8.14**).
Step 21: Create the L_Shoulder, L_Elbow, and L_Wrist joints using the same technique. This means starting in the front View Panel by placing the joint, but using the side View Panel to middle-mouse-drag the joint into place (**Fig. 8.15**). Note, we are still in the Joint Tool.

FIG 8.14 Middle-mouse-dragging a joint to position it better while still in the Joint Tool.

FIG 8.15 Shoulder, elbow, and wrist.

Tips and Tricks

Sometimes even adjusting in the persp is a challenge. But in this View Panel (or any of them), it can sometimes be tough to see what all is happening in wireframe. Try hitting 5 on the keyboard to get a solid form, and then in a View Panel, choose Shading > X-Ray Joints. This will make the joints always visible as they will draw on top.

Hand

Amazingly at this point, we should still be in the Joint Tool (never exited since we started creating the L_Clav). Here, we can keep creating the joints for the hand.

Step 22: Create joints down the hand through the alien's pointer finger. Be sure to be adjusting in all the views to get them into the appropriate position (**Fig. 8.16**). Finally, now hit Enter to exit the Joint Tool.

FIG 8.16 Continuing down the hand to the end of one finger.

Why?

We're extending down this finger simply because it's the one that is closest to a straight line from the wrist. In other characters – a five-fingered character for instance – the middle finger (birdie) might be a more appropriate one to use.

Tips and Tricks

Again, this is a game character, so we are making a very simplified rig. A high-poly rig might include joints for things like forearm twist, metacarpal joints to allow for a more realistic deformation of the palm of the hand. However, for this character, we are going to have fingers with one less joint than usual and very simplified arm and hand chains.

Step 23: Create the other finger joint chains by building joints off of the L_Wrist joint. Remember to build a chain off an existing joint, just activate the Joint Tool and make sure the first click is on an extant joint (**Fig. 8.17**).

FIG 8.17 Complete hand joints.

Step 24: Take a moment to name all the joints. Be sure that all these start with a L_ prefix. The exact names are unimportant.

Orienting Joints

The orientation of joints actually becomes a pretty important issue when it comes to animating. If a joint – the elbow for example – is oriented straight up and down, instead of along a line that goes from the shoulder to the wrist, when it is animated, it will have to turn along all three axes instead of one to bend correctly. In a simple pose, this might not be so bad, but the math is a lot more complex as Maya attempts to go from key pose to key pose and problems abound. Being able to rotate a joint just along the axis that it should rotate along (like the elbow, knee, and fingers do) will solve lots of problems. There are some automatic tools that help make sure that the joints are indeed oriented appropriately, but first we can do a little bit of adjustment.

As the joints were placed, you likely made your best guess as to where the joints should be. And these guesses often seem to make great sense right when the joint was placed, but when you got back and look at the joints – particularly in persp View Panel (where you can really rotate around a joint and see where it is within the mesh) – sometimes it becomes clear that things aren't quite right.

No sweat. At this point, it's not too late to adjust this. There are some things that are important to remember. First, move the joints into a better place – do not rotate them. By moving the joints, the joints above will automatically orient to point at this new location (which is good). More importantly, as these joints auto-orient, their Rotation values remain 0, 0, 0, which will come in really handy when it comes time to get the character back into a neutral position.

Step 25: Examine joints and move them into better locations if needed. Remember to only use the Move Tool to do this – do not rotate them.
Step 26: Select the L_Clav joint and choose Animation|Skeleton > Orient Joint.

Why?

The changes here will be very, very slight, so you'll have to watch closely to see them. What will likely happen is a slight twitch of the joints indicating that they have altered orientation to be pointing to the next joint. If you make any moves to any of the joints, firing this Orient Joint can help to ensure that the joints are indeed oriented correctly.

Cleaning Up
Step 27: Select the joints on the end of each of the fingers and delete them (the joints to delete are shown in **Fig. 8.18**).

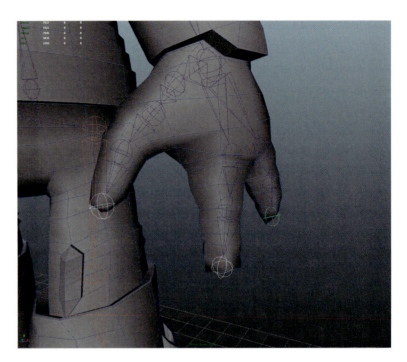

FIG 8.18 Delete these joints.

Why?

If we were going to delete them, why create them in the first place? Well, these fingertip joints give the joints above them a place to point at, so that their orientation is correct. However, these joints won't actually influence any geometry (the joint above them will actually be controlling the fingertip geometry), so there's no reason to have them cluttering up the data set.

Step 28: Mirror the L_Clav joint chain. Do this by selecting L_Clav and then choosing Animation|Skeleton > Mirror Joint. The settings from last time we used this command should still be in effect. The results will be a completed skeleton.

Step 29: Make Back_Base a child of Root. Remember to do this, in the Outliner, middle-mouse-drag Back_Base onto Root.

Foot Roll Rig

Animating the foot can be trickier than it would seem. When we walk, the mechanics of the foot comes so automatically that it seems strange that it would be hard at all; but the mechanics of how our foot comes off the ground, how it is posed as it travels through the air, and how it hits the ground are all very specific. Setting up a rig that allows for an easily controllable foot will make animating the character much, much easier.

To do this, we're going to create some handles that allow for us to control the IK handles. We're also going to make use of some techniques that protect the transform values (Position, Rotation, and Scale) of a handle, so that it stays clean (0, 0, 0).

Step 30: Make the IK handles sticky. Select any of the IK handles (for instance the L_ToeIK) in the Outliner, and in the Attribute Editor, look for the tab that has the name of the IK handle on it (L_ToeIK in this case). Expand the IK Handle Attributes Section and change the Stickiness to Sticky. Repeat for all the other IK handles.

Why?

Every time when I show this in class, there is a great deal of snickering. "Sticky" and "Stickiness" hardly seem like technical terms, but they are actually quite descriptive. What this will do is make sure that the IK handle sticks to its place in space. It means that if the Root is moved, the feet will stay stuck in place.

Step 31: Create a NURBS circle handle. Do this by first turning off Interactive Creation (Create > NURBS Primitives > Interactive Creation). Then, create a new NURBS Circle via Create > NURBS Primitives > Circle (Options). Here, change the Normal Axis to X and hit Create. Rename the new circle to L_Toe_Cntrl. The results will be a circle that's standing up at 0, 0, 0 in world space (Fig. 8.19).

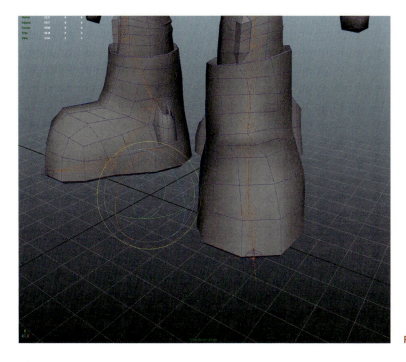

FIG 8.19 L_Toe_Cntrl on creation.

339

Why?

Turning off Interactive Creation means that the circle is created right where we can see it and importantly has Translate X, Y, and Z values of 0. Changing the Normal Axis to X means that it is rotated vertically but still has Rotate X, Y, and Z values of 0. If you want to scale it, go ahead, but be sure to choose Modify > Freeze Transformations if you do, so that you also have Scale X, Y, and Z values of 0. We are working hard here to create a handle that has "clean" transforms.

Step 32: Select L_Toe_Cntrl and group it to itself. Do this by either hitting Cntrl-g or choosing Edit > Group. Rename this new group as `L_Toe_Cntrl_Group`.

Why?

Weird, huh? Grouping the handle to itself? The idea here is that we are really making the curve a child of a null object. This parent null object will absorb all the dirty transform data (we can rotate it, scale it, move it, etc.) and make sure that the circle itself retains its clean transform data.

Step 33: Snap the L_Toe_Cntrl_Group to the L_Toe joint. Do this by first making sure the *group* is selected by selecting it in the Outliner. Then in the View Panel, change to the Move Tool and holding the v key down (snapping to vertex), move the group (which will take the circle with it) to the L_Toe joint (**Fig. 8.20**).

FIG 8.20 L_Toe_Cntrl_Group snapped to the L_Toe joint.

Step 34: Orient Constrain the group to the toe. In the Outliner, select the L_Toe joint, and then hold Cntrl down (command on a mac) and also select L_Toe_Cntrl_Group. Choose Animation|Constrain > Orient (Fig. 8.21).

FIG 8.21 L_Toe_Cntrl_Group orient constrained to L_Toe joint.

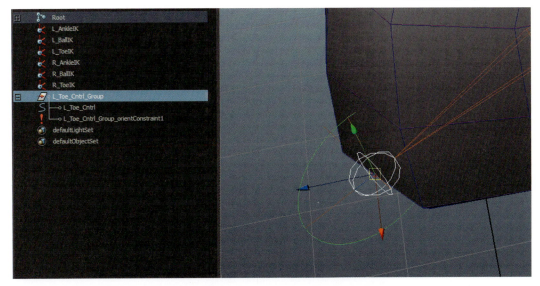

Warnings and Pitfalls

It can be a little tricky keeping track of whether you are working with the group that contains the circle or the actual circle itself as selecting either looks the same in the View Panel. However, it is critical that you know which you have selected. It's the reason why selecting in the Outliner for this sort of thing is preferable as you can see specifically which you have selected. In this case, it *must* be the group and *not* the curve.

Why?

Constraints are really tools that tie together certain attributes. An Orient Constraint ties the rotation values of objects. By setting up this Orient Constraint, the L_Toe_Cntrl_Group has matched the rotation of the L_Toe joint.

Importantly, what this does is make the group's orientation match the rotation of the joint and so it has "dirty" transforms (the rotate values are non-zero). However, if you select the circle itself (L_Toe_Cntrl), you'll see that it still has clean (0, 0, 0) values for its Rotate values.

Step 35: Delete the L_Toe_Cntrl_Group_orientConstraint1 node. Do this in the Outliner by just selecting this node with the "!" symbol and hitting Backspace or Delete on the keyboard.

Why?

The Orient Constraint constantly checks the rotation of the source and passes that value onto the target. We don't want this to be continually done at this point – we just wanted to make sure the group was appropriately oriented to begin with. Deleting the node tells Maya to stop worrying about passing values every frame between the joint and the group.

Step 36: Repeat this process for L_Ball. The results will be a L_Ball_Cntrl circle inside a L_Ball_Cntrl_Group that is snapped to the L_Ball joint. This group should be oriented to match the L_Ball joint with the Orient Constraint node deleted.

Step 37: Create a new NURBS circle handle named L_Heel_Cntrl. Group it to itself – name the group L_Heel_Cntrl_Group, and then snap that group to the *heel* of the character (this is the geometry where the heel of the boot would touch the ground (**Fig. 8.22**).

FIG 8.22 L_Heel_Cntrl_Group and L_Heel_Cntrl_Group snapped to heel.

Why?

The core idea behind these handles is that they indicate the axis that the foot will rotate around. These axes happen to be places where the foot makes contact with the ground. For the toe and ball, the joint happens to be in this spot, but for the heel, we need to use the geometry to snap the handle as we want to rotate around the heel – and not the ankle.

The Power of Hierarchy

The next few steps are all about making objects children of others. By making an IK handle, a child of one of our circle handles, it shifts that IK handles axis of rotation to the rotation of the circle handle.

> Step 38: Make L_AnkleIK a child of L_Ball_Cntrl. Do this by middle-mouse dragging L_AnkleIK onto L_Ball_Cntrl.

Why?

When L_Ball_Cntrl rotates, it will control the L_AnkleIK and rotate the heel off the ground.

> Step 39: Make L_BallIK, a child of L_Toe_Cntrl.
> Step 40: Make L_Ball_Cntrl_Group, a child of L_Toe_Cntrl.

Why?

This means that the IK handles for L_BallIK and L_AnkleIK are both children of the L_Toe_Cntrl. So when the L_Toe_Cntrl circle handle is rotated, it will rotate the entire foot off the ground with the toe as the axis.

> Step 41: Make L_ToeIK, a child of L_Heel_Cntrl.
> Step 42: Make L_Toe_Cntrl_Group, a child of L_Heel_Cntrl.

Why?

Now, in the same way that the L_Toe_Cntrl circle handle will rotate the entire foot off the ground from the toe, the L_Heel_Cntrl will rotate the entire foot off the ground but this time centered on the heel.

Warnings and Pitfalls

Notice that this method leaves the L_Heel_Cntrl handle behind when the L_Toe_Cntrl is used to rotate the foot. This is OK. It's not quite as elegant as it could be – but getting that to all be that elegant involves some stuff we really don't need to worry about here. Just note that this is planned behavior.

Create a Master Foot Handle

> Step 43: Create a circle that lays flat on the floor plane. Do this with Create > NURBS Primitives > Circle (Options) and change the Normal Axis to Y. Name it `L_Foot_Cntrl`.

Step 44: Group L_Foot_Cntrl to itself and name the new group L_Foot_Cntrl_Group.

Step 45: Move the L_Foot_Cntrl_Group and snap it to L_Ball_Joint.

Step 46: Orient Constrain the L_Foot_Cntrl_Group to the L_Ball joint. Remember to do this, in the Outliner, first select L_Ball joint, then Cntrl-select L_Foot_Cntrl_Group and choose Animation|Constrain > Orient. Then be sure and delete the orient constrain node it creates.

Step 47: Shape the handle. To do this, right-click on the L_Foot_Cntrl curve in the View Panel and select Control Vertex from the marking menu. Move the vertices (only along the X and Z axis) to create a shape you like around the foot (**Fig. 8.23**).

FIG 8.23 Shaping the handle around the foot.

Warnings and Pitfalls

It's fairly critical that the control vertices do not lift up off the floor plane. Be very careful to only move them using the X and Z handles.

Why?

The exact shape is fairly arbitrary. The goal is to get that foot handle, so that it is easy to see and grab to control the foot rig. Definitely make it bigger than the foot geometry, but not so big that it will get visually tangled with the other foot.

Step 48: Make L_Heel_Cntrl_Group, a child of L_Foot_Cntrl.

Step 49: Repeat steps 30–48 for the right foot.

Further Organization

We're in a good place for this rig. There are other things that could be done (individual handles for each of the back joints for instance). But for now we have a solid foot rig that will allow the lower body to be animated. The upper body will be animated by selecting the joints directly and rotating them.

What's left is to make sure we have the rig set up, so we can easily move the whole thing. So there's just a bit of extra organizing to be done.

Step 50: Create a really big letter. To do this, go to Create > Text (Options). In the Text input field, enter C (the alien's name just became Carl). Click the Create button.

Step 51: Look in the Outliner for an object called Text_C_1. This is the parent of the parent of the actual C curve. Expand Text_C_1 and Char_C_1 beneath it and select the curve1 object. Hit P (that's shift-p) to unparent this curve. Delete Text_C_1 and Char_C_1. Rename the curve to Carl.

Step 52: Scale and position the Carl curve, so it sits on the ground beneath the alien (**Fig. 8.24**).

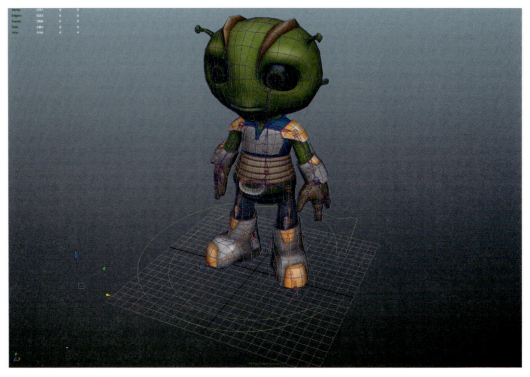

FIG 8.24 Positioned C.

345

Step 53: Clean up the C. Do this by first, moving the C's axis to 0, 0, 0 in world space. The easiest way to do this is to hold d and x down (d to move the axis and x to snap to grid) and dragging the manipulator handle into the center of the floor grid. Then choose Modify > Freeze Transformations.

Why?

All we're doing here is making sure that the C's handle makes sense – right beneath the alien – and that we have clean transformations for the C.

Step 54: Make all the joints and handles children of Carl. Do this at a time by middle-mouse dragging L_Foot_Cntrl_Group onto Carl, then middle-mouse dragging R_Foot_Cntrl_Group, and finally middle-mouse dragging Root onto Carl.

Warnings and Pitfalls

Safest to do this one at a time. If you shift-select all of these three objects and make them children of Carl, there can be some reshuffling of the hierarchy that is not good.

Step 55: Save and take a break.

Tutorial 8.2 Skin Weighting

Skin weighting or skinning is the process of attaching joints to a polygon mesh and deciding how the joints will actually deform the mesh. You've undoubtedly noticed that the joints of the rig will move but they don't actually do anything to the alien; there is no relationship between the two.

The process will consists of really two major steps. The first is establishing the initial link between mesh and joints, which we'll do with a **Smooth Skin**. In this step, Maya will make a guess as to which vertices are influenced by which joints.

The second step will be refining that initial guess that Maya makes. In some areas, Maya's guess will be pretty good, but in others, it will be terrible. Through a process called **Skin Weights Painting**, we will go in and help Maya understand exactly which vertices are deformed by which joints.

Step 1: Make the eyes children of the Head joint. To do this, in the View Panel, select one eye, then shift-select the other. Finally, shift-select the Head joint and hit p.

Tips and Tricks

Note you could also have done this in the Outliner by middle-mouse dragging each of the eyes onto the Head joint.

Why?

Parenting meshes to a joint is the easiest way to tie polygons to a joint. In this particular game situation, we aren't going to worry too much about animating the eyes. So, making sure that the eyes move when the Head joint moves will do the trick.

Step 2: Bind the mesh to the joint structure. To do this, in the Outliner, select the mesh that is the body and then Cntrl-select the Root joint. Choose Animation|Skin > Bind Skin > Smooth Bind (Options). In the Smooth Bind Options window, change Normalize Weight: Interactive and set Max Influence: 3. Hit the Bind Skin button.

Why?

There's a lot to this window, and actually now Maya allows for different ways of creating and controlling skin weights. The way we are going to use this feature provides the best understanding of the magic behind the curtain. Later, you may decide to use some of the other methodology to manage skin weights.

The core idea to take from this step is that we are telling each vertex that it can be influenced by up to three joints (Max Influence = 3). There could certainly be cases where this might want to be higher (a complex back rig), but for our game character where there are few joints, there are really no situations in which any one vertex should be controlled by any more than three joints. And in fact, most will be influenced by two joints, and some vertices should only be affected by one.

Step 3: Test the bind. Start doing this by selecting the Root joint and using the Move Tool to move this joint. This will probably look alright. But then start using the Rotate Tool to rotate joints like the Head joint or the L_Shoulder joint. The results will be pretty strange (Fig. 8.25). Be sure to undo any rotations you make to get him back into his bind pose.

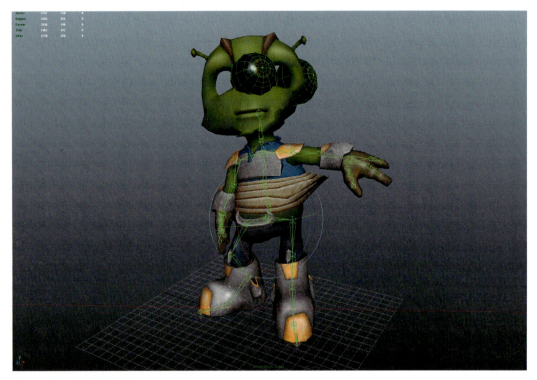

FIG 8.25 Testing the default bind. The results are usually pretty bad.

Component Editor

There are some areas where the binding will be pretty harsh. The head is one of those places. All of the vertices of the head should be influenced 100% by the Head joint. Among the quickest way to define this is through a tool called the Component Editor.

The Component Editor is basically a spreadsheet that will help us see where vertices are lending their influence to. Importantly, we can numerically define what the influences should be. The important thing to know is the paradigm that skin weights work within here.

The influence of each vertex is defined between 0 and 1. A joint that has an influence of 1 on a vertex has 100% influence – the vertex does what that joint does. A joint that has an influence of 0 on a vertex has no influence at all. A vertex can have its influence shared between joints – it can be .5 on one and .5 on another. Or, it can be .2 on one, .3 on a second, and .5 on a third. The key is the sum of the influences on any one vertex will always be equal to 1.

This means that if we define the influence for a vertex by any one joint to 1, Maya will strip all influence of any other joints on that vertex.

Step 4: Mask out the ability to select joints. Do this by turning off the joint mask at the top of the interface (**Fig. 8.26**).

FIG 8.26 Turning off the ability to select joints.

Why?

We need to be able to select some very specific components in the coming steps (vertices mostly). The problem is that Maya assumes that what you want to select are joints. This is very handy when animating and you want to be able to select through a mesh to grab hold of a joint; but it's really a pain for us here. By turning off the joint mask, we can select vertices without grabbing joints.

Step 5: Select the vertices of the head. The easiest way to do this is right-click on the alien mesh and select Vertex from the marking menu. Then Marquee select the head – this will select the vertices all the way through the head.

Tips and Tricks

It's a little hard to see selected vertices in a screenshot, so I'm not going to include one, but do make sure and rotate around the head to get an accurate selection on both sides of the head. The key here is to get all of the vertices of the head, but not down the neck.

Step 6: Assign the influence 100% to the Head joint. Do this by opening the Component Editor (Window > General Editors > Component Editor). Within the Component Editor, look for the Smooth Skins tab. There you will see rows that indicate the selected vertices (i.e., vtx156) and columns that indicate joints. Find the column labeled Head. Select the top cell in that column by clicking on it. Then scroll all the way down and shift-select the last cell in the Head column. Enter 1 and hit Enter.

Why?

The interface will clean up considerably. By assigning 1 to all the vertices of the Head joint, Maya has removed influence from all other joints and so removes them from the Component Editor for these vertices.

Step 7: Test the Head joint by selecting it and rotating it. The head should be holding its shape much better now (**Fig. 8.27**).

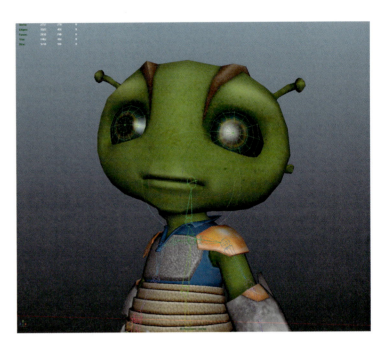

FIG 8.27 Updated head that maintains its shape through effective Component Editor manipulation.

Tips and Tricks

Since we've turned off the ability to select joints in the View Panel, you'll find the quickest way to do this step is to select the Head joint in the Outliner.

Painting Skin Weights

Using the Component Editor is a very cerebral way to adjust skin weights. Indeed, the entire mesh could be managed this way by numerically entering desired weights for each vertex; but man, what a drag that would be. This, in addition to the fact that it'd take forever to adjust the weights this way.

Maya has provided some other methods to make this happen. The most visually intuitive method is through a Painting Skin Weights methodology. The only problem with this is that painting skin weights is really not much like painting a house and much more like painting a portrait; it's an art and it takes a great deal of practice and experience.

This makes it a particularly challenging thing to write about (try writing out how to paint a portrait). It is best learned by doing it. So be prepared to do some experimentation to get the skin weights just right. But here are the basics of the technique.

Step 8: Enter the Paint Skin Weights Tool. You can do this one of two ways. First, right-click on the mesh and select Paint Skin Weights from the

marking menu. Alternatively, if the mesh is selected, choose Skin > Edit Smooth Skin > Paint Skin Weights (Options). Either way, the Tool Settings window will open on the left side of the View Panels (Fig. 8.28).

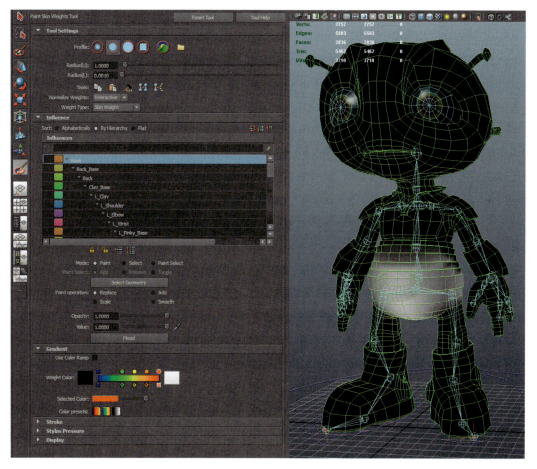

FIG 8.28 Paint Skin Weights Tool settings.

Paint Skin Weights Tool

There are several things that are important to talk through here before we get going on using this tool. The first is to realize this works with Maya's painting mechanism. When the Paint Skin Weights Tool is active, moving the mouse over the mesh will show a red circle that represents the size of the virtual paint brush that the user will paint with. By holding the b key down and dragging the mouse left and right, the paint brush size can be made bigger or smaller.

Next, take a close look at Fig. 8.28 and notice the Influence section. What is shown there are all the joints that are influencing the selected mesh. When any of these joints are selected within this Influences section, the influence of that joint will highlight on the mesh in the View Panel. So for instance, in Fig. 8.28, the Root joint is selected in the Influences section, and the influence of that joint

is highlighted white in the View Panel. The parts of the model that are white are influenced 100% by the selected joint, whereas parts that are completely black have 0% influence. And grays are everything in between.

The Mode area's default is Paint; which is generally what we'll use here as the idea is to paint the value of the influence of the selected joint. The Paint Operation indicates what to do to the painted vertices (in this case Replace the value). Below that in the Value input field is the value of the influence that it is going to be replaced with. So, in this case (Fig. 8.28), anywhere that the mesh was painted on would be assigned 100% (Value of 1) to the Root joint.

So my personal work flow for the painting process is as follows:

1. Start with extremities (work from the end of the toe up to the Root or from the finger tips to the spine).
2. Paint with 1 in areas that a joint should be influencing 100%. So for the L_Elbow joint for instance, I would paint (Replace with a value of 1) all the vertices from the elbow to the wrist – these are the vertices that should be moving when the elbow joint rotates.
3. Flood with a Paint Operation of Smooth. This softens the border areas where the influence goes from 1 to 0 and makes for a slightly softer transition in skin weights.
4. Repaint areas to fine tune the results of the flood.
5. After doing all the joints in the left side of the body, start again with the extremities. It usually takes three or four passes before the deformations on one side of the body are working as I'd like. The reason for this is the fluid nature of painting skin weights. Because vertices have a total influence of between 0 and 1, if influence is added to a particular joint, that influence is taken from someplace else. This means that areas that have been painted might not stay exactly as you painted them. Multiple passes start to narrow down and solidify your choices.
6. Mirror Skin Weights.

So let's see this in action.

> Step 9: With the Paint Skin Weights Tool active, paint the influence of the L_Ball. Do this by selecting L_Ball in the Influences section and painting (Paint Operation: Replace, Value: 1) from the ball out to the toe to match Fig. 8.29.

Why?

So why not paint anything to the L_Toe? Well, in reality, the vertices shown here would only be influenced by the L_Ball joint. In the other parts of the body (the fingertips and head), we deleted that last joint – but for the foot – to facilitate the foot roll rig, we left the joint there. But it shouldn't have any influence on the vertices.

FIG 8.29 Skin weight for the L_Ball.

Tips and Tricks

Don't forget to get the sole of the shoe.

Step 10: Smooth the transition. To do this, in the Paint Skin Weights Tool Settings, change the Paint Operation to Smooth and click the Flood button.
Step 11: Paint the skin weights for L_Ankle. Again, swap the Paint Operations back to Replace and paint in the areas the L_Ankle should be controlling (**Fig. 8.30**).

FIG 8.30 Ankle Skin Weights.

Why?

So notice that these initial passes are a little aggressive and tend to go a little wider that you'd originally think. Part of this is because we're going to flood the smooth operation, and we want to keep the core influence intact.

Tips and Tricks

For the ankles, be sure to get a really good solid influence painted on the heels.

Step 12: Repeat up the leg for the knee (**Fig. 8.31**) and the hip (**Fig. 8.32**). Continue and paint the area for the Root (**Fig. 8.33**).

FIG 8.31 First pass of knee skin weights.

FIG 8.32 Skin weights for hip.

FIG 8.33 Skin weights for Root.

Tips and Tricks

Remember that we are only painting for the left side of the body. For some things like the foot and leg, this is easy to remember, but also keep this in mind when working on joints like the Root. Even though the Root joint will eventually influence both sides of the mesh, you only need to paint one side now.

Step 13: Repeat the process for the arms by starting on the fingertips and moving up the hierarchy to the back (**Figs 8.34–8.36**).

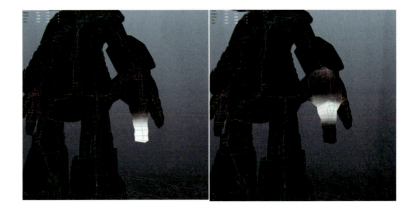

FIG 8.34 Finger skin weights.

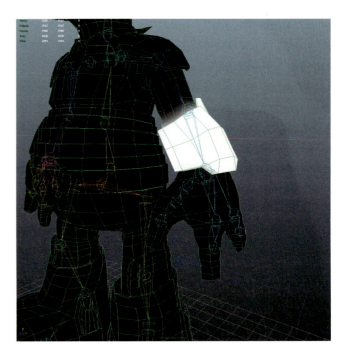

FIG 8.35 Elbow skin weights.

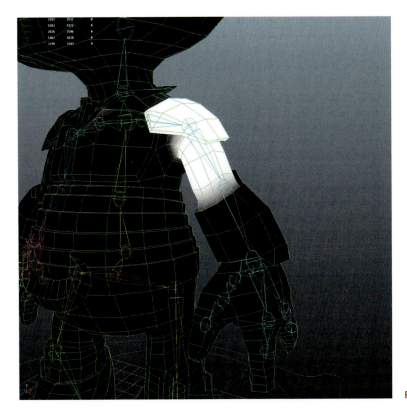

FIG 8.36 Shoulder skin weights.

Step 14: Repeat again from the neck down to the root.

Testing

Getting the skin weights right is unique to each and every model. The first pass through skin weights is almost never right. The way to test the skin weights efficacy is to start posing the character: start rotating the joints in the upper body. Move the feet control handles, and see if the character is deforming as planned. It probably won't.

Not to worry though. Remember that you can paint the skin weights when the character is posed. So move that leg up to a walking position, and then select Paint Skin Weights and paint the skin weights as they ought to be. Then just be sure to get all the joints back into position (enter 0 for Rotate X, Y, and Z for upper body, and enter 0 for Translate X, Y, and Z for the foot controllers).

Mirror Skin Weights

After testing one side, you can quickly move the skin weight work done on that side to the other.

Step 15: Mirror the skin weights. Do this by selecting the mesh and choosing Skin > Edit Smooth Skin > Mirror Skin (Options). Here, make sure Mirror Across: YZ and check the Direction: Position to Negative (+X to −X) check box. Hit Mirror.

Why?

The Mirror Across option here should be pretty clear by now (we're mirroring across a plane that would pass through the Y and Z planes). We check the positive to negative option because we have been painting the character's left – which is on the positive side of the X direction, and we want to copy from the positive X part of the character to the negative X.

Step 16: Test some more.
Step 17: Paint and adjust some more.
Step 18: Test some more.
Step 19: Paint some….ah, heck, you get the idea.

Conclusion

Painting skin weights is a journey. When it's working right, effective skin weights are magic as suddenly the character feels alive. But it takes a while to get them right. Even when you think they are right in this version, once the character starts to animate, new problems will appear that weren't obvious in the painting process. My solution is available for download at the supporting website, and I guarantee as I write the animation chapter, I'll discover problems that need to be addressed – and will go back and fix the skin weights. It's all part of the process.

Have fun with skin weights. It really can be a very zen-like experience filled with moments of interesting problem solving. Block off some good time to do this. A sloppy skin weight will forever affect the look of the animations you make with this rig. Getting it right is important.

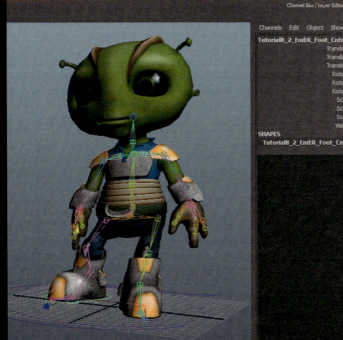

Animation in Maya

Animation is movement. Ironically, this means that a book on animation can present some interesting challenges. It's tough in the staid and static form of any book to show movement. There are some great examples of people breaking down movement through series of drawings (see Preston Blair's, Richard William's, Frank Thomas's, and Ollie Johnston's books); but sometimes the best way to see how to animate is to see it in action – which we obviously can't do here.

To further complicate things – and the reason I love animation – is that one can almost always get better at it. Every time I see some of my own animated work long after I've completed it, I'm a little mortified by what I'd produced. As I animate, I continually learn and get better. This means you've never really learned "to animate." True, you can learn to make things move, but ultimately, learning to animate is never a completed task.

It is within these restrictions that we begin this chapter with the disclaimer that the focus here is not going to be on the principles of animation, but the *tools* of animation that Maya provides. Now, within this scope, we will be talking about when to use which tools – which will necessitate discussion of animation situations and principles, but the focus is really on Maya.

This brings up one of the real fallacies of 3D animation. People think that if they know the tools, they know how to animate. This is very far from the truth and is akin to saying, "I know how to hold the paint brush – I can paint the Mona Lisa!" Learning the tools is necessary to start your animation masterpiece – but they don't animate for you, and don't create good animation by default. Getting the movement you want will evolve when the art of animation is realized through the technology we are covering in this book. The art part, well, that's up to you.

How Does Animation Work?

Walt Disney may have been a major influence on the original design of Mickey Mouse, but he never animated it. All the early animations of the new star Mickey Mouse (whom Disney originally wanted to name "Mortimer") were done by his longtime creative partner Ub Iwerks.

Iwerks was a master at the rubber-hose-like animation of the early '20s and '30s. Indeed, his work in the young industry of animation was frequently copied and widely admired. Of special importance was that Iwerks was fast and he could draw lots of frames quickly. This is important as what animation really *is* is a collection of still images – each slightly different from the last, that when played rapidly (as in 24 drawings per second) gives the illusion of movement. This means that just a few seconds of animation is literally hundreds of drawings. Iwerks could draw hundreds of drawings quickly, but as a founding member of Disney Studios – he was also a part owner, and expensive.

As the Mickey Mouse shorts – starting with *Steamboat Willie* in 1928 – began to take off and rise in popularity, Disney came to Iwerks with a proposition. Most studios were working in an assembly-line sort of way in which the Master Animator (the senior animator) would draw the most important frames – the **keyframes** – and then pass off the shot to cheaper, younger, and less-experienced animators to draw the frames in between these keyframes. This meant that the majority of the frames were drawn by those with the least experience – but it also meant that most of the frames were drawn by the cheapest work force.

This is how animation in 3D works. You are the Master Animator and you define the keyframes that define a movement. Then, the computer – the cheap workforce – fills in all the frames in between. Like its real-life counterpart, this means that the least-qualified animator – the computer – is drawing the most frames; but the Master Animator – you – can go back in and add additional keyframes to help the computer better understand how to animate the stuff in between.

By the way, Iwerks did not take well to this suggestion and left Disney Studios not too long after this (although there were other issues besides this). The junior animators who ended up drawing most of the frames became known as "in-betweeners" or "betweeners" or even just "tweeners." This is actually still

how this industry works today, although most of the in-betweening usually takes place in China or Korea.

Tutorials to Learn Maya's Animation Tools

In this chapter, we are going to approach animation in three tutorials. The goal of these tutorials is to learn many (although not all) of the tools that Maya provides to create good animation.

The first tutorial will be the classic hopping ball. Through this tutorial, we'll learn how to create keyframes and the start of an important tool called the Graph Editor. In the second tutorial, we will look at the Wave/Whip Principle and how it can be facilitated through the Dope Sheet. Finally, we'll start putting it all together into the final tutorial in which we'll animate the alien in a walk cycle.

Tutorial 9.1: Animating a Bouncing Ball

I've had several students go to interviews with a studio, and the studio – after the interview – performs a brief skills test. The test was, "So, you're tool is Maya? Ok, cool. Over there on that machine is Maya. Please animate a nicely bouncing ball. We'll be back in 10 minutes to see how you're doing."

The reason for this is simple. There are a lot of important animation principles going on with a bouncing ball – most critically, the idea of Squash & Stretch. It's the veritable flour sack (the movement test of many early 2D animators) of 3D animation. So let's see what we can do.

Step 1: Create a new scene and in this scene create a polygon plane for the ground and a polygon sphere for the ball (**Fig. 9.1**).

FIG 9.1 Sphere and plane.

Step 2: Move the axis to the bottom of the ball. In the side View Panel, select the sphere and the hold d and then v down (d to move the object's axis and v to snap to a vertex), and move the axis of the sphere to the very bottom of the ball.

Why?

The default manipulator is in the middle of the sphere, which means that when the sphere squashes the bottom of the sphere would lift off the ground (it will scale from the middle of the sphere). What needs to happen is that the sphere should squash from the bottom of the sphere (where the sphere will contact the ground), so we need to move the sphere's axis there.

Step 3: Snap the sphere to sit right on the ground. In the side View Panel, hold x (snap to grid) and move the sphere up so that it's sitting right on the plane (**Fig. 9.2**).

FIG 9.2 Moved sphere with appropriate axis.

Why?

Sometimes, close is good. But when animating something walking or hopping, "close" isn't good enough. That ball needs to really hit the ground – not pass through it, not float above it – but be right on the ground. The same would go for feet if the character was walking. This is where snapping to grid or vertices becomes very valuable.

Step 4: Freeze transformations. Select the sphere and choose Modify > Freeze Transformations.

Why?

We've moved the sphere from where it was first created. This means that it has dirty transforms (likely Translate Y = 1). This means that to get the sphere back on the ground, we need to get Translate Y to exactly 1 (and remember that this happens to be the value for this situation). A more intuitive method is to just have the sphere be a Y = 0 when it is on the ground. By freezing the transformations, we tell the sphere to make this position its origin. After this, if we ever want to be sure that the sphere is on the ground, we can just enter 0 in the Channel Box for its Translate Y.

Step 5: Set the Animation preferences. Do this by choosing Windows > Settings/Preferences > Preferences. In the left of the Preferences window, look for the Settings section and click on the Time Slider section beneath that. Then, change the Playback Speed to Real-Time (24 fps). Click the Save button to save changes and close the window.

Why?

Maya, by default is a bit of a show off. When an animation is played, it plays every frame as fast as it can. While this might show how great Maya can handle information, it's useless for animators attempting to find timing. By changing this Playback Speed to Real-Time, Maya will play the frames back at 24 frames per second. If it can play it back faster than that – it'll restrain itself and still only show 24 fps.

Of course, the bad part of this is that if the scene is too complicated for Maya to playback at 24 fps, it will start dropping frames to keep the playback speed. Luckily for us, we won't be working with a scene that is complicated enough for that to be a problem.

Time Slider & Range Slider

There are actually a lot of animation tools to which Maya gives access to the animator. However, it provides a default tool that is surprisingly powerful as part of its default layout.

Figure 9.3 shows a screenshot of Maya's Time Slider and Range Slider. What you're seeing there are hash marks that represent individual frames. By default, Maya (in a nod to its cinematic roots) animates at 24 frames per second (24 fps). So the duration of time for which 24 frames are displayed in the Time Slider is one second.

FIG 9.3 Time Slider and Range Slider.

The dark box represents the Current Frame Marker. This box can be moved (scrubbed) through the Time Slider and Maya will display the state of things at that particular time. At the right of the Time Slider is an input field that represents which frame this Current Frame Marker is on (and can be changed by altering the text in the input field).

To the right of that are some very DVD-player-esque controls that allow the animation to be played forward or backward, fast forwarded or reversed, and advanced (or reversed) frame by frame or keyframe by keyframe.

Beneath the Time Slider is the Range Slider. What this allows an animator to do is decide how many frames will be displayed in the Time Slider. So notice that by default, the Range Slider has defined that the Time Slider will show between frames 1 and 24, but that there are actually 48 frames currently in this animation. The Range Slider has a dark gray bar with numbers and boxes on either side. By dragging the boxes on either end of that slider the frames visible in the Time Slider can be increased or decreased. Similarly, the input fields on both sides of the slider allow for the total frames (far left and far right values) to be changed or the actual frames displayed (inside left and right values).

Importantly, whenever an object has a keyframe assigned to it, when it is selected, a little red line will appear in the Time Slider. However, the Time Slider will only display keyframes for the selected object(s).

Setting Keyframes

When an object is selected, there are several ways to set a keyframe for that object. The most basic way is to hit s on the keyboard. The good thing about this method is that it blankets all the assets and sets keyframes for everything that is keyable. By default, this means there is a keyframe set for Translate X, Y, Z; Rotate X, Y, Z; Scale X, Y, Z; and Visibility – 10 keys (all represented in the Channel Box).

But keys can also be set for individual attributes. Shift-w will set keys for Translate X, Y, and Z. Shift-e sets keys for Rotate X, Y, and Z. Shift-r sets keys for Scale X, Y, and Z. Additionally, in the Channel Box, any channel can be assigned a key by right-clicking it and choosing Key Selected.

There is a time and place for all these methods. For our basic work today, we will be just hitting s.

One final note about where to set keyframes. Tutorials have this illusion of creation as a linear process. The author says to move to a certain frame, set a key, move to the next specific frame, and set a key. In reality, animation is a very circular process. Setting a key is really a guess as to how long it will take to make a particular motion. As you animate more and more, your initial guesses will get better and better – and there are some general guidelines for timing (march time for walks for instance), but remember that the timing of any and all these keys are subject to change. You can and should adjust where these keys are to refine any and all motion into something of use.

Step 6: Set a keyframe at frame 1 for the sphere. Do this by selecting the sphere and hitting s.

Why?

It seems like nothing happens, but if you look at the Time Slider, there will be a red line on frame 1 (assuming that the Current Time Marker is at frame 1) indicating that this is a keyframe.

This first keyframe is important as it lets Maya know "this is where the animation should start, and the shape of the sphere before it starts deforming."

Step 7: Animate the squash with a keyframe at frame 8. To do this, first move the Current Time Marker to frame 8. Then, with the Scale Tool, first scale the sphere down in Y only by dragging on the green cube handle. Then, scale the sphere up in all directions by dragging on the middle light blue cube. Finally, be sure and hit s to set the key (**Fig. 9.4**).

FIG 9.4 Setting the squash (with consideration for Conservation of Volume).

Why?

To make a ball believably hop on its own accord, we must take hints from how a person would hop. The first thing a person does when hopping is compress the muscles that will provide the upward thrust – he squashes.

But it's not enough just to make the sphere get squattier. There is an important concept in animation called "Conservation of Volume," which focuses on the amount of material that is in an object remaining constant regardless of how it deforms. If this sphere were a balloon and we pressed down on the top, the amount of air within the balloon wouldn't change, it would just reshape. This means that as the sphere gets shorter in Y, it has to get wider (fatter) in X and Z.

Step 8: Animate the stretch at frame 12. Do this by moving the Current Time Marker to frame 12 and then use the Scale Tool again to scale the sphere tall (with the green cube handle), and then very skinny (with the blue cube handle). Hit s to set the key (**Fig. 9.5**).

FIG 9.5 Setting the stretch keyframe.

Why?

This is the second half of the critical Squash & Stretch principle. As a person jumps, he uncoils those compressed muscles and stretches out to a long pose *before* lifting off the ground. This explosion of energy happens much faster than the squash (this is happing over four frames here).

Notice that we are also still working with Conservation of Volume. As the sphere gets really tall, he needs to get really skinny.

Step 9: Set the keyframe for the top of the hop. To do this, move the Current Time Marker to frame 24. Use the Move Tool and move the sphere up into the air along the Y axis to where you figure the top of the hop would be (I'm using Y = 8). Then, in the Channel Box, change the Scale X, Y, and Z values to 1. Hit s to set the key (**Fig. 9.6**).

Why?

One of the advantages of freezing the transformations as we did earlier is that when the ball needs to get back to regular size (Scale), we can just set the Scale X, Y, and Z to 1 in the Channel Box and we're there.

In other news, in this step, we are both moving and scaling, but hitting s once will set the keys for Scale and Position (and Rotation too, by the way, even though we aren't changing this).

FIG 9.6 Ball at the top of the hop.

Step 10: Increase the visible frames to 48. Do this with the Range Slider by dragging the right end of it out to fill the entire 48 frames.

Step 11: Set the keyframe for the landing. To do this, we'll explore a little bit different method. This keyframe on the landing will look very similar to the keyframe where the sphere leaves the ground (frame 12). Move the Current Time Marker to frame 12 and then right-click-hold on it and choose Copy. Then, move the Current Time Marker to frame 36 and again right-click-hold and choose Paste > Paste (**Fig. 9.7**).

Why?

This is frequently a problem for students. They know that when the character hits the ground, they squash. The important detail here is that it's *because* the character hits the ground that he squashes. This means that the moment the ball touches the ground, it still needs to be stretched. It'll squash in just a bit.

This method of copy and pasting keyframes can help speed time up and generate some nice consistency across the animation. It turns out that Maya's copy/paste mechanism is really deep and can be really complex. But for this situation, the standard method shown in step 11 works great.

FIG 9.7 Setting the key that defines the moment of impact.

Step 12: Copy and paste the squash keyframe to frame 40. Copy the key at frame 8 and paste it into frame 40.

Step 13: Copy and paste the rest key from frame 1 to frame 48.

Step 14: Play the animation. Do this with the VCR looking controllers in the Time Slider or by hitting Alt-v (Alt-v will also stop the playback).

Refining Animation

Well, it's moving. And it's got squash and stretch happening. But it's still a long way from plausible or appealing. This is the nature of animation – at least for me. My first pass is almost always wrong – or at least not right.

This is where the power of the computer as an animation tool starts to emerge. We're not tied into the choices of timing or position, and in fact, we can change things in a hurry.

Overwriting Keys

The first way we're going to look at editing animation is to simply write over an existing keyframe. This is pretty easy; just move the Current Time Marker to a frame that already has a key, make changes and when s is hit again, this new key will replace the old one.

Step 15: Make the hop higher. To do this, move the Current Time Marker to frame 24 (the top of the hop). Use the Move Tool to move the sphere higher (say Y = 12). Hit s to overwrite the keyframe.

The Graph Editor

The Graph Editor is an extremely powerful – although not always intuitive – method of adjusting animation. To access it go to Window > Animation Editors > Graph Editor. What this will do is provide a graph of the keyframes assigned to any given object.

For instance, **Fig. 9.8** shows the Graph Editor for pSphere1. Along the left side you can see the object selected, and a list of all the attributes that have keyframes (Translate X, Translate Y, etc.). If any of these attributes are clicked, the graph on the right will show only the keyframes for that attribute.

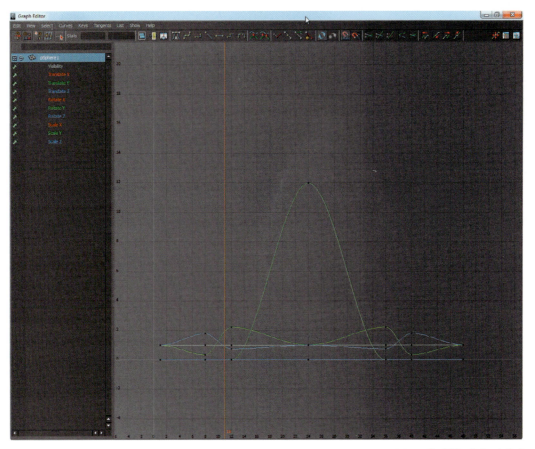

FIG 9.8 Graph Editor for first draft of the sphere's jump.

Keys are represented by black dots within the graph area. These keys can be selected and moved, scaled, or rotated. Maneuvering in this graph space is consistent in Maya. Alt–middle-mouse-drag pans around, Alt–right-mouse-drag zooms in and out. Finally, hitting f on the keyboard will focus the active elements.

The Graph Editor will always show the time (by frames) across the X axis. The Y axis will be values that change depending on what attribute is selected. For instance, if Translate Y is selected, the Y values represent centimeters (the default Maya unit). But, if Rotate Y is selected, the Y values represent degrees.

One key thing that is a little different here is that to move a key either in time (by shifting it along the X axis) or in value (by shifting it along the Y axis) requires you to first be in the Move Tool (hit w on the keyboard) and then middle-mouse-dragging.

Step 16: Make the hop still higher through Graph Editor manipulation. The height of the bounce is defined by the Translate Y values. With the sphere selected, in the Graph Editor, click on the Translate Y in the left side list of attributes (this will show only the keys for Translate Y). Swap to the Move Tool (hit w on the keyboard). Select the key that represents the top of the hop. Hold Shift down and middle-mouse-drag the key up to around Y = 16 (**Fig. 9.9**).

FIG 9.9 Adjusting animation by moving keys in the Graph Editor.

Anatomy of a Curve

The Graph Editor is about curves. Being able to read the curves and manipulate those curves is what makes this tool powerful. Consider the following curves (**Fig. 9.10**).

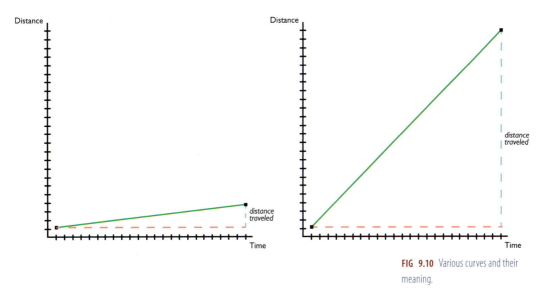

FIG 9.10 Various curves and their meaning.

These curves represent a Translate curve within the Graph Editor. Again, the X axis shows time and the Y axis shows distance. In both the curves, notice that the movement happens over the same amount of time, but the one in the left travels a far shorter distance than that in the right. This means that the graph on the right shows an object traveling much faster. Steeper curves represent faster movement.

Now, to continue on with this, check out the curves in **Fig. 9.11**.

In these two examples, the two keyframes are in identical locations. The difference is how Maya is interpolating between the two. In both the cases, I've split up the time into two equal halves. Notice that in the image on the left, the distance traveled is a lot more over the first half of the time covered than in the second half. This means that this object shoots off in a hurry and then eases to a stop.

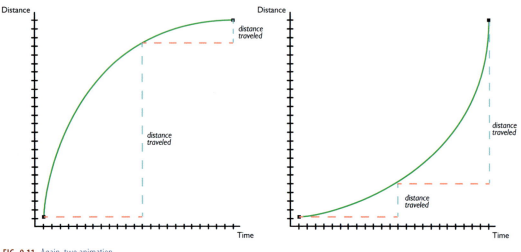

FIG 9.11 Again, two animation curves as they would appear in the Graph Editor.

Conversely, the image on the right shows a curve in which the distance traveled over the first half of the time covered is very little compared to that traveled over the second half of the time. This is an object that travels very slowly at first and speeds up as it goes.

The funny thing about those two graphs is that the keyframes themselves are identical – it's all about how that curve goes between the two. Clearly, controlling that curve makes a big difference in the movement of an object.

Bezier Curves, Anchors, and Handles

The Graph Editor allows you to adjust curves in much the same way that tools like Adobe Illustrator do. We've looked at Bezier Curves in earlier tutorials, and the core idea here is the same. Each of the keyframes acts as the anchor, and off of that anchor will be two handles that determine how the curve comes in and goes out of that anchor (**Fig. 9.12**).

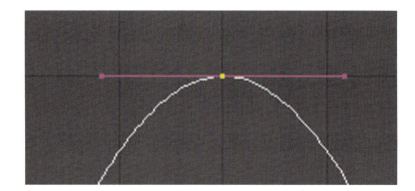

FIG 9.12 Default tangents of a selected keyframe.

To manipulate tangents, first the keyframe must be selected. When this is done, the keyframe will highlight yellow and the tangents will highlight pink. Now here's where it gets a little clumsy. By default, the curves that Maya builds in the Graph Editor use Locked, Non-weighted Tangents. What this means is that the tangent handles are the same length for every anchor (non-weighted) and are unable to be lengthened (locked). We want to be able to grab ahold of those tangent handles and bend them in all directions and change their lengths to really have control over how those curves – and thus the motion – work coming in and out of keyframes. Let me show you why (**Fig. 9.13**).

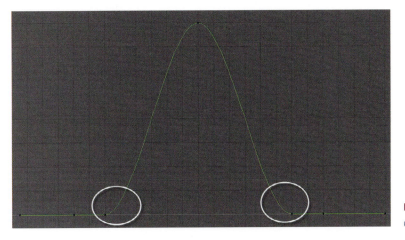

FIG 9.13 The Translate Y curve for our sphere.

Of particular interest are the two highlighted areas at frames 12 and 36. Frame 12 is where the sphere leaves the ground and frame 36 is where it touches down again. Notice that before frame 12 and after frame 36, the line is flat – meaning that the sphere does not move in Y at all (which is what it should be doing). The problem is that at frame 12, the curve is flat going out of the key. And then again, in frame 36, the curve is very flat coming into frame 36. This means that at the frames immediately following lift off (frame 12) – when the sphere has exerted enough force to lift it off the floor (an *explosive* amount of energy), it is traveling very slowly. Likewise, at frame 36, when the sphere has been falling the farthest, it suddenly – right before hitting the ground – slows down. Both are just plain wrong.

What should be happening is a very sharp vertical curve coming off of frame 12 and a very sharp vertical curve coming into frame 36. To do this, we need to be able to control the tangents – and specifically to break them.

> Step 17: Weight the Tangents. To do this, select the sphere and then in the Graph Editor click on the Translate Y attribute. Hit f to frame this curve. Click on the green curve in the graph area. Choose Curves > Weighted Tangents.

Why?

The handles will change a little bit in the Graph Editor. The tangent handles themselves will get slightly larger circles on their ends. But importantly, they will no longer be the same length going in and out of the anchor (take a close look at the tangent handles at frames 12 and 36 for example).

Step 18: Free the Tangent Weights. To do this, with the Translate Y curve still selected, choose Keys > Free Tangent Weight.

Why?

The handles will change in appearance again. The end of the tangent handles will appear as squares. This means that now these handles can be grabbed and shortened or lengthened.

Step 19: Add some extra hang time. At the very top of the hop the sphere's upward energy is giving way to gravity. This is the point where the speed of the sphere in Y will be the slowest. To help pump this up, we'll make the curve flatter at the apex. To do this, marquee drag around one of the tangent handles for the key at frame 24 (at the top of the hop). Using the Move Tool, and while holding Shift down, middle-mouse-drag the tangent handle outward (**Fig. 9.14**).

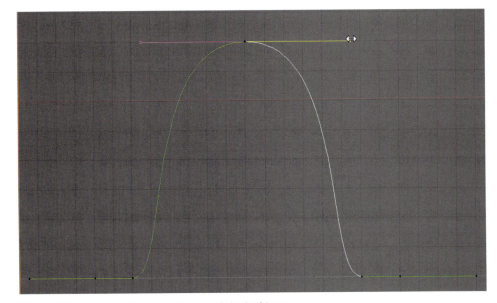

FIG 9.14 Adding hang time by flattening out the curve at the height of the jump.

Why?

So now the curve coming in and out of that key is flat, meaning that the sphere is traveling very slowly through the frames before and after this key.

Tips and Tricks

Selecting things in the Graph Editor can be a little tricky. Get used to using the marquee-select (dragging across the curve or key you want to select). It's different than simply clicking on a curve or key; and for our purposes will actually expose the things we need to adjust.

Step 20: Explode off the ground. Do this by breaking the tangents at frame 12. To make this happen, marquee-select the key at frame 12 (all this is done within the Graph Editor). Then, choose Keys > Break Tangents. Marquee-select the handle on the right and middle-mouse drag it straight up (**Fig. 9.15**).

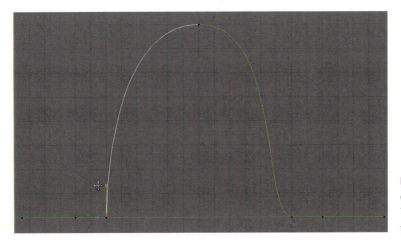

FIG 9.15 Creating a quick explosion off the ground by breaking the Translate Y tangent and pointing the tangent straight up.

Why?

A unified tangent means that the two handles on either side of the tangent are connected. So when one handle is grabbed, the other side stays straight in line – as though they were two ends of a stick. In this case, we want there to be a clear, sharp break at the key. So breaking the tangents allows us to alter one handle without changing the other. By moving this tangent straight up, the curve going out of the key at frame 12 becomes very sharp, which means that the speed will be very fast; the sphere will be exploding off the ground with enough energy to overcome the force of gravity.

Step 21: Repeat for the key at frame 36 (**Fig. 9.16**).

FIG 9.16 Broken tangent with sharp tangent at landing key.

> **Why?**
>
> The sphere will travel faster the farther it falls (until it reaches terminal velocity). It should be traveling the fastest right before it hits the ground. This means that the Graph Editor's curve should be the most vertical going into the frame 36. Breaking the tangent and making it vertical does just that.

Step 22: Play the animation. Do this back in the View Panel with the Time Slider. You should see an immediate difference.

Conclusion

Pretty cool, huh? The animation of that sphere should immediately feel more lifelike and like it has real weight. This comes from effective Graph Editor work and knowing what the curve should look like.

In my university classes 7 out of 10 times, the problems with assignments turned in can be solved with further work in the Graph Editor. It can sometimes feel "unartistic" to be mired deep in Graph Editor curves, but an animator who is comfortable in the Graph Editor produces better animation faster and more efficiently. Make the Graph Editor your friend.

Tutorial 9.2: Wagging a Tail

The bouncing ball is a good start and shows some great understanding of concepts like Squash & Stretch and Conservation of Volume. Another key idea of animation is the Wave/Whip Principle – the idea of organic motion happening like a whip.

For instance, consider a dog's tail. The part of the tail nearest the dog's body will move first, with each vertebrae of the tail farther away moving slightly later. When each part of the tail is moving just a little later than the part before, the beautiful wave begins to emerge.

Maya provides some very quick ways to get this just right. On the one hand, you could manually go in and set a whole lot of keyframes to get that motion correct. But we can also set a bunch of keyframes en masse and then go back and adjust the timing to get the wave principle to emerge.

To look at this, we'll create a string of joints that we'll animate. In this example, we won't bother skinning the joints to any geometry, but it would work just the same if the joints were actually deforming a mesh.

Step 1: Create a new file.
Step 2: In the top View Panel, create a tail as a string of joints (**Fig. 9.17**). The exact number and size is unimportant. I'm using 11 joints that I snapped to the grid (holding x down) so they were pretty much in a straight line (although this too is cosmetic).

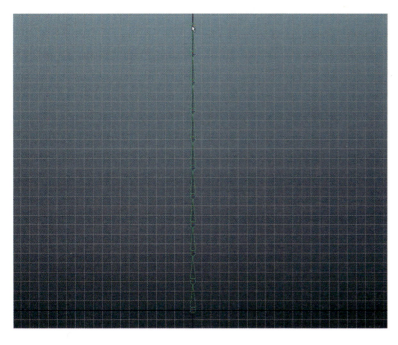

FIG 9.17 Creating the tail with a string of joints.

Step 3: Pose all the joints rotated to one side and set a keyframe for all. Do this by shift selecting each of the joints individually, starting from the tip and moving up to the base. Then, using the Rotate Tool, rotate all of the joints at once (**Fig. 9.18**). Hit s to set a keyframe for all these selected joints.

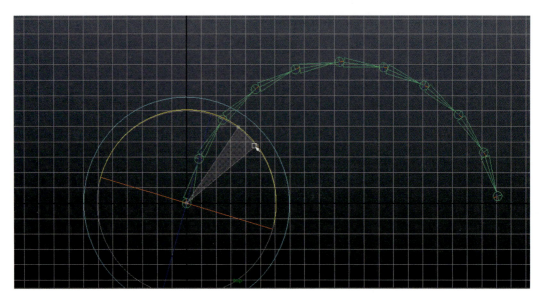

FIG 9.18 Rotating all the joints
15 degrees to one side.

Why?

By selecting all the joints – one at a time – and rotating them together like this, we know that each of the joints are rotated the same amount. It saves loads of time being able to rotate them all at once – the cumulative effect is a quick curve. This also means that when hitting s to set a keyframe, each of the joints all get their own keyframe – just what we need.

Tips and Tricks

You may take note of what the Rotate Y value is in the Channel Box (mine is 15). This will just allow for some nice symmetricality when posing to the other side.

Step 4: Set a keyframe for the joints rotated in the opposite direction. To do this, first move the Current Time Marker to frame 10. While all the joints are still selected either rotate using the Rotate Tool, or simply look at the Channel Box and make the Rotate Y value a positive value (if it was negative). Hit s to set another keyframe for all of these joints (**Fig. 9.19**).

Why?

Scrubbing between frames 1 and 10 will show the tail moving, but it will look really stiff. Yes, all the joints are rotating over this period, but there is no wave principle happening. We need to fix that.

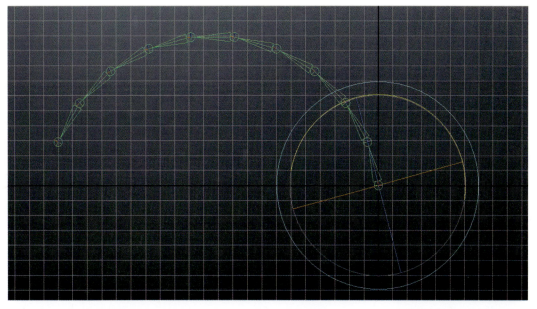

FIG 9.19 Rotating the joints in the opposite direction. This can either be done with the Rotate Tool, or by entering a positive value in the Channels Box.

Step 5: Increase the overall length of the animation. Do this in the Range Slider by changing the input field that reads 48 (the overall length of the animation) to 150. Then, use the Range Slider to show all 150 frames by dragging the bar wide so it includes from frames 0 to 150 (**Fig. 9.20**).

FIG 9.20 Adding frames to the length of the animation.

Step 6: Copy and paste the two keys to frame 20. To do this in the Time Slider click on frame 1 and then Shift-drag across to include frame 10 (it will highlight in red). Right-click-hold anywhere in the red area and choose Copy. Click on frame 20 to move the Current Time Marker there, and then right-click-hold and choose Paste > Paste.

Step 7: Paste to frames 40, 60, 80, 100, 120, 140. For each of these frames, click on the frame, then right-click-hold and choose Paste > Paste.

Why?

What's happening here is that we are copying the pair of frames and pasting them every 20 frames. The net result will be the tail wagging back and forth. Since the pose at frame 20 is the same as at frame 1, when Maya rotates between frames 1 and 10, it will then rotate back to the pose it has at 1 (now pasted to frame 20).

Dope Sheet

Figure 9.21 shows the Graph Editor for the current animation. All of the joints are selected and there is one monolithic green curve (Rotate Y). All the joints are rotating the same amount at the same time.

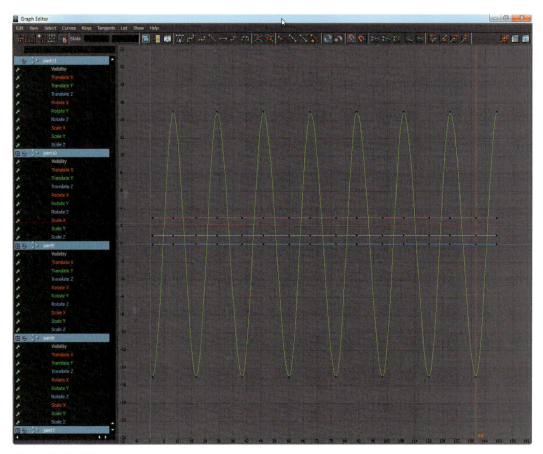

FIG 9.21 The Graph Editor for our current animation. All the joints are moving the same amount at the same time.

To get the wave principle working, we need each joint to do the same rotation, but just a little later than the joint above it in the hierarchy. While this could be done in the Graph Editor – or even in the Time Slider – it would be exceedingly laborious.

But this sort of frame offsetting is perfect for the Dope Sheet. Historically, the Dope Sheet was a planning document used in 2D animation that allowed a director to plan parts of the shot. This could include everything from action-specific notes to camera movement ideas.

In Maya, the Dope Sheet (Fig. 9.22) is accessible via Window > Animation Editors > Dope Sheet. It is also a sort of visual spread sheet but is more about

timing than values. It shows what keyframes are on what object at what time – but doesn't provide much in terms of values of those keys.

FIG 9.22 The Dope Sheet.

I like to use the Dope Sheet to offset keyframes. When moving keyframes in time, the Dope Sheet automatically snaps to a frame (so you don't end up with a keyframe at frame 12.462), and it provides a more condensed way to access collections of keys than the Graph Editor does.

Again, maneuvering within this space is the same: Alt-middle-mouse-drag pans across the time while Alt-right-mouse-drag zooms in and out. Selecting keys in this view also works best by marquee-selecting them, and actually manipulating them (like moving them) uses the middle-mouse-drag mechanism.

Step 8: Offset all the keyframes for joint2 and down by one frame. Do this in the Dope Sheet by first zooming out to see all the keys. Marquee

around all the keys for joints joint2–joint11. Activate the Move Tool (hit w) and middle-mouse-drag the keys one frame to the right (**Fig. 9.23**).

FIG 9.23 Offsetting keys by one frame.

Step 9: Repeat, but this time select the keys for joints3-joint11 (**Fig. 9.24**).

FIG 9.24 Again offsetting keys, but this time from joint3 to joint 11.

Step 10: Repeat all the way down the chain; each time leaving off one more joint and each time sliding the keys down one frame (**Fig. 9.25**).

FIG 9.25 All the joints' keys offset.

<div style="border:1px solid">

Why?

So the results here are all the same animations happening, but each joint's animation is happening one frame later than the joint above it. This makes quick work of adjusting a lot of keyframes.

</div>

Step 11: Play the animation. There should be a sexy looking wagging tail full of great looking wave principle.

Conclusion

So this idea of breaking down a string of joints goes way beyond the scope of just wagging tails (although its illustration is particularly clear here). A character walking will exhibit this wave principle in their arms (shoulder, elbow, wrist, and even fingers for lanky characters), their backs, and especially in things like floppy hats or even ears. Being able to create effective wave principle by creating poses and then offsetting the keys in the Dope Sheet allows for a beautiful fluid animation in a short time.

Tutorial 9.3: A Walk Cycle

Yes, it's a big jump to go from a wagging tail to a walk cycle. Walks are among the most complex animations around – a symphony of rotations, twists, and weight; and often students attempt it way too early. Walk cycles are often best done by animators who have set a whole lot of keyframes in their career.

So, with that understanding, we're going to tear into it here. The goal, of course, is not to have a perfect walk cycle at the end, but to have a decent cycle that helps explain one approach to character animation.

Game Character vs High-Rez Character

Carl—the alien—is a low-poly character. He's been modeled, textured, and rigged as a game character. We are going to continue this trend with this walk cycle.

This means that we are going to make a true cycle. High-rez characters – for things such as movies and TV – should hardly ever have a true cycle. When we walk down the street, each step is just a little different from the one before. We are constantly adjusting for changes in the surfaces we are walking across, we're looking around, walking different if it's a man approaching us than if it's a woman. And still different depending on how attractive the person is who's approaching us.

But in games, we are looking for a narrower, sleeker collection of data. While a character for a movie might have a walking animation that is 1200 frames long, for a game we'll want to keep this much shorter; in this case, 24 frames.

Further, for TV/film, it will be important that when the foot lands on the ground, or a step, or a rock, that it stays there until it's time for it to lift again for the next step. We don't want any slippery feet. But for a game, the actual translation of a character is usually driven by script and user input. What happens is the game engine tells the character, "Move forward, and while you're doing it, go ahead and play the walk cycle animation." The rough visual effect is the character walking along the surface; but a really close look will often yield a bit of sliding of those feet across the surface.

This means that we'll be animating this character as though he were walking on a treadmill; the imaginary floor will be sliding beneath him while he stands in place. This is actually a really nice way to start learning to animate a walk cycle as the character stays in the middle of the screen.

Layered Animation

There are lots of different ways of approaching a walk cycle. There is so much happening there, that sometimes the biggest challenge is just keeping track of what is happening when. Some animators like to go from completed pose to completed pose – they pose every joint on the character (setting keys for each joint as they go) – and then move to the next keyframe and completely pose every joint for this new time. This can work, but can get pretty tricky to keep everything straight.

I prefer to work with a much more layered approach. I tend to animate just the legs first and get the cycle complete with just the legs animating. Then, animate the feet within that movement, then the back, and then the arms. This happens in multiple passes with all the keys for all the frames being set for the particular region being animated. It means the animation looks goofy at first, but helps me keep in mind when everything should be doing what.

Step 1: Set the project and make a new file.

Step 2: Select File > Create Reference. Navigate to the rigged version of your alien and click the Reference button.

Why?

Referencing a file links to that file – but doesn't import it directly. This is a great way to work in animation situations. What it means is that if you have 40 scenes that all use the same referenced character, and you make changes to the original character, every scene that the character is referenced in will be automatically updated. This is of great help when animating and discovering skin weights issues, as you can adjust skin weights in the original and not have to reimport or reanimate all the situations where the character is placed.

Animating a referenced character is the same as though you were actually animating the original. The restrictions are that you can't delete any parts of a referenced file. And, if you need to adjust the skin weights, you have to open the original and change things there, then re-open the Maya scene where the file is referenced. Still the benefits wildly outweigh the drawbacks.

Step 3: Save the scene as `Alien_Walk.mb`.

Anatomy of a Walk

There are several ways to attack a walk. For us, here we will be splitting the walk into five main poses: left footfall, low, passing, high, and right footfall (**Fig. 9.26**).

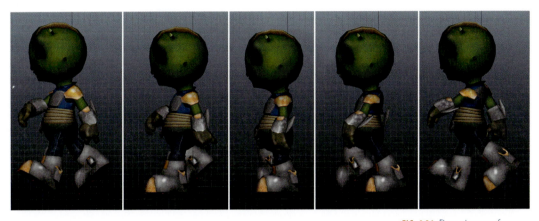

FIG **9.26** Five main poses of the walk.

There are other things that happen between these poses – particularly in the feet; but these five are the key poses.

Standard march time is a walk cycle in one second. This means for us our left footfalls will be on frames 1 and 24 (one cycle). The right footfall will be in the middle (frame 12). Passing poses will be halfway between each (at frames 6 and 18). The low and high poses happen between the footfalls and passing poses. For simplicity's sake, we'll have low poses for one side at frame 4 with its high at frame 9 and for the other side low will be at frame 15 and high at 21.

Knowing these numbers will give us a good groundwork upon which to start to set keyframes for the hips and feet.

Step 4: Position the alien. Select the big C (or whatever your letter is) and move the alien so that his root is about at $Z = 0$ (**Fig. 9.27**).

Why?

In my case, the alien was modeled not sitting with his center of weight in the Z axis. Although this isn't critical, it makes seeing where the weight of the character is and how far forward each of the feet is much easier.

This is really the beauty of the master curve – the big C. We can move everything at once to wherever the animation is to begin.

Step 5: Animate hip Y rotation for left footfall pose. When the left foot is forward, the left hip will be forward and vice versa for the right foot. Select the Root joint (which controls the hips). Make sure the Current Time

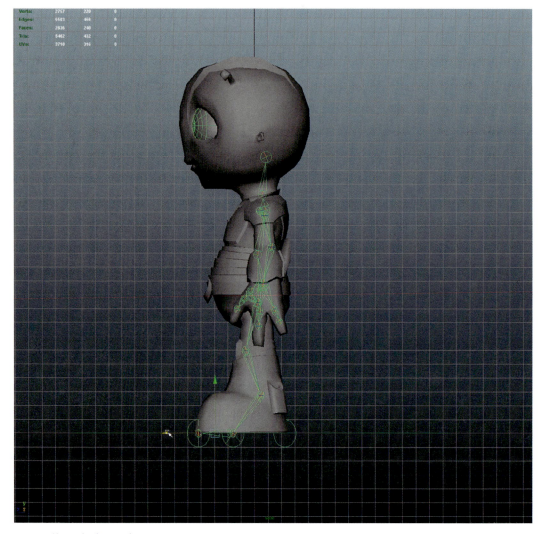

Verts:	2757	220	0
Edges:	6683	466	0
Faces:	2836	240	0
Tris:	5462	432	0
UVs:	3710	316	0

FIG 9.27 Moving the alien into place by using the big C.

Marker is at frame 1 and rotate the hips around −10 degrees in Y. You can do this either with the Rotate Tool, or by manually entering −10 in the Channel Box (**Fig. 9.28**). Hit s to set the keyframe.

Step 6: Set an identical key at frame 24. Still with the Root selected, move the Current Time Marker to frame 24 and hit s again.

Why?

We're animating a cycle here, so the first frame and the last frame should be the same. By setting the key twice while the object is selected, we keep things clean and avoid having to do a lot of copy/pasting of keys later.

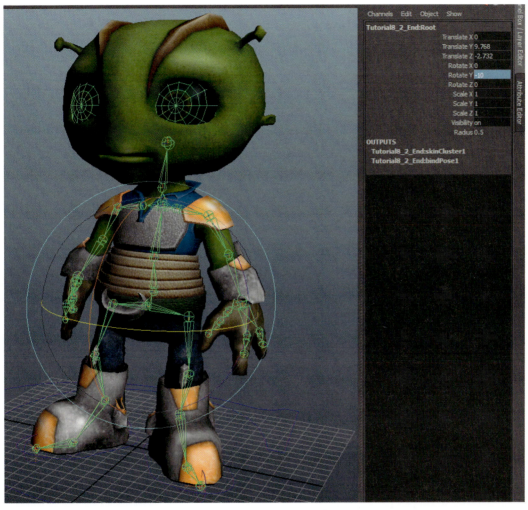

FIG 9.28 Setting the first hip rotation pose by setting a keyframe for the Root joint.

Step 7: Set hip Y rotation for right footfall pose. Move the Current Time Marker to frame 12 and rotate the hips to Y = 10. Hit s to set the key.

Tips and Tricks

When changing values in the Channel Box, hitting s won't set the key. Be sure to move the mouse over to the View Panel before hitting s.

Why?

Frame 12 is the frame where the right footfall pose will be; thus, here's where the hips will be rotated opposite of the left footfall pose.

Step 8: Set keys to show weight on passing poses. When the weight is all on one foot (as it is in the passing poses), the hips will rotate to show this. Additionally, the hips will slide over the top of the leg that is bearing the weight. Move the Current Time Marker to frame 6 (when the left foot is on the ground and the right foot is passing). Select the Root and rotate it around its Z by 5 degrees (this can be done visually or in the Channel Box) and move the joint over in X so that it is more over the left foot (for my scale this was 1.5 units [Fig. 9.29]).

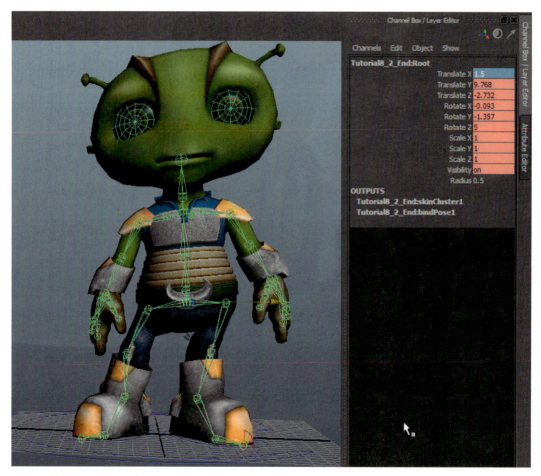

FIG 9.29 Setting keys to show weight in hips.

Step 9: Repeat for the other passing pose at frame 18. Of course, here the hips will be shifted over the right foot (−1.5 units in X) and rotated opposite (Rotate Z = −5).

Tips and Tricks

For fun, play the animation now. Groovy little dance he's doing.

Why?

There are other hip animations that need to take place – particularly its animation in Y for the high and low poses. However, we're going to hold off on this for the moment as it will be easier to see how high or low it should be once we get the feet in place.

Step 10: Position the feet (L_Foot_Cntrl and R_Foot_Cntrl) for a left footfall. Notice that this does not include the foot roll at all, it's just the placement of the feet. Don't take very big steps, but get the left foot in front and the right foot behind. Place them so the character looks balanced between the two (Fig. 9.30). Be sure that after posing L_Foot_Cntrl, you hit s and then pose R_Foot_Cntrl and hit s again.

FIG 9.30 Placing the feet for a left footfall.

Why?

I know, he looks broken right now. Part of this is because we are asking the leg to stretch farther than it is able. Not to worry though, once we get those feet rolling, this will clean up.

Step 11: Set keys for both at frame 24. Do this by moving the Current Time Marker to frame 24 and then select each of the controls and hit s for each.

Why?

Still animating the loop. Frames 1 and 24 should be the same.

Step 12: Position the feet for right footfall (just mirrored of left footfall) at frame 12. Be sure and set a key for each.

Step 13: Set keys for passing poses. Do this at frame 6 by lifting the R_Foot_Cntrl just a little off the ground and setting a key (**Fig. 9.31**). Then again at frame 18 lift the L_Foot_Cntrl just a bit and set another key.

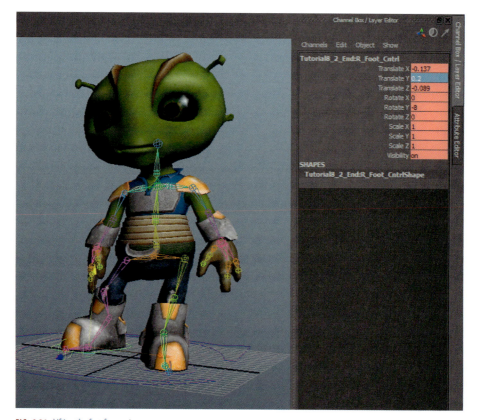

FIG 9.31 Lifting the feet for passing pose.

Foot Rolls

Now that we have basic placement, we need to start to get the foot roll working for us. This will help solve some of the hyperextending knee problems that we have and put us in position to better place the root.

A few notes about the foot roll rig. Each of our foot roll handles is built to give the foot a new axis along which to rotate. This means that the best solution will be to generally have only one of them activated at a time. If the heel handle is activated at the same time as the toe, it will lift the foot in strange ways.

To help keep this from happening, I like setting keyframes for all three handles on each foot, at every place there is a foot roll key. So if the character is posed with its heel touching the ground (like he will on left footfall), I set a key not only for the L_Heel_Cntrl, but also for L_Ball_Cntrl and L_Toe_Cntrl.

> Step 14: Pose the left foot roll for left footfall. This is done at frame 1. Rotate the L_Heel_Cntrl up (Rotate X = −30) to make it so that the heel is hitting the ground (**Fig. 9.32**). Hit s to set the key. Also be sure to select L_Ball_Cntrl (hit s) and then select L_Toe_Cntrl (hit s).

FIG 9.32 Using the left foot roll rig to pose the left foot at the left footfall pose.

Step 15: Jump to frame 24 and set a key for each of the three foot roll handles again.

Step 16: Set the left foot to be flat on the down pose. Do this by moving the Current Time Marker to frame 4 and rotating the L_Heel_Cntrl back to 0. Hit s to set the key and do the same for L_Ball_Cntrl and L_Toe_Cntrl.

Step 17: Keep it flat to the passing pose at frame 6. Move the Current Time Marker to frame 6 and make sure that L_Heel_Cntrl, L_Ball_Cntrl, and L_Toe_Cntrl are all set to Rotate X, Y, Z = 0 (the foot flat). Set a key for each.

Why?

When that foot is the only thing holding the character up, the foot will be flat as long as possible. Keeping it flat between the down pose and passing pose will help ground the character.

Step 18: Rotate the foot up on the ball at the up pose. Do this by moving to frame 9 (up pose). Make sure the L_Toe_Cntrl and L_Heel_Cntrl are both rotated to 0. But, make sure that L_Ball_Cntrl is activated and rotated up (I used Rotate X = 20). Set a key for all three handles as you check or alter each (**Fig. 9.33**).

FIG 9.33 Rotating the foot up to the ball on the up pose.

Step 19: Rotate the foot up onto the toe at the right footfall pose. Move the Current Time Marker to frame 12 (right footfall pose) and rotate the L_Toe_Cntrl to rotate the foot up (I used Rotate X = 40). Hit s. Set both L_Heel_Cntrl and L_Ball_Cntrl to be rotated to 0. Be sure to hit s to set a key for each of those (Fig. 9.34).

FIG 9.34 Rotating up to the toe on right footfall.

Step 20: Finish the left foot by refining the passing pose. Move the Current Time Marker to frame 18 and make sure that the L_Toe_Cntrl is set to Rotate X = 40 (hit s), but that L_Ball_Cntrl and L_Heel_Cntrl are set to Rotate X = 0 (hit s for both).

Why?

I know this is going to look all sorts of broken right now. Hang with me. We'll get much of this fixed as we work through the position of the Root joint in a bit.

Step 21: Repeat this foot roll process for the right foot as well.
Step 22: Update the Root joint's positioning for the left footfall, right footfall, and both passing positions. Be sure that with each pose adjustment at each frame that you hit s. This will likely entail moving the Root forward a little bit at each of those poses, and perhaps dropping it a bit to avoid hyperextension (Fig. 9.35).

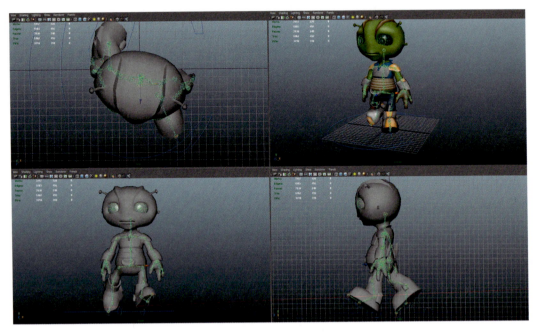

FIG 9.35 Adjusting Root control to fix any knee hyperextension.

> **Why?**
>
> Now that the foot roll is rotating like it should, there can be havoc to clean up with the knees. Ironically, the way to correct problems with the knees is to change where the Root joint is. By tweaking the Root joint to be appropriate to the footwork, things will smooth out.

Upper Body

Now that the lower body is animated, animating the upper body is largely about counteracting what's happening in the hips. When the left hip is forward, the right shoulder is forward. We can make this happen by rotating the joints that define our back.

After the back is defined, we can go back and add the rotation of the arms as appropriate.

Step 23: Balance the body through a torsion twist of the back. We'll do this at frames 1, 12, and 24 (the footfall poses). Select the joints that are the back (Back_Base, Back, Clav_Base) and then starting at frame 1, rotate them so that the shoulders are opposite to the hips (so, for instance, at frame 1, the right shoulder is rotated forward by rotating all the three joints 12 degrees [Fig. 9.36]). Take note of what the rotate values are here as they will be just opposite at frame 12. Values at frame 24 will match those at frame 1.

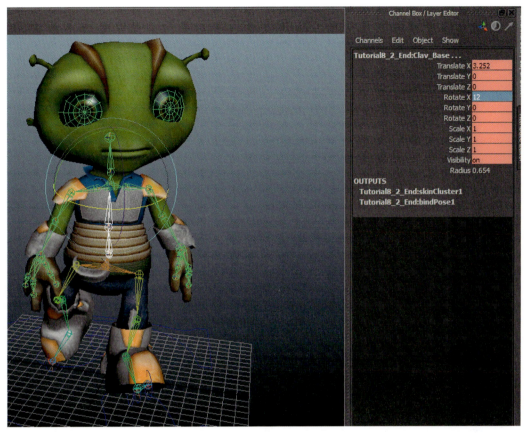

Channels Edit Object Show

Tutorial8_2_End:Clav_Base . . .

Translate X	3.252
Translate Y	0
Translate Z	0
Rotate X	12
Rotate Y	0
Rotate Z	0
Scale X	1
Scale Y	1
Scale Z	1
Visibility	on
Radius	0.654

OUTPUTS
Tutorial8_2_End:skinCluster1
Tutorial8_2_End:bindPose1

FIG 9.36 Rotating the back and shoulders to counteract the rotation of the hips.

Step 24: Balance the back at passing poses. This one is a little trickier; but the concept is the same. Take a look in the front view and look at frames 6 and 18. Because the hips are rotated to show the weight on one leg, the whole body will be crooked. Select each of the back joints one at a time, and rotate (only along Y) to counteract and balance the form (**Fig. 9.37**). You'll need to do it one at a time because positive Y for one joint may rotate the back in the opposite direction as the joint above it (some will need to rotate positive and some negative). The results should be a more balanced alien like Fig. 9.37.

Step 25: Balance the head. At the same frames 1, 12, and 24 (footfall poses) and again at passing poses (frames 6 and 18), rotate the head so that it is level.

Why?

So the idea here is to animate the hips and then, working up the body, balance each part of the body to counteract the rotation that is happening beneath it. It's what your body does when it walks as well.

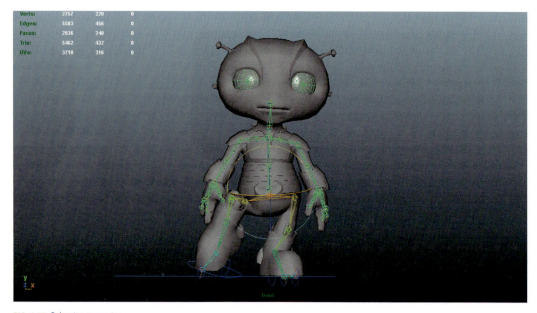

FIG 9.37 Balancing on passing poses.

Step 26: Pose the arms. At frame 1, rotate the shoulders, elbows, and wrists to match **Fig. 9.38**. Notice that the arms are opposite to the legs – so if left foot is forward, then right arm is forward. Remember that each time you move a joint, be sure to hit s to record the key. Also be sure to set a key-frame at frame 24 to match frame 1 for each joint. Move to frame 12 and rotate the arms opposite.

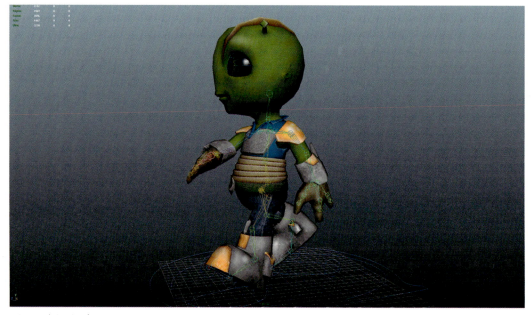

FIG 9.38 Animating the arms.

Step 27: Tweak, tweak, and tweak. Basically, the mechanics of the walk are done. But there are loads and loads of changes that can and still should be made. What can you do to add good wave principle to the arms? How should the hands be posed? Can you add more weight to the head? Tweaking is the real fun of animating; so be sure to have fun doing it.

Rendering Animations

Once you are sure you've got a good animation, it can be fun to render the animation out. Yes, I know, this is a game character and would be rendered in real-time in game. But, let us pretend this is part of a TV or film project.

Maya works best when you render animation as a series of sequential stills. Recent versions of Maya allow you to render directly to .avi or .mov, but I still recommend rendering to sequential stills. With sequential stills as the core output, changes can be easily made to just a few frames, and then you only have to re-render those few frames and not have to worry about finding where they go in the sequence.

Of course the drawback to this sequential still approach is you need to have some software that will allow you to assemble the stills. But there are lots that will do this, Adobe Premiere, AfterEffects, or the $29.95 version of Quicktime Pro. Maya even includes a sequential still viewer – Fcheck – that we'll look briefly at.

To render an animation, have your scene set up with the lighting scheme you have planned and the camera positioned as you want. Then choose Window > Render Editors > Render Settings.

Here you can choose things we've already talked about (rendering engine, resolution, etc.). Of particular importance are the highlighted areas of Fig. 9.39.

Frame/Animation ext: allows you to define how the images are going to be named. This becomes very important when dealing with hundreds of output frames. My favorite for animation is "name_#.ext" For this project, this would output files named "Alien_Walk_001.iff, Alien_Walk_002.iff, etc." The Frame Padding setting tells Maya how many 0's to put in front of the frame number so that the stills are really seen as sequential in various editing packages.

The Frame Range area allows you to define what frames are to be rendered. The default is between frames 1 and 10; but in this case, we would want frames 1–24. Or to be even more sophisticated, since frames 1 and 24 are the same – and we wouldn't want that frame played twice if the animation is looped, we could render from frames 1 to 23 so a looped animation would be smooth.

FIG 9.39 Render Settings for animation.

Click Close when the settings are finished.

To actually render the frames using these settings choose Rendering | Render > Batch Render. This is a pretty anticlimactic step as all you'll see is on the bottom of the interface a single line that tells you the progress of the render (**Fig. 9.40**).

// Result: Percentage of rendering done: 93 (Z:/Documents/Getting Started in 3D with Maya/Raw/GameCharacter/Game_Character/images/Alien_Walk_01.iff)

FIG 9.40 Rendering progress line letting you know that Maya is working away on the render.

These stills will be rendered to the images folder of your project.

To view them quickly, open FCheck (on a PC it can usually be found under the Start Menu > All Programs > AutoDesk > Autodesk Maya 2012 > FCheck. On a Mac go to the Applications folder > Autodesk > maya2012 > FCheck.

Once in FCheck choose File > Open Animation. Then navigate to the first frame of the sequence, hit Open and FCheck will load the frames into memory where you can view the animation playing in real-time and even scrub through it by dragging across the image.

Conclusion

Don't sweat it if the walk doesn't come right away. Truth be told, short characters with big feet can be particularly tricky to animate. If you're really struggling with this, you may try using a more traditionally proportioned character – like the one built for my other Focal Publishing book *Creating 3D Games with Unity and Maya*. The rig we build in that book is available online at http://creating3dgames.com.

My final animation for this little character is on the supporting website for this book at http://gettingstartedin3D.com.

And with that we're done. We've come a long way in this volume and covered a huge number of new concepts. Hopefully, the tutorials have provided a good groundwork upon which you can increase your skills and talents. The key will be moving beyond the tutorials – doing projects that aren't laid out in tutorials.

The next step will be to take all the new ideas and design and create your own room, level, furniture, textures, character, rig, and animation. It's where you'll get to test how well you really understand the ideas we've talked about. It'll be a sort of self-assessment. Come back and brush up if there's an area you're shaky on – but keep building your own vision.

Good luck!

Homework

1. Revisit the bouncing ball. Have it hop forward four or five times. How would the animation change? How would his poses help broadcast his intent to jump forward or to land?
2. Make that alien run in a run cycle.
3. How would the alien move differently if he had a heavy gun in his hand. Try the walk and run with a heavy item in one of his hands.

Appendix A: Preparing Character Style Sheets

Character style sheets are the front and side drawings of a character. These hand drawings *can* be an invaluable resource for a modeler as they provide an important visual template upon which to build polygons. However, they can also be a terrible hindrance if they are not properly done and prepared.

In this appendix we will be looking quickly at how to prepare character style sheets so that they become the effective tool they need to be. Whether you drafted the style sheet yourself or inherited it from another character's designer, a bit of time in Photoshop will ensure assets that speed and inform the modeling process.

Before we get too far into Photoshop, a few general notes about drawing style sheets that will help keep things clean:

1. Do the initial drawings on graph paper. The core issue here is really about making sure that the front and side views line up. The nose for the front view needs to match **exactly** the nose for the side view. If they are off by just a little bit, it wreaks havoc in Maya as you don't know which drawing to trust.
2. For the front view, consider just drawing one half of the character. We're about to discard one half of the drawing anyway, so sometimes just drawing half saves time and effort. This largely depends on you as an artist, though – some people can only find the form when they see the character in its entirety and so need to draw the whole form (and that's ok too).
3. Unless you're really good at illustrating in Photoshop, color your sketch with traditional media. Some folks – like Jake Green in the style sheet below – are very good at coloring in Photoshop and are able to define some great form for musculature and bones through deft handling of Photoshop's tools. However, overwhelmingly, when my students turn in sketches that were colored in Photoshop – it ends up looking like a Microsoft Paint project from 1986. Don't underestimate the power of effective coloring for defining how a form is actually built. If you aren't ready to spend the time to define this through many, many layers in Photoshop, just pick up your Prismacolors, paints, or even crayons to get that form right.

Tutorial A: Preparing Style Sheets

Figure A.1 is the style sheet created by Jake Green as part of the homework assignment for the organic modeling chapter. It's a great drawing; and, because he's also a modeler, it has been done with a great amount of

attention to having a nicely prepared style sheet for modeling. However, it will also serve as a great example of how to prepare individual images for use as Image Planes within Maya.

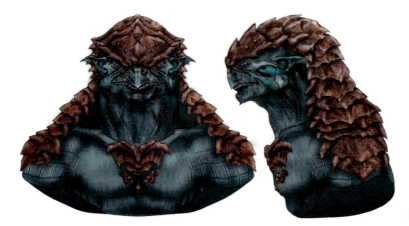

<div align="right">

FIG A.1 Character style sheet.

</div>

All of the following steps are done in Photoshop.

Step 1: Flatten layers. Once the file is open, go to Layer>Flatten Image.

> **Why?**
>
> It's going to be very important that the front and side versions of the style sheet are the same size. If, during the painting process, there are multiple layers, or if the front and side were assembled separately, you can end up with situations where a selection may include empty pixels – that will be lost if that selection is copied and pasted to a new document. Flattening the image makes sure there are not empty pixels anywhere and that you just have a flat collection of pixels that make up both sides of the image.

Step 2: Crop away unneeded image (**Figure A.2**). Just leave the actual character with very little background.

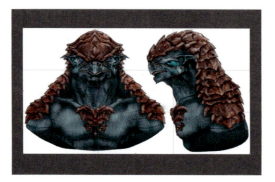

<div align="right">

FIG A.2 Cropping down to just the character.

</div>

Most of the time, your character sketch is going to be fairly high resolution. This one for example is at 300 dpi. This can be good as you're going to be modeling quite tightly on the character (it's really important to be able to zoom right into how the lips come together in Maya). However, Maya actually deals with these large images surprisingly poorly and your performance can take a real hit with these large images. One solution is to reduce the resolution of the image – but this makes for a really pixelly image when you need it most within Maya. Another solution is to make sure you're not carrying around any pixels you don't need by cropping the excess away.

Step 3: Create comparison guides. Do this by first hitting Cntrl-r to bring out the rulers. Then, drag a horizontal guide from the rulers at the top down onto the image. Pull this guide down to the top of the head of the front view. Drag another down for the chin. Add a third for the top of the ear and a fourth for the bottom of the ear (**Figure A.3**).

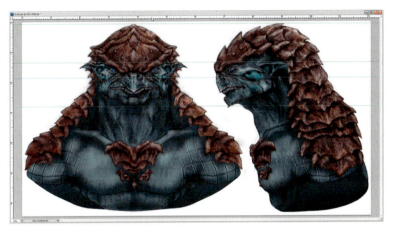

FIG A.3 Adding the first collection of horizontal comparison guides.

These horizontal guides serve the important purpose of ensuring that the two sketches line up. If the ear is higher in the side sketch than it is in the front sketch, we'll have real problems in Maya.

Step 4: Adjust if needed. This can take a couple of forms. Sometimes things don't line up because the sketches are rotated. To fix this, select everything with the Rectangular Marquee Tool and hit Cntrl-T to activate the Free Transform tool. Rotate the selection until the sketches line up better.

In some situations this may be more complex and you might need to make use of tools like Liquify (Filter>Liquify) to nudge parts of the anatomy into position.

Why?

"C'mon," you may be saying, "I drew it, let's just get it into Maya and build it." This is a real temptation, but the few minutes it takes to get things lined up here in Photoshop will yield incredible benefits in Maya. If these sketches aren't lined up, there is great head scratching and form compromising when the polygons have to be unyieldingly placed to describe the form. Working out the problems here will pay dividends in the 3D world.

Step 5: Add additional horizontal guides. Do this for everything imaginable: top and bottom of the eyes, middle of the eyes, top and bottom of the nostrils, ends of the lips, middle of the lips, top and bottom of the collar bones, top and bottom of any other meaningful anatomical part. For full characters where the sketch is the entire body, this should include things like the bottom of the crotch, shoulders, arm pits, elbows, hands, fingers, knees, feet, and especially any armor.

Why?

Again, having things lined up makes the modeling much, much easier. Making guides are cheap and easy but they can help in a hurry and let you know if there are problems that need to be dealt with before the modeling begins.

Step 6: Make adjustments as needed. Again, this could be about scaling, rotating, or even liquefying one side of the sketch so that the front and side line up perfectly.

Separating into Two Images

Up to now, the front and side have been together in one image – which is really what we want and need as we work through the comparison of the two. However, once the two line up and you're confident that the front and side are set to go, we need to get these into the discreet images that we'll use as image planes in Maya.

Step 7: Select the part of the image that makes up the side view. Do this with the Rectangular Marquee Tool, but make sure that your selection starts right at the top of the image and goes completely to the bottom

(**Figure A.4**). This is most easily done by starting the selection above the image in the canvas area and then dragging down to below the image (also in the canvas area).

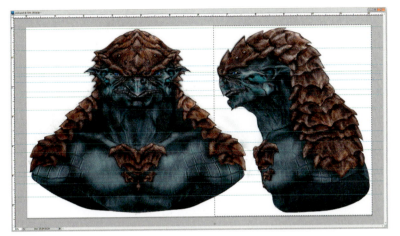

FIG A.4 Selecting the side sketch.

Why?

A common pitfall is for people to get the front and side images all lined, up and then when splitting into two separate images not copying and pasting selections that are the same height. When this happens, it becomes very difficult to get these two images to line up right in Maya. By making sure that you are getting a selection that goes the entire height of the image, you can ensure that the front and side images are indeed going to be of identical height.

Step 8: Copy and paste this selection into a new file. Do this by selecting Edit>Copy then File>New and then Edit>Paste (**Figure A.5**). Save the file as `YourCharactersName_Side.jpg`.

FIG A.5 Side View.

Tips and Tricks

At this point, it's largely cosmetic, but if you'd like, you can paint out chunks of the front view that may have made their way over to this side image. However, make sure you don't change the size of the image overall.

Step 9: Back in the original aligned style sheet, make a new selection (again from the very top of the image to the very bottom) that is one half of the front view. This selection needs to be very accurate, so take your time and get exactly half that image (**Figure A.6**).

FIG A.6 Selecting one half of the front view.

Why?

If you have an assymetrical character, you may want to skip this step entirely. However, if the character is symmetrical, it will make things much easier in Maya if the center of the image is really the center of the character. This will mean that when the front image is brought into Maya as an image plane, the image's center is at X = 0.

Step 10: Copy and paste this selection into a new file. Again, Edit>Copy then File>New and then Edit>Paste (**Figure A.7**).

FIG A.7 Copying and pasting the half of the front view into a new file.

Step 11: Change the Canvas Size to be twice as wide. Do this by choosing Image>Canvas Size…Change the settings to match **Figure A.8**. This will move the current image over to the left side and make the canvas exactly twice as wide as it is.

FIG A.8 Setting the Canvas Size to be twice as wide.

407

Step 12: Choose Edit>Paste to paste another copy of one half of the front view into this same image.

> **Why?**
>
> One half of the image will be stored in memory so simply hitting paste again will keep you from having to go back to the original image.

Step 13: Flip this new copy with Edit>Transform>Flip Horizontal. This will create a mirrored version of the selection.

Step 14: Use the Move Tool to move this flipped half over to the other side of the image. If Shift is held down while the selection is dragged, it will keep it from shifting up and down. This second half snaps into place once it's over against the other side of the canvas image (**Figure A.9**). Save the file as `YourCharactersName_Front.jpg`.

FIG A.9 Symmetrical front view.

Conclusion

And the rest you know. Now that you have a good front and side view and you know that they line up and that the front is truly symmetrical, the images are ready for use within Maya and can be imported as image planes into the front and side View Panels.

There is great power in good front and side image planes. If you're modeling your own design, you will be able to move with much great efficiency as you place polygons. If someone else is inheriting your design, they will praise your name if the style sheets arrive on their machine properly prepared. In all cases, the half hour it takes to complete the steps listed in this tutorial will be time well spent.

Appendix B: Creating Seamless Textures

In the texture chapters, I've continually lauded the great online resource cgtextures.com. In a pinch it's a great place to go to grab textures to place in your scene. Generally though, textures that are easily available online are great because they *are* quickly available online – and also not great because they are quickly available online. It means that not only you, but every other 3D artist with an Internet connection can grab and use these texture resources. I've personally seen multiple demo-reels where I've recognized a texture from cgtextures on a wall.

In some of our tutorials we've looked at one way to mitigate this problem through heavy manipulation and layering of texture assets. Using multiple layers with various Blending Modes can quickly customize a texture into a look that is unique to your project. However, of further customization is the ability to use your own photography assets to be the basis of the textures. This will ensure a completely unique look; and since you took the photos, this always ensures you have the rights to the texture files.

This does require a little bit of extra work – but the original results are generally worth it. There are a few problems that emerge from your own photographs (which, by the way, can be a problem with some online resources too). The biggest problem is the problem of seams.

Figure B.1 shows a photo of a chunk of a wall that I need to extract a stucco texture off of. The selected area is the chunk of that texture I copied and pasted into a new file.

FIG B.1 Raw image of a stucco wall with the chunk of the photo used for texture.

411

The problem is that this chunk of the wall, when applied to geometry, ends up looking like **Figure B.2**.

FIG B.2 Applied texture – see the seams?

Suddenly, our stucco looks more like bricks. The problem is that when the texture repeats, we can see the seams of where each tile of the texture stops and ends. Part of this has to do with color, and part of it has to do with the breakdown of texture.

In this appendix's tutorial we will look at removing seams from source photography. To yield a texture that tiles well across a form. But before that, let's look briefly at a few tips on taking your own photography for use in textures.

Texture Photography Tips

1. Take the photo as straight on to the surface as possible. The lens of the camera and the surface of interest should be parallel. Getting a flat image will save loads of time and avoid all sorts of muddying of the image from over adjustment in Photoshop.
2. Don't use a flash. Ever. Flashes create strange hotspots across the surface that are very difficult to work out.
3. Either take the photograph in the shade, or with the sun straight onto the surface. The key idea here is to avoid cast shadows from raised parts of the texture onto the surface itself. We want to make sure that a stucco wall isn't locked into looking like the sun is at 3:00 PM in the afternoon (we'll want to define that in our scene).
4. If available, use a telephoto lens and be as far from the surface as possible. Wide angle lenses will provide fish-eyed photographs where parallel lines (like mortar between bricks) are suddenly not parallel. A telephoto lens tends to collapse perspective and will keep your texture as flat as needed.

5. Take the photos to cover a big chunk of texture, but make sure you are capturing at a high resolution. A big 8000x8000 pixel image that covers a whole wall (that you'll extract a small 512x512 image from) provides many more options than a tightly shot 512x512 one. In the end you'll have the same sized texture, but the flexibility to pick the part of the texture that works best.

So, assuming that you have some good photography, or even mediocre images (my shot for this tutorial is included in the support files on the supporting website: www.GettingStartedin3D.com), we can start working through how to work the seams out.

Tutorial B Creating Seamless Textures

Step 1: Open the original photograph (you can use mine or your own), and using the Rectangular Marquee Tool, select a chunk of texture that might work well for the texture base (Figure B.1).

Tips and Tricks

Try to avoid picking a chunk of texture that may include a very noticeable element that would stick out if repeated. For instance, don't select a chunk that includes a bug on the wall, as that bug regularly repeated will certainly destroy the look of the material later. Similarly, look for a chunk that is as evenly lit as possible.

Step 2: Copy and paste this selection into a new file. Save it as ColorResource.jpg (the file type here doesn't really matter).
Step 3: Create another new file and paste the image into this one again. Save this as Stucco_Color.jpg (**Figure B.3**).

FIG B.3 Copied and pasted texture chunk.

Step 4: Work in Stucco_Color.jpg and select Filter>Other>Offset. Change
the Horizontal and Vertical sliders to values that allow you to see the
seams somewhere in the middle of the image (**Figure B.4**). Hit OK.

FIG B.4 Using the Offset Filter to
bring the seams into the middle of
the image.

Step 5: Remove the color by selecting Image>Adjustments>Desaturate (**Figure B.5**).

FIG B.5 Grayscale results of Desaturate.

Why?

Notice that as soon as this is done, some of the seams become much less apparent – in this case the vertical seam practically vanishes. Getting a constant color balance across the image is a huge part of eliminating visible tiles. Not to worry however, we'll get the color back into this in coming steps.

Step 6: Use the High Pass Filter to further unify the surface. To get to the High Pass Filter, go to Filter>Other>High Pass. Tweak Radius slider so that you are left with a further flattened image (**Figure B.6**).

Step 7: Use the Clone Stamp Tool to work out the still visible seams. To use the Clone Stamp Tool, Alt (or Option)-click on a spot to define a source. Then release the Alt/Option key, and where you then click and drag will clone the part of the image you defined the source as (**Figure B.7**).

Step 8: Reintroduce color to the texture. To do this, first make sure that both Stucco_Color.jpg (which you're working on) and ColorResource.jpg are both open in Photoshop. Then, select Image>Adjustments>Match

FIG B.6 Using the High Pass Filter to further flatten the image.

FIG B.7 Working out the remaining seam with the Clone Stamp Tool.

Why?

The Clone Stamp Tool can be tremendously useful, but it's usefulness is very situational. Sometimes, like for this stucco, a wide brush with a soft edge (defined up at the top of the Photoshop interface), provides a great way to work out the seam. But in other situations – say a collection of pebbles or bricks, using a much harder edged brush will allow you to work the seams out by cloning the exact edges of stones or bricks into place. Similarly, using a low Flow setting for the tool can sometimes allow for a very subtle layering of cloned pixels; but at other times it can just create a muddied mess across the seam that doesn't work at all. It sometimes takes a bit of experimentation in each situation to find what works best with the asset at hand.

Color. In the Match Color dialog box go down to the Source section and choose ColorResource.jpg. Click OK (**Figure B.8**).

FIG B.8 Using the Match Color to reintroduce color to the stucco.

> ### Why?
>
> What's happening here is Photoshop is looking at the colors from our original ColorResource image and applying it to the gray-scaled version we have been working with. Photoshop looks at the luminance value of the pixels to try and match up what colors should be where – and it usually does quite a good job.

Step 9: Adjust Levels/Color saturation to taste (**Figure B.9**). I like using the Image>Adjustments>Curves mechanism.

FIG B.9 Results of adjusting Color Balance and Levels.

> **Why?**
>
> Through the course of desaturating the image and then using the High Pass Filter, sometimes the image can end up a little dark and lose a lot of its contrast. After you've got a seamless image, taking some time to adjust the results can get you back to the initial look of the original photography.

Step 10: Save. Test (**Figure B.10**).

FIG B.10 Applied seamless version.

Conclusion

Seamless textures are important; and with the steps listed above are not too difficult to create. Keep in mind that much of the efficacy of this technique relies on the quality of the source photography. If it just isn't working, go take the photo again to get the raw stuff you need.

At the end, there's little excuse for not getting any surface to be just right. All you need to do is find its real world equivalency, and the texture can be reworked into a good seamless repeating texture to make your work unique.

Index

Page numbers followed by *f* indicates a figure and *t* indicates a table.